Meant to Be Shared

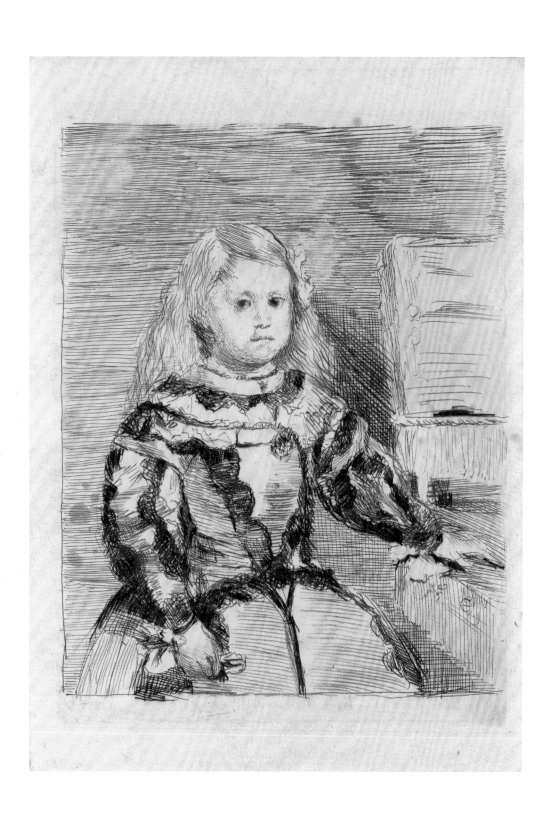

Meant to Be Shared

The Arthur Ross Collection of European Prints

Suzanne Boorsch, Douglas Cushing, Alexa A. Greist, Elisabeth Hodermarsky, Sinclaire Marber, John E. Moore, and Heather Nolin

With a foreword by Janet C. Ross

YALE UNIVERSITY ART GALLERY
New Haven

DISTRIBUTED BY YALE UNIVERSITY PRESS
New Haven and London

Publication made possible by the
Arthur Ross Foundation.

First published in 2015 by the
Yale University Art Gallery
1111 Chapel Street
P.O. Box 208271
New Haven, CT 06520-8271
www.artgallery.yale.edu/publications

and distributed by
Yale University Press
302 Temple Street
P.O. Box 209040
New Haven, CT 06520-9040
www.yalebooks.com/art

Published in conjunction with the exhibition
Meant to Be Shared: Selections from the Arthur Ross Collection of European Prints at the Yale University Art Gallery, organized by
the Yale University Art Gallery.

Yale University Art Gallery
December 18, 2015–April 24, 2016

Samuel P. Harn Museum of Art,
University of Florida, Gainesville
January 29–May 8, 2017

Syracuse University Art Galleries, New York
August 17–November 19, 2017

Tiffany Sprague, Director of Publications and Editorial Services
Christopher Sleboda, Director of Graphic Design

Proofreaders: Penelope Cray, Zsofia Jilling,
and Marsha Pomerantz

Set in Lyon Display and Lyon Text
Printed at GHP, West Haven, Conn.

Library of Congress Control Number: 2015940302
ISBN 978-0-300-21439-0

10 9 8 7 6 5 4 3 2 1

JACKET ILLUSTRATION (FRONT): Detail of Francisco Goya, *Modo de volar* (A Way of Flying), also known as *Donde hay ganas hay maña* (Where There's a Will There's a Way), from *Los disparates (Los proverbios)* (Follies [Proverbs]), ca. 1816–19, published 1864; JACKET ILLUSTRATION (BACK): Giovanni Battista Piranesi, *Ichnographiam Campi Martii Antiquae Urbis* (Ichnographia [Plan] of the Campus Martius of the Ancient City), 1757; FRONTISPIECE: Edgar Degas, after a painting attributed to Juan Bautista Martínez del Mazo, *The Infanta Margarita*, 1861–62; PAGE XII: Detail of Francisco Goya, *Modo de volar* (A Way of Flying), also known as *Donde hay ganas hay maña* (Where There's a Will There's a Way), from *Los disparates (Los proverbios)* (Follies [Proverbs]), ca. 1816–19, published 1864; PAGE 12: Detail of Pietro Campana, Carlo Nolli, and Rocco Pozzi, after Giovanni Battista Nolli and Giovanni Paolo Panini, *La pianta grande di Roma* (The Large Plan of Rome), 1748; PAGE 42: Detail of Honoré Daumier, *Le ventre législatif* (The Legislative Belly), 1834; PAGE 46: Detail of Giovanni Battista Piranesi, *Antiqvvs Circi Martial cvm monvm adiacentia prospectvs ad viam Appiam* (Ancient Circus of Mars with Neighboring Monuments Viewed at the Via Appia), frontispiece to volume 3 of *Antichità romane* (Roman Antiquities), 1756; PAGE 58: Detail of Francisco Goya, *Pepe Illo haciendo el recorte al toro* (Pepe Illo Making the Pass of the *Recorte*), plate 29 from *La tauromaquia* (The Art of Bullfighting), 1815, published 1816; PAGE 66: Eugène Delacroix, *Méphistophélès dans les airs* (Mephistopheles in the Skies), from Johann Wolfgang von Goethe's *Faust*, 1827, published 1828; PAGE 78: Detail of Giovanni Battista Piranesi, *Piramide di C. Cestio* (Pyramid of Gaius Cestius), from *Vedute di Roma* (Views of Rome), 1756

Contents

Director's Foreword

In December 2012, the Yale University Art Gallery was honored to receive a most generous and significant gift from the family of Arthur Ross (1910–2007) and the directors of his eponymous foundation: more than 1,200 seventeenth- to twentieth-century Italian, French, and Spanish prints of the highest quality, including numerous complete sets of important eighteenth- and nineteenth-century print series.

Arthur Ross, a native New Yorker, businessman, and philanthropist, created the Arthur Ross Foundation in 1955. Through his foundation, Ross supported social and cultural nonprofit organizations, contributed to fellowship and scholarship funds, and, beginning in about 1980, meticulously and methodically collected works of art by some of the most renowned printmakers of the last four centuries, including Giovanni Battista Piranesi, Francisco Goya, and Édouard Manet. Ross collected great works of art not to adorn the walls of his foundation's office but to share it publicly—especially through partnerships with educational institutions—for viewing and studying. He continually lent to museums on academic campuses with which he had a personal association and actively sought new collaborators, then encouraged them to generate their own exhibitions from the collection. Consequently, some portion of the ever-expanding collection was accessible to the public for thirty years. Reading through some of the forewords and statements that Ross wrote for exhibition catalogues, one becomes keenly aware of his appreciation for the creative genius of the artists whose work he so assiduously collected and of his deep commitment to sharing this genius with others.

It was with this same spirit of generosity, as well as a desire to keep the Arthur Ross Collection intact, that the directors of the foundation—Janet C. Ross, George J. Gillespie III, William J. vanden Heuvel, and Edgar Wachenheim III—together with Ross's family, decided to bequeath the collection in its entirety to the Gallery, knowing full well that we would continue not only to care for the collection but also to share it with a broad audience of students, scholars, and the public.

This important collection was first brought to my attention by Ross's younger son, Clifford, though how this happened was quite by accident. I had met Clifford not long after becoming the Gallery's director in 1998, he being one of many notable alumni artists who had received their training either as undergraduates or graduates at Yale and with whom I sought to engage. Clifford had left his alma mater in 1974 with a bachelor's degree in art and art history and had quickly gone on to become an artist, one now highly regarded for both his traditional photography and his more recent creative uses of photography's digital form. Like his father, Arthur, Clifford had also developed an interest in works on paper, and he soon became an avid and generous collector. It was during a visit to the father and son's shared art-storage facility in New York that I first beheld both the range of modern works Clifford had been collecting and the substantial quantity of Old Master and modern prints that his father had expertly acquired, then framed, matted, crated, and kept at the ready to lend to museums throughout America and abroad. Not long before, I had lured Suzanne Boorsch from the Metropolitan Museum of Art, in New York, to the Gallery, to become its curator of prints, drawings, and photographs, and Clifford told me during this meeting that it was Suzanne who had organized an exhibition at the Italian Cultural Institute of New York featuring all of the etchings in his father's collection by the outstanding Venetian artist Canaletto. Clifford suggested that I make an appointment with Suzanne to meet his father and his father's wife, Janet, an opportunity that soon came to pass with a very pleasant conversational visit to the couple's apartment and a tour of their beautiful array of paintings and works on paper.

We at the Gallery are now happily carrying on Arthur Ross's legacy, and in so doing, we are reaffirming a commitment we made in 2010, when we launched our Andrew W. Mellon Foundation–funded Collection-Sharing Initiative. Through this project, we opened our collections to curators from six academic museums, offering them the opportunity to curate exhibitions that they would otherwise have been unable to mount at their museums. Since then, we have continued to value the sharing of the Gallery's collections with a wide range of both public and private academic art museums. Thus, *Meant to Be Shared: Selections from the Arthur Ross Collection of European Prints at the Yale University Art Gallery*, the inaugural exhibition of the Arthur Ross Collection at Yale, will travel to two additional venues, both beyond the confines of the Northeast corridor. One, the Samuel P. Harn Museum of Art at the University of Florida, Gainesville, is on the campus of a public university, while the other, the Syracuse University Art Galleries, is on the campus of a private school. It is our hope that, through close looking at the

exemplary objects in this exhibition, audiences at all three institutions will better appreciate Ross's keen eye and will realize that he collected only the best.

In addition to serving as the definitive source on the Arthur Ross Collection, the present catalogue, released concurrently with the inaugural exhibition, is intended to inspire other museums to use the collection as a teaching resource, thus allowing the collection to reach an ever-wider audience. As well as an introductory essay by Suzanne Boorsch, now the Robert L. Solley Curator of Prints and Drawings at the Gallery and the lead curator of the exhibition, the publication includes a collection of essays written by a diverse group of authors— academics and museum professionals with different areas of expertise and at various stages in their careers—from Yale and two of our sister museums, the Blanton Museum of Art at the University of Texas at Austin and the Smith College Museum of Art, further emphasizing the collaboration that the collection has fostered. These essays detail the ways in which Ross's collection may continue to circulate and teach new audiences.

Finally, the catalogue and its concurrent exhibition are meant to honor Arthur Ross, his generous spirit, and his vision, as well as the collection itself—one it took him roughly a quarter century to assemble. In the foreword to the 1989 Columbia University exhibition *Graphic Evolutions: The Print Series of Francisco Goya*, Arthur Ross stated that Goya "opened the way to the stimulating and provocative journey on which modern art continues to carry us." We are grateful that the Arthur Ross Foundation has chosen the Gallery to be the steward of this collection, assuring its proper care and always sharing it generously with active learners of all ages.

Jock Reynolds
The Henry J. Heinz II Director

Donor's Foreword

The often-repeated Laozi quote "A journey of a thousand miles begins with a single step" could be applied to the journey of the Arthur Ross Collection, which has recently arrived at the Yale University Art Gallery and is now being celebrated with this inaugural publication and traveling exhibition.

The journey began in New York City one day in the late 1970s. My husband, Arthur Ross, and his younger son, Clifford, stepped into the Weyhe Gallery at 794 Lexington Avenue. They were on a mission. By the time they stepped out, a short while later, Arthur had purchased a first-edition print, number 56 of Francisco Goya's series *Los caprichos* (below). He was struck by its caption, *Subir y bajar*—"To rise and to fall," or "Now you are up, now you are down." This was an ironic reference to the plight of its subject, an unwitting, laughing

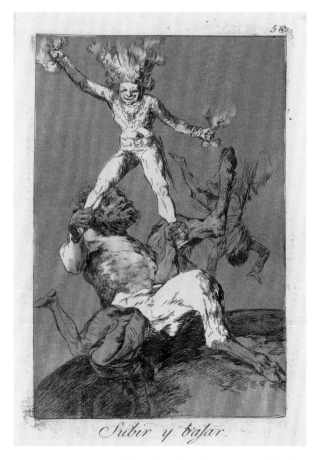

FRANCISCO GOYA, *Subir y bajar* (To Rise and to Fall), plate 56 from *Los caprichos* (The Capriccios), 1797–98, published 1799. Etching and burnished aquatint, 12 3/8 × 9 3/16 in. (31.4 × 23.3 cm). Collection of Mrs. Arthur Ross

youth being playfully tossed in the air by a grotesque figure of the god Pan. The giddy young man is heedless of the two terrified figures plummeting past him to earth.

Arthur, optimistic but pragmatic, had come of age during the Great Depression and was captivated by Goya's wry philosophy; thus, seeking to know more of Goya, he embarked on a collector's journey and eventually purchased a full set of the *Caprichos*.

In 1979 Arthur first exhibited the *Caprichos* at the Low Memorial Library of Columbia University. In a collector's statement a decade later, he wrote,

> The first of Goya's graphic series, which he significantly named *Los caprichos,* represented a major artistic initiative and established a direction for the etchings that followed. The word *capricho* refers to the goat, *cabra,* who scorns the huddle of the sheep on the valley floor to browse dangerously on the cliffs. So Goya, in this and subsequent graphic works, broke ranks with the classical tradition and ushered in a new era of creativity, liberated from the shackles of conventional subject matter and artistic techniques.

Subsequently, the Arthur Ross Collection was formed. Its purpose was to lend first-class prints—free of loan fees—to educational institutions in the United States and abroad that would not otherwise have access to such objects for study and enjoyment. In 1985 Clifford Ross steered a portion of the collection toward the Peggy Guggenheim Collection on the Grand Canal in Venice for the exhibition *Tauromaquia: Goya-Picasso*, the first special exhibition to be shown there that was not culled from the Peggy Guggenheim Collection. Over time, there followed European exhibitions of other prints from the Arthur Ross Collection, including further exhibitions of Goya and several of Giovanni Battista Piranesi's *Vedute di Roma*, in cities such as Barcelona, London, Madrid, Paris, Rome, and Venice.

Pleasurable journeys benefit from good company; along the way, many, too numerous to single out, have joined in this one—historians who contributed illuminating essays and lectures, curators of university galleries and museums, and dealers. Essential to the formation of the collection, however, and to its ongoing quality has been Frederick G. Schab, the expert dealer in fine prints (see Greist, fig. 2). His deep knowledge and insights have been as substantial as any treasures he brought to our

attention. Early on among the historians were the late Eleanor Sayre, a Goya expert at the Museum of Fine Arts, Boston, and Suzanne Boorsch, who provided generous consultation while she was at the Metropolitan Museum of Art, in New York, and who is now, happily, the Robert L. Solley Curator of Prints and Drawings at the Gallery.

The family of Arthur Ross and the former trustees of the Arthur Ross Foundation wish to express appreciation for the invaluable contributions of Gail Lloyd, former executive director of the foundation, who, with Arthur, combed catalogues, galleries, and print shows and researched all acquisitions. In addition to her other foundation duties, she was responsible for every item on every journey that the objects in the collection made until their safe arrival in New Haven.

At times family members, including me, have expressed surprised awareness of the depth of the collection that Arthur had been building. This new home provides us with a chance to join the "active learners" that Jock Reynolds mentions in his foreword to this catalogue, a description that fits the collector perfectly. We are grateful that after these inaugural exhibitions, the Arthur Ross Collection will remain at Yale, cared for by expert curators and shared, as my late husband intended it to be. We believe that being in contact with the more than 1,200 prints in the collection by such formidable artists will launch others on at least as many interesting journeys.

Janet C. Ross

Arthur and Janet Ross at the American Academy in Rome, 1984

Acknowledgments

Prime among those to whom we express gratitude on the occasion of the exhibition *Meant to Be Shared: Selections from the Arthur Ross Collection of European Prints at the Yale University Art Gallery*, and the publication of this comprehensive catalogue of the collection, is the Arthur Ross Foundation itself, for its extraordinary generosity in donating to the Yale University Art Gallery the more than 1,200 prints that Arthur Ross amassed over a period of a quarter century. Pride of place in our thanks goes to those who were instrumental in bringing the collection to Yale: Arthur Ross's widow, Janet C. Ross, President of the Arthur Ross Foundation; his son Clifford Ross, B.A. 1974; and Arthur Ross Foundation Board members George J. Gillespie III, William J. vanden Heuvel, and Edgar Wachenheim III, as well as the executive director of the foundation, Gail P. Lloyd. We extend sincere thanks also to the Ross family, including Beverly; Alfred and Jane; and Adrian and Caroline, M.M. 2013.

It has been a pleasure to work with Rebecca Martin Nagy, Director of the Samuel P. Harn Museum of Art, and her colleagues at the University of Florida, Gainesville, where the inaugural exhibition will travel in early 2017, after its presentation at Yale. Later that year, the exhibition will be shared with the academic community at Syracuse University and the wider public in that region, and we are delighted to thank Director Domenic Iacono and his staff at the Syracuse University Art Galleries for their enthusiastic participation in the enterprise.

We are also most fortunate to have had the collaboration and assistance of colleagues at the Blanton Museum of Art at the University of Texas at Austin, and at the Smith College Museum of Art, where focused exhibitions drawn from the Arthur Ross Collection will be showcased in 2016. Research for these projects is reflected in two essays in this volume, one on Giovanni Battista Piranesi by John E. Moore, Professor and Associate Chair of the Art Department at Smith, and one on Francisco Goya by Douglas Cushing, the 2014–15 Andrew W. Mellon Fellow at the Blanton; we are grateful for both of their contributions. In planning these special exhibitions, it was a great pleasure to work closely with, at the Blanton, Simone J. Wicha, Director, and Francesca Consagra, Senior Curator of Prints and Drawings and European Paintings; and at

Smith, Jessica Nicoll, Director and the Louise Ines Doyle '34 Chief Curator, and Aprile Gallant, Curator of Prints, Drawings, and Photographs, as well as with Barbara Kellum, Professor of Art.

At the Yale University Art Gallery, tremendous gratitude is first and foremost extended to Jock Reynolds, the Henry J. Heinz II Director, without whose vision and enthusiasm the collection would not have found its permanent home here. Pamela Franks, Deputy Director for Exhibitions, Programming, and Education and the Seymour H. Knox, Jr., Curator of Modern and Contemporary Art, has been an invaluable partner in every phase of planning the exhibition, and Laurence Kanter, Chief Curator and the Lionel Goldfrank III Curator of European Art, provided steady support throughout the development of the project. The contributions of Heather Nolin, Assistant Director of Exhibitions, Programming, and Education, to the shaping and organization of the exhibition, and also to the catalogue, have been truly incalculable, and I am profoundly indebted to her for her unstinting devotion to the project and her unfailingly judicious recommendations. Heather has also provided a thoughtful essay to the present publication on the Gallery's Collection-Sharing Initiative and its forthcoming manifestations with the Arthur Ross Collection.

Numerous other colleagues were involved in producing this catalogue and the associated inaugural exhibition, as well as in the integration of the objects into the collection. In the Department of Prints and Drawings, Elisabeth Hodermarsky, the Sutphin Family Senior Associate Curator, contributed an enlightening essay to the catalogue on nineteenth-century French print series based on literary texts, a major segment of the Arthur Ross Collection; the collegial encouragement she gave throughout the process is also much appreciated. Suzanne Greenawalt, Senior Museum Assistant, and Alexa A. Greist, former Florence B. Selden Fellow, did the initial intense and detailed cataloguing of the works in the Gallery's collection database. Alexa also wrote an essay for the catalogue that focuses on Arthur Ross himself. Theresa Fairbanks Harris, Senior Conservator of Works on Paper, provided her unsurpassed expertise, assuring the optimum physical condition of the objects, and Diana Brownell, Senior Museum Technician/

Preparator, offered her usual meticulous work in housing the objects, including framing several extraordinarily large works. Lucy Gellman, the Florence B. Selden Fellow in the department from 2013 to 2015, helped immeasurably with research for the catalogue, and Rebecca A. Szantyr, who joined us as the Selden Fellow in summer 2015, has amiably continued to carry out this work.

Many students also contributed to the project, including Sinclaire Marber, B.A. 2014, and Caroline Sydney, SM '16, both of whom made significant contributions during their time as Nancy Horton Bartels Scholar interns; Sinclaire also contributed to the catalogue a history of the numerous exhibitions of the Arthur Ross Collection before it arrived at Yale. Most sincere thanks are due to Nancy and the late Henry Bartels for their generous support of the Gallery through this internship. Jakub Koguciuk, a PH.D. candidate in Art History and Renaissance Studies, provided important and wide-ranging research for the project, and Sarah Ana Seligman, graduate student in the Institute of Sacred Music, and Fiona Drenttel, a student at the Hopkins School, each provided valuable assistance during a summer internship.

The Registrar's Office, headed by L. Lynne Addison, put particular effort into this enterprise, and special thanks go to Senior Associate Registrar Anne Goslin, who carried out the demanding work of integrating the collection into the Gallery's holdings, both physically and digitally, and Amy Dowe, Senior Associate Registrar, who provided invaluable help with the traveling exhibition. Carol DeNatale, Deputy Director for Operations, and Burrus Harlow, Director of Collections, contributed ongoing and willing support when needed. Andres Garces, Conservation Assistant, managed the logistics of making every object in the collection available for photography, each one carefully captured by Anthony De Camillo and Richard House of the Visual Resources Department, led by John ffrench.

It is nearly impossible to convey ample gratitude to Tiffany Sprague, Director of Publications and Editorial Services, who with her always exacting care and seemingly infinite patience has shepherded this catalogue, including contributions by seven different authors, to publication. She was ably assisted by Julianna White, Editorial Assistant, as well as Olivia Armandroff, BK '17, who provided editorial assistance during a summer internship. The brilliant work of Christopher Sleboda, Director of Graphic Design, on the design of both the catalogue and the exhibition was executed with his usual combination of diligence and inspiration.

Jeffrey Yoshimine, Deputy Director for Exhibition and Collection Management; Clarkson Crolius, Exhibitions Production Manager; and Anna Russell, Museum Assistant, carried out, always thoughtfully and helpfully, the nearly innumerable tasks, large and small, needed to get an exhibition of this size ready; their professionalism and care are greatly appreciated.

Molleen Theodore, Assistant Curator of Programs, consulted and advised on the numerous aspects of programming in conjunction with the exhibition, and Jill Westgard, Deputy Director for Advancement; Brian McGovern, Assistant Director of Advancement; Jessica Labbé, Deputy Director for Finance and Administration, and Charlene Senical, Assistant Business Manager; Joellen Adae, Director of Communications; and Leonor Barroso, Director of Visitor Services, all contributed greatly to the wide scope and outreach of the exhibition.

Besides those mentioned above, for help of a variety of kinds most grateful thanks are due to Vincent Buonanno, David Friedman, Barbara Hayes, Sebastian Hierl, Marvin Newman, Georgina Parker, Andrew Robison, Frederick G. and Margery Schab, and Janis Tomlinson.

In addition to the donation of the collection itself, the Arthur Ross Foundation made possible the present exhibition and catalogue through generous funding. We also express grateful thanks to the Isabel B. Wilson Endowment, which provided funding for the exhibitions traveling to the Blanton Museum of Art and the Smith College Museum of Art.

Suzanne Boorsch
The Robert L. Solley Curator of Prints and Drawings

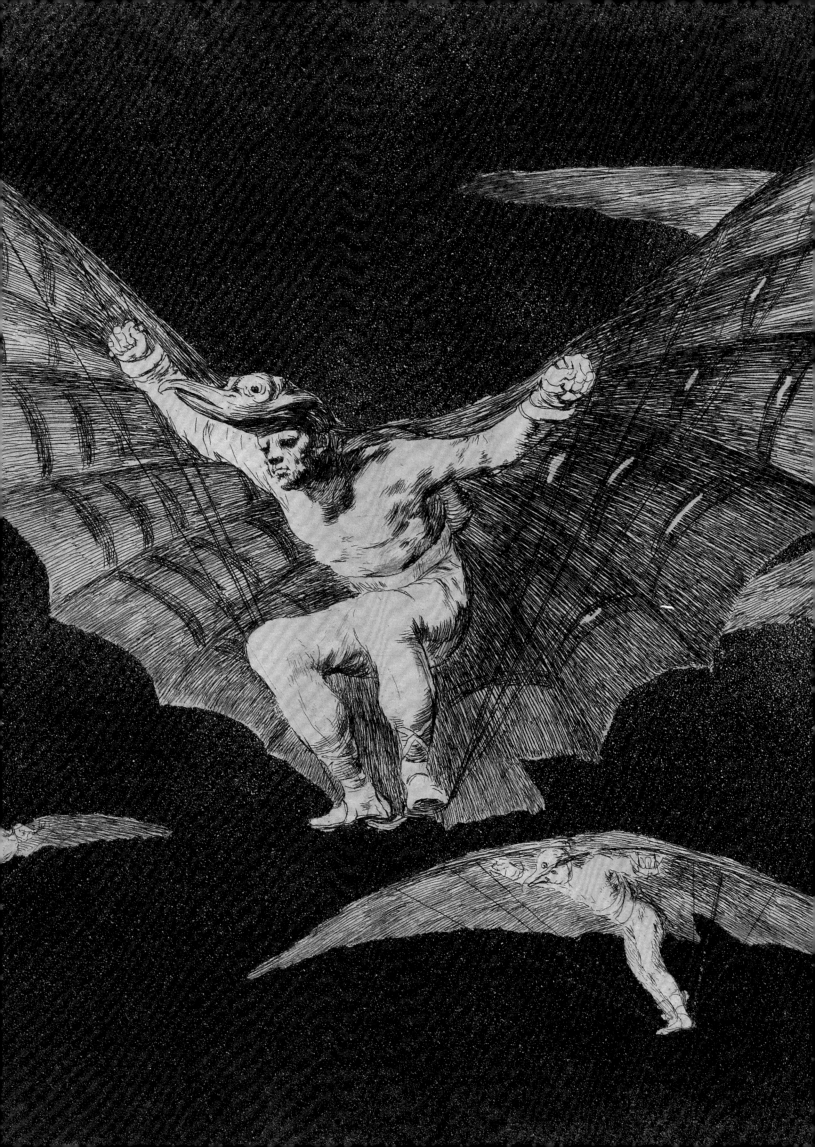

Arthur Ross: The Collector

ALEXA A. GREIST

THE ARTHUR ROSS COLLECTION strongly bears the mark of its collector. The high quality of the impressions, the distinct themes within the collection, and the continued emphasis on the accessibility of the works of art are all a result of care taken by Ross himself (see fig. 1) as he formed this group of more than 1,200 prints over almost three decades.

Arthur Ross was born in Manhattan on November 25, 1910. In 1927 he enrolled at the University of Pennsylvania, but after three years he transferred to Columbia University, in New York, to help support his family during the Great Depression while finishing his undergraduate degree. Ross graduated in 1931 and began his career the following year, working until 1938 at Sutro Brothers and Company, a Wall Street brokerage firm. Upon leaving Sutro Brothers, he joined Central National Corporation (now Central-National Gottesman, Inc.), an investment-banking subsidiary of Gottesman and Co., a privately held company specializing in the distribution of pulp, paper, paperboard, and newsprint. Ross was a director at the company for forty years and an officer for nearly seventy. From 1938 to 1978, he managed the company's investments, and he served as Vice Chairman from 1974 until his death on September 10, 2007, at age ninety-six.[1]

In 1955 Ross formed the Arthur Ross Foundation, a philanthropic organization that would support a broad range of goals—from promoting the visual arts, historic preservation, and civic and environmental beautification to higher education and national and international affairs research. The foundation supported institutions in New York, Philadelphia, and Washington, D.C., as well as organizations abroad. Over the years, it funded such diverse projects as the Arthur Ross Pinetum in Central Park, the Arthur Ross Hall of Meteorites at the American Museum of Natural History, the Arthur Ross Prize for Distinguished Reporting and Analysis on Foreign Affairs, and the Arthur Ross Gallery at the University of Pennsylvania.

According to Ross's widow, Janet, two things inspired Ross's philanthropic methodology: first, the previous generation of philanthropists, including Andrew Carnegie, Henry Clay Frick, and John Pierpont Morgan, and the lasting impact that their projects had on society, and second, the charitable giving of Ross's contemporaries, including his friend William T. Golden, a fellow investment banker and philanthropist who referred to his own contributions as providing "the first tank of gas."[2] With these past and present role models in mind, Ross chose projects that he could "put his arms around"—areas where his strong initial contribution would help not only to launch the project but also to stimulate others to become involved.[3]

The Arthur Ross Foundation began to purchase works of art in the late 1970s with the express intention of creating a collection that could be shared with academic institutions, museums, and cultural spaces. Janet Ross remembers trips to print rooms and libraries abroad with her husband during which he remarked on the difficulty of accessing prints in such institutions; he wanted to see works on paper exhibited in public venues, where people could interact with them without having to pay a fee or surrender a passport for entrance.[4] Ross's younger son, Clifford, credits his father's desire to build a collection to having had to rebuild his life and that of his family after the Depression. Furthermore, collecting not for his own sake but for the enjoyment of a broader public "added a sense of robustness to his desire to collect and also avoided any potential embarrassment over the activity of buying art."[5] Through the agency of his foundation, Ross could assemble a highly personal collection without it being perceived as one intended for private consumption, which would have gone

against his idea of what forming an art collection under the aegis of his foundation was about.

Ross chose to collect prints rather than other media because prints by the artists that interested him were plentiful on the market at the time and were priced such that it was possible to accumulate a large collection of strong impressions. Furthermore, prints, especially those in series, could be stored efficiently—as opposed to works such as drawings, paintings, or sculpture, which vary more in size or format—and were easier to send out on exhibition. In time, the most popular series and individual prints in the foundation's vast collection were framed and kept crated in the foundation's storage facilities in Manhattan, ready for exhibition.

Ross was an inquisitive man, and his curiosity seemed only to increase as he came to learn more about a print-maker, subject, or particular work.[6] As such, he was actively involved in every acquisition for his foundation. He worked closely with his advisor, Frederick G. Schab (fig. 2), a dealer

of Old Master prints, to seek out impressions of the highest quality.[7] The archives of the foundation include numerous queries from Ross to Schab about specific prints he had seen for sale in a dealer's catalogue or at auction. The collector loved to discuss his acquisitions and those he was considering with his family, colleagues at the foundation, dealers, and the people he enlisted to write exhibition catalogues. He would look at works in person whenever possible, authorizing Schab to act for him on trips to Europe when it was not feasible to go himself. He kept an eye out for prints that completed series that he was collecting or complemented existing holdings, carefully ensuring that each new acquisition expanded the collection, either by adding to an existing group of works or by taking it in a new but related direction. The archives also reveal Ross's acumen as a collector: on a number of occasions, he recorded the happy victory of having bought a better impression at a much lower price than current market value.

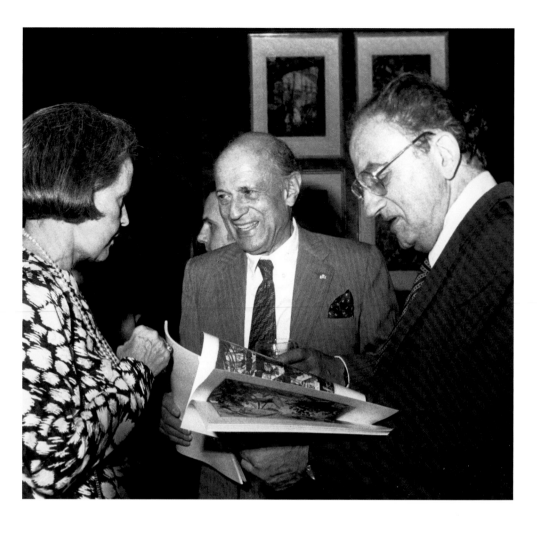

The works collected by Ross reflect his interests in particular artists or subjects and fall into three main categories: eighteenth-century Italian prints, including images of the places that would have been visited by gentlemen making the Grand Tour; works by Francisco Goya, including his images of the bullfight; and nineteenth-century French prints, including illustrations of great literature.[8] The first prints he acquired were from Goya's *Caprichos* series (see donor's foreword). Goya's keen observations of human behavior were what first drew Ross to this artist's work. In the preface to the brochure of an exhibition at the Corcoran Gallery of Art in 1986 and 1987, he wrote, "One finds deep satisfaction in [Goya's] compassionate, sometimes cynical, sometimes humorous portrayal of the foibles of the human spirit. His illustrations of the heroism, the cruelty, the hypocrisies and the fantasies of men and women have been widely acclaimed."[9] According to Clifford Ross, the range of emotional tone that Goya displayed in his prints fascinated his father, from the bawdy hilarity of the *Caprichos* to the disturbing images of human cruelty in the *Disasters of War* and the profoundly enigmatic ones of the *Disparates* (see fig. 3).[10]

Inspired by his initial purchase of prints by Goya, Ross began to collect as much of the artist's printed oeuvre as he could, focusing on early editions or states and insisting on strong provenances. Three years after acquiring Goya's *Tauromaquia* in 1981, he acquired the *Tauromaquia* series by Pablo Picasso.[11] Given the subject matter, Picasso's Spanish heritage, and the artist's debt to his Spanish predecessor, Ross's purchase of the Picasso series seems a natural expansion of his interest; additionally, Clifford Ross remembers that his father was drawn to the way in which Picasso used the fluid medium of aquatint to capture his subject.[12] In 2005 Ross acquired some prints from a set of hand-colored bullfight etchings from 1790 by Antonio Carnicero (see fig. 4), complementing the Goya and Picasso images.[13]

In the 1980s, he began collecting prints by the greatest Italian printmakers of the eighteenth century—Giovanni

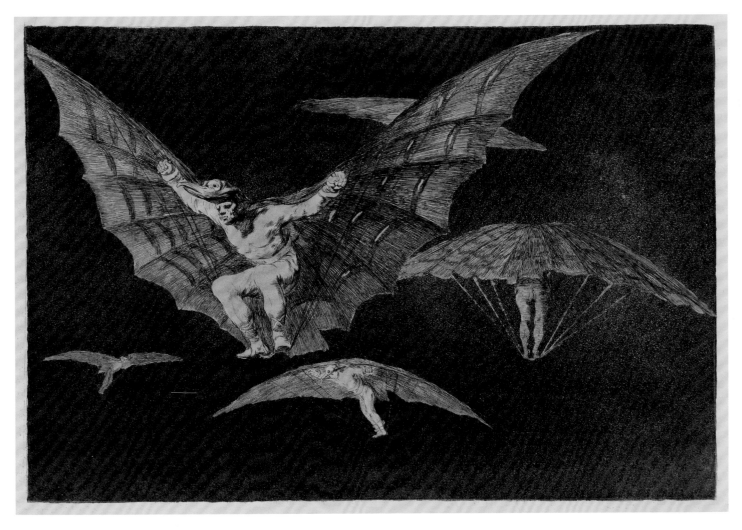

FIG. 3.
FRANCISCO GOYA, *Modo de volar* (A Way of Flying), also known as *Donde hay ganas hay maña* (Where There's a Will There's a Way), from *Los disparates (Los proverbios)* (Follies [Proverbs]), ca. 1816–19, published 1864. Etching, aquatint, and drypoint, 9 5/8 × 13 3/4 in. (24.5 × 35 cm). Yale University Art Gallery, The Arthur Ross Collection, 2012.159.40.14

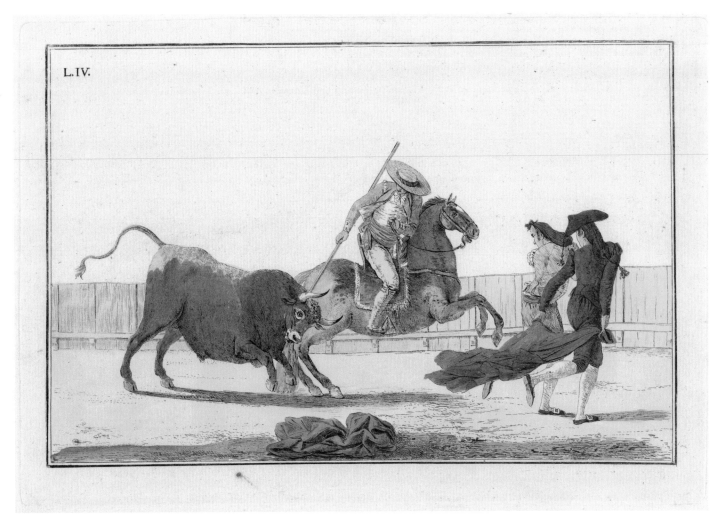

FIG. 4.
ANTONIO CARNICERO, plate 4 from
*Colección de las principales suertes de
una corrida de toros* (Collection of the
Main Actions in a Bullfight), 1790.
Etching, hand-colored, 7 ¹⁵⁄₁₆ × 11 ⅝ in.
(20.1 × 29.5 cm). Yale University Art
Gallery, The Arthur Ross Collection,
2012.159.45.5

Battista Piranesi, Canaletto, and Giovanni Battista Tiepolo and his sons Giovanni Domenico and Lorenzo Baldissera—as well as prints by other Italians that would complement these artists' works. When a number of complete series or volumes of Piranesi's works came onto the art market, Ross acquired the bulk of his prints by this artist. Ross sought both famous prints, such as the *Vedute di Roma*, as well as lesser-known works, like the later four-volume series *Antichità romane*, in which Piranesi illustrated the ancient substructure of the city, including plates of Roman construction techniques (see fig. 5). With these purchases, Ross wished to not only add depth to his collection but also show as complete as possible a picture of Piranesi's investigations into ancient Rome and its environs. He also collected maps of Rome, including the twelve-plate engraved map following the designs of Giovanni Battista Nolli and Giovanni Paolo Panini (see Boorsch, fig. 20), acquired in 1990, both to give context to the Piranesi prints and to be able to mount richer and more varied exhibitions of Italian views.[14] He saw Piranesi's work as a natural

addition to the collection because of the artist's impact on later generations of etchers, especially Goya. There is a visual and psychological resonance between the fantastical elements of Piranesi's work, in particular the *Carceri*, and the dark, deep emotional intensity of Goya's work. Ross wrote that this kinship is "clearly evident in [Goya's] etchings, particularly in the *Caprichos* and *Proverbios* in which Goya also felt free to let his imagination have full rein, vying with his artistry for domination of his work."[15]

In 1986 Ross acquired Piranesi's *Carceri* (see fig. 6), imaginative scenes whose dark spaces and shifting planes of reality seem a far cry from the artist's clearly etched views of Rome. But Ross was drawn to their architectural fantasy and fascinated by their incompleteness, writing, "Like life itself, so many of one's hopes, aspirations, and potentialities remain unrealized."[16] In fact, the undertaking of mentally excavating the ancient fabric of the city required as vibrant an act of the imagination as the creation of the *Carceri*, something Ross not only understood but also valued.

FIG. 5.

GIOVANNI BATTISTA PIRANESI, *Modo col quale furono alzati i gressi Travertini...* (Method by Which Large Pieces of Travertine Are Hoisted...), plate 53 from volume 3 of *Antichità romane* (Roman Antiquities), 1756. Etching, platemark: 15 1/16 × 20 5/16 in. (38.3 × 51.6 cm); additional text plate: 3 1/8 × 20 5/8 in. (7.9 × 52.4 cm). Yale University Art Gallery, The Arthur Ross Collection, 2012.159.12.3.53

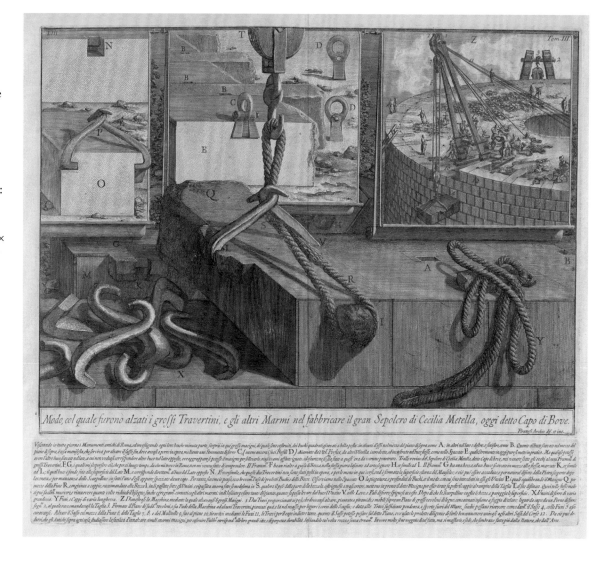

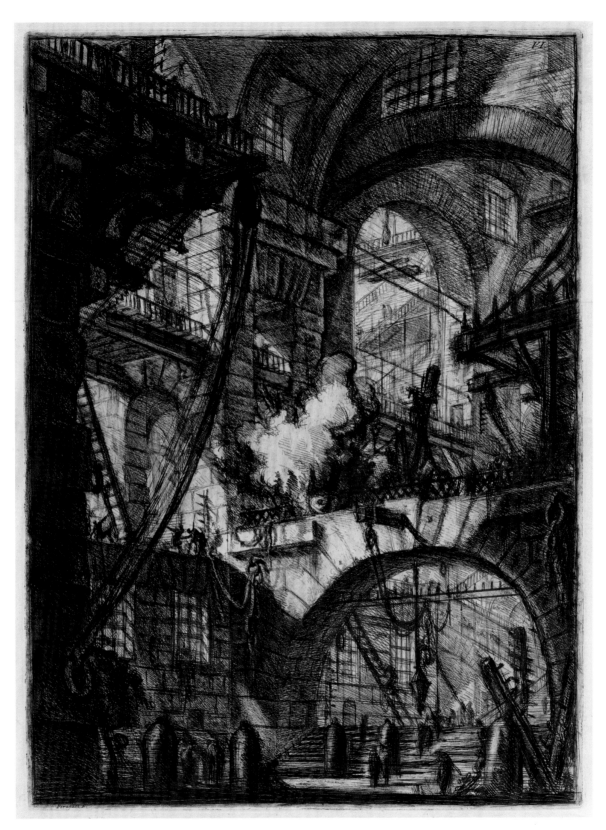

FIG. 6.
GIOVANNI BATTISTA PIRANESI, *The Smoking Fire*, plate 6 from *Carceri* (Prisons), ca. 1750, published 1761. Etching, 21⅝ × 16⅛ in. (55 × 41 cm). Yale University Art Gallery, The Arthur Ross Collection, 2012.159.18.6

To complement Piranesi's views of Rome, during the 1990s Ross added to the collection the etched images of Venice and its environs by Canaletto. Etchings by Mortimer Menpes (see fig. 7), a British artist who was a faithful student of James McNeill Whistler, brought the collection's group of *vedute* into the twentieth century. These works reflect the experience of the Grand Tour. The sheer number of prints depicting views of Rome and Venice clearly attests to the collector's interest in this popular eighteenth-century European tradition. During the 1980s and 1990s, Ross visited the cities and regions of the Tour, including Florence, Rome, Bologna, Sicily, and Venice. In 1983 he visited Naples with his friend Henry Hope Reed, Jr., an architectural historian and critic who famously advocated for classical design in the face of modernism. In the same period, Ross also visited the Palladian villas near Venice for the first time.[17] These visits to Italy inspired his push to collect Italian material more broadly.

Clifford Ross reflects that "the prints themselves were, in a way, [his father's] own Grand Tour—not only in the traditional sense, as depictions of famous destinations, but also in their exploration of the human psyche."[18] He recalls that the collection "became for [his father] a compendium of the human condition, created and realized through the act of collecting. It was a tour of humanity."[19] The prints of Italian subjects, with their ruins of classical sites and monuments, call to mind Romantic themes of glory and decay, while the works by Goya, Tiepolo, Eugène Delacroix, and Édouard Manet explore universal aspects of the human condition, such as desire, strife, humor, fate, and, ultimately, dignity.

Ross's passion for the classical world is evident in both the works he collected and his philanthropy. The Arthur Ross Foundation supported the organization Classical America (now the Institute of Classical Architecture and Art); with this group, the foundation sponsored the publication of books and endowed the annual Arthur Ross Awards, presented to artists, architects, and patrons pursuing the classical tradition in the United States. The foundation was also a faithful supporter of the American Academy in Rome, where the research library bears the names of Janet and Arthur Ross. Ross read widely about the ancient world and was particularly interested in the Romantic idealization of Italy in the minds of eighteenth-century northern Europeans. Adele Chatfield-Taylor, president of the American Academy in Rome from 1988 to 2013, remembers Ross relating that his love of and interest in Italy could be traced to his reading of the poetry of Alexander Pope.[20] He was drawn to Italian classicism for the same reasons we continue to be drawn to it: its visual and emotional power.

In 1998 Ross began to acquire prints by nineteenth-century French artists, including Paul Cézanne, Jean-Baptiste-Camille Corot, Honoré Daumier, Delacroix, Paul Gauguin, Manet, and Camille Pissarro—works that reflected both what was available on the market at the time and the collector's lifelong interest in craftsmanship and process. To Ross, these works represented the creativity of artists "who transformed the development of printmaking with originality."[21] Clifford Ross recalls his father's interest in the "materiality" of these later prints and the techniques that produced them, such as the woodcut, first represented in the collection by several works by Gauguin (see fig. 8), and

FIG. 7.

MORTIMER MENPES, *San Giorgio Maggiore*, 1910–13. Etching and drypoint, 7 13/16 × 11 7/8 in. (19.8 × 30.1 cm). Yale University Art Gallery, The Arthur Ross Collection, 2012.159.101

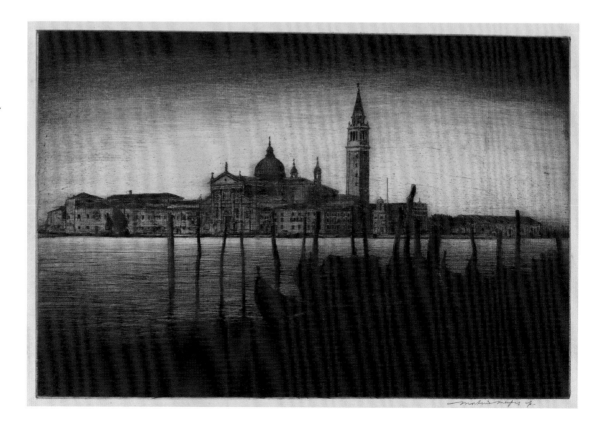

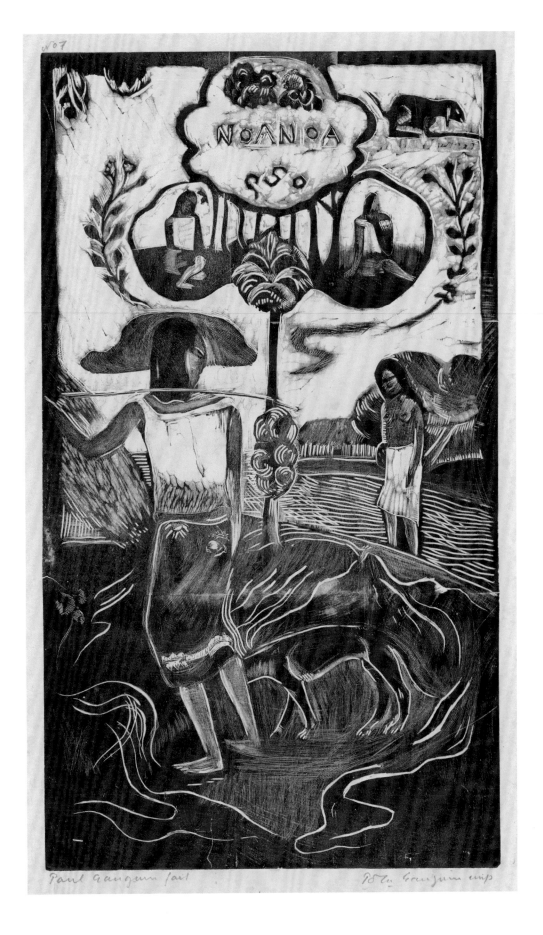

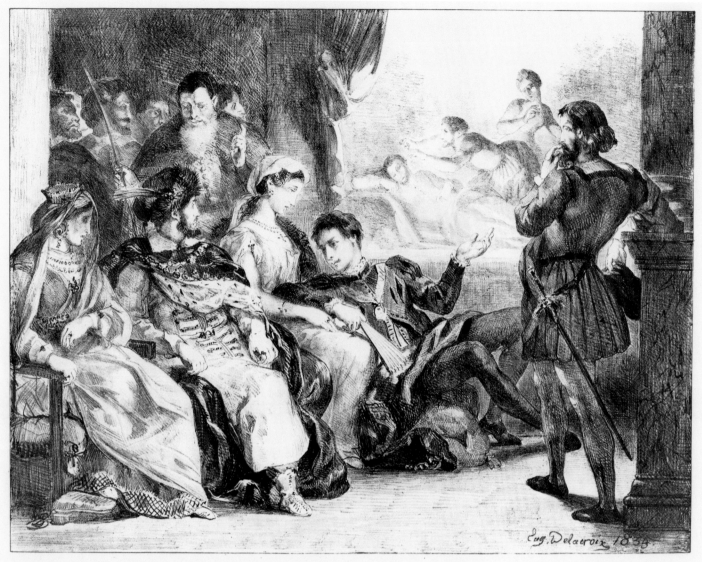

C'est une intrigue scélérate; mais qu'importe? Votre Majesté et nous avons la conscience libre, cela ne nous touche en rien..... vous voyez : il l'empoisonne dans le jardin pour s'emparer de son royaume........ l'histoire est réelle écrite en bel italien .

FIG. 9.
EUGÈNE DELACROIX, *Hamlet*
fait jouer aux comédiens la scène de
l'empoisonnement de son père (Hamlet
Has the Actors Play the Scene of the
Poisoning of His Father), Act 3, Scene 2,
from William Shakespeare's *Hamlet*,
1835, published 1843. Lithograph,
9 ⅞ × 12 ¹³⁄₁₆ in. (25 × 32.5 cm). Yale
University Art Gallery, The Arthur
Ross Collection, 2012.159.56.6

the *cliché-verre*, a hybrid medium of photography and print-making that captivated many artists in the mid-nineteenth century because of its portability, spontaneity, and tonal range. This medium is represented by two prints by Corot (see Highlights, pl. 54).[22] The nineteenth-century art purchases added to the collection etchings, lithographs, zincographs, and works of a vastly different appearance than those of Piranesi, Canaletto, or Goya. At the same time, like the earlier artists' prints, these works reflected the concerns and changing fascinations of the times and the places in which they were made, in multiple images that could be circulated and enjoyed by a wide audience.

Ross's tendency to purchase series extended to his acquisitions of nineteenth-century works, seen, for instance, in his prints illustrating masterpieces of literature, including Delacroix's lithographs of *Faust* and *Hamlet* (see fig. 9) and Manet's illustrations of Edgar Allan Poe's poem *The Raven*

(see Hodermarsky, fig. 3).[23] The large number of prints in series in the Arthur Ross Collection also highlights Ross's appreciation of the richness of printmaking techniques, showcasing artists' depth of skill across a sequence of related images.[24]

Many donors are equally concerned with sharing exceptional works with a broad public; indeed, there are a number of examples of donors working directly with curators to purchase works for an institution. What was unusual about Ross was his desire to create a collection independent of a museum. Allying himself with a museum during his lifetime would have taken away his pleasure: he would have been "funding another vision" instead of his own.[25] As a result, the Arthur Ross Collection is a highly personal expression of one man's passion for and abiding curiosity about printmaking and his constant goal that the works be widely shared.

1. Kenneth L. Wallach, Chief Executive Officer, Central-National Gottesman, Inc., e-mail to the author, September 8, 2014.

2. William T. Golden, quoted in Frank H. T. Rhodes, "Biographical Memoirs: William T. Golden," *Proceedings of the American Philosophical Society* 153, no. 4 (December 2009): 463, http://www.amphilsoc .org/sites/default/files/proceedings /GGGoldenBio1530407.pdf.

3. Arthur Ross, quoted by Janet Ross, e-mail to the author, August 8, 2014.

4. Janet Ross, e-mail to the author, August 8, 2014.

5. Clifford Ross, telephone conversation with the author, August 22, 2014.

6. Ibid.

7. Ross looked at impressions of prints that became available on the market and were already held by the foundation to ensure that the foundation always had the best-possible impressions.

8. In addition to these broad categories of prints, there are two drawings in the collection: one by Giovanni Domenico Tiepolo (2012.159.25) and the other an anonymous French nineteenth-century drawing in the style of Thomas Lawrence (2012.159.58). The collection also includes a series of photographs by the American twentieth-century photographer Marvin E. Newman (see Boorsch, fig. 27; Highlights, pls. 69–70).

9. Arthur Ross, in *Goya: Selected Prints from the Collection of the Arthur Ross Foundation*, exh. broch. (Washington, D.C.: Corcoran Gallery of Art, 1986), 1.

10. Clifford Ross, telephone conversation with the author, August 22, 2014.

11. In 1985 Ross also purchased a large lithograph from Goya's series the *Bulls of Bordeaux* (Boorsch, fig. 5).

12. Clifford Ross, telephone conversation with the author, August 22, 2014.

13. Carnicero's series is one of the earliest treating bullfighting, and it would have been known to both Goya and Picasso.

14. Gail Lloyd, notes to the author, August 5, 2014.

15. Arthur Ross, foreword to Malcolm Campbell, *Piranesi, the Dark Prisons: An Edition of the "Carceri d'Invenzione" from the Collection of the Arthur Ross Foundation*, exh. cat. (New York: Arthur Ross Foundation, 1988), 7.

16. Ibid.

17. Janet Ross, e-mail to the author, March 9, 2015.

18. Clifford Ross, telephone conversation with the author, August 22, 2014.

19. Clifford Ross, e-mail to the author, March 12, 2015.

20. Adele Chatfield-Taylor, telephone conversation with the author, August 7, 2014.

21. Arthur Ross, "Tiepolo/19th-century remarks," exhibition planning folders, *Bearded, Turbaned, and Wise: Heads by Tiepolo, A Collection of Etchings from the Arthur Ross Foundation* and *Lasting Impressions: Nineteenth-Century French Prints from the Arthur Ross Foundation* (both Art Gallery of the Graduate Center, City University of New York, 2004), Arthur Ross Foundation Archive, Department of Prints and Drawings, Yale University Art Gallery.

22. Clifford Ross, telephone conversation with the author, August 22, 2014.

23. For more on these works, see the essay by Elisabeth Hodermarsky in this volume.

24. When possible, Arthur Ross preferred to acquire complete sets or series, as in the case of the Piranesi *Vedute di Roma* (Views of Rome), but in some cases, such as those of the Tiepolo heads of old men or Canaletto's *Vedute* (Views), this was not possible because of the scarcity of the works on the market at the time.

25. Clifford Ross, telephone conversation with the author, August 22, 2014.

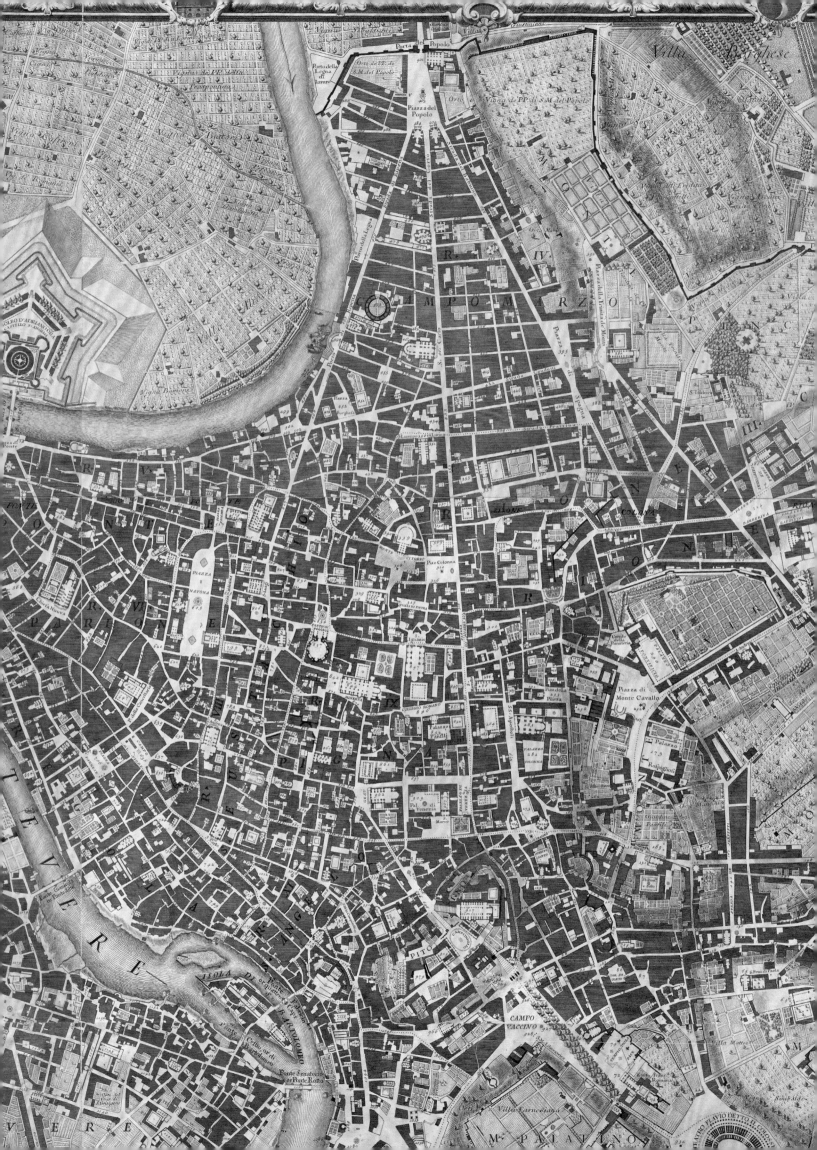

Building a Collection Meant to Be Shared

SUZANNE BOORSCH

IN 2012 THE ARTHUR ROSS FOUNDATION donated the entirety of its extraordinary collection of European prints to the Yale University Art Gallery. This donation, the largest single gift of prints ever made to the Gallery, has enlarged and enriched Yale's holdings in this area immeasurably. The remarkable collection, including more than 1,200 prints, was compiled for the foundation over a period of a quarter century by the New York businessman and philanthropist Arthur Ross. The largest group of prints in the collection, numbering close to eight hundred, is by eighteenth-century Italian etchers, most notably Giovanni Battista Piranesi, Giovanni Antonio Canal (called Canaletto), and Giovanni Battista Tiepolo and his sons Giovanni Domenico and Lorenzo Baldissera. The collection also includes close to two hundred prints by Francisco Goya, the truly astounding artist who began his career working for the Spanish court and died, at age eighty-two, in exile in Bordeaux, having produced some of his greatest creations in his last years. Goya's printed oeuvre has continuously intrigued viewers, and it includes scores of works that, to this day, have defied satisfactory explication. Yet another significant group of prints Ross collected consists of about 150 images by several of the major artists of nineteenth-century France, among them Jean-Baptiste-Camille Corot, Eugène Delacroix, Honoré Daumier, Camille Pissarro, Édouard Manet, Edgar Degas, and Paul Gauguin.

The prints themselves are outstanding, as are the artists who made them, but two aspects of the collection are particularly unusual. First, it was never meant for private enjoyment but was always intended to be shared: the principal mission of the collection was to have the works shown, in venues easily accessible to the public. The second somewhat unusual aspect of the collection is that when Ross made his first purchases of prints for the foundation, he was seventy years old, and he continued collecting with unflagging acumen and enthusiasm for a quarter of a century, until the year before he died.

Created in 1955, the Arthur Ross Foundation supported enterprises and institutions both international and local, from the American Academy in Rome to restoration of a wisteria pergola and a pinetum, a four-acre grove of pine trees, in New York's Central Park. But Ross had always wanted to do something charitable with art. When the idea came to him that he could add another facet to his already expansive and varied philanthropic interests, by building an extensive collection of art intended neither to be enjoyed privately nor to be given away but instead meant to be shared, the Arthur Ross Collection came into being.

Goya

It began with Goya. Arthur Ross was initially intrigued, in the 1970s, by some prints from the artist's early series of 1799, the *Caprichos*, and he eventually acquired the entire series for his personal collection (see donor's foreword). His imagination was captivated, and soon he was drawn to examine the full extent of Goya's work. By September of 1980, Ross had made his first purchase of prints for the foundation: all eighteen etchings of the first edition of the last, smallest in number, and most profoundly mysterious of Goya's four series of etchings. This group, posthumously published as *Los proverbios* (The Proverbs), is today more often referred to by the title Goya himself used in handwritten inscriptions on many of the prints, *Los disparates*—often translated as "Follies," although the cognate "disparities" or a word like "irrationalities" would be closer to the Spanish, and to the content of the prints. Goya made this group of etchings, which depict monstrous beings and people engaged in irrational and/or violent acts, around 1816–19, but they were not published until 1864, well after his death, for fear

of the Inquisition. This institution had been ruthless in its methods to maintain orthodoxy in Spain for several centuries but had been suppressed by Napoleon in 1808, only to be reinstated by the absolutist monarch Ferdinand VII. Goya, already ostracized from the court, may have feared that the images would be seen as an indictment of the established authorities. *Los ensacados* (fig. 1) is typical of the mood of profound disorientation of the *Disparates* series. Of these prints, Goya scholar Manuela B. Mena Marqués wrote, "In what amounts to a kind of final denunciation of human folly, Goya creates scenes that cause viewers to lose their way as they simply try to determine what is happening."[1] Some years later, Arthur Ross acquired the publication that includes four additional images that were originally part of this series but were on plates that had become separated from the others and thus were not printed with the rest in 1864; these were published in the French periodical *L'art* in 1877. Still later, Ross acquired trial proofs for plates 8 and 9 of the series.

The spring following his purchase of the *Disparates*, Arthur Ross acquired two more of Goya's famous series, one being the thirty-three plates of the *Tauromaquia* in its first edition, of 1816 (see fig. 2). Perhaps the least known of Goya's series, the *Tauromaquia*, like the *Disparates*, is deeply enigmatic. By no means simply a retreat to a "safe" subject that Goya could illustrate without fear of censorship, the *Tauromaquia* still awaits a comprehensive explanation, but it can plausibly be read, at least on one level, as alluding to a history of the Spanish people through the development of their unique national sport—the highly ritualized goading and eventual killing of a bull—by, in sequence, the barbarians, the Moors, the nobles, and the Spaniards of Goya's time. Ross subsequently also acquired the third edition of the *Tauromaquia*, which included an additional seven plates that had been rejected for the first edition; the other sides of these had been used for subjects that were part of the original series.

FIG. 1.

FRANCISCO GOYA, *Los ensacados* (The Men in Sacks), also known as *So el sayal, hay al* (There Is Something beneath the Sackcloth), from *Los disparates (Los proverbios)* (Follies [Proverbs]), ca. 1816–19, published 1864. Etching and burnished aquatint, 9 ⅝ × 13 ¾ in. (24.5 × 35 cm). Yale University Art Gallery, The Arthur Ross Collection, 2012.159.40.9

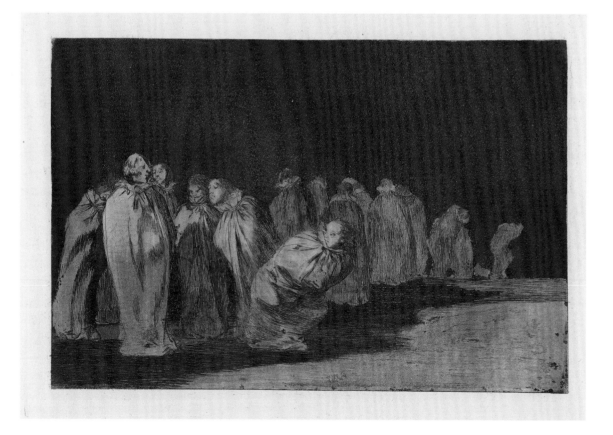

FIG. 2.

FRANCISCO GOYA, *Echan perros al toro* (They Loose Dogs on the Bull), plate 25 from *La tauromaquia* (The Art of Bullfighting), 1816, published 1816. Etching, burnished aquatint, and drypoint, 9 ⅝ × 14 in. (24.5 × 35.5 cm). Yale University Art Gallery, The Arthur Ross Collection, 2012.159.38.25

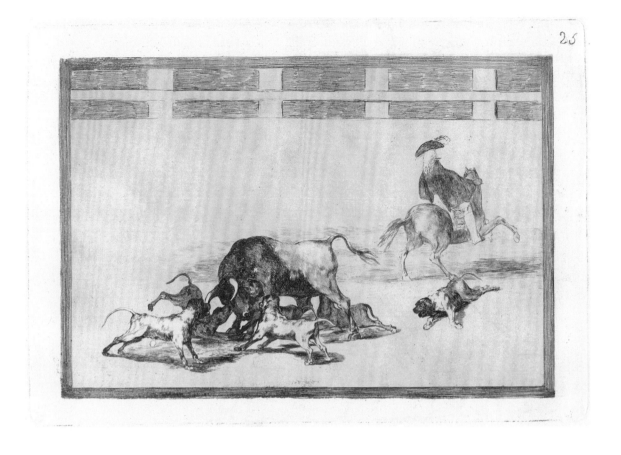

FIG. 3.

PABLO PICASSO, *Echan perros al toro* (They Loose Dogs on the Bull), from *La tauromaquia* (The Art of Bullfighting), 1957, published 1959. Aquatint, 7 ¹³⁄₁₆ × 11 ¾ in. (19.9 × 29.9 cm). Yale University Art Gallery, The Arthur Ross Collection, 2012.159.161.11

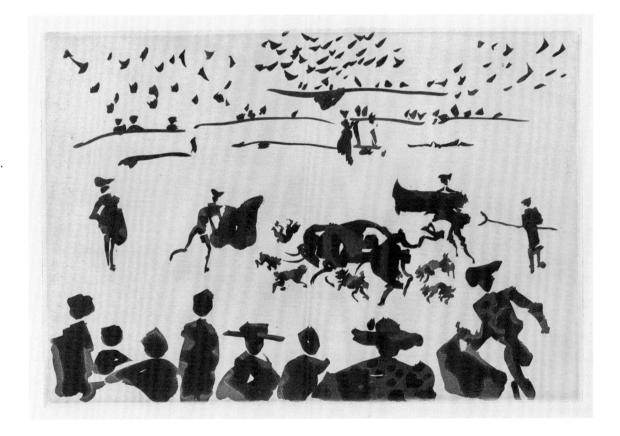

To add to the quintessentially Spanish bullfighting theme, in the mid-1980s Ross acquired the twenty-six aquatints on this subject by the other towering Spanish artist whose oeuvre includes an extraordinary production of prints: Pablo Picasso. Picasso's *Tauromaquia* prints (see fig. 3) were published in Barcelona in 1959, accompanying what had become the standard text on bullfighting, written in 1796 by the torero José Delgado Hillo (Pepe Illo). Just as for Goya, bulls and the bullfight were part of Picasso's core being as a Spaniard, and the bull itself, as well as the mythical hybrid the Minotaur, recurs frequently in his protean oeuvre. This series was a tour de force even for Picasso's superlative creative power: he made all twenty-six plates of the series in a single afternoon.

In 2005 Ross acquired yet another group of bullfight images, the first seven prints of a rare series of twelve published in 1790 by Antonio Carnicero (see fig. 4). Carnicero's series was inspired by a text on bullfighting by Nicolás Fernández de Moratín, published in 1777. Goya clearly knew Carnicero's prints, which are charming and which, even with their somewhat naive, static quality, likely satisfied their didactic purpose. Picasso probably knew them as well, and both of these artists must have felt that the subject demanded more spirited treatment. Goya's series, made

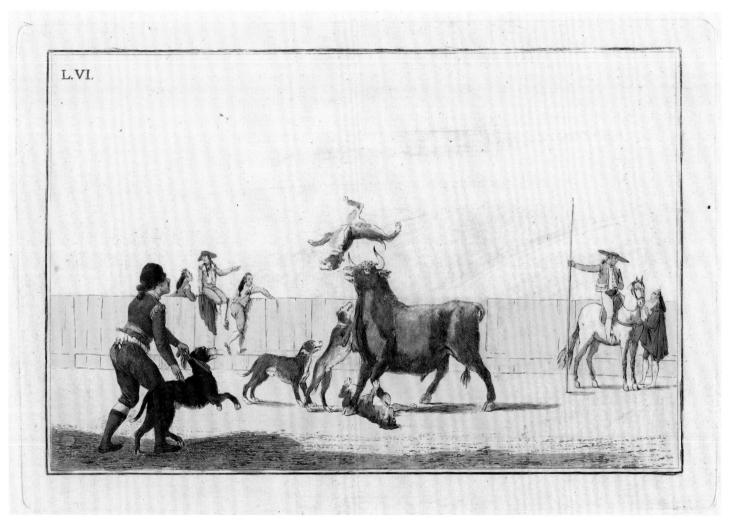

FIG. 4.
ANTONIO CARNICERO, plate 6 from *Colección de las principales suertes de una corrida de toros* (Collection of the Main Actions in a Bullfight), 1790. Etching, hand-colored, 7 ¹⁵⁄₁₆ × 11 ⅝ in. (20.2 × 29.5 cm). Yale University Art Gallery, The Arthur Ross Collection, 2012.159.45.7

a quarter of a century after Carnicero's, and Picasso's, made almost a century and a half after Goya's, both capture the intensity, discipline, and element of danger inducing high suspense that have kept Spaniards in thrall to bullfighting for centuries.

The Arthur Ross Collection also contains one of the famous lithographs from the *Bulls of Bordeaux* (fig. 5), the series that Goya made after his flight in 1824 from a repressive Spain to the relative liberality of France. There, at almost eighty years old, working in the medium of lithography—which had been invented only recently, in Germany, at the end of the eighteenth century—having been deaf for over thirty years and with his eyesight beginning to fail, Goya produced a handful of lithographs, of which the four bullfight subjects, published in 1825, are among the undisputed masterpieces by any artist in the medium.

In addition to the *Disparates* and *Tauromaquia* series, Arthur Ross also acquired the famous series of eighty images known generally as the *Disasters of War*, called by Goya *Fatal Consequences of Spain's Bloody War with Bonaparte, and Other Emphatic Capriccios* (see fig. 6). In this first edition, eight plates initially included inscriptions that were later corrected; the series in the Arthur Ross Collection includes six plates with inscriptions still uncorrected. Like the *Disparates*,

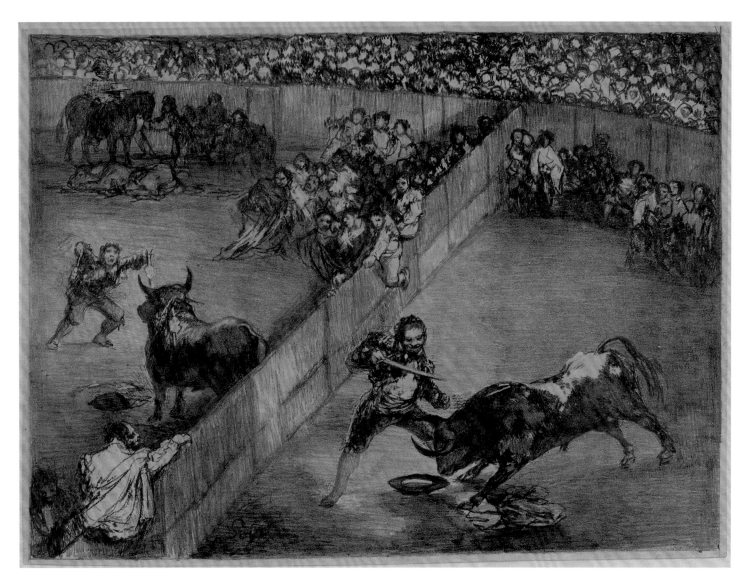

FIG. 5.
FRANCISCO GOYA, *Bullfight in a Divided Ring*, from *Bulls of Bordeaux*, 1825. Lithograph, 11 13/16 × 16 5/16 in. (30 × 41.5 cm). Yale University Art Gallery, The Arthur Ross Collection, 2012.159.43

these prints were made during the second decade of the nineteenth century but were not published until much later, in this case in 1863, thirty-five years after Goya's death, and a year before the *Disparates*. In a recent publication, Goya scholar Janis Tomlinson set forth a rough division of the series, made between about 1810 and 1814, into five chronological groups, which are fairly consistent in theme and style and also in such material considerations as the quality and condition of the plates.[2] Tomlinson names these Carnage, Atrocity, Passions of War—with the word *passion* carrying its older meaning of *suffering* as well as its more modern one—Hunger, and the "Emphatic Capriccios." This last is

not a unified group but includes reconjured scenes of war, allegories, satires, and fables. Susan Sontag, in a radio interview in 2008, spoke eloquently about these images: "What's interesting about Goya, what is magnificent and admirable about Goya, is that these are images of protest. . . . Goya is actually saying we should be horrified. We should not just find this horrible, we should be horrified. We should protest, we should deplore. We should take a moral position."[3] To this day, no other single series of prints has been created that makes as powerful a statement against war.

Besides these renowned works in series, the Arthur Ross Collection includes a few of Goya's individual plates:

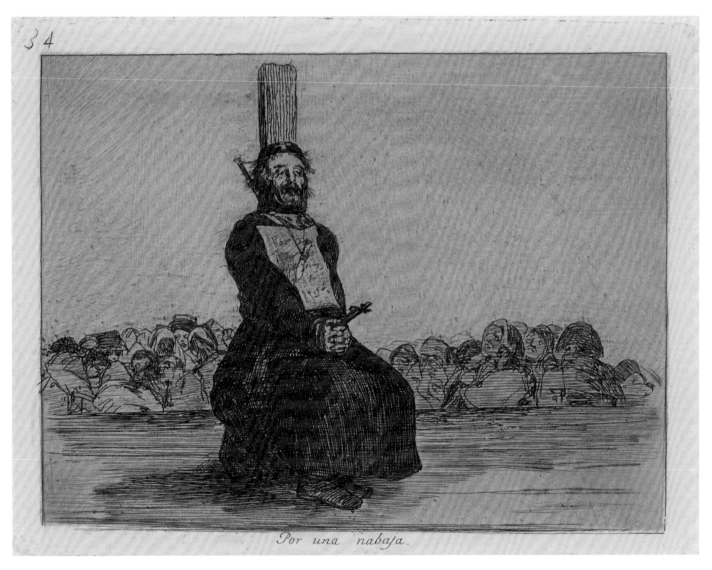

FIG. 6.

FRANCISCO GOYA, *Por una nabaja* [*sic*] (On Account of a Knife), plate 34 from *Los desastres de la guerra* (The Disasters of War), ca. 1811–12, published 1863. Etching, drypoint, burin, and burnisher, 6⅛ × 8¹⁄₁₆ in. (15.5 × 20.5 cm). Yale University Art Gallery, The Arthur Ross Collection, 2012.159.37.35

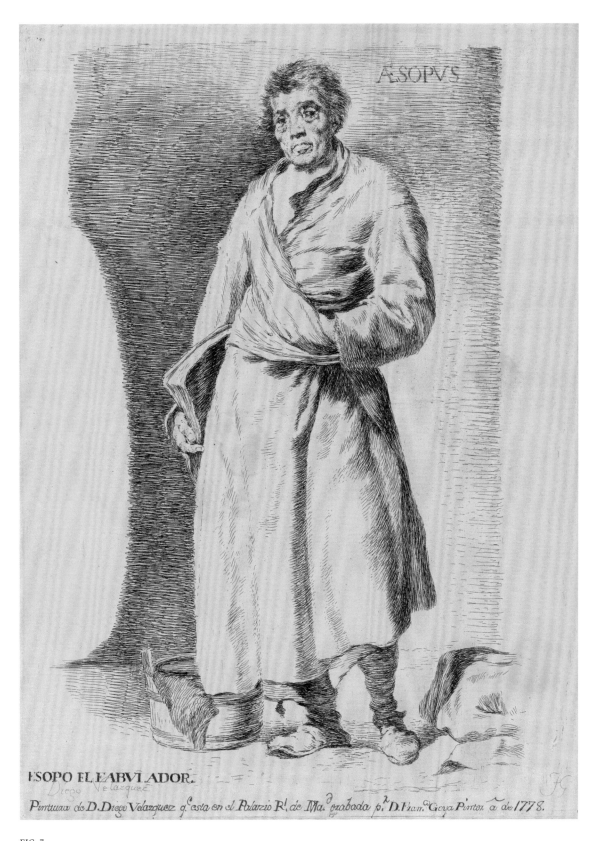

FIG. 7.
FRANCISCO GOYA, AFTER DIEGO
VELÁZQUEZ, *Aesopus*, after 1778.
Etching, 11¹³⁄₁₆ × 8⁷⁄₁₆ in. (30 ×
21.5 cm). Yale University Art Gallery,
The Arthur Ross Collection,
2012.159.34

one of the artist's earliest etchings, the rare *Caritas* (Charity; Saint Francis de Paul), of about 1780, and the copies after paintings by Diego Velázquez, *Barbarroxa* (see Highlights, pl. 29)*, Aesopus, Moenippus*, and *Un enano* (A Dwarf; see Highlights, pl. 30). The impression of *Aesopus*, made very early, still shows the drypoint inscription *Diego Velazquez* and initials *F.G.*, which were erased when the title was put on the plate (fig. 7).

Piranesi, His Views of Rome, and the Nolli Map

It is the prints by the Piranesis—the father, Giovanni Battista, and a few by his son, Francesco—that constitute the largest part of the Arthur Ross Collection. The close to 600 etchings by Giovanni Battista include all 135 images from the *Vedute di Roma* (see fig. 8)—plus two proof impressions—which were made over a span of several decades, beginning a few years after the young Piranesi arrived in Rome in 1740 and continuing until 1774. For Piranesi, the creation of these views was an ongoing homage to the adopted city that he promoted passionately. Their

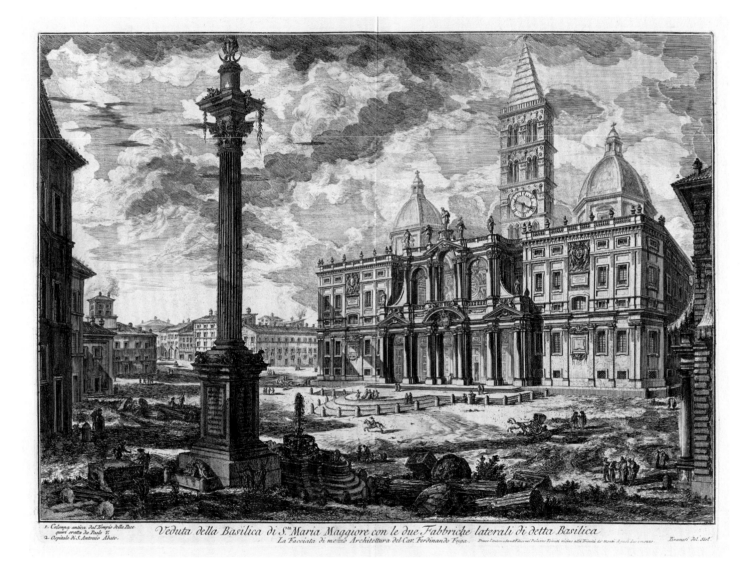

FIG. 8.
GIOVANNI BATTISTA PIRANESI, *Veduta della basilica di S.ta Maria con le due fabbriche laterali di detta basilica* (View of the Basilica of Santa Maria [Maggiore] with Its Two Flanking Wings), from *Vedute di Roma* (Views of Rome), 1749. Etching, 14 ¾ × 21 ¹⁄₁₆ in. (37.5 × 53.5 cm). Yale University Art Gallery, The Arthur Ross Collection, 2012.159.11.5

sale would also have provided a reliable source of income. Today, the *Vedute* are sought after by collectors, but they are also invaluable images documenting the appearance of Rome in the middle of the eighteenth century, although the viewer should be aware that Piranesi augmented the drama of his views: Johann Wolfgang von Goethe is reputed to have been disappointed upon arriving in Rome, in 1786, after having had his expectations of the city shaped by Piranesi's *Vedute*.

Other Piranesi highlights of the Arthur Ross Collection are the four *Grotteschi* (see fig. 9)—fantasies made shortly after the artist returned to Rome from a trip to Venice in the mid-1740s that reflect the influence of the great Giovanni Battista Tiepolo, whom Piranesi most likely visited at that time. The collection also includes all sixteen of the immense, dramatic, illogical structures known as the *Carceri*, with *The Drawbridge* in both its first and second states (figs. 10–11). Fourteen of the *Carceri* were made in the 1740s, like the *Grotteschi*, and these were first published together in 1750 with the title *Invenzioni capric de carceri* (Capricious Imaginary Prisons), thus also reflecting the influence of

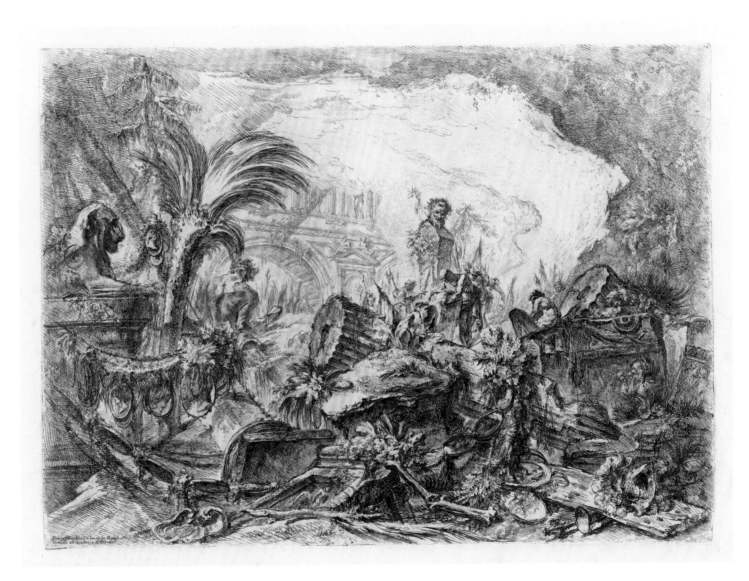

FIG. 9.
GIOVANNI BATTISTA PIRANESI, *The Triumphal Arch*, from *Grotteschi* (Grotesques), 1740s. Etching, 15 9/16 × 21 5/8 in. (39.5 × 55 cm). Yale University Art Gallery, The Arthur Ross Collection, 2012.159.16.2

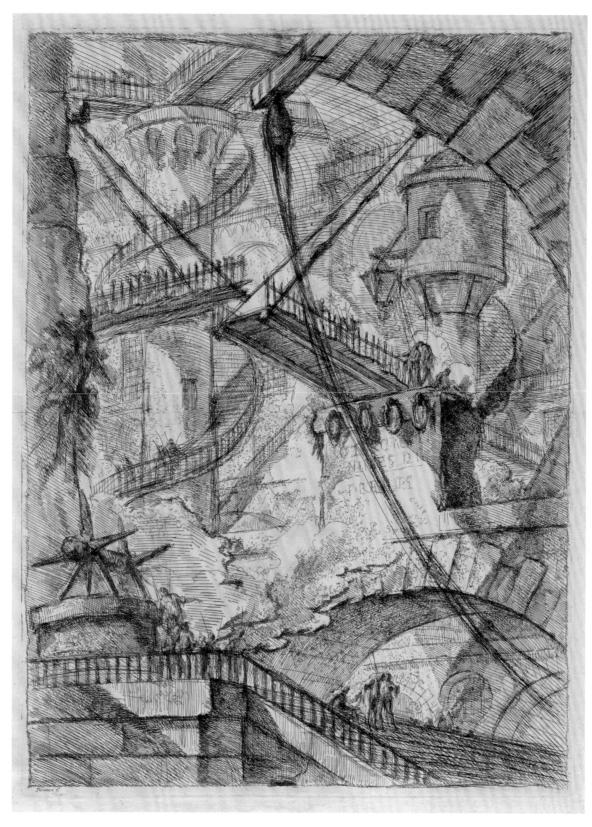

FIG. 10.

GIOVANNI BATTISTA PIRANESI,
The Drawbridge, plate 7 from *Carceri*
(Prisons), ca. 1750, published ca. 1750.
Etching, state i/ii, 21 5/8 × 16 1/8 in. (55 ×
41 cm). Yale University Art Gallery,
The Arthur Ross Collection,
2012.159.19

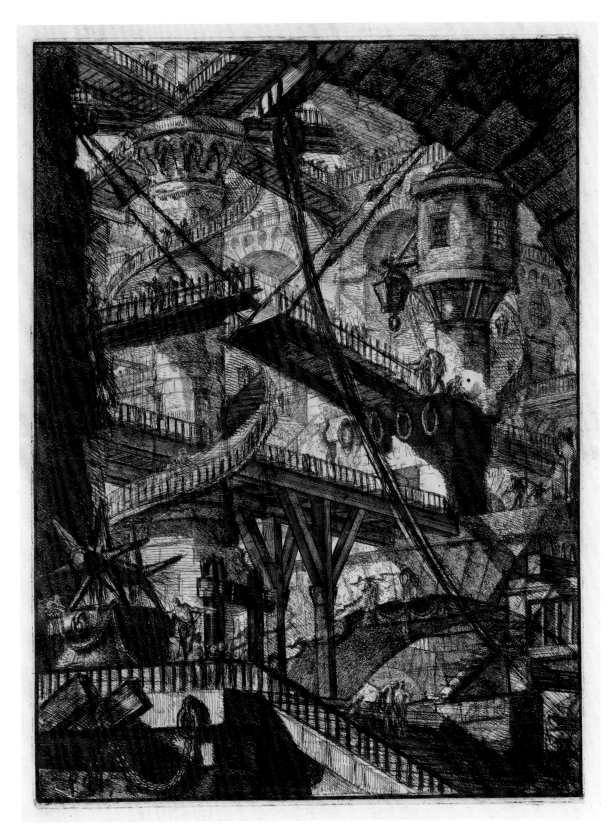

FIG. 11.
GIOVANNI BATTISTA PIRANESI,
The Drawbridge, plate 7 from *Carceri*
(Prisons), ca. 1750, published 1761.
Etching, state ii/ii, 21⅝ × 16⅛ in.
(55 × 41 cm). Yale University Art
Gallery, The Arthur Ross Collection,
2012.159.18.7

Piranesi's encounter in Venice with Tiepolo, whose recently published series of ten prints were called *Vari capricci* (see fig. 12). With their vast spaces and oblique viewpoints, the *Carceri* also make evident Piranesi's early training in stage design as well as, perhaps, his frustration at not receiving commissions as an architect, the term he always used to describe himself. In 1761 Piranesi took up the *Carceri* again, creating two additional subjects and reworking the originals, overlaying a brooding darkness onto the already disorienting lack of balance or coherence. This group—perhaps the most famous of all of the artist's works—has caused many to perceive Piranesi as essentially unintellectual, Romantic, even veering toward madness, whereas, in fact, his archaeological and scholarly pursuits define him unequivocally as a figure of the Enlightenment. Piranesi was obsessive, and he was on the wrong side of the famous Greco-Roman controversy of the time, insisting on what had, until then, been generally assumed: that Rome was the fountainhead of Western art. The publication in Paris in 1758 of Julien-David Le Roy's *Les ruines des plus beaux monuments de la Grèce* and, a bit later, the volumes of James Stuart and Nicholas Revett, *The Antiquities of Athens Measured and Delineated*, published in London beginning in 1762, showed definitively that Roman architecture derived from Greece, and this view was reinforced by the eminent French connoisseur Pierre-Jean Mariette and the German art historian Johann Joachim Winckelmann, who lived in Rome from 1755 until his death in 1768. Through his study of antiquity, particularly sculpture,

Winckelmann became persuaded that Roman art and architecture derived from Greece, and his book promoting this view, *Geschichte der Kunst des Alterthums*, published in 1764, was extremely influential. It must be stressed, however, that Piranesi, even if mistaken in his championing of the primacy of Rome (or Italy) over Greece—which put him in opposition not only to the publications that were appearing in distant places and to the redoubtable Winckelmann in Rome itself in his own day, but also to the eventually universal acknowledgment of the correct sequence—was not mad.

A highly unusual project that Piranesi had a hand in was an album published in Rome in 1764, reproducing in etching or engraving thirty-two works of art, mostly drawings by the seventeenth-century Bolognese artist Giovanni Francesco Barbieri, known as Guercino. By the mid-eighteenth century, collecting drawings was a relatively commonplace activity, and those by Guercino were highly sought after. But the reproduction as prints of a group of drawings by a single artist, to be published together in an album, had never been done. The Florentine printmaker Francesco Bartolozzi had etched a group of these reproductions of Guercino drawings, and just before leaving for England in 1764 he sold them to Piranesi, who added a few plates and a half-title page that he designed and etched himself (fig. 13), a trompe l'oeil of a slightly crumpled drawing. It belonged to the Roman sculptor and dealer Bartolomeo Cavaceppi, but its location is,

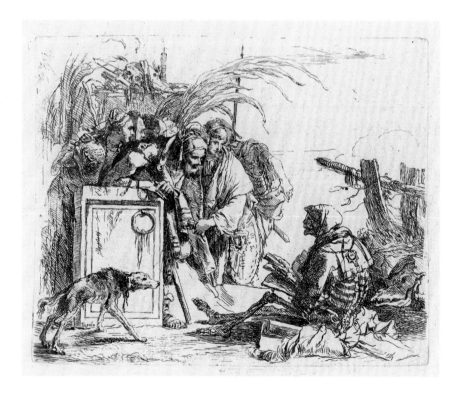

FIG. 12.
GIOVANNI BATTISTA TIEPOLO, *Death Giving Audience*, from *Vari capricci* (Various Capriccios), 1740–42. Etching, 5½ × 6¹⁵⁄₁₆ in. (14 × 17.6 cm). Yale University Art Gallery, The Arthur Ross Collection, 2012.159.5.9

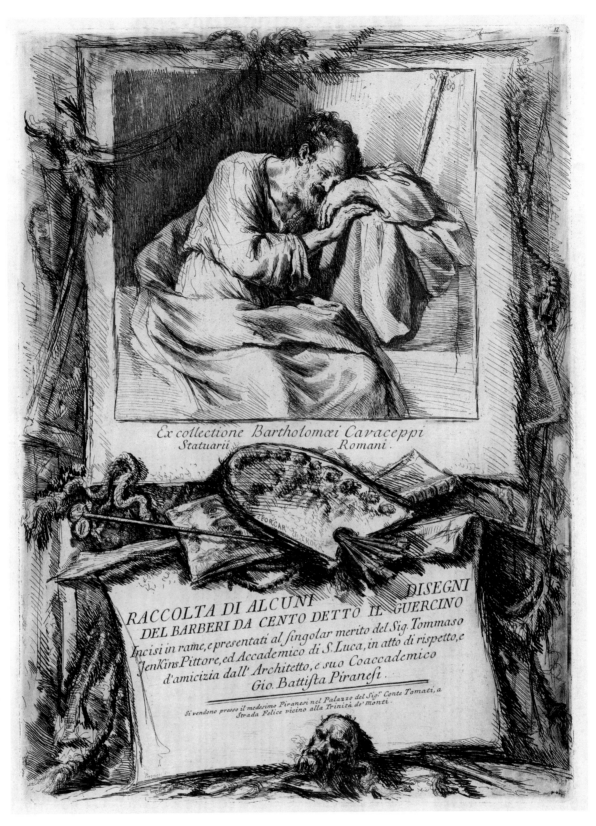

FIG. 13.
GIOVANNI BATTISTA PIRANESI, AFTER GIOVANNI FRANCESCO BARBIERI, CALLED GUERCINO, half-title page with *Saint Joseph*, plate 2 from *Raccolta di alcuni disegni del Barberi* [sic] *da Cento detto il Guercino* (Collection of Some Drawings by Barbieri da Cento, called Guercino), 1764. Etching and engraving with red and black ink, 18⅞ × 13¹⁵⁄₁₆ in. (48 × 35.4 cm). Yale University Art Gallery, The Arthur Ross Collection, 2012.159.1.2

unfortunately, unknown today. This page is printed in black and red—the only plate by Piranesi known to have been printed in color—and numerous other plates in the album are also printed in sanguine in addition to the customary black, in imitation of the chalks used in the drawings. (An unintended consequence of this publication was the emergence shortly afterward of an artist who produced a group of fake Guercino drawings, based on these etched reproductions of real ones![4])

As mentioned, throughout his life Piranesi called himself an "architect," and the urban landscape of Rome, along with the city's history and that of its architecture, was his abiding passion. Besides the well-known *Carceri* and *Vedute*, and also the four *Grotteschi*, the Arthur Ross Collection includes in abundance the works that are the fruit of Piranesi's study of the ancient fabric of the city: the 30 etchings of his *Antichità romane de' tempi della repubblica e de' primi imperatori* (generally known as *Alcune vedute di archi triomphali*), of 1748;

FIG. 14.

GIOVANNI BATTISTA PIRANESI, *Framm.ti di marmo della pianta di Roma antica* (Fragments of the Marble Plan of Ancient Rome), plate 3 from volume 1 of *Antichità romane* (Roman Antiquities), 1756. Etching, 18 × 15 in. (46 × 38 cm). Yale University Art Gallery, The Arthur Ross Collection, 2012.159.12.1.6

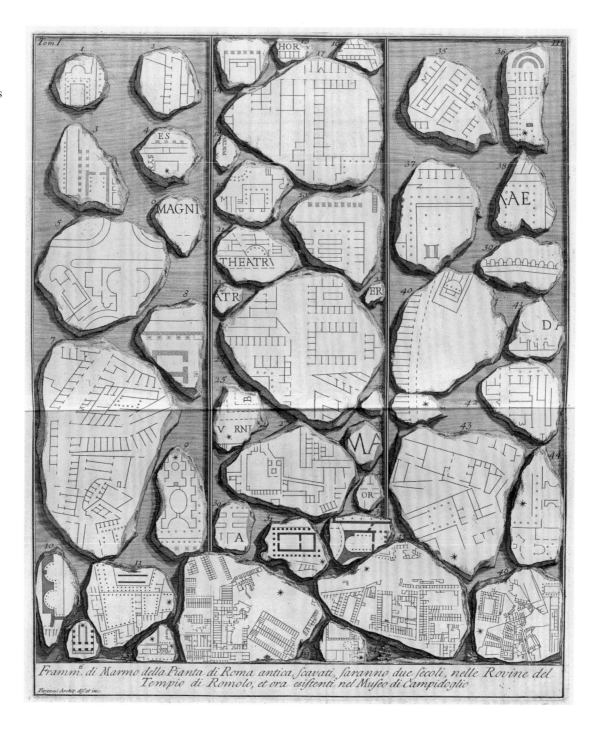

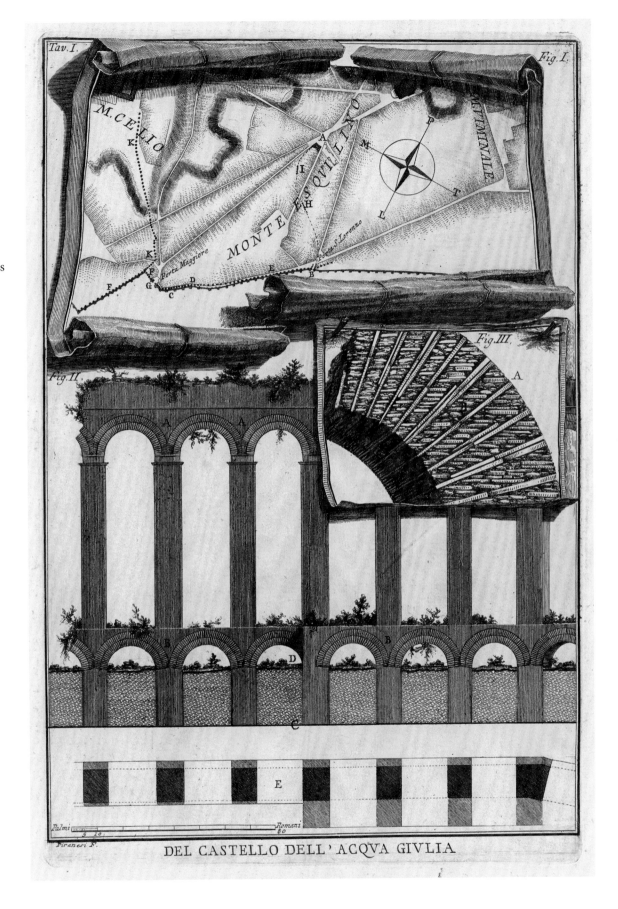

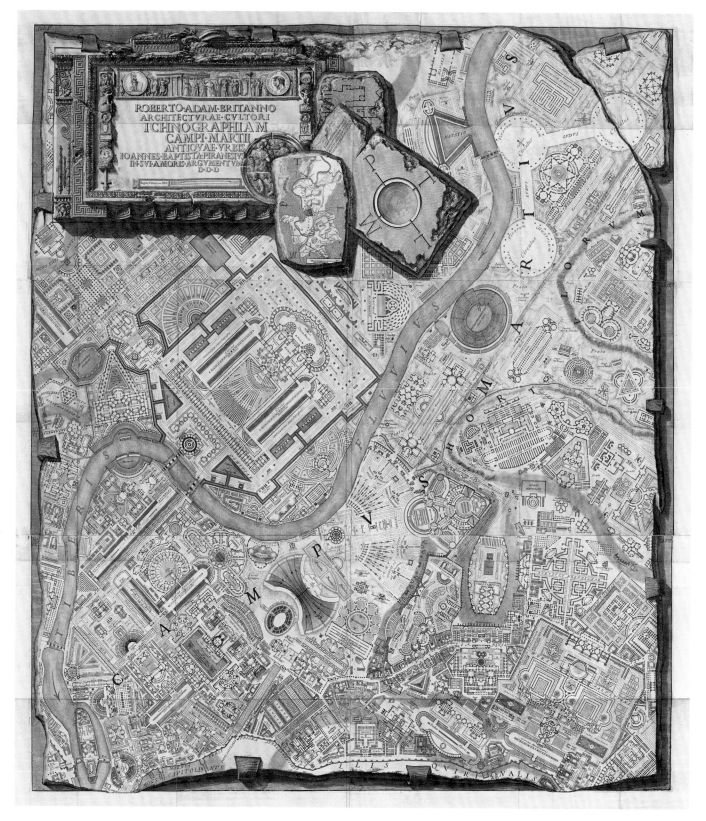

FIG. 16.

GIOVANNI BATTISTA PIRANESI, *Ichnographiam Campi Martii Antiquae Urbis* (*Ichnographia* [Plan] of the Campus Martius of the Ancient City), 1757. Etching, overall 53 × 45 9/16 in. (134.6 × 115.7 cm). Yale University Art Gallery, The Arthur Ross Collection, 2012.159.14

the 255 of his *Antichità romane* published in four volumes in 1756; the 56 of *Della magnificenza, Osservazioni, Parere,* and *Della introduzione* (bound together, even though published in 1761 and 1765) and the 25 of *Le rovine del castello dell'Acqua Giulia* (bound), of 1761; and, finally, the 53 of *Il Campo Marzio dell'antica Roma* (bound), of 1762. These works include many plates depicting elevations in the familiar mode and style of the *Vedute* but also precise and elegant images embodying Piranesi's expertise in both archaeology and engineering (see figs. 14–15). If just one work among the many lesser-known prints by the artist could be said to demonstrate Piranesi's abiding focus and extraordinary intellectual energy, it might well be the *Ichnographia* of 1757 (figs. 16–17), a map of the Campus Martius area straddling the Tiber River between the Capitoline, Quirinal, and Pincian Hills, as Piranesi imagined it looked in antiquity. Printed from six plates, the work measures about 53 × 46 inches when assembled. In his zeal to share his passion for ancient Rome, Piranesi mentally stripped away all the accretions of the medieval, Renaissance, and Baroque city to create a plan of an astonishingly—and impossibly—richly developed area of circuses, stadia, and other monumental structures, all designed on precise geometrical principles. It was an imaginative reconstruction that was based in Piranesi's solid archaeological knowledge but must also be described as his scientific genius in service to his visionary gifts.

In 1777 Piranesi traveled with his son Francesco to the ancient Greek city of Paestum, on the coast south of Naples, where the recent rediscovery of three extraordinarily well-preserved temples was a cause of excitement among antiquarians as well as a magnet for artists and for gentlemen on the Grand Tour. The twenty-one etchings that resulted from this trip are Piranesi's last publication; he signed eighteen of the plates, and his son signed the other three (in the collection checklist in this volume, all twenty-one are listed under Giovanni Battista). Piranesi's genius at creating dramatic views is still evident in these works, although the presence of out-of-scale figures in several of the images he signed unfortunately tends to mar their effect; these figures are most likely the work of Francesco.

Arthur Ross, in keeping with his practice of deepening his collection in areas in which he already had significant holdings, acquired a rare set of etchings of Paestum, made in 1765 by Filippo Morghen after Antonio Joli, when they came on the market in 1992. Like the juxtaposition of Carnicero's bullfight series with Goya's *Tauromaquia* (see figs. 2, 4), a comparison of the Morghen/Joli images with those of the same sites by Piranesi (figs. 18–19) provides fascinating insight into how the same subject in the hands of artists with unequal imaginative powers is rendered to strikingly different effect. Nonetheless, it does seem likely

that Piranesi recognized the excellent choice of viewpoint that Joli had made some dozen years earlier.

The most extraordinary document of eighteenth-century Italy in the Arthur Ross Collection, however, is the map of Rome published in 1748, on twelve separate plates, designed by the surveyor Giovanni Battista Nolli and engraved by Pietro Campana, Carlo Nolli, and Rocco Pozzi (fig. 20). Giovanni Battista Nolli began his surveying work to prepare the map in 1736. The map, corresponding to some eight square miles of the city, measures nearly 6 × 7 feet, and its accompanying index lists 1,320 sites. Every palazzo and every church is shown, as well as, unsurprisingly, the well-known monuments from antiquity—the Colosseum, the Pantheon, the arches and columns. But well beyond these, every set of steps—those ascending to the church of Santa Maria in Aracoeli and to the Capitoline Hill, and the Spanish Steps—and every fountain, even every sewer opening, can be found. Among dozens of remarkable details are the two carefully marked compass points in Gianlorenzo Bernini's Saint Peter's Square from which the perfect oval shape of the piazza was generated. The map is the first one of Rome to put north at the top, and further, to indicate both magnetic north and astronomical north. As if the astonishing detail of the map itself were not enough, Nolli also incorporated a dozen of the best-known Roman landmarks, following drawings by the illustrious Giovanni Paolo Panini, in the lower corners, putting antique (pagan) Rome at the left and

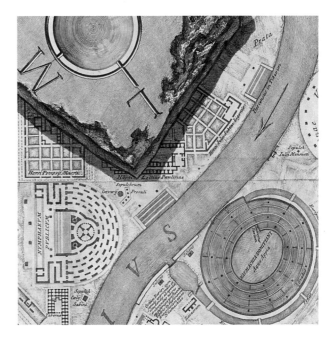

FIG. 17.
Detail of fig. 16

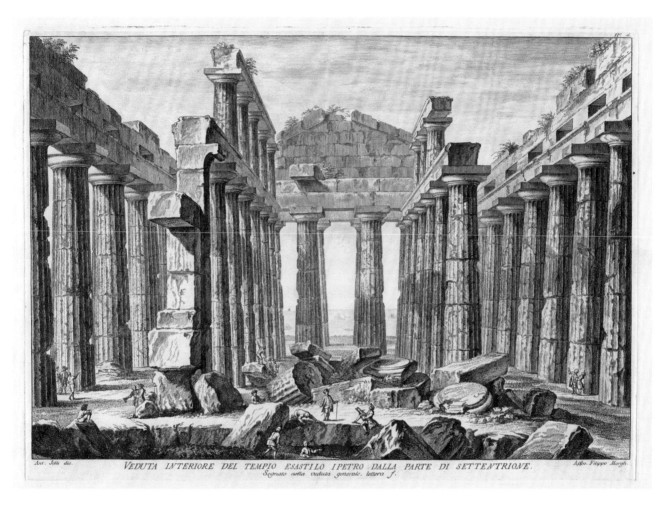

FIG. 18.

FILIPPO MORGHEN, AFTER ANTONIO JOLI, *Veduta
interiore del tempio esastilo ipetro dalla parte di
settentrione* (Interior View of the Hexastile Hypaethral
Temple from the North), from *Antichità di Pesto*
(Antiquities of Paestum), 1765. Etching, 10 ⅞ × 15 ¼ in.
(27.6 × 38.8 cm). Yale University Art Gallery, The Arthur
Ross Collection, 2012.159.30.5

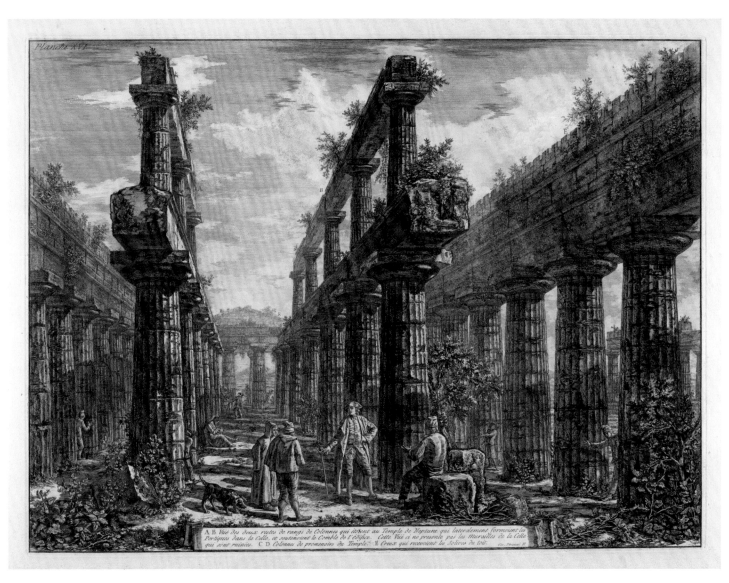

FIG. 19.

GIOVANNI BATTISTA PIRANESI, *A., B. Vuë des deux restes de rangs de colonnes qui étoient au Temple de Neptune qui latéralement formoient les portiques dans la celle, et soutenaient le comble de l'édifice . . .* (A., B. View of the Remains of the Two Rows of Columns in the Temple of Neptune That Formed the Colonnades along the Sides of the Cella and Supported the Uppermost Part of the Roof . . .), from *Différentes vues de . . . Pesto* (Different Views of . . . Paestum), 1778–79. Etching, 19 ½ × 26 ½ in. (49.5 × 67.3 cm). Yale University Art Gallery, The Arthur Ross Collection, 2012.159.17.17

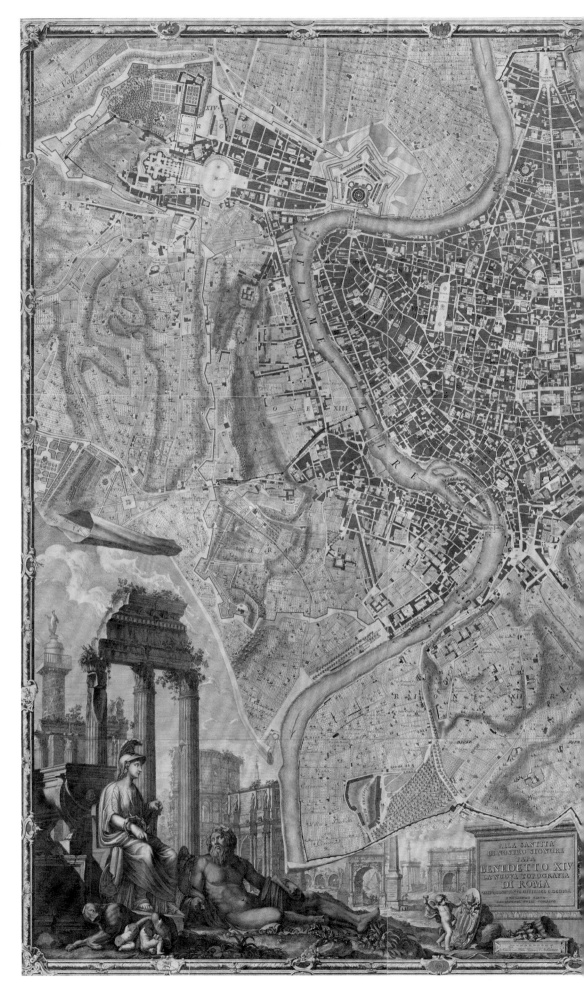

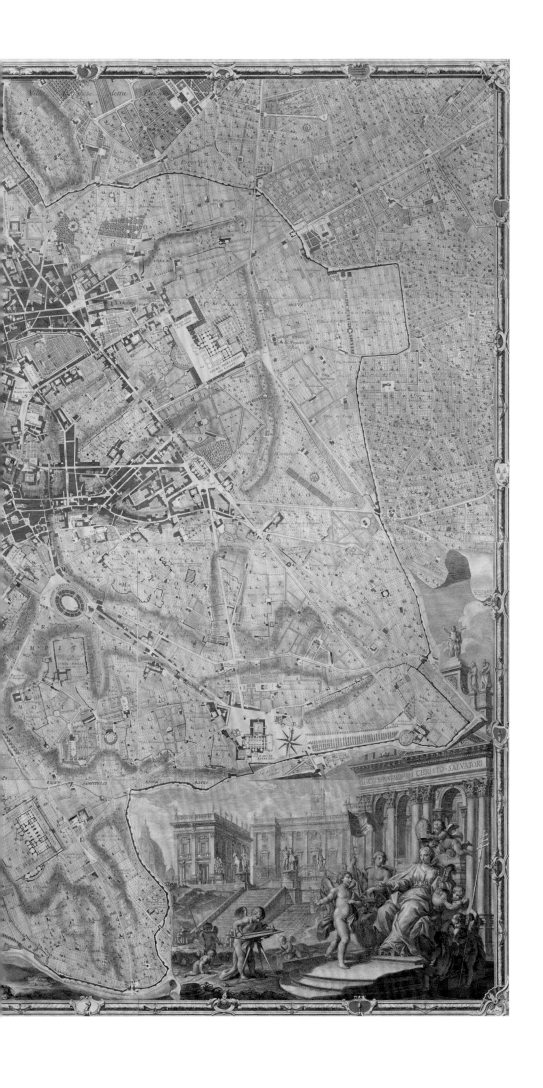

modern (Christian) Rome at the right. The project took twelve years to prepare, and until the middle of the twentieth century it was the most accurate map of the city of Rome in existence.[5]

Piranesi also had a connection to Nolli's project, for at some point in the 1740s—possibly even before his return mid-decade to his native Venice—the young artist collaborated with Nolli to make a smaller-scale version of the immense map of Rome; this was also published in 1748. Piranesi contributed the vignettes of Roman sites—Saint Peter's, the Fountain of the Four Rivers in the Piazza Navona, Santa Maria Maggiore, and others—along the bottom of this (relatively) small map.

Canaletto and the Tiepolos

After his acquisitions of Goya and Piranesi, during the 1990s Arthur Ross began to concentrate on the eighteenth-century Venetian artist Canaletto. In the span of just a few years, Ross collected almost all of this artist's printed oeuvre of thirty-five etched images—sparkling views of scenes along the Brenta River between Venice and Padua, a few of Venice itself, and some of unknown or imaginary sites. Canaletto's chosen subject was the view, even though other genres—principally, so-called history subjects, those that illustrate episodes from the Bible or other literature, or actual historical events—were more highly esteemed by the cultural establishment. Nonetheless, Canaletto drew, painted, and etched only

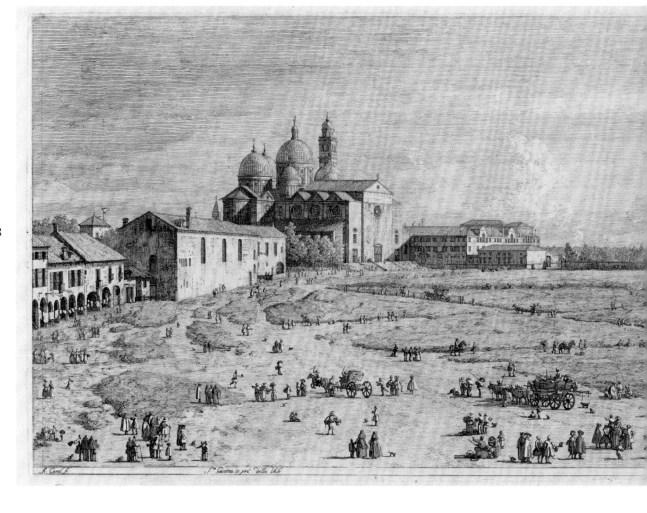

FIG. 21.
GIOVANNI ANTONIO CANAL, CALLED CANALETTO, *S.a Giustina in prà della Vale* [*sic*] and *Prà della Valle* (Santa Giustina in Prato della Valle *and* Prato della Valle), from *Vedute* (Views), 1741-44. Etching on 2 plates, overall 11¾ × 33¹¹⁄₁₆ in. (29.9 × 85.6 cm). Yale University Art Gallery, The Arthur Ross Collection, 2012.159.6.7–.8

views, of his native city and nearby areas—as well as some in England—and these images have now become classic and enormously sought after. In 1725 a collector who had requested pictures by Luca Carlevarijs, an older view painter in Venice, was advised instead to buy the work of the young Canaletto: "It is like that of Carlevarijs, but you can see the sun shining in it."[6] Many of Canaletto's paintings were made for patrons doing the Grand Tour; the etchings, on the contrary, were probably created because of a slowing, or cessation, of those visitors. Late in 1740, the War of the Austrian Succession broke out, and international travel became dangerous. It was probably in 1740 or 1741 that Canaletto, with his nephew Bernardo Bellotto, made the twenty-five-mile trip along the Brenta River to

Padua. Among the most delightful of the resulting etchings is the view on two sheets of the Prato della Valle in Padua, with the church of Santa Giustina at the left and the square, now a park but then a vast, somewhat marshy meadow, rendered as an immense and airy expanse (fig. 21).

Giovanni Battista Tiepolo, a year older than Canaletto, was the last of the three superb Venetian etchers whose works Ross acquired. The collection includes all ten of the *Vari capricci* (Various Capriccios), made in the early 1740s, which, as mentioned earlier, Piranesi would have seen on his return trip to Venice in the mid-1740s. Ross was also particularly attracted to the series *Raccolta di teste* (Collection of Heads) by Giovanni Domenico Tiepolo, after designs by Giovanni Battista—which would have

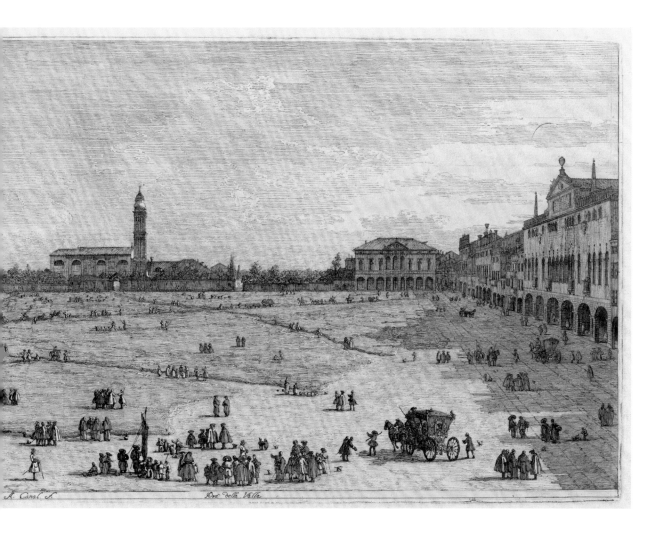

FIG. 22.
GIOVANNI DOMENICO TIEPOLO, AFTER GIOVANNI BATTISTA TIEPOLO, *Old Man with a Large Hat*, from *Raccolta di teste* (Collection of Heads), ca. 1757. Etching, 6 × 4½ in. (15.3 × 11.5 cm). Yale University Art Gallery, The Arthur Ross Collection, 2012.159.29

FIG. 23.
GIOVANNI DOMENICO TIEPOLO, AFTER GIOVANNI BATTISTA TIEPOLO, *Dwarves and Dogs*, ca. 1770. Etching, 8 × 11¹³⁄₁₆ in. (20.3 × 30 cm). Yale University Art Gallery, The Arthur Ross Collection, 2012.159.27

been inspired by seventeenth-century prints of similar subjects by Rembrandt, Giovanni Benedetto Castiglione, and Salvator Rosa—and the collection includes thirty-two of the sixty etchings of these heads known to exist (see fig. 22). In addition to the *Teste*, the collection includes two other etchings by Giovanni Domenico, including the delightful *Dwarves and Dogs* (fig. 23). Ross also acquired just one print of the eleven made by Giovanni Domenico's younger brother Lorenzo Baldissera Tiepolo, *Rinaldo and Armida* (see Highlights, pl. 26). This subject from the great sixteenth-century Italian epic *Gerusalemme liberata* by Torquato Tasso reflects another of Ross's interests, one that shows up particularly in the nineteenth-century French works he acquired: scenes from literature.

The French Artists

It seems more than a coincidence that, having begun the collection for the Arthur Ross Foundation with prints by Goya, when he began to collect work by French artists, Ross favored Édouard Manet. Among the French artists whose work Ross collected, Manet is the most connected to Spain, and to Goya. His great painting *The Execution of Emperor Maximilian* (Kunsthalle Mannheim, Germany), of 1868–69, refers directly to Goya's *The Third of May 1808* (Museo del Prado, Madrid), painted in 1814, and he made numerous prints of bullfighting subjects. Manet was profoundly attracted to Spain and inspired by Spanish art, and, like Goya, he made prints after paintings by Velázquez, such as the portrait of Philip IV in the Arthur Ross Collection. Also included in the collection is an impression of the etching of 1862 of the Spanish dancer Mariano Camprubi (fig. 24), who was part of a troupe visiting Paris.

Most extraordinary among the works by Manet, however, are his five lithographs illustrating the translation into French of Edgar Allan Poe's *The Raven* by the Symbolist poet Stéphane Mallarmé, published in 1875 (see Hodermarsky, fig. 3). Manet and Mallarmé, who can be seen, respectively, as the founders of modern painting and poetry (and who, coincidentally, lived on the same street in Paris), combined to create a truly revolutionary portfolio, in which the dissolution of form in the work of the poet—ten years younger than the artist—is likely to have had a profound influence on the images. The version of this work in the Arthur Ross Collection includes not only the rare first state of the third image, *At the Window*, but also a unique impression of this image before the first state, as well as the title page, advertisement page, text, and justification.[7] Complementing this album, Arthur Ross also acquired an etched portrait of Mallarmé at age forty-nine,

FIG. 24.
ÉDOUARD MANET, *Don Mariano Camprubi, primer bailarin del teatro royal de Madrid* (Don Mariano Camprubi, First Dancer of the Teatro Royal de Madrid), 1862. Etching, 11 ¾ × 7 ¾ in. (29.9 × 19.7 cm). Yale University Art Gallery, The Arthur Ross Collection, 2012.159.77

made in 1891 by Paul Gauguin, in a rare second state of four, before the numbered edition (see Highlights, pl. 62). The poet is shown in the lower-left quadrant of the plate, looking out toward the left, with a large raven behind and above his head. Other Gauguin prints were the first additions of different media to the collection; there are a zincograph and three woodcuts, two from the *Noa Noa* series (see Greist, fig. 8), evoking Gauguin's sojourn in the early 1890s in the South Seas, and another, actually made there a bit later (fig. 25).

In addition to Manet's interpretations of *The Raven*, Ross's attraction to prints illustrating literature is manifested in the two series of literary illustrations by Eugène Delacroix that he acquired in the mid-1990s. The young Delacroix, still near the beginning of his career, turned to the new medium of lithography for the spontaneity and speed it afforded, as did the aging Goya at around the same time. The seventeen lithographs illustrating Goethe's *Faust* (see Hodermarsky, fig. 1), begun in 1827 and published in 1828 by Charles Motte along with a portrait of Goethe, were Ross's first acquisitions of works by Delacroix. This series is one of the high points of Romantic book illustration; of the

series, the seventy-nine-year-old Goethe wrote, "M. Delacroix is a man of great talent, who has found in *Faust* his proper nourishment. . . . And I must confess that M. Delacroix has surpassed my own conceptions in these scenes; how much more will the reader find them vivid beyond his imagination!"[8] Delacroix had a great love for the theater, and he attended numerous performances during a trip to England in 1825, among them a theatrical adaptation of *Faust* and plays by Shakespeare. Ross also acquired, a year after the *Faust* series, the artist's thirteen illustrations for his first edition of *Hamlet* (see Hodermarsky, fig. 2), made beginning in 1834 and published in 1843.

The last series that Arthur Ross acquired, in 2004, was the relatively little-known set by Honoré Daumier called *Les bas-bleus* (The Bluestockings). These forty lithographs, published in the daily *Charivari* between January and August 1844, poke rather unkind fun at the feminists of the day—admirers of George Sand who had literary aspirations but who were perceived as physically unfeminine and criticized as neglectful of their obligations at home. Although some of Daumier's prints courageously satirized those in power, with this series

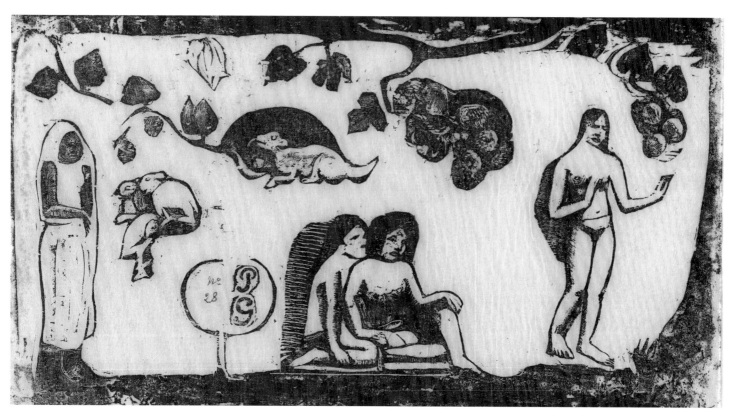

FIG. 25.
PAUL GAUGUIN, *Women, Animals, and Foliage*, 1898. Woodcut, 6⁷⁄₁₆ × 12 in. (16.3 × 30.5 cm). Yale University Art Gallery, The Arthur Ross Collection, 2012.159.93

Daumier's attitude reflected the widespread derisory opinion of these women and thus did not put him, or his newspaper, in any danger (after all, women did not get the vote in France until exactly a century after this series was made, in 1944). In one of these images, a mother is sitting dejectedly at a table while her husband leads away a crying little boy (fig. 26). "Damned squealing child," she is saying, "let me compose in peace my ode to the joys of motherhood!" Daumier even inserted himself into the series, in an image toward the end (see Highlights, pl. 52): a woman, just entering from outdoors, shows a newspaper to another, who clenches her fists and looks heavenward in exasperation. The caption reads, "How could it be! another caricature about us, this morning, in *Charivari*! . . . ah, my days! I hope that this time it's the last! . . . and if ever I get my hands on this Daumier, it will cost him dearly to have allowed himself to knit up [this is a pun: the same word, in archaic usage, means "beat up"] some Bluestockings." The series was so successful that a number of complete sets were printed on white paper, and it is one of those sets, rather than the images on newsprint, that is in the Arthur Ross Collection.

One of Ross's last acquisitions, made in 2006, is also perhaps the rarest work in the collection, as well as one of the most enchanting. The only print by Degas in the collection, it is a rare first state of his etching after the painting in the Musée du Louvre, Paris, of the Infanta Margarita of Spain that was thought at the time to be by Diego Velázquez (see catalogue frontispiece).[9] The print is one of only two impressions known in that state (the other is in the Bibliothèque nationale de France, Paris). A story that is often repeated—and that, even though it has more than one source, cannot be definitively confirmed—is that Degas and Manet first met while Degas was making this etching, in the Louvre in 1861 or 1862. Degas was working directly on the copper plate, and the slightly older Manet, seeing him, is said to have exclaimed when he saw that Degas was working on the plate with no intermediate drawing. He introduced himself and congratulated Degas for his audacity. (Manet himself made an etching of the same image around the same time, but it is assumed he made it in his studio, following a preparatory image.[10]) Whether the story is true or not, the two artists maintained a relationship—on the whole friendly if occasionally marred by disagreement—until

FIG. 26.

HONORÉ DAUMIER, *Satané piallard d'enfant va! . . . laisse moi donc composer en paix mon ode sur le bonheur de la maternité! . . .* (Damned squealing child! . . . let me compose in peace my ode to the joys of motherhood! . . .), from *Les bas-bleus* (The Bluestockings), 1844. Lithograph, 9 1/16 × 7 1/2 in. (23 × 19 cm). Yale University Art Gallery, The Arthur Ross Collection, 2012.159.62.14

LES BAS-BLEUS.

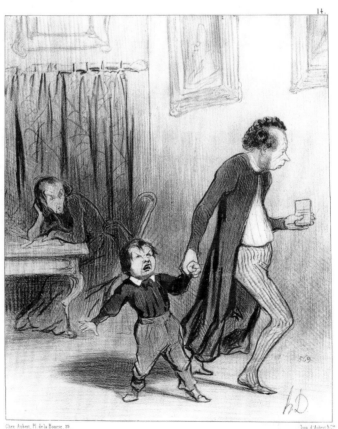

Manet's death in 1883. Within the Arthur Ross Collection, the Degas etching resonates both with the works by Goya after Velázquez that were some of the first prints acquired and with works by Manet, purchased in the following decade. It also epitomizes the superb quality of the prints that Arthur Ross assembled throughout the quarter century during which he steadfastly worked to amass his foundation's superlative collection.

Two Unusual Artists

Finally, some perhaps surprising inclusions should be mentioned, relatively sizable groups of works by two artists somewhat less well known than most in the collection: fifty-seven prints by Mortimer Menpes, who was born in what is now Australia, and forty-two photographs by a contemporary American artist, Marvin E. Newman. Menpes immigrated to England and became a friend of James McNeill Whistler; the prints in the Arthur Ross Collection include numerous romantic views of Venice similar to those by Whistler (see, for example, Greist, fig. 7; Highlights, pl. 65). Because out of the more than seven hundred prints that Menpes made, the collection includes only his Venetian subjects plus two portraits of Whistler (see Highlights, pl. 64), these etchings may, in a sense, be seen as stand-ins for Whistler prints, of which there are none in the collection; by the time Ross began acquiring prints, it was extremely difficult to find Whistlers in impressions that met his high standards. The romantic Menpes views provide a contrast to the classically rendered scenes of the Veneto depicted in the thirty-two prints in the collection by Canaletto, made a century and a half earlier. The Newman photographs, from his series Open Spaces,

Temporary and Accidental (see fig. 27), made in the 1970s, bring one of the major themes in the collection—the urban view—into the twentieth century. The views by Newman in the Arthur Ross Collection, however, as opposed to numerous ones by Canaletto and Piranesi that can still be seen relatively unchanged two-and-a-half centuries later, were all inherently temporary, destined to disappear as construction proceeded. The photographs captured a surprising collateral benefit, as it were, of the relentless cycle of destruction and new construction taking place in New York City. In the words of drama and architecture critic Brendan Gill, these photographs record "the opening up of many unexpected vistas, which give delight to the eye and add immeasurably to the charm of our street life even as they inconvenience us."[11]

Finally, to pull down the curtain, as it were, on this short summation of the Arthur Ross Collection, this account will end by citing one of Daumier's classic, and justifiably famous, images, one of six single lithographs by the artist that, along with the Bas-bleus series, the Gallery is delighted to have added to its holdings. In 1834 Daumier caricatured King Louis-Philippe pointing to a blind Justice, with the Chamber of Deputies behind. As caption, he chose the famous last words of François Rabelais: Baissez le rideau, la farce est jouée (Lower the curtain, the farce has ended) (fig. 28).

This brief overview of the Arthur Ross Collection has been able to do no more than call attention to a few of its most exceptional highlights. The possibilities that the collection offers for exhibition, research, and teaching are virtually endless, and indeed, this publication is just the beginning of the rewards to be reaped from the study and enjoyment of this extraordinary gift.

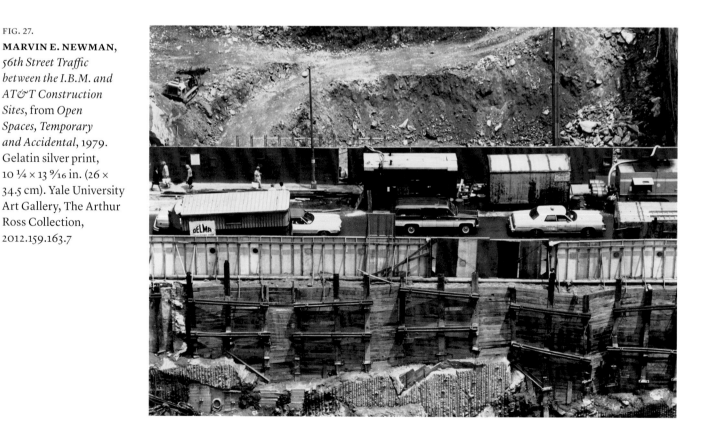

FIG. 27.
MARVIN E. NEWMAN, *56th Street Traffic between the I.B.M. and AT&T Construction Sites*, from *Open Spaces, Temporary and Accidental*, 1979. Gelatin silver print, 10 ¼ × 13 ⁹⁄₁₆ in. (26 × 34.5 cm). Yale University Art Gallery, The Arthur Ross Collection, 2012.159.163.7

FIG. 28.
HONORÉ DAUMIER,
Baissez le rideau, la farce est jouée (Lower the Curtain, the Farce Has Ended), 1834. Lithograph, 7 ⅞ × 10 ¹⁵⁄₁₆ in. (20 × 27.8 cm). Yale University Art Gallery, The Arthur Ross Collection, 2012.159.59

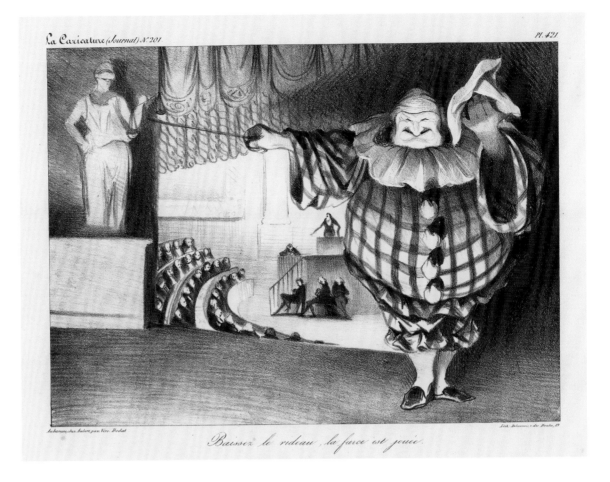

1. Manuela B. Mena Marqués, in Stephanie Loeb Stepanek, Frederick Ilchman, and Janis A. Tomlinson, *Goya: Order and Disorder*, exh. cat. (Boston: MFA Publications, Museum of Fine Arts, 2014), 79.

2. Janis A. Tomlinson, *Goya's War: Los desastres de la guerra* (Pomona, Calif.: Pomona College of Art, 2013).

3. Susan Sontag, interview with Kurt Anderson, *Studio 360*, February 29, 2008, http://www.studio360.org /story/107606-susan-sontag-art-that -means-war/transcript/.

4. See Prisco Bagni, ed., *Il Guercino e il suo falsario: I disegni di figura* (Bologna, Italy: Nuova Alfa, 1990).

5. The best printed sources for the Nolli map are Allan Ceen, *Rome 1748: The Pianta Grande di Roma of Giambattista Nolli in Facsimile* (Highmount, N.Y.: J. H. Aronson, 1984); and Mario Bevilacqua, *Roma nel secola dei lumi: Architettura erudizione scienza nella pianta di G. B. Nolli, "celebre geometra"* (Naples: Electa, 1998). See also the interactive website, http://nolli .uoregon.edu.

6. Alessandro Marchesini, letter to Stefano Conti, July 14, 1725, transcribed in Dario Succi and Annalia Delneri, eds., *Marco Ricci e il paesaggio veneto del Settecento* (Milan: Electa, 1993), 338.

7. For a fuller discussion of this series, and of those by Delacroix illustrating literary works, see the essay by Elisabeth Hodermarsky in this volume.

8. John Gage, ed. and trans., *Goethe on Art* (Berkeley: University of California Press, 1980), 239.

9. Since the 1960s, the scholarly consensus has been that this painting is not by Velázquez. In Guillaume Kientz, *Velázquez*, exh. cat. (Paris: Réunion des Musées Nationaux, 2015), no. 107, it is attributed to Juan Bautista Martínez del Mazo, Velázquez's son-in-law and principal follower. See also Javier Portús Pérez, in Gary Tinterow and Geneviève Lacambre, *Manet/Velázquez: The French Taste for Spanish Painting*, exh. cat. (New York: Metropolitan Museum of Art, 2003), no. 78.

10. See Jean C. Harris, *Édouard Manet: Graphic Works, A Definitive Catalogue Raisonné* (New York: Collectors Editions, 1970), no. 14; and Jay McKean Fisher, *The Prints of Édouard Manet* (Washington, D.C.: International Exhibitions Foundation, 1985), no. 30.

11. Brendan Gill, *Breaking Ground: Open Spaces, Temporary and Accidental*, exh. cat. (New York: The Municipal Art Society, 1981), n.p.

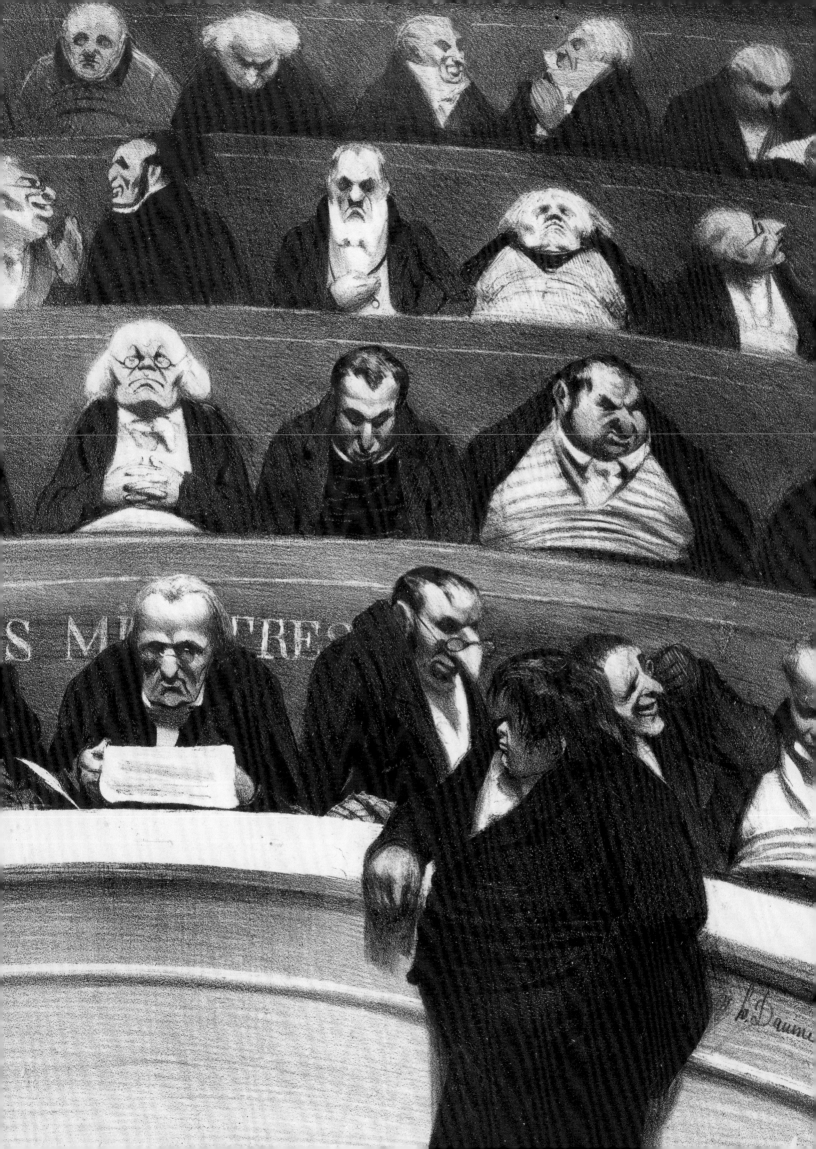

Beyond the Print:
Creative Approaches to Sharing
the Arthur Ross Collection

HEATHER NOLIN

THE TRUSTEES OF THE Arthur Ross Foundation gave its founder's extraordinary collection of prints to the Yale University Art Gallery with an awareness of the museum's proven commitment to proactively sharing its holdings through its Collection-Sharing Initiative, and the kinship that this program had with Arthur Ross's vision and lending practices. Indeed, as one can see by reading his writings in the foundation's archives or the exhibition history in the present catalogue, Ross frequently lent his substantial collection of prints to dozens of museums, often those on academic campuses, and he championed the acquisition and exchange of knowledge.

Although the Gallery's encyclopedic collection has long played a vital role in the education of students across the Yale campus, the innovative Collection-Sharing Initiative makes this resource available to a much broader and more diverse audience. In 2008 the Andrew W. Mellon Foundation awarded a planning grant to help the Gallery develop the experimental initiative and explore how such a program might contribute most significantly to the academic impact of college and university art museums. After a successful planning period, in 2010 the Mellon Foundation awarded the Gallery additional funding to launch the inaugural phase of the program. Over the next three years, the Gallery lent a large number of works to six museums on academic campuses. The museums in turn used the works to develop exhibitions and related curricula tailored to the pedagogical needs of their institutions.[1] These loans expanded opportunities for faculty from a wide variety of disciplines—including anthropology, art history and conservation, classical studies, computer science, education, gender studies, German, history, Jewish studies, philosophy, poetry, political theory, and theater—to teach from original works of art.[2]

Moreover, many faculty members had never made use of their institutional museums' collections in their teaching prior to becoming involved with this initiative.

The gift of the Arthur Ross Collection has prompted the Gallery to move into the next stage of its Collection-Sharing Initiative. The present exhibition, *Meant to Be Shared: Selections from the Arthur Ross Collection of European Prints at the Yale University Art Gallery*, welcomes this important group of works to its new home, but in the spirit of the collector, the exhibition also travels in spring 2017 to the Samuel P. Harn Museum of Art at the University of Florida at Gainesville and in fall 2017 to the Syracuse University Art Galleries, in New York. Additionally, substantial portions of the Arthur Ross Collection travel to unique exhibitions at the Blanton Museum of Art at the University of Texas at Austin, in summer 2016, and the Smith College Museum of Art, in Northampton, Massachusetts, in fall 2016.

The Blanton's exhibition, *Goya: Mad Reason*, is organized by Douglas Cushing, a PH.D. student in Art History at the University of Texas at Austin and that museum's 2014–15 Andrew W. Mellon Fellow, under the supervision of Francesca Consagra, Senior Curator, Prints and Drawings and European Paintings. The show explores Francisco Goya's responses to his culture and society and, above all, how his art, especially his printed output, presents a tension between his visual poetry and social commentary.[3] The centerpiece of the exhibition is the majority of the Arthur Ross Collection's almost two hundred etchings by the artist. Smith's exhibition, *When in Rome: Prints and Photographs, 1550–1900*, is organized by Aprile Gallant, Curator of Prints, Drawings, and Photographs at that museum, and features a large number of Giovanni Battista Piranesi's etchings from

the Arthur Ross Collection. These prints are juxtaposed with sixteenth- and seventeenth-century engravings and nineteenth-century photographs from Smith's own collection as a means of studying the many ways in which the city of Rome has been pictured over time.

While the pilot phase of the Gallery's Collection-Sharing Initiative focused on sharing objects, it showed that collaboration among institutions could also include the exchange of new research and teaching approaches. Thus, this new phase includes a student-exchange program, close-looking sessions, curriculum support, and other opportunities for constituents to share their practical experiences and have direct contact with objects and each other. Chief among these outlets is a workshop day hosted by the Gallery in January 2016 that brings together scholars, faculty, and graduate and undergraduate students from Yale, the University of Texas at Austin, Smith College, the University of Florida at Gainesville, and Syracuse University. Participants will offer their perspectives on and insights into the Arthur Ross Collection, work directly with the original prints that will travel to their respective museums, explore ways to enrich student experiences, and share teaching methods.

Other collaborations around the collection have already begun to take place. In fall 2014, for example, Smith Professor of Art Barbara Kellum brought students from her first-year seminar, "On Display: Museums, Collections, and Exhibitions," to the Gallery for extended study of prints by Piranesi; their observations were integrated into group research projects, which will generate content for Smith's *When in Rome* exhibition. In summer 2014, Olivia Armandroff, a History of Art major at Yale, served as the Yale Curatorial Fellow at the Blanton, assisting Consagra with preparation for *Goya: Mad Reason* and thus gaining an important curatorial mentor at another institution. That winter, Cushing made a reciprocal visit to New Haven to study the Arthur Ross Collection's Goya prints and conduct research in its archives; conversations about the collection with curators and staff in the Gallery's Department of Prints and Drawings augmented his experience. As a further step in this student exchange, upon returning to New Haven, Armandroff joined the Gallery's Department of Publications and Editorial Services as a summer bursary student, where she used the knowledge she acquired at the Blanton to assist in the production of this very catalogue.

Like these exhibitions and associated fruitful collaborations, the following essays, which explore the three greatest strengths of the Arthur Ross Collection—a veritable trove of etchings by Piranesi; superb editions of Goya's print series *Los desastres de la guerra*, *La tauromaquia*, and *Los disparates* (*Los proverbios*); and Delacroix's and Manet's illustrations of literary works by Johann Wolfgang von Goethe, William Shakespeare, and Edgar Allan Poe—reinforce the collection's legacy as a catalyst for intellectual exploration. Their authors investigate and celebrate the genius of the artists represented in the Arthur Ross Collection and thus, in a way, the genius of the collector himself. Arthur Ross once wrote that the oeuvre of his favorite artist, Goya, "eloquently reflects the humanistic philosophy of the artist and the dedication of his great talent to the enlightenment of mankind."[4] So, too, the Arthur Ross Collection seems to reflect the humanistic philosophy of its collector and his dedication to sharing the genius of all artists in his collection so that their prints might enlighten and inspire those who view them.

1. The six collection-sharing projects were: *Learning to Paint* (January 26–July 12, 2010) and *Methods for Modernism* (April 1–July 12, 2010), Bowdoin College Museum of Art, Brunswick, Maine; *Reconstructing Antiquity* (September 21, 2010–June 3, 2012), Mount Holyoke College Art Museum, South Hadley, Massachusetts; *Reflections on a Museum* (April 7, 2011–June 9, 2013), Williams College Museum of Art, Williamstown, Massachusetts; *Investigations into the Ancient Mediterranean* (May 5–June 24, 2012), Hood Museum of Art, Dartmouth College, Hanover, New Hampshire; *Transcending Boundaries: The Art and Legacy of Tang China* (September 16–December 18, 2011) and *Pursuing Beauty: The Art of Edo Japan* (February 17–May 27, 2012), Smith College Museum of Art, Northampton, Massachusetts; and *Religion, Ritual, and Performance in the Renaissance* (August 28, 2012–June 30, 2013), Allen Memorial Art Museum, Oberlin College, Ohio.

2. To aid in cross-disciplinary outreach, several of the partner institutions created websites and other didactic materials. For example, the Bowdoin College Museum of Art created an interactive site for their two-part exhibition *Methods for Modernism* and *Learning to Paint*; see http://www.bowdoin.edu/art-museum/exhibitions/methods-for-modernism/. The Mount Holyoke College Art Museum produced a website, which includes a complete checklist and resource links, for their exhibition *Reconstructing Antiquity*; see http://antiquity.mtholyoke.edu/home. The Hood Museum of Art produced a website for *Investigations into the Ancient Mediterranean*; see http://www.dartmouth.edu/~yaleart. The Allen Memorial Art Museum produced an educators' resource packet, family guides, and podcasts in conjunction with *Religion, Ritual, and Performance in the Renaissance*; see http://www.oberlin.edu/amam/RRP_Renaissance.html.

3. See the essay by Douglas Cushing in this volume.

4. Arthur Ross, in *Goya: "The Disasters of War" and Selected Prints from the Collection of the Arthur Ross Foundation*, exh. cat. (New York: Spanish Institute, 1984), 5.

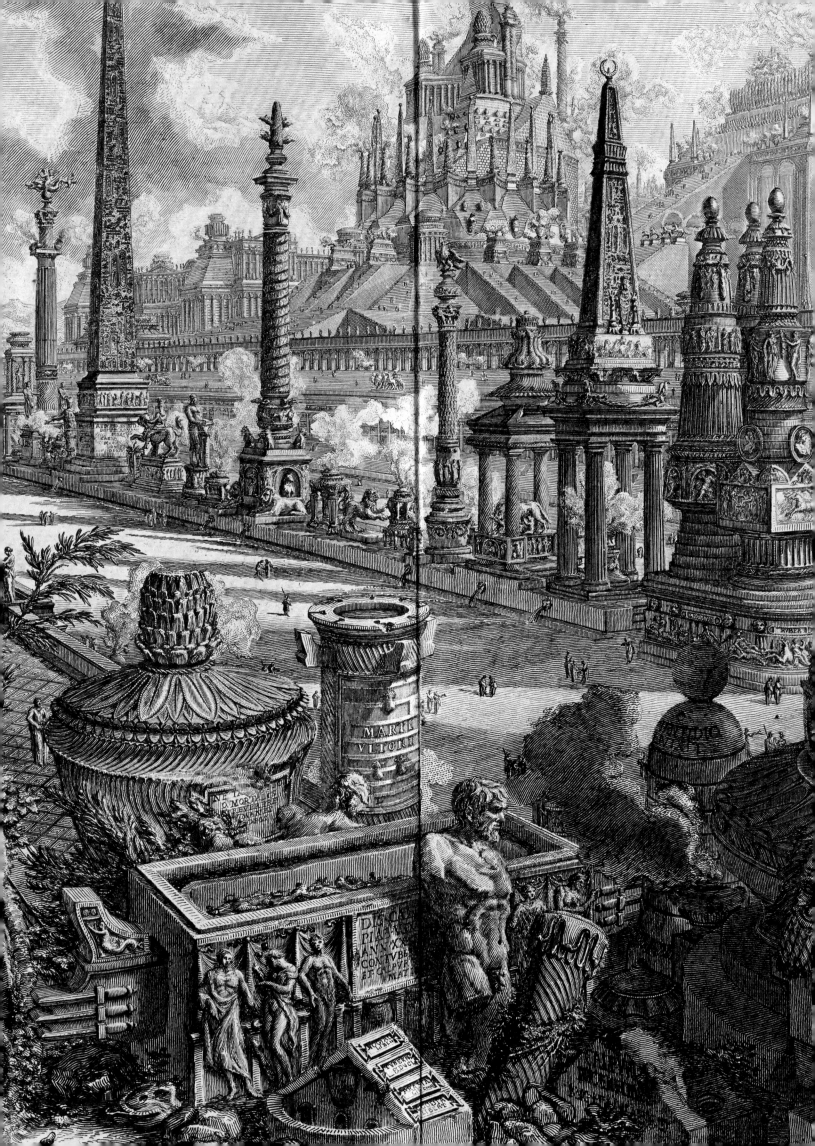

Hubris, Humor, Guts, and Glory: Piranesi in the Eighteenth Century

JOHN E. MOORE

IN EIGHTEENTH-CENTURY EUROPE, perspective views documented urban panoramas, prominent buildings, aristocratic countryseats, elegant gardens, and faraway places.[1] Depictions of Rome took pride of place because of the city's unique status as erstwhile capital of a great empire, seat of the papacy, artists' classroom, and peerless crucible of humanist, archaeological, and antiquarian studies. Aged twenty when he first arrived in the Eternal City from his native Venice, Giovanni Battista Piranesi quickly determined to make his mark in this arena, bringing out, over the course of his career, numerous independent print series and richly illustrated books.

During his lifetime, Piranesi was considered high-strung, one who, according to the travel writer Lady Anna Miller, "would be called a humorist, consequently uncertain and capricious," or, in today's parlance, a piece of work (see fig. 1).[2] In 1763 the architect Luigi Vanvitelli questioned the printmaker's sanity; he also considered Piranesi a poor candidate for a never-executed project at Saint John Lateran, the cathedral of Rome, because of perceived (and inauspicious) similarities between his persona and artistic temperament and those of Francesco Borromini, author of that building's thoroughgoing seventeenth-century interior reconfiguration.[3] Vanvitelli also derogatorily insisted that Piranesi was a printmaker, not an architect.[4] Nevertheless, Piranesi's skillfully deployed etching needles made him a rich man. His printmaking generated revenues, Vanvitelli wrote, that surpassed those of the Calcografia Camerale Romana, the Papal States' official print shop.[5] In an ironic twist, that institution purchased the artist's copperplates in December 1838, and by the early 1840s was pulling impressions from them for sale to the public.[6]

Piranesi sold his works, bound and unbound, directly to customers in Rome and through agents to those living elsewhere, but he also sought seed money for his projects by persuading patrons to accept dedications of books and single-sheet prints; these patrons, in turn, would provide financial support. For example, Piranesi offered to dedicate an expanded suite of his and others' etchings originally published around 1750 to the Irish Grand Tourist and future statesman James Caulfeild, 1st Earl of Charlemont.[7] Unfortunately, their relationship soured when the nobleman balked at the actual scope of the project—an artistic and scholarly enterprise that had developed into the four-volume *Antichità romane*, each with its own etched frontispiece, the earliest editions of which name Charlemont and praise him as a promoter of learning and the fine arts.[8] A pamphlet titled *Lettere di giustificazione*, published in 1757, sets out Piranesi's partisan account of events.[9] He claimed not to be motivated by pecuniary considerations but undercut that argument by recording certain incurred costs—1,200 *scudi* to prepare the four dedicatory copperplates, and an additional 640 to purchase the paper for the prints.[10] "Whether the work [be] good or bad, worthy or not of its protector's name," Piranesi erred in thinking that whatever gifts Charlemont might bestow for having accepted the dedication would correspond in some directly calculable way to the artist's expended time and money.[11] Piranesi misunderstood the world of eighteenth-century European book dedications, in which the dedicator did not dictate terms; the dedicatee, however, was free to act as he pleased.

In high dudgeon, Piranesi also acted, expunging references to the earl in all four plates as if they were examples of ancient Roman *damnatio memoriae*. The revised frontispiece to the third volume includes the base of a ruined rostral column with spiral fluting: a visibly excised eight-line text is replaced with two Latin words—*Marti*

FIG. 1.

FELICE FRANCESCO POLANZANI, *Portrait of Giovanni Battista Piranesi,* 1750. Etching and engraving, 15 3/16 × 11 3/8 in. (38.6 × 28.9 cm). Yale University Art Gallery, The Arthur Ross Collection, 2012.159.7

FIG. 2.

GIOVANNI BATTISTA PIRANESI, *Antiqvvs Circi Martial cvm monvm adiacentia prospectvs ad viam Appiam* (Ancient Circus of Mars with Neighboring Monuments Viewed at the Via Appia), frontispiece to volume 3 of *Antichità romane* (Roman Antiquities), 1756. Etching, 15 5/8 × 23 7/8 in. (39.7 × 60.6 cm). Yale University Art Gallery, The Arthur Ross Collection, 2012.159.12.3.2

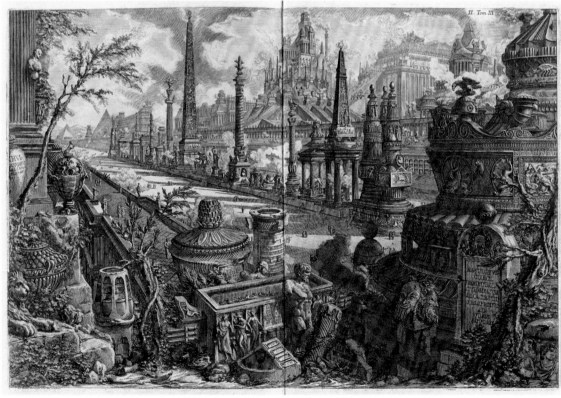

vltori, "to Mars the Avenger"—each occupying one line (fig. 2). Piranesi knew that Mars was a divine progenitor of the Julian line, that there stood in the Forum of Augustus a temple to Mars Ultor, and that Augustus avenged Julius Caesar's assassination. For the artist to invoke that history here constitutes a strikingly imaginative leap. Though manifestly troubled by what he perceived as Charlemont's vagaries, Piranesi never escaped the need to secure wealthy individuals' financial backing.[12]

To keep international print buyers au courant and to promote himself, Piranesi produced—no later than March 1, 1761, just under a month after his nomination to Rome's Accademia di San Luca on February 2—a single-sheet sale list with an elaborately etched border.[13] Functioning as an efficient and inventive curriculum vitae, the sale list allowed the public to know the artist by his works. Some impressions were personally inscribed with a recipient's title and name.[14] In a pattern analogous to today's glossy catalogues that are shipped with items ordered online, employees in Piranesi's shop doubtless slipped in sale lists when wrapping clients' unbound acquisitions. As a result, these broadsides eventually made their way into bound volumes, as with the sixth edition, found in the fourth volume of the *Antichità romane* in the Arthur Ross Collection (fig. 3).[15] The sheet features engraved titles and descriptions of print series such as the *Carceri* and the *Vedute di Roma*, along with a book title, *Della magnificenza, ed architettura de' Romani*, all presented as though written on unrolled pieces of pinned-up paper, the largest of which obscures Piranesi's titles and honors. Seven pairs of faintly etched lines beneath the title of the as-yet-unnumbered sixtieth *Veduta*, *Del Pantheon*, confidently indicate that additional views are on the way. Prices are engraved not in numerals but in words, which were technically possible but not so easy to alter. What is more, any such revisions might have confused or disappointed purchasers who would have expected to find accurate information in the widely disseminated sale list. Still, one change was effected, resulting perhaps less from increased costs of time and raw materials than from Piranesi's desire to enhance profits derived from a bestselling series. The brief title of *Del Pantheon* occupies the same line as a new price, three *paoli* (.30 *scudo*)—20 percent higher than the two-and-a-half *paoli* price enumerated at the beginning of the list, in the descriptive text that precedes the subject of the first *Veduta*.

The sale list was subsequently updated, as in the thirty-second edition (fig. 4), brought out not long after Piranesi's death by his sons and daughter, who continued to run their father's successful enterprise. To accommodate the titles of a greatly expanded inventory, a second copperplate and larger sheets were needed. From this point forward and at high prices, prints after famous ancient sculptures on display in Rome were on sale in the shop—including the Dying Gladiator in the Capitoline Museum, at five *paoli*; the Vatican Meleager, at six; and the Farnese Bull, at ten—along with other new items.

Added to the sale list over time were prints of three renowned artists' works that speak to Piranesi's savvy grasp of what would appeal to Grand Tourists. Piranesi commissioned, for example, a portfolio of his and his collaborators' etchings after drawings by Guercino held in Roman private collections, Piranesi's among them (see Boorsch, fig. 13).[16] Moreover, he obtained from Paris Nicolas Dorigny's copperplates after Raphael's *Transfiguration* and Daniele da Volterra's *Deposition*.[17] So it was that Piranesi's print shop, sited "in the palace of Count Tomati on the Strada Felice, near Trinità dei Monti [via Sistina, 46]," the church in which the frescoed *Deposition* can still be seen, encouraged customers to engage in one-stop shopping. During his visit to Rome in 1775, for instance, archduke Maximilian of Austria visited Santissima Trinità dei Monti and there admired the *Deposition*; on the same day, "he honored with a visit the studio of Piranesi, a celebrated etcher of antiquities."[18] Just days later, as a gift from Pope Pius VI, Maximilian received ten volumes of the artist's works and those "of the Calcografia Camerale."[19] A year earlier, in 1774, two diplomats reported on an identical donation, this time by Pope Clement XIV, to Henry Frederick, Duke of Cumberland and Strathearn, a brother of George III.[20]

As early as 1756, Piranesi remarked that "his works had been requested in Germany, Denmark, Sweden, and Russia."[21] Impressions of the *Antichità romane* resided "in many public libraries of Europe, and in particular that of the Most Christian King."[22] In 1763, having for some time wanted to approach Charles Emmanuel III, duke of Savoy and king of Sardinia, with the offer of a gift, Piranesi drafted a memorandum. Writing in the third person, he figured the anticipated royal recipient as "a most eminent protector of littérateurs and professors of the fine arts." Count Giovanni Battista Balbis Simeone di Rivera, the Sardinian ambassador in Rome, transmitted this document to the royal court in Turin and, in his own letter, noted that the printmaker had offered his works to "other great sovereigns," who had accepted them "with pleasure." Rivera wondered if the nine volumes in question had been sought "in particular by the University or by the Royal Museum, since all these works explore Roman antiquities." He correctly assessed these volumes' value at somewhere between 84 and 90 *scudi* unbound, approximately 138 *scudi* if "bound so as to be presented to His Majesty," who could, if he chose, additionally reward Piranesi with "a little bonus [*gratificazione*]" of 80 *scudi*. According to the diplomat's personal knowledge, Piranesi wanted "all monarchs" to receive examples of his oeuvre and approve his achievements.[23]

FIG. 4.

GIOVANNI BATTISTA PIRANESI, *Catalogo delle opere date finora alla luce da Gio.Battista Piranesi* (Catalogue of Works Brought to Light So Far by Gio[vanni]Battista Piranesi), ca. 1780. Etching and engraving, platemark: 15 ⅝ × 11 ⅝ in. (39.7 × 29.5 cm), additional text plate: 3¹⁄₁₆ × 11 ⅝ in. (7.8 × 29.7). Yale University Art Gallery, Everett V. Meeks, B.A. 1901, Fund, 2015.81.2

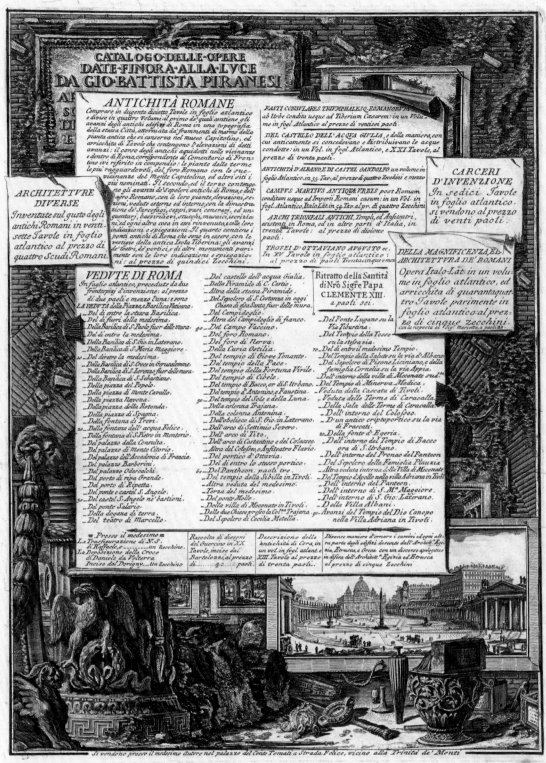

Rivera also forwarded on Piranesi's behalf a handwritten list of works for the court's consideration (figs. 5–6): it explicitly numbers the *Vedute di Roma* at sixty, inventories those completed "up to the year 1762," and provides descriptions of the contents or subjects of the other proffered volumes and suites of prints.[24] Piranesi undoubtedly had this manuscript prepared so as to omit the earlier printed sale list's prices—to have included them would have been indecorous. That the king had the means to pay any asking price was indisputable; at issue was his choice to express his munificence freely and graciously. Unfortunately, writing from Turin, Carlo Flaminio Raiberti, an official in the secretariat of state for foreign affairs, declined the offer. He noted that the subjects treated "things already published, for the most part, by other talented printmakers" and that "more than one

FIG. 5.
"Opere di Giovan Battista Piranesi Pubblicate fino all'anno 1762," recto, insert in a letter from count Giovanni Battista Balbis Simeone di Rivera to Carlo Flaminio Raiberti, Rome, August 13, 1763. Materie politiche per rapporto all'estero, Lettere Ministri Roma 252, Archivio di Stato di Torino

FIG. 6.
Verso of fig. 5

impression of Piranesi's very same works" was already available locally.[25] Back in Rome, Rivera certainly let the artist know that the king had been directly apprised of the offer yet may have diplomatically omitted the court's potentially irksome and invidious comparison.

Though Piranesi's memorandum did not have the desired effect, his prestige as a printmaker spread unabated. Today's scholars of Roman antiquity rarely if ever turn to the artist's weighty, erudite tomes, and the same seems to have been true of eighteenth-century antiquaries.[26] Nevertheless, the artist's works found their way into libraries far and wide. A Boston newspaper reported that in 1772 Thomas Palmer donated to his alma mater, Harvard University, "a . . . work said by Connoisseurs to be executed with an Elegance and Exactness to satisfy the most curious Observer."[27] Although the article does not name Piranesi, it is his prints that are glowingly described.[28] Thanks to Palmer's generosity, the Connecticut-born John Trumbull, a Harvard student and future painter, was later able to consult "a set of Piranezi's prints."[29] Forging a tangible link between statecraft and the support of learning and scholarship, Joseph Bonaparte donated a complete set of Piranesi's works to the municipal library on a visit to Ghent in 1803.[30] In a similar vein, those officials who, in the name of the king of the Two Sicilies, distributed the *Antichità d'Ercolano*—lavishly illustrated folios recording the finds unearthed at archaeological sites in the Bay of Naples— also engaged the republic of letters with gifts to professors, learned societies, and libraries at Paris, Cambridge, Oxford, and Göttingen.[31]

With their dramatic worm's-eye or bird's-eye views, the jumble and tumble of hypnotically detailed and carefully juxtaposed images executed with variably spaced, bit, and inked lines, Piranesi's etchings dramatically fill a room. Whether gathered loose in boxes or bound in volumes, as is the case with the works by the artist in the Arthur Ross Collection, his prints reward close looking; when framed and hung on walls, they encourage voluntarily calibrated movements through real space that inflect one's appreciation of pictorial space. In 1746 an advertisement announced a discounted set of "PRINTS [of the Channel Islands, which] . . . when put in Frames and Glasses make very agreeable Furniture."[32] Prints were movable and thus susceptible to changes in an owner's thinking or mood. In 1751 "TWELVE Perspective Views" by the "famous Painter Piranesi," on sale in an optician's shop and three other London venues, were identified as "not only beautiful furniture, but most delightful for the Concave and Diagonal Mirrors, and are allowed by Connoisseurs to excel for either Purpose"—a reference to optical devices used in the home that magnified viewers' patient engagement with the artist's sweeping vision.[33]

In addition, Grand Tourists studied prints carefully before they embarked for the Continent, continued to do so while abroad, and sometimes discovered that visual images could deceive: "The ruins we have seen," wrote Lady Anna Miller, "greatly exceed our ideas formed of them from books and prints." The author opined that "when [Piranesi] is in good humour, he is very useful, informing and agreeable to strangers." She took pains to "[make] an ample collection of the most valuable [of his prints]," yet his stature did not foreclose critique. She held that "Piranese's [*sic*] [prints] are too confused to give a clear idea [of Rome's ruins]" and uses a view of the Pantheon (fig. 7) as an example: "He is so ridiculously exact in trifles, as to have injured the fine proportions of the columns of the portico . . . by inserting, in his gravings, the papers stuck on them, such as advertisements, &c." Miller implies that Piranesi should have redacted quotidian evidence of the monument's living presence but then elsewhere says that "[he] sometimes is carried by his taste into romance."[34] Hester Lynch Piozzi, however, makes the opposite point, calling attention to "[Piranesi's] judicious manner . . . of keeping all coarse objects from interfering with the grand ones," a practice that, she maintains, "produce[s] disappointment as to general appearances."[35] Writing in October 1787, Goethe found that Piranesi's views surpassed the monuments themselves. With a view of the Baths of Caracalla in mind (fig. 8) and remembering the "many rich effects that Piranesi made up in advance," he acknowledged that the ruins "can hardly give any satisfaction to the present-day eye accustomed to painterly effects."[36]

About a decade after Piranesi's death in 1778, London booksellers sold his works by catalogue and at auction. Their practice was to consolidate the contents of distinguished individuals' libraries and then bring them to market. An advertisement for a catalogue published in the *World* on December 17, 1789, offered "Piranesi's Works, complete, 17 vols." Immediately following this corpus are two famous treatises, the full set of the "Antichita d'Ercolano 8 vols." and "Grævius and Gronovius's Antiquities, 76 vols. large paper"; Bernard de Montfaucon's "Antiq[uité expliquée]" comes soon after.[37] Similar groupings in newspaper advertisements suggest that book buyers with a developed interest in Roman antiquity came to consider Piranesi's works indispensable. In another context, Piranesi emerges as an essential reference source in a personal library dedicated to the history of art as a discipline and the needs of a professional in the field: "Richard Dalton, Esq. deceased Late Surveyor of his Majesty's Pictures," once owned "Piranesi's Works complete," along with the "Musaeum Florentinum, all the scarce Galleries," monographs on esteemed artists, Old Master drawings,

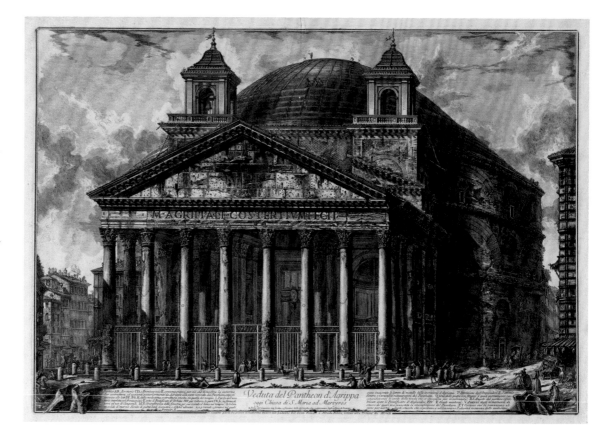

FIG. 7.
**GIOVANNI BATTISTA
PIRANESI**, *Veduta del
Pantheon d'Agrippa oggi
Chiesa di S. Maria ad
Martyres* (View of the
Pantheon of Agrippa
[actually the Pantheon
of Hadrian], today Santa
Maria ad Martyres),
from *Vedute di Roma*
(Views of Rome),
1761. Etching, 18 ⁵⁄₁₆ ×
26 ¹⁵⁄₁₆ in. (46.5 ×
68.5 cm). Yale University
Art Gallery, The Arthur
Ross Collection,
2012.159.11.60

and prints.[38] Finally, as was the case with many valuable commodities, a notable provenance could spur purchasers' interest, as when, in 1791, the auctioneer "Mr. Christie" sold "26 vols. superbly bound and gilt," which included prints of Rome by Piranesi and others. An unnamed "distinguished personage of high rank, deceased"—in other words, a Grand Tourist—had received this gift from Clement XIV himself.[39]

Illustrated editions of Shakespeare may not seem to relate to Piranesi, but surviving primary sources tell a different story. Boydell's Shakespeare Gallery, an ambitious, subscription-financed publishing enterprise intended to bring out luxurious folios of the author's plays and stimulate history painting in Britain, failed from its inception to inspire Horace Walpole. In December 1786, he wrote, "I am not favourable to sets of prints for authors . . . but mercy on us! *Our* painters to design for *Shakespeare*! . . . Salvator Rosa might, and Piranesi might dash out Duncan's Castle—but Lord help Alderman Boydell and the Royal Academy!"[40] His skepticism aside, Walpole took it for granted that his correspondent would effortlessly envisage the transcendent qualities that linked an English playwright and poet like Shakespeare to the Venetian-born printmaker.

By the late eighteenth century, Piranesi's very surname evinced a meme: it instantly evoked grandeur and genius and even conjured a persona, one that required no

qualification and could be occupied at will. Describing a print published by Boydell of a scene from *The Third Part of King Henry the Sixth*, an item in Philadelphia and Boston newspapers in 1791 took a tack different from Walpole's. The pseudonymous author, a certain "Piranezi," praised "the passions . . . strongly represented on the countenances" in a battle scene depicting, among other things, a parricide and a filicide.[41] Figures in Piranesi's prints are hardly inert or irrelevant, but they normally have small bodies and indistinct faces; intact modern or ruined ancient buildings are the pictorial elements that always loom majestic. Yet "Piranezi" assumed that some of his North American readers would recognize, in his pen name, a byword for the emotionally transformative power of visionary imagery—and would apply that byword to a new context and medium. Referring to a list of things to accomplish before he left Rome and, in particular, a print of the Cloaca Maxima (fig. 9), Goethe recalled the "concept [of the] colossal, for which Piranesi had prepared us," thereby implying that the artist's enduring success lay in having forged a new aesthetic category.[42] In our own day, his work has lost none of its potency.

GIOVANNI BATTISTA PIRANESI, *Rovine delle Terme Antoniniane* (Ruins of the Antonine Baths [Baths of Caracalla]), from *Vedute di Roma* (Views of Rome), 1765. Etching, 16 9/16 × 27 3/16 in. (42 × 69 cm). Yale University Art Gallery, The Arthur Ross Collection, 2012.159.11.76

GIOVANNI BATTISTA PIRANESI, *Veduta delle antiche sostruzioni fatte da Tarquinio Superbo dette il Bel Lido, e come altri erette da Marco Agrippa a tempi di Augusto, in occasione ch'Egli fece ripurgare tutte le cloache fino al Tevere* (View of the Ancient Substructures Built by Tarquinius Superbus called the Bel Lido, and Like Others, Erected by Marcus Agrippa in the Time of Augustus, When He Had All of the Sewers Leading to the Tiber Cleaned [the Cloaca Maxima]), from *Vedute di Roma* (Views of Rome), 1776. Etching, 16 15/16 × 26 3/8 in. (43 × 67 cm). Yale University Art Gallery, The Arthur Ross Collection, 2012.159.11.125

1. For a typical range of subjects, see *Whitehall Evening Post or London Intelligencer*, no. 711, August 30–September 1, 1750. All quotations from British eighteenth-century newspapers derive from http://gdc.gale.com/products/17th-and-18th-century-burney-collection-newspapers.

2. [Lady Anna Miller], *Letters from Italy, Describing the Manners, Customs, Antiquities, Paintings, &c. of That Country, in the Years MDCCLXX and MDCCLXXI, to a Friend* (Dublin: n.p., 1776), 3:123, http://find.galegroup.com/ecco.

3. Luigi Vanvitelli, letters to abbot Urbano Vanvitelli, Portici, October 1, 1763; Naples, February 11, 1764; and Caserta, October 25, 1766, published in Franco Strazzullo, *Le lettere di Luigi Vanvitelli della Biblioteca Palatina di Caserta* (Galatina: Congedo, 1977), 3:82, 116, and 357, respectively.

4. Luigi Vanvitelli, letter to abbot Urbano Vanvitelli, Caserta, May 15, 1764, in ibid., 154.

5. Luigi Vanvitelli, letter to abbot Urbano Vanvitelli, Naples, August 4, 1767, in ibid., 437.

6. See Ginevra Mariani, ed., *Giambattista Piranesi: Matrici incise, 1743–1753* (Milan: Edizioni Gabriele Mazzotta, 2010), 9–13.

7. At issue is the book titled *Camere sepolcrali degli antichi Romani le quali esistono dentro e di fuori di Roma*. See John Wilton-Ely, *The Mind and Art of Giovanni Battista Piranesi* (London: Thames and Hudson, 1978), 46–47; and Wilton-Ely, *Giovanni Battista Piranesi: The Complete Etchings* (San Francisco: Alan Wofsy Fine Arts, 1994), 1136.

8. Wilton-Ely, *Mind and Art*, 62–63. For an illustration of the first state of the frontispiece to volume one, see Wilton-Ely, *Giovanni Battista Piranesi: The Complete Etchings*, 1:329.

9. For a recent study of this illustrated pamphlet, see Heather Hyde Minor, "Engraved in Porphyry, Printed on Paper: Piranesi and Lord Charlemont," in *The Serpent and the Stylus: Essays on G. B. Piranesi*, ed. Mario Bevilacqua, Heather Hyde Minor, and Fabio Barry, *Memoirs of the American Academy in Rome*, Supplementary Volume 4 (Ann Arbor: University of Michigan Press, 2006), 123–47.

10. Giovanni Battista Piranesi, *Lettere di giustificazione scritte a milord Charlemont e a' di lui agenti di Roma*, August 25, 1756, ix; published in John Wilton-Ely, ed., *Giovanni Battista Piranesi: The Polemical Works, Rome 1757, 1761, 1765, 1769* ([Farnborough, England]: Gregg Press International, 1972), n.p.

11. Ibid., vi–vii.

12. See Jonathan Scott, *Piranesi* (London: Academy Editions, 1975), 165–66, 311n4.

13. For Piranesi's donation of his works and the sale list to the Accademia in 1761, see Arthur M. Hind, *Giovanni Battista Piranesi: A Critical Study with a List of His Published Works and Detailed Catalogues of the Prisons and the Views of Rome* (London: Cotswold Gallery, 1922), 6; and Wilton-Ely, *Giovanni Battista Piranesi: The Complete Etchings*, 1:14. The Accademia's impression of the sale list is reproduced in Susanna Pasquali, "Piranesi Architect, Courtier, and Antiquarian: The Late Rezzonico Years," in Bevilacqua, Minor, and Barry, *Serpent and the Stylus*, 192, fig. 9. An impression of Piranesi's *Lettere di giustificazione* includes a tipped-in impression of the sale list; see Metropolitan Museum of Art, New York, inv. no. 51.632.1. On the verso are two inscriptions in ink in the same hand: one reads, "Catalogue / of Piranesi's Prints / 1761," and the other, "Catalogue of / Piranesi's Prints 1762" (emphasis in the original). The writer canceled the 2 by overwriting it with a large and dotted number 1.

14. An impression of the first edition is dedicated "Agli Eccellentissimi Sig. Accademici di S. Luca"; the Metropolitan Museum of Art impression is dedicated "A Sua Eccellenza Milord il Conte di Morton." For an impression dedicated "All'Illmo, e Rmo Signore, Monsignor Bottari," an indefatigable supporter of Piranesi, see Wilton-Ely, *Giovanni Battista Piranesi: The Complete Etchings*, 1:15, who incorrectly states (1:14) that it is "the earliest known version." The author is grateful to Andrew Robison for sharing the fruits of his unpublished research on the sale list's various states.

15. For other examples of the practice, see Hind, *Giovanni Battista Piranesi*, 5–6.

16. Wilton-Ely, *Giovanni Battista Piranesi: The Complete Etchings*, 2:1108–9.

17. For Piranesi's purchase of Dorigny's copperplates, see Scott, *Piranesi*, 240–41, 315–16nn8–9; and Ginevra Mariani, "'Le Antichità Romane opera di Giambattista Piranesi architetto veneziano,'" in *Giovanni Battista Piranesi: Matrici incise, 1756–1757, Le antichità romane, Lettere di giustificazione 2* (Milan: Mazzotta, 2014), 32–33.

18. Chracas [family], *Diario ordinario* [newspaper published discontinuously in Rome], n.s., no. 62, August 5, 1775, 12.

19. Ibid., n.s., no. 64, August 12, 1775, 13–14.

20. "Anche di due Casse, con le Vedute di Roma Antica, e Moderna del Piranesi; e con varie raccolte delle più Celebri stampe della Calcografia Camerale"; Sächsisches Hauptstaatsarchiv Dresden, H.St.A 2827, Des Hofrath Dr. Bianconi Negociation am Römischen Hofe betr. 1764–1775, newsletter from Rome, April 16, 1774, insert in Giovanni Lodovico Bianconi, letter to [count Sacken], Rome, April 16, 1774. Horace Mann, the British envoy in Florence, also heard of this event: "[B]efore he left Rome a royal present was made to him of . . . 27 volumes in folio richly bound of all the best stamps and works of Piranesi"; Horace Mann, letter to Horace Walpole, Florence, April 23, 1774, published in W. S. Lewis, ed., *The Yale Edition of Horace Walpole's Correspondence*, vol. 23, *Horace Walpole's Correspondence with Horace Mann*, vol. 7, ed. W. S. Lewis, Warren Hunting Smith, and George L. Lam (New Haven, Conn.: Yale University Press, 1967), 566. The British royal traveler who received the gift from Pope Clement XIV was misidentified as the "Duke of Gloucester, the young son of George III," in Scott, *Piranesi*, 315n2.

21. Piranesi, *Lettere di giustificazione*, vi.

22. Ibid., xii.

23. Giovanni Battista Balbis Simeone di Rivera, letter to Carlo Flaminio Raiberti, Rome, August 13, 1763, Materie politche per rapporto all'estero, Lettere Ministri Roma 252, Archivio di Stato di Torino (hereafter LM Roma 252). Piranesi's memorandum is an undated insert in this letter.

24. Undated insert in a letter from Rivera to Raiberti, August 13, 1763, LM Roma 252. The Turin manuscript catalogue's terminus ante quem suggests a terminus post quem of 1763 for the

edition of the printed catalogue published in Wilton-Ely, *Giovanni Battista Piranesi: The Complete Etchings*, 15.

25. Raiberti, letter to Rivera, Turin, August 24, 1763, LM Roma 252.

26. Pasquali, "Piranesi Architect, Courtier, and Antiquarian," 194.

27. *The Massachusetts Gazette and the Boston Weekly News-Letter*, no. 3480, May 14, 1772, [2], http://infoweb .newsbank.com.

28. For the attribution to Piranesi, see Arthur S. Marks, "Angelica Kauffmann and Some Americans on the Grand Tour," *American Art Journal* 12, no. 2 (1980): 20.

29. Theodore Sizer, ed., *The Autobiography of Colonel John Trumbull, Patriot-Artist, 1756-1843* (New Haven, Conn.: Yale University Press, 1953), 12.

30. Maarten Delbeke et al., ed., *Piranesi: De prentencollectie van de Universiteit Gent* (Ghent: A&S/books, 2008), 7.

31. John E. Moore, "'To the Catholic King' and Others: Bernardo Tanucci's Correspondence and the Herculaneum Project," in *Rediscovering the Ancient World on the Bay of Naples, 1710-1789*, ed. Carol C. Mattusch, Studies in the History of Art 79, Symposium Papers 56 (Washington, D.C.: National Gallery of Art, 2013), 103-4.

32. *General Advertiser*, no. 3575, April 11, 1746.

33. *General Evening Post*, no. 2678, January 31-February 2, 1751.

34. For these comments, see Miller, *Letters from Italy*, 1:280; 3:123; 1:280; and 3:122, respectively.

35. Hester Lynch Piozzi, *Observations and Reflections Made in the Course of a Journey through France, Italy, and Germany* (Dublin: n.p., 1789), 389, http://find.galegroup.com/ecco.

36. Johann Wolfgang von Goethe, *Italienische Reise*, 4th ed. (Hamburg: Christian Wegner Verlag, 1959), 425.

37. *World*, no. 920, December 17, 1789. The advertisement was reprinted four times: no. 921, December 18, 1789; no. 922, December 19, 1789; no. 924, December 22, 1789; and no. 930, December 29, 1789.

38. *World*, no. 1311, March 15, 1791, reprinted in no. 1313, March 17, 1791. See also *World*, nos. 1358-59, May 9-10, 1791. For Dalton, who traveled through the Mediterranean with Charlemont in the 1750s and knew Piranesi, see Scott, *Piranesi*, 156-57; and *Oxford Dictionary of National Biography*, s.v. "Dalton, Richard," http://www.oxforddnb.com.

39. *World*, no. 1286, February 14, 1791, reprinted in nos. 1288-89, February 16-17, 1791; *Gazetteer and New Daily Advertiser*, nos. 19406-7, February 17-18, 1791; and *Morning Post and Daily Advertiser*, no. 5569, February 19, 1791.

40. Horace Walpole, letter to Lady Ossory, Berkeley Square, December 15, 1786; published in W. S. Lewis, ed., *The Yale Edition of Horace Walpole's Correspondence*, vol. 22, *Horace Walpole's Correspondence with the Countess of Upper Ossory*, vol. 2, ed. W. S. Lewis and A. Dayle Wallace (New Haven, Conn.: Yale University Press, 1965), 546-47.

41. The object under discussion is John Ogborne the Elder's engraving after a painting by Josiah Boydell. The "Third Part of King Henry VI. Act. II. Scene V." is correctly identified in *Dunlap's American Daily Advertiser* (Philadelphia), October 31, 1791, [3], http://infoweb.newsbank.com. In a Boston newspaper the identification is erroneous on one count: "Third part of King Henry IV [*sic*; VI]. Act. 2. Scene 5"; *Argus* (Boston), December 2, 1791, [3], http://infoweb.newsbank.com.

42. Goethe, *Italienische Reise*, 548.

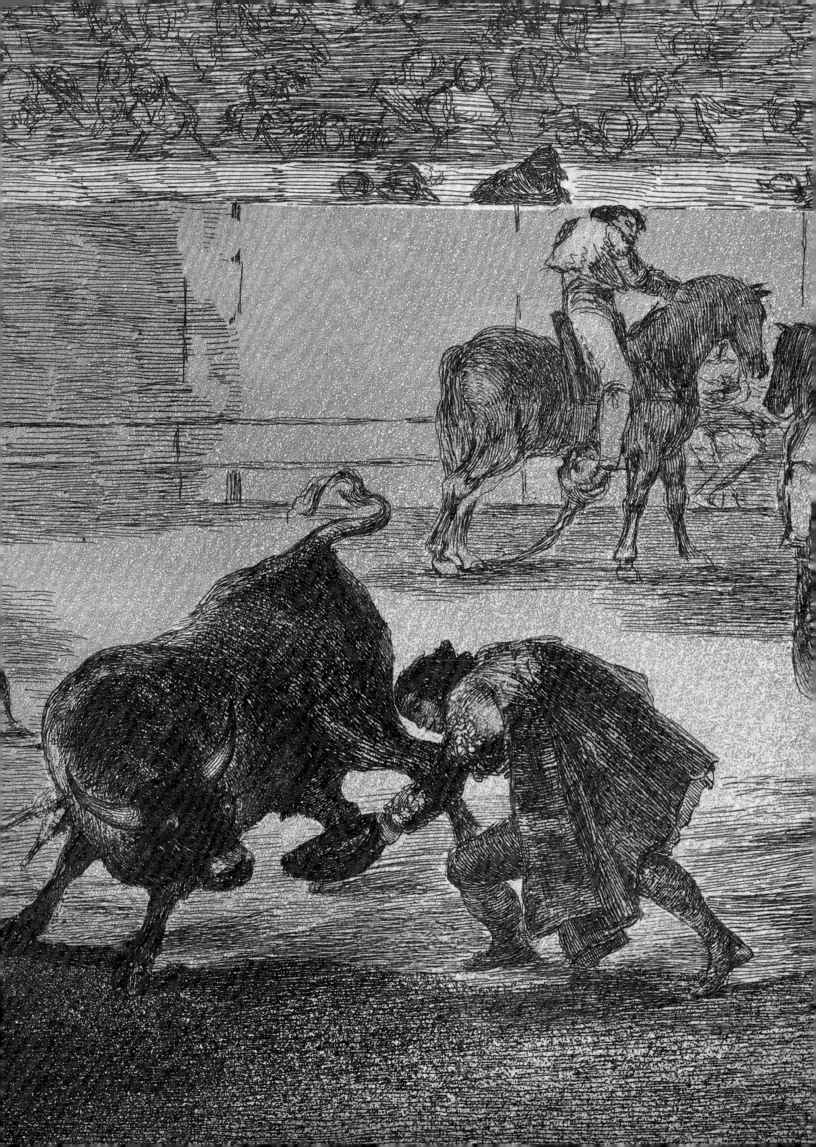

Reason and Its Follies:
Reading Goya as a Modern Viewer

DOUGLAS CUSHING

WHY SHOW THE PRINTS of Francisco Goya (1746–1828) in the twenty-first century? Of what use are these objects to a contemporary audience, such as that at the University of Texas at Austin?[1] The critical eye that Goya turned toward his own world seems to have been a result of his perennial desire to expose injustices and improve humanity. Often, the artist expressed this desire for social change with an irony befitting our own day. Indeed, Goya's art expresses principles—liberty, justice, working toward a common good, learning, skepticism, agency of identity, and creativity—that resonate with the ethical concerns of today's audiences and, in particular, with the educational values of universities and their museums in the United States.

A June 1896 commencement address delivered by the first president of the University of Texas, George Tayloe Winston, articulated the degree to which universities in the United States value the same principles that Goya espoused in his work. Winston argued that public education and robust universities are essential for generating progress, prosperity, and happiness for the nation and its citizens. "Great is the commonwealth whose foundations are liberty and learning," he proclaimed.[2] Painting an alternate vision, Winston cautioned, "In the twilight of knowledge chimeras stalk; chimeras of superstition, of religious fanaticism, of social prejudice, of political delusion. . . . There is no cure for darkness but light; the twilight will not be gone until the sunrise."[3]

How reminiscent of Goya's images Winston's words are! Both find their source in the eighteenth-century European Enlightenment, which broadly promoted learning, religious tolerance, the social contract, and personal as well as national improvement. Notably, the movement also elevated reason above superstition and liberty over tyranny. The founding fathers of the United States adapted these same concepts for their new nation, forging an enlightened disposition

in its constitution and institutions. In an essay on education, Benjamin Franklin wrote that students should learn to debate so as to "be sensible of the Use of *Logic*, or the Art of Reasoning to *discover* Truth."[4] So universal are these rational principles today that they find broad appeal across America's political divides. Through such shared principles, a contemporary audience is predisposed to participate in the ethical discourse implicated in Goya's work.

Goya's prints reveal an artist imploring his viewers to embrace and improve human existence. In an advertisement for his print series *Los caprichos* (The Capriccios; see donor's foreword), Goya argued that art was as valid a medium for social criticism as literature, asserting his belief that art could just as forcefully convey political thought.[5] Much of Goya's work synthesized Enlightenment principles with Romantic concerns of morality and the power of irrational, inventive imagination.[6] The result offers a far-reaching assertion: if we know ourselves and are ethically just, we can improve our society. Distrustful of claims of absolute truth and grand narratives, today's academy has begun to doubt models of human history that describe progress as a cumulative, universal trajectory whose aim is the perfection of society, and the American public widely foresees regression rather than development.[7] Conversely, Goya's rich, textural darkness, both figural and formal, allows the light of rational and irrational hope for improvement to shine more brightly.

Goya's works are accessible to a contemporary audience precisely because the ideas that they convey remain significant beyond their historical circumstances. Nevertheless, this does not negate the usefulness of context. Goya lived in Bourbon Spain during the country's halting entry into its own limited, hybridized Enlightenment, which began most earnestly with King Carlos III's reforms of industry, agriculture, and education.[8] Drawing power and wealth from Spain's

lingering medieval decentralization and poorly educated populace, aristocrats and church institutions often resisted change.[9] Then, under Carlos IV—who promoted Goya from Painter to the King to the highest rank of First Court Painter—reform faltered. France, home to Enlightenment luminaries such as Jean-Jacques Rousseau and Voltaire, violently threw off the mantle of its monarchy in 1789, threatening Spanish absolutism. Shortly thereafter, that nominal ally became an imperial invader under Napoleon Bonaparte. The

resulting conflict, known outside of Spain as the Peninsular War, lasted from 1808 until 1814, after which the Bourbon restoration of Ferdinand VII signaled a return to darkness for progressive Spaniards. Historically, this failure benefited Spain's detractors who, since the sixteenth century, had derided the country as backward, barbaric, and exotic.[10] Under Ferdinand, political and religious oppression flourished. Liberal intellectuals fled or were persecuted, and Goya himself left Madrid for Bordeaux in 1824.[11] While we commonly

FIG. 1.
FRANCISCO GOYA, *Farándula de charlatanes* (Charlatans' Show), plate 75 from *Los desastres de la guerra* (The Disasters of War), ca. 1813–14, published 1863. Etching and aquatint, 6 ⅞ × 8 ¹¹⁄₁₆ in. (17.5 × 22 cm). Yale University Art Gallery, The Arthur Ross Collection, 2012.159.37.76

FRANCISCO GOYA, *Ni por esas* (Neither Do These), plate 11 from *Los desastres de la guerra* (The Disasters of War), ca. 1811–12, published 1863. Etching and aquatint, 6⁵⁄₁₆ × 8 ¼ in. (16 × 21 cm). Yale University Art Gallery, The Arthur Ross Collection, 2012.159.37.12

recognize ourselves as the Enlightenment's self-assured and advanced heirs, Goya's chimeras pay little heed to history. They stalk in the twilight even today.

In a letter to his friend Martín Zapater, Goya wrote that he had "no fear of witches, goblins, ghosts, etc., nor any being except human beings."[12] The artist was derisive toward those who superstitiously imagined monsters everywhere. War, however, made the monsters real—and human. In his *Desastres de la guerra* series, the artist unflinchingly portrayed the atrocities of the Peninsular War—dismemberments, summary executions, mass starvation, and Ferdinand's terrible return. Goya's titles are plaintively laconic. For example, *Por que?* [*sic*] (Why?) depicts French soldiers hanging a man from a too-short tree, pulling him horizontally by the legs until the noose is taut. The act is logical madness.

The final plates of the *Desastres*, called *caprichos enfáticos* (emphatic capriccios), are imaginative allegories of the war and its aftermath.[13] In his *Farándula de charlatanes*, Goya depicts a vulturelike creature dressed in clerical garb (fig. 1). On its knees, the creature zealously sermonizes before a crowd of humanoids and animals, including an ass, the artist's frequent symbol of folly. The title makes it explicit that this preacher is a fraud, and the spectacle reduces its participants to an animal state. Many church officials in Goya's day secured their power by peddling misinformation, fear, and false promises. Controlling knowledge through limiting curricula and banning books maintained that arrangement.[14] Likewise,

some in our own time use their positions of authority to advance their personal goals, means, and prejudices. These figures, existing in every culture and spanning secular and sacred sectors alike, invoke their own beliefs as justification for marginalizing those unlike themselves. Goya may well have been a faithful Catholic, but he blamed elements of the church, especially the Inquisition, for rampant ignorance and superstition. Goya's complaint was not against religion or governance per se, but rather against abuse—an issue familiar to us today.

A frequent theme throughout the *Desastres* is France's use of terror for deterring or punishing insurgency during the Peninsular War. In one trio of prints, entitled *No quieren* [*sic*] (They Don't Like It), *Tampoco* (Nor [Do These] Either), and finally *Ni por esas* (Neither Do These), Goya commented on the use of sexual violence against women as a weapon of war and intimidation.[15] In *Ni por esas* (fig. 2), soldiers assault women under a dark archway as a baby lies discarded. The topic of violence against women has been a matter of prominent discourse in the twenty-first century. Thus, viewing the *Desastres* today, audiences will recognize species of violence that persist in our own day as they did in Goya's, inhumanities that the Enlightenment failed to abolish.

For many in Spain's liberal, intellectual circles in the late eighteenth and early nineteenth centuries, the power of brutality and senseless violence to undermine the foundations of moral good was not limited to the atrocities of the

FIG. 3.
FRANCISCO GOYA,
Pepe Illo haciendo el recorte al toro (Pepe Illo Making the Pass of the *Recorte*), plate 29 from *La tauromaquia* (The Art of Bullfighting), 1815, published 1816. Etching, drypoint, and aquatint, 9 ⅝ × 13 ¾ in. (24.5 × 35 cm). Yale University Art Gallery, The Arthur Ross Collection, 2012.159.38.29

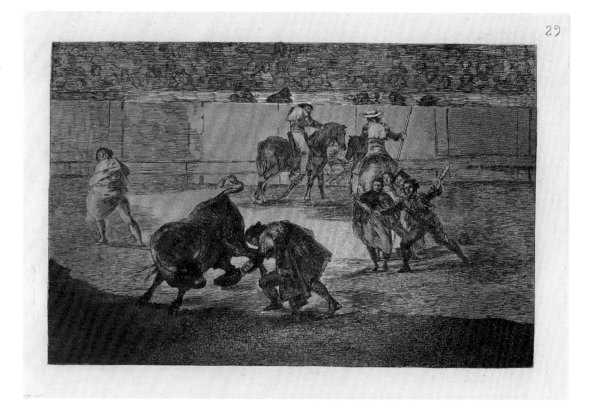

battlefield or the Inquisition's interrogations. The Bourbon rulers and intelligentsia of Goya's day generally disapproved of bullfighting as well, holding that it morally debased its viewers. Carlos III allowed only charitable *corridas*, or bullfights, and Carlos IV banned them outright. Despite these condemnations, bullfights were wildly popular in Goya's time.[16] Goya understood the subject of his *Tauromaquia* (The Art of Bullfighting) series as both an *aficionado* and a Spaniard.[17] A struggle that pitted skill and courage against both nature and fate, bullfighting was likely appreciated as possessing a particular beauty; importantly, the pastime was also authentically Spanish. Viewed against the backdrop of foreign occupation, this understanding made bullfighting all the more meaningful for many in Goya's milieu. Not merely a sport but rather a ritual of belonging, bullfighting, with its history and heroes as Goya depicted it, was an implicit expression of the artist's cultural identity.[18] In *Pepe Illo haciendo el recorte al toro*, Goya depicted a famous bullfighter of his generation (fig. 3). The main spectacle unfolds along the edge of a shadow that crosses the ring. The bull, with decorated, barbed darts called *banderillas* protruding from its side, has just lunged at Illo, who dodges and bows. The curling line of the animal's body emphasizes the bullfighter's doffed hat, marking his respect for the creature. This spectacle may seem foreign to many in the United States, and yet we are

connected to it. Through colonialism, the *corrida* was exported to the Americas, and bloodless bullfighting is practiced in states such as California and Texas even today. Despite misgivings about the brutality of bullfighting, a contemporary audience might still consider the noble grace that Goya identified in his subject, for it is not merely a ritual of another time and place but also a part of living culture. Alternatively, by contemplating differences—of ethics, values, or cultural background—viewers might examine the construction of their own identities, a critical social engagement at once aesthetic and symbolic.

Following the *Tauromaquia*, Goya produced his most enigmatic print series. Reminiscent of the *Caprichos* in their imagination and symbolism, the series *Los disparates* lacks extended explanatory texts. Historians have tried, often unconvincingly, to match these works with Spanish maxims.[19] Possessing a poetic quality that exceeds simple exposition, these prints may actually have no single intended meaning. Instead, the *Disparates* reveal a modern master who loved learning and celebrated artistic, intellectual, and even irrational creativity. Formally, these late works demonstrate Goya's perfected use of tonal variation and expressive marks, produced with aquatint and line etching. In his *Disparate de miedo* (fig. 4), an enormous hooded figure terrorizes a group of soldiers who fall over one another in

fright.[20] None, however, appears to notice a curious, caricatured face emerging from one sleeve of its robe—a smiling visage betraying the possibility that the figure might be more or less than it seems. The soldiers' frenzied response suggests the blindness of their fear. Behind them, a solitary, crooked tree set against boundless darkness locates the scene outdoors, but it reveals little else. Grounded in an irrational space of endless depth, this placeless quality, which is repeated throughout the *Disparates*, frees the composition to be read as any location or time. Audiences might arrive at countless meanings for this work, but the nature of the specter seems central. In the modern world where the populace might be driven to fear countless bogeymen by ideologues, charlatans, or their own unchecked imagination, how many will learn to master their fear before others use it to master them?

Goya's work belongs not merely to the culture of art but to culture more widely, and the issues that he raised remain relevant to a broad audience even today. His prints may be regarded as both phenomena of their particular historical moment and catalysts for discourse across a wide spectrum of audiences and disciplines, including anthropology, history, law, literature, philosophy, and religious studies. In the commencement address cited at the beginning of this essay, Winston argued that the duties of the university are "training, investigation, and inspiration," placing the greatest

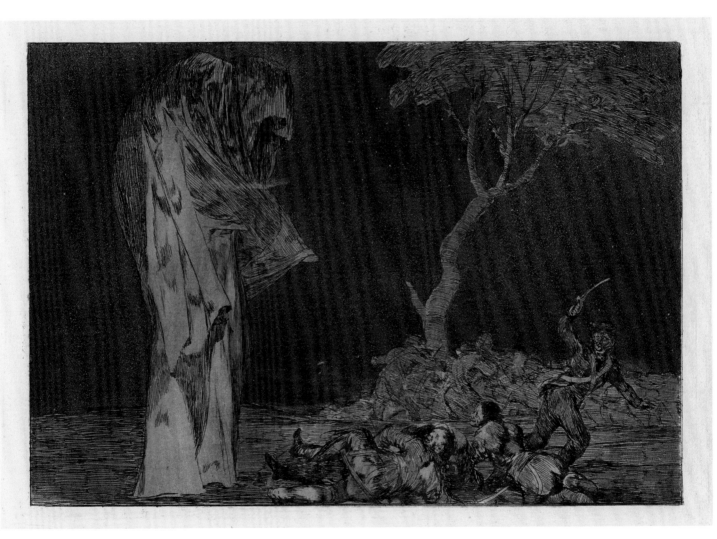

FIG. 4.
FRANCISCO GOYA, *Disparate de miedo* (Folly of Fear), also known as *Por temor no pierdas honor* (Do Not Lose Honor through Fear), from *Los disparates (Los proverbios)* (Follies [Proverbs]), ca. 1816–19, published 1864. Etching, 9 ⅝ × 13 ¾ in. (24.5 × 35 cm). Yale University Art Gallery, The Arthur Ross Collection, 2012.159.40.3

importance on the last function.[21] Goya's prints continue to have value today because they inspire and provoke reflection, and they remain a beacon for the bounty of human creative potential. These works embody many of the same ideals and principles that universities hold at their core: learning, discovery, opportunity, responsibility, and freedom to think and act. Goya's commitment to these principles is admirable, even if his world failed to uphold them. Despite the prodigious work required to produce both the *Desastres* and the *Disparates*, Goya published neither series during his lifetime.[22] Given Spain's political climate during and after the war, and the series' powerful critique of the government and church, the artist likely suppressed these works out of a sense of danger for himself and his family. Nevertheless, Goya felt compelled to set down his ideas in visual form, and he chose printmaking as his medium, ensuring a wide future audience. While Goya may have been disenchanted by the failure of the Enlightenment in Spain, he found light in his own work. And because he rendered it in repeatable and transmissible form, many can share his vision today, thus allowing us to wield it against the chimeras of our own time.

Arthur Ross seems to have been keenly aware of the power of Goya's prints to inspire later generations. At the opening of an exhibition on Goya drawn from his collection and held at the University of Pennsylvania, he spoke of his days as a student at the university between 1927 and 1931, a period that saw the social and economic challenges of the stock market crash of 1929 and the Great Depression that followed. Ross recalled, "It was a critical period in most everyone's personal affairs as well as that of the nation. Action and reaction were in the air. Courage, daring, and innovative thinking were necessary to stay afloat both for the individual and the country. The ability to break away from familiar clichés and to develop new views on old problems was what was required. It was a breaking away from the status quo, and what artist was probably the first to symbolize these qualities? It was Goya."[23]

1. This essay appears as a prelude to *Goya: Mad Reason* (June 19–September 25, 2016), an exhibition organized by the Blanton Museum of Art at the University of Texas at Austin as part of a collection-sharing project initiated by the Yale University Art Gallery. The exhibition draws heavily on the works in the Gallery's Arthur Ross Collection.

2. George Tayloe Winston, "The Influences of Universities and Public Schools on National Life and Character," commencement speech, University of Texas at Austin, June 17, 1896.

3. Ibid.

4. Benjamin Franklin, "Proposals Relating to the Education of Youth in Pennsylvania," in *Franklin: The Autobiography and Other Writings on Politics, Economics, and Virtue*, ed. Alan Houston (Cambridge: Cambridge University Press, 2004), 211. All capitalizations and italics are Franklin's.

5. For a reproduction of this advertisement, see Tomás Harris, *Goya: Engravings and Lithographs* (Oxford: Bruno Cassirer, 1964), 1:103. For general comments on this series, see, for example, Alfonso E. Pérez Sánchez and Eleanor A. Sayre, eds., *Goya and the Spirit of Enlightenment*, exh. cat. (Boston: Museum of Fine Arts, 1989), xcviii–ci.

6. Depending upon one's definition, labeling Goya a Romantic proper may be historically problematic. Nevertheless, in Goya's Western world, one might broadly identify Romanticism as a philosophical and cultural counter-current to pure empiricism. Throughout Europe, Romanticism emerged variously in the realms of literature, art, philosophy, music, and politics. To label much of Goya's work—especially his later production—as an inherently Spanish form of Romanticism allows it to be culturally unique while still resonating with the wider thought that began to coalesce in the late eighteenth century.

7. A 2013 Pew study indicates America's widespread concerns over economic progress. See Pew Research Center, "Economies of Emerging Markets Better Rated During Difficult Times," Pew Global Attitudes Project, May 23, 2013, http://www.pewglobal .org/files/2013/05/Pew-Global -Attitudes-Economic-Report-FINAL -May-23-2013.pdf.

8. For a discussion of Spanish Enlightenment historiography and the qualities that made Carlos III's enlightened despotism a unique and hybrid manifestation of the movement, see Gabriel B. Paquette, *Enlightenment, Governance, and Reform in Spain and Its Empire, 1759–1808* (New York: Palgrave Macmillan, 2008).

9. For useful explorations of Spain's limited entry into the Enlightenment and the challenges faced by the Bourbon reforms, see, for example, Richard Herr, *The Eighteenth-Century Revolution in Spain* (Princeton, N.J.: Princeton University Press, 1958); and Jean Sarrailh, *L'Espagne éclairée de la seconde moitié du XVIIIe siècle* (Paris: Klincksieck, 1954).

10. *La leyenda negra*, or the Black Legend, was an anti-Spanish topos that appeared from the sixteenth through the twentieth century, taking on many forms. For an overview of this subject, see, for example, Benjamin Keen, "The Black Legend Revisited: Assumptions and Realities," *Hispanic American Historical Review* 49, no. 4 (1969): 703–19.

11. Ferdinand's administration compelled Goya to prove his loyalty under the occupation. The artist likely had to answer for having received the award of the Royal Order of Spain from José I as well as for his portraits of the Bonaparte court. It seems that he was successful in arguing his innocence, but he must not have felt secure enough to remain in Madrid amid worsening political conditions. For a biographical treatment of the Bourbon restoration's impact on Goya and his flight to France, see Robert Hughes, *Goya* (New York: Alfred A. Knopf, 2003), 320–401.

12. Quoted in Sarah Symmons, *Goya: A Life in Letters*, trans. Philip Troutman (London: Pimlico, 2004), 193–94. This translation is a composite of Troutman's and the present author's. For the original Spanish text, see Francisco Goya, *Diplomatario de Francisco de Goya* (Saragossa, Spain: Institución Fernando el Católico, 1981), 252–53.

13. For brief discussions of the *Desastres de la guerra* and the nature of the *caprichos enfáticos*, see, for example, Alfonso E. Pérez Sánchez and Julián Gállego, *Goya: The Complete Etchings and Lithographs* (New York: Prestel, 1995), 90; Pérez Sánchez and Sayre, *Goya and the Spirit of Enlightenment*, 185; Janis A. Tomlinson, *Francisco Goya y Lucientes, 1746–1828* (London: Phaidon, 1994),

191–202; and, more recently, Janis A. Tomlinson, *Goya's War: Los desastres de la guerra* (Claremont, Calif.: Pomona College Museum of Art, 2013). Based upon differences in the numbering of plates, Tomlinson has suggested that the *caprichos enfáticos* might have originally been intended as an independent series (or multiple series), despite their inclusion with the rest of the *Desastres* in a mockup album owned by Goya's friend Ceán Bermúdez. She notes that some of the images that employ allegorical animals might be related to an 1813 Spanish translation of Giambattista Casti's poem *Gli animali parlanti* (The Talking Animals). Moreover, given the thematic variety among the works traditionally grouped under the title *caprichos enfáticos*, Tomlinson suggests that those images might not have been intended as a single interpretively cohesive body at all. See Tomlinson, *Goya's War*, 85–86.

14. Herr, *Eighteenth-Century Revolution in Spain*, 164–83, 203–8.

15. Since groups of mixed gender are grammatically masculine in Spanish, Goya's use of the feminine plural pronoun *esas* (these/those [nearby]) in *Ni por esas* serves to direct the viewers' attention to the women—who are rejecting the violence being done to them—and to their plight. Moreover, the grammatical choice of a demonstrative pronoun, which points and specifies, opens a critical distance for viewers, who are meant to bear witness to the atrocities being enacted upon "these" women.

16. For a description of bullfighting during this period, see Charles E. Kany, *Life and Manners in Madrid, 1750–1800* (New York: AMS Press, 1970), 101–10.

17. For useful discussions of the *Tauromaquia*, see, for example, Pérez Sánchez and Gállego, *Goya: Complete Etchings and Lithographs*, 146; and Verna Curtis and Selma Holo, eds., *La Tauromaquia: Goya, Picasso, and the Bullfight*, exh. cat. (Milwaukee: Milwaukee Art Museum, 1985), 15–32.

18. For an expanded argument regarding Goya's depiction of Spanish identity and bullfighting, see Andrew Schulz, "Moors and the Bullfight: History and National Identity in Goya's *Tauromaquia*," *Art Bulletin* 90, no. 1 (June 2008): 195–217.

19. When the series was published in 1864, the Real Academia de Bellas Artes de San Fernando in Madrid gave them the name *Los proverbios* (Proverbs), but the

discovery of drawings with the thematic title *Los disparates* suggests another meaning. The late scholar Tomás Harris suggested common eighteenth- and nineteenth-century Spanish sayings that he believed might fit individual works, but scholars now doubt many of these associations. For Harris's readings, see Harris, *Goya: Engravings and Lithographs*, 1:193–212, 2:372–407. For general comments on the series, see, for example, Pérez Sánchez and Gállego, *Goya: Complete Etchings and Lithographs*, 176; Tomlinson, *Francisco Goya y Lucientes*, 255–60; and Janis A. Tomlinson, "Francisco José Goya y Lucientes: Approaching *Los disparates*," *Romance Quarterly* 54, no. 1 (2007): 3–8.

20. For a discussion of two major interpretations of this work and a proposition for a synthetic reading, see Elena Aldea, "Disparate de miedo: Una crítica política bajo un velo de hermetismo," *Romance Quarterly* 54, no. 1 (2007): 17–22.

21. Winston, "Influences of Universities."

22. Goya left the plates with his son, Javier. From there, they made their way to the Real Academia or private collections. The Real Academia first published the *Desastres de la guerra* in 1863 and the *Disparates* in 1864. For discussion of the latency in the prints' publication, see, for example, Tomlinson, *Francisco Goya y Lucientes*, 191, 255–56.

23. Arthur Ross, transcript of remarks made at the opening of the exhibition *Francisco Goya y Lucientes* (University of Pennsylvania, Philadelphia, 1981), collector's papers, Arthur Ross Foundation Archive, Department of Prints and Drawings, Yale University Art Gallery.

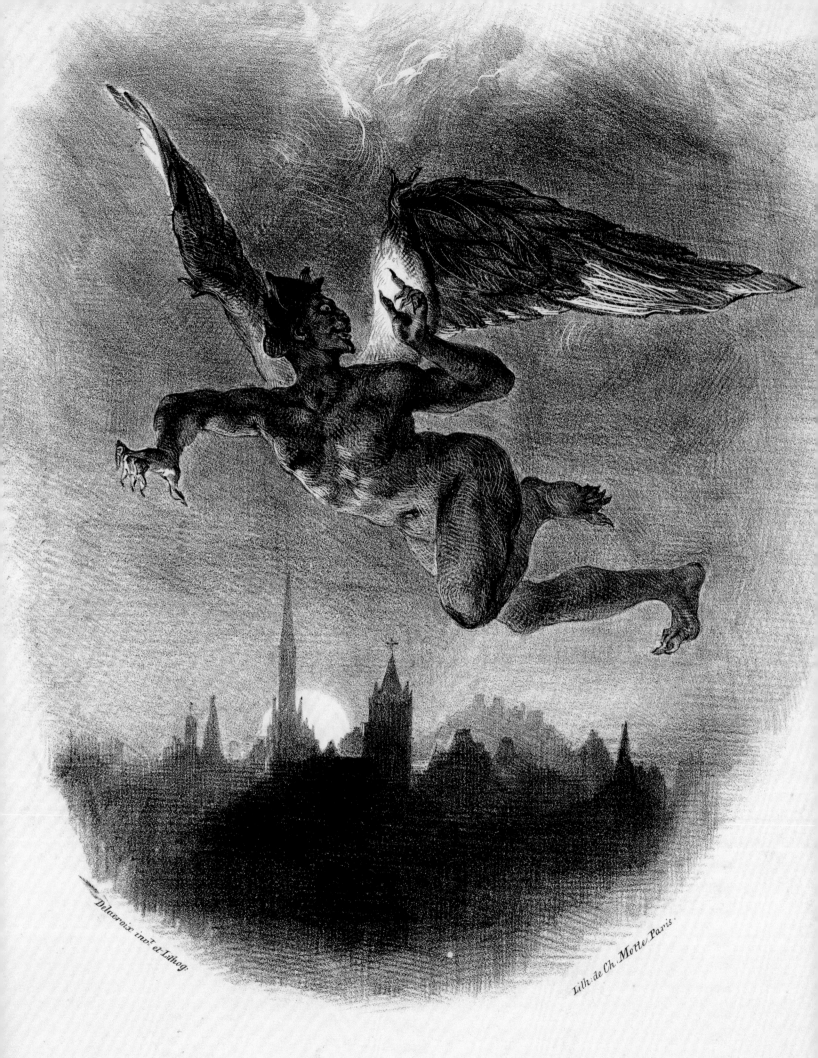

De temps en temps j'aime à voir le vieux Père,
Et je me garde bien de lui rompre en visière.

Lith: de Ch. Motte, Paris.

"Once upon a Midnight Dreary," French Artists Illustrated the Dark and Eerie: Nineteenth-Century French Print Series in the Arthur Ross Collection

ELISABETH HODERMARSKY

ARTHUR ROSS WAS AN impassioned collector with a distinct fondness for prints that were descriptive in nature—particularly those in the form of print series. In the Arthur Ross Collection, this penchant is apparent in three distinct types of print "serials": first, those of a topographical nature that illustrate a particular place, such as Piranesi's *Vedute di Roma*; second, series that convey social histories, such as the chronicle of bullfighting captured by Francisco Goya in his *Tauromaquia*; and third, series that are narrative in nature, illustrating texts such as poems, dramas, and novels. It is this third group—the serial narrative—that was the great and particular passion of French artists of the nineteenth century, many of whom Ross avidly collected, and with which the present essay concerns itself.

The nineteenth century was a richly creative time throughout Europe, during which literature, music, and the visual arts held primacy: one thinks of the writings of Sir Walter Scott, Honoré de Balzac, and Charles Dickens; of the music of Frédéric Chopin, Richard Wagner, and Giuseppe Verdi; and of the art of Caspar David Friedrich, James Mallord William Turner, and Edgar Degas. This creative passion was particularly evident in France, from the onset of the Romantic movement at the turn of the nineteenth century to the Impressionist and Post-Impressionist movements at the cusp of the twentieth. Book illustration reached its apex in nineteenth-century France as artists indulged in interpreting wide-ranging texts, from the fables of Aesop to the plays of William Shakespeare to modern poetry. The works of Miguel de Cervantes, Alexandre Dumas, and Victor Hugo were all favorite sources for French illustration of the period.[1] As the French poet, journalist, and critic Théophile Gautier recalled, "There reigned in every spirit an effervescence of which we have no idea today; we were intoxicated by Shakespeare, Goethe, Byron and Walter Scott . . . we toured the galleries with gestures of frenetic admiration that would make the present generation laugh."[2]

The unprecedented synergy of text and image in France in this era was fueled by developments in print- and bookmaking that revolutionized illustration in the Western world. The invention of lithography at the end of the eighteenth century, the invention of photography in the late 1830s, and technological innovations spurred on by the Industrial Revolution greatly modernized book production and simplified the integration of text and image.[3] The rather rabid vogue for the *roman noir*, or Gothic novel, played another role in the obsession with illustration. French artists in particular were preoccupied with the fatal heroes of the poems of Lord Byron, the knights victorious of the novels of Sir Walter Scott, and the tormented souls of the rambling purgatories of Dante Alighieri.[4] There was a particular predilection among nineteenth-century French artists to explore the dark and macabre in their work, and a distinct French appetite for the occult, the complexities of the inner workings of the psyche, and the unknown creatures that roam the earth at night. This is very much reflected in the nineteenth-century French prints in the Arthur Ross Collection.

This essay focuses on three print series that celebrate the dark and sinister and that are among the very finest within the Arthur Ross Collection: Eugène Delacroix's illustrations to Johann Wolfgang von Goethe's *Faust* and William Shakespeare's *Hamlet*, and Édouard Manet's illustrations to Edgar Allan Poe's *The Raven*.

Eugène Delacroix's Faust

Delacroix's first idea for creating illustrations to Goethe's *Faust* (fig. 1) came in 1824, when he and his friend Jean-Baptiste Pierret shared an interest in the sinister tale.[5] While in London in 1825, Delacroix attended a performance of *Dr. Faustus* by George Sonane and Daniel Terry, which opened at the Drury

FIG. 1.

EUGÈNE DELACROIX, Illustrations to Johann Wolfgang von Goethe's *Faust*, 1827, published 1828. Lithographs, dimensions variable. Yale University Art Gallery, The Arthur Ross Collection, 2012.159.54.1–.18

Portrait de Goethe (Portrait of Goethe)

Méphistophélès dans les airs (Mephistopheles in the Skies)

Faust dans son cabinet (Faust in His Study)

Faust et Wagner (Faust and Wagner)

Faust, Wagner et le barbet (Faust, Wagner, and the Spaniel)

Méphistophélès apparaissant à Faust (Mephistopheles Appearing to Faust)

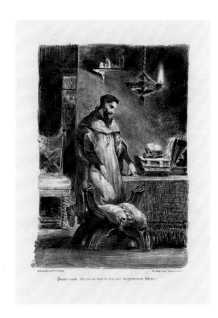

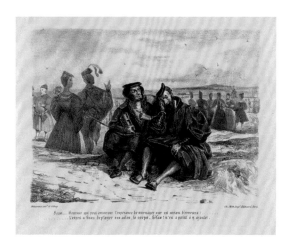

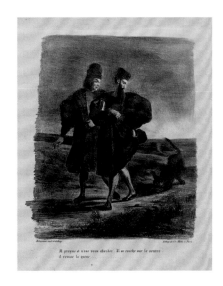

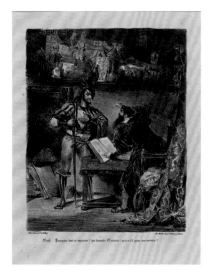

Méphistophélès recevant l'écolier (Mephistopheles Receiving the Student)

Méphistophélès dans la taverne des étudiants (Mephistopheles in the Students' Tavern)

Faust cherchant à séduire Marguerite (Faust Seeking to Seduce Marguerite)

Méphistophélès se présente chez Marthe (Mephistopheles Presents Himself in Marthe's Home)

Marguerite au rouet (Marguerite at the Spinning Wheel)

Duel de Faust et de Valentin (Duel between Faust and Valentin)

Méphistophélès et Faust fuyant après le duel (Mephistopheles and Faust Fleeing after the Duel)

Marguerite à l'église (Marguerite in Church)

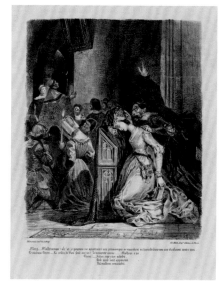

Faust et Méphistophélès dans les montagnes du Hartz (Faust and Mephistopheles in the Hartz Mountains)

L'ombre de Marguerite apparaissant à Faust (Marguerite's Ghost Appearing to Faust)

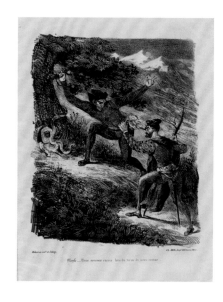

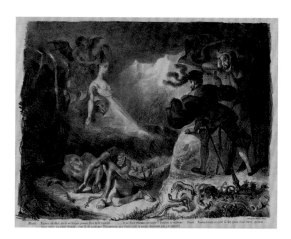

Faust et Méphistophélès galopant dans la nuit du Sabbat (Faust and Mephistopheles Galloping on the Night of the Witches' Sabbath)

Faust dans la prison de Marguerite (Faust in Marguerite's Prison)

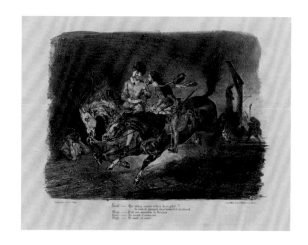

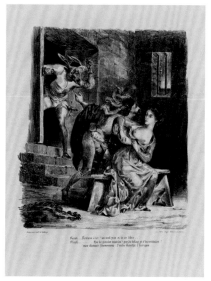

Lane Theater on May 16, 1825. Delacroix described that performance in a letter to Pierret of June 18, 1825: "I saw here a play about Faust which is the most diabolical thing imaginable. The Mephistopheles is a masterpiece of character and intelligence. It is an adaptation of Goethe's *Faust*; the principal elements are retained. They have made it into an opera with a mixture of broad comedy and some extremely sinister effects. The scene in the church is played with priests singing and distant organ music. Theatrical effect can go no further."[6]

In *Faust*, Goethe tells the tale of Dr. Heinrich Faust, a man who sells his soul to the devil, Mephistopheles, in exchange for limitless worldly pleasures and an understanding of the workings of the universe. Faust is a scholar with broad knowledge, having studied theology, medicine, law, and philosophy, and has even dabbled in the occult. His good works on earth as a teacher and physician have earned him a place in heaven, but the restless Faust feels that, despite all of his study, he has yet to understand the deepest mysteries of the cosmos. The devil makes a wager with God that he will be able to tempt away the devout Faust, and the plot is thus hatched. Mephistopheles lures Faust into a pact in which they agree that Mephistopheles will do everything that Faust wants while Faust is on earth and in turn Faust will give the devil his immortal soul.

Between 1825 and 1827, Delacroix created seventeen lithographs based on part one of Goethe's *Faust*, as well as a portrait of the author as a frontispiece.[7] His original plan was to publish a portfolio of just twelve unbound illustrations without captions, but one of the editors, Auguste Sautelet, proposed to use this as an opportunity to reissue Frédèric-Albert-Alexandre Stapfer's 1823 French translation of Goethe's text; thus, excerpts from Stapfer's text were added beneath each of Delacroix's lithographs.[8] For the *Faust* series, the thirty-year-old Delacroix exploited the marvelous range of tonal effects and painterly qualities of the lithographic medium.[9] Delacroix's characters and settings are drawn so as to play to the viewer, to mimic an actual stage performance: the sharp, rodentlike profiles and stiff limbs of Mephistopheles and Faust are so convincingly rendered as to seem to embody the devil/evil within. Throughout the series, the relentless grotesquerie, the preponderance of night scenes, the juxtaposition of light and dark dress, and the unnerving jagged scratching in the dark blacks to create nervous white highlights (a technique called *manière noire*) are all masterfully manipulated by Delacroix not only to convey, in graphic terms, good versus evil but also to fully celebrate the dramatic possibilities of black-and-white lithography. In 1827 Victor Hugo wrote, "The beautiful has but one type; the ugly a thousand,"[10] a sentiment invoked in this series, in which the beatific face of Faust's beloved Marguerite provides the only relief from the repulsive visages of Faust, Mephistopheles, and a gruesome array of ghastly demons.

Goethe himself was initially impressed by Delacroix's lithographs for *Faust*, admitting that the artist had led the author to

discover his work anew: "The powerful imagination of this artist forces us to rethink the situations as perfectly as he has himself. And if I must admit that in these scenes M. Delacroix has surpassed my own vision, how much more strongly the readers will find all of it alive and superior to what they were imagining!"[11] Yet, when Goethe received a leather-bound copy of the illustrated *Faust* a year and a half later, his friend Staatskanzler Friedrich von Müller reported that Goethe was less enthusiastic about Delacroix's images, noting that Goethe commented: "One can only be partially satisfied with Delacroix's illustrations, some are altogether too wild and lurid, badly done even, and throughout they are too gloomy. But some are brilliantly composed."[12] In France, the publication met with a rather hostile public reception. The convention for literary illustration up to this point was, after all, the small, static, impassive engraving; in this singular, boldly expressive publication, Delacroix's large, exaggerated, *ugly* images broke every standard, every long-established rule of book illustration.

Eugène Delacroix's Hamlet

Delacroix's career was bookended by his obsession with dark literary themes: his first important painting, exhibited at the Salon of 1822, depicted a scene from Dante's *Inferno*; at his last Salon, the Salon of 1859, Delacroix exhibited oils picturing episodes from Scott's *Ivanhoe* and *The Bride of Lammermoor*, and Shakespeare's *Hamlet*.[13] In between these years, the texts of Goethe, Byron, and Alexandre Dumas were all mined by the artist for their complex Gothic themes. When it came to Shakespeare, Delacroix nearly always chose tragedies as source material, regularly pillaging *Romeo and Juliet*, *Macbeth*, and *Othello*. By far Delacroix's most favored Shakespeare drama, however, was the most tragic of all of the tragedies, *Hamlet*—the story of a young Danish prince caught between betrayal and revenge, love and hate. Throughout the course of his life, Delacroix produced a total of eleven paintings based on the play, as well as numerous drawings and sixteen lithographs (fig. 2).

Delacroix produced his lithographic illustrations of *Hamlet*—his second major lithographic series of narrative illustrations—between 1834 and 1843.[14] As with his *Faust* series, the artist's motivation to produce these lithographs can be directly linked to an actual stage production: from September 1827 through July 1828, a British Shakespearean troupe that included William Charles Macready, Edmund Kean, Charles Kemble as Hamlet, and Harriet Smithson as Ophelia performed in English at the Odéon Theater in Paris.[15] In a letter from September 28, 1827, to his friend the amateur artist Charles Soulier, Delacroix wrote, "The English have opened their theater. They have worked miracles, for they draw such crowds to the Odéon that all the paving-stones in the neighborhood rattle under the carriage wheels. In a word, they are all the rage."[16]

FIG. 2.

EUGÈNE DELACROIX, Illustrations
to William Shakespeare's *Hamlet*,
1834–43, published 1843. Lithographs,
dimensions variable. Yale University
Art Gallery, The Arthur Ross
Collection, 2012.159.56.1–.13

La reine s'efforce de consoler Hamlet
(The Queen Tries to Console Hamlet),
Act 1, Scene 2

Hamlet veut suivre l'ombre de son père
(Hamlet Wants to Follow His Father's
Ghost), Act 1, Scene 4

Le fantôme sur la terrasse (The Ghost
on the Terrace), Act 1, Scene 5

Polonius et Hamlet (Polonius and
Hamlet), Act 2, Scene 2

Hamlet et Guildenstern (Hamlet and
Guildenstern), Act 3, Scene 2

*Hamlet fait jouer aux comédiens la
scène de l'empoisonnement de son père*
(Hamlet Has the Actors Play the
Scene of the Poisoning of His Father),
Act 3, Scene 2

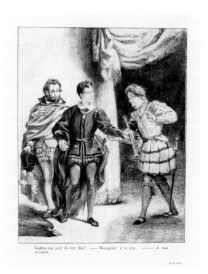

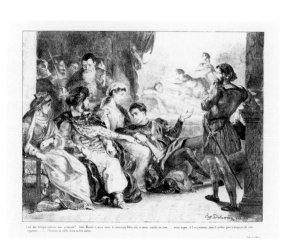

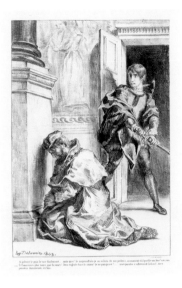

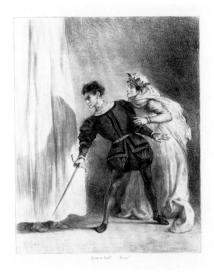

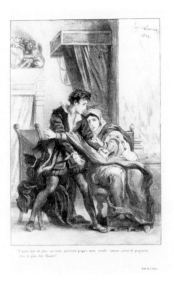

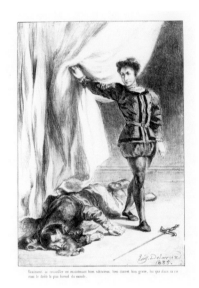

Hamlet tente de tuer le roi (Hamlet Attempts to Kill the King), Act 3, Scene 3

Le meurtre de Polonius (The Murder of Polonius), Act 3, Scene 4

Hamlet et la reine (Hamlet and the Queen), Act 3, Scene 4

Hamlet et le cadavre de Polonius (Hamlet and the Corpse of Polonius), Act 3, Scene 4

Mort d'Ophélie (Death of Ophelia), Act 4, Scene 7

Hamlet et Horatio devant les fossoyeurs (Hamlet and Horatio before the Grave Diggers), Act 5, Scene 1

Mort d'Hamlet (Death of Hamlet), Act 5, Scene 2

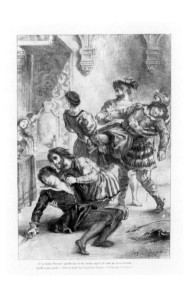

Delacroix's *Hamlet* suite was published in 1843 as *Hamlet/Treize sujets dessinés*, identifying the illustrations not as prints but as *dessins*, or drawings.[17] And indeed, they are as sumptuously and freshly rendered as drawings: Delacroix exploited the full palette of darks to lights achievable in lithography, from the starkly contrasted deep blacks and bright whites of the foreground action to the full scope of grays used to articulate the interior and exterior settings. It is clear that Delacroix studiously combed Shakespeare's text and extracted the lynchpins of the complicated plot for his illustrations. Delacroix then strung the prints together visually, literally choreographing the movements of the characters from one scene to the next so that they read as a kind of lyrical dance: compare, for example, *Hamlet Wants to Follow His Father's Ghost* with the ensuing scene, *The Ghost on the Terrace*: in the first, Hamlet lunges forward, in the next, he recoils, almost in a precisely reverse motion. Similarly, compare *The Murder of Polonius* with the ensuing scene, *Hamlet and the Queen*: in the first, Hamlet bends to the left, away from the figure of the Queen, while in the next, he bends to the right, toward the Queen, again in an almost mirror action.

The meticulous articulation of facial expressions and bodily movements is remarkable in Delacroix's *Hamlet*—one of the most highly sought after series of the artist's printed oeuvre. The scenes are so well chosen, and so sensitively drawn, in fact, that it is possible to understand much of Shakespeare's complicated plot through a close "reading" of just Delacroix's images.

Édouard Manet's The Raven

Edgar Allan Poe's *The Raven* was first published in the New York *Evening Mirror* on January 29, 1845, and received immediate popular and critical praise. It is doubtless to this day one of the best-known poems in American literature.[18] French Symbolist poet Stéphane Mallarmé began his prose translations of Poe as early as 1862, but it was not until 1872 that they were first published. Shortly thereafter, Mallarmé met Manet and the two became lifelong friends.[19]

Similar to the male protagonists in Goethe's *Faust* and Shakespeare's *Hamlet*, the central figure in *The Raven*, who is also the narrator, is revealed as a deeply thoughtful, introspective man. As the poem opens, he attempts to distract himself from memories of his beloved lost love, Lenore, by reading "curious volume[s] of forgotten lore," shown in Manet's first illustration from the series (fig. 3). He is interrupted while "nearly napping" by a gentle "rapping at [his] chamber door," thus establishing within the first stanza that what is about to transpire is potentially real, or—given the agitation of the narrator—a figment of his subconscious. The narrator opens his chamber door to investigate but finds nothing. He then hears a slightly louder rapping at his window and, upon his opening the shutter, a raven swoops in and proceeds to perch on the bust of Pallas Athena above the narrator's door.[20] To any question the man

poses, the raven responds only, "Nevermore," from which the narrator then surmises that his new "friend" will soon fly out of his life just as "other friends have flown before," namely his love, Lenore. He pulls a chair in front of the raven, convinced it portends an imminent event. But when he asks the raven if he will be reunited with Lenore in Heaven, it responds with its singular reply, "Nevermore."[21] In the last stanza, the narrator reveals that the raven is "still sitting" on the bust of Pallas, and that his soul is trapped beneath the raven's shadow, which will be lifted "nevermore." Beauty and mortality are the themes of the poem, and, for Poe, sadness was the highest manifestation of beauty. As he wrote in 1846, "Beauty of whatever kind, in its supreme development, invariably excites the sensitive soul to tears. Melancholy is thus the most legitimate of all the poetical tones."[22]

Manet's sketchily rendered illustrations of Poe's sad tale would seem to echo the dreamlike, unfocused mood of Poe's words. Though the five images are usually described as transfer lithographs, the process Manet used to create them is more likely *gillotage*, a direct, nonphotographic transfer process that necessitated a rather quick execution, completely in sync with the spontaneous spirit of Manet's conception. *Gillotage* involves painting on sheets of paper with an oily black liquid known as *tusche* and then transferring the drawings while still wet to zinc plates by running them through a press.[23] The speed of execution reinforces the stylistic character of the illustrations, which read as rapidly conceived sketches. The suite was printed on loose sheets of paper, interleaved with text sheets carrying Poe's poem in English on one side and Mallarmé's prose translation in French on the other.[24] As with Delacroix's illustrations to *Hamlet*, it is telling that Manet's illustrations for *The Raven* were in fact called *dessins* rather than lithographs on the printed poster that announced the publication.[25]

That Arthur Ross focused a part of his collecting on these nineteenth-century lithographic exegeses of psychologically complex literary texts is a testament not only to his intellectual vigor but also to his predilection for such expansive explorations of the print medium. The allure of these series is palpable: how can one help but be seduced by Delacroix's diabolical Mephistopheles, by his earnest Hamlet, or by Manet's mournful narrator of *The Raven*? Theirs are the images that provide both visual and emotional "finish" to the rich texts of Goethe, Shakespeare, and Poe; theirs are the images that ignite our imaginations and lend fodder to our own dark visualizations of the stories. Goethe's, Shakespeare's, and Poe's texts never cease to engage since their deeply moral messages remain ever relevant; likewise, Delacroix's and Manet's classic lithographic illustrations remain to this day the images we conjure when we recall these classic tales.

FIG. 3.
ÉDOUARD MANET, Illustrations to Edgar Allan Poe's *The Raven*, translated by Stéphane Mallarmé as *Le corbeau*, 1875. Transfer lithographs, dimensions variable. Yale University Art Gallery, The Arthur Ross Collection, 2012.159.81.1, .2, .4–.6

Under the Lamp

At the Window

The Raven on the Bust of Pallas

The Chair

Flying Raven (ex libris)

The phrase "Once upon a Midnight Dreary" opens Edgar Allan Poe's *The Raven*, discussed in this essay.

1. For a fuller discussion of this phenomenon, in particular the French appetite for British texts, see David Blayney Brown, "Literature and History: Shakespeare, Scott, Byron and Genre Historique," in *Constable to Delacroix: British Art and the French Romantics*, ed. Patrick Noon, exh. cat. (London: Tate Britain, 2003), 124–27.

2. Théophile Gautier, *Les beaux-arts en Europe* (Paris: n.p., 1855), 2:47, quoted and translated in Patrick Noon, "Colour and Effect: Anglo-French Painting in London and Paris," in Noon, *Constable to Delacroix*, 13.

3. For more on the development of the printed image in this period, see David Bland, *A History of Book Illustration: The Illuminated Manuscript and the Printed Book* (London: Faber and Faber Limited, 1958), 276–300.

4. The appetite for the Gothic novel was indeed very much a French and German one; during the nineteenth century, the British were far more preoccupied with landscape than with medievalism. See Bland, *History of Book Illustration*, 285.

5. The story of Faust originated as a German folktale, dating well back into the Middle Ages. Christopher Marlowe was the first writer to bring it to the stage, in a 1604 adaptation of the story. But it is Goethe's version, published two centuries later, in 1808, that is the version still today considered the classic.

6. Jean Stewart, ed. and trans., *Eugène Delacroix: Selected Letters, 1813–1863* (Boston: MFA Publications, 1970), 124–25.

7. Delacroix executed his first lithograph in 1819, five years after his first experiments in the etching medium. His first published lithographs were caricatures, which appeared in several issues of *Miroir* in 1821 and 1822. Delacroix clearly took delight in making the *Faust* illustrations themselves but claimed some difficulty in producing the portrait of Goethe for the frontispiece. He wrote to the publisher Charles Motte in October 1827, "I am forced to admit my inadequacy in the matter of lithographical portraits, which always require a certain degree of finish"; Stewart, *Eugène Delacroix: Selected Letters*, 141–42.

8. These were not in Delacroix's original plan. In addition, one of the lithographic stones, that for *Mephistopheles Receiving the Scholar*, was either broken or lost after only partial printing. It was replaced by a copy made by another artist.

9. Many artists of the period embraced the lithographic process as a way to avoid the problems inherent in wood or copper engraving—namely, the necessity of a middleman to transfer the artist's image to the woodblock or copper plate. With lithography, the artist required no special skills; he could draw his design directly on the stone, which was then inked and printed.

10. Victor Hugo, *Oliver Cromwell* (1827), vol. 9 of *Dramas*, trans. I. G. Burnham (Philadelphia: George Barrie and Son, 1896), 9: 35.

11. See Beth S. Wright, *The Cambridge Companion to Delacroix* (Cambridge: Cambridge University Press, 2001), 191–92n12. Wright is referencing Bartélémy Jobert, *Delacroix* (Princeton: Princeton University Press, 1998), 108, citing Johann Peter Eckermann, *Conversations de Goethe avec Eckermann*, trans. J. Chuzeville (Paris: n.p., 1949, 1988), 171–72 (conversation of November 29, 1826).

12. See Robert Vilain, "'An Excess of Savage Force'?: Faust in French: Stapfer, Delacroix, and Goethe," *Princeton University Library Chronicle* 73, no. 3 (2012): 359.

13. For more information on Delacroix's involvement with literary themes, see Paul Joannides, "Delacroix and Modern Literature," in Wright, *Cambridge Companion to Delacroix*, 130–53. The 1822 scene from Dante's *Inferno* was, in fact, Delacroix's first masterpiece, *The Barque of Dante*, purchased by the French government for the Musée de Luxembourg, Paris (now in the Musée du Louvre, Paris).

14. The thirteen lithographs of *Hamlet* were executed in two short spurts, from 1834 to 1835 and from 1842 to 1843.

15. The composer Hector Berlioz attended the production and fell instantly in love with Harriet Smithson, the Irish actress playing Ophelia, and later married her. Berlioz's *Symphonie fantastique* (1830) was composed during their courtship as a tribute to Smithson. See Edwin Binney, *Delacroix and the French Romantic Print: An Exhibition from the Collection of Edwin Binney, 3rd* (Washington, D.C.: Smithsonian Institution Traveling Exhibition Service, 1974). The troupe's performances of numerous Shakespeare plays inspired other French painters, including Théodore Chassériau (who made illustrations to *Othello*) and Achille Devéria (who made illustrations to *Romeo and Juliet* and *Hamlet*).

16. Stewart, *Eugène Delacroix: Selected Letters 1813–1863*, 139.

17. This first edition, which is the one included in the Arthur Ross Collection, was published in an edition of eighty (twenty sets on *chine* and sixty on white wove paper). It was printed by Villain and published by the Gihaut brothers. When the portfolio was reissued in 1864, an additional three lithographs were included: *Hamlet et Ophélie* (Act 3, Scene 1); *Le chant d'Ophélie* (Ophelia's Song; Act 4, Scene 5); and *Hamlet et Laertes dans la fosse d'Ophélie* (Hamlet and Laertes in Ophelia's Grave; Act 5, Scene 1). For these prints, see Delteil 107, 114, and 117, respectively.

18. *The Raven* is written in trochaic octameter (eight trochaic feet per line; one stressed syllable followed by one unstressed).

19. In the early 1870s Manet and Mallarmé both lived on rue de Moscou and saw each other nearly every day from about 1872 until Manet died on May 7, 1883. In 1875, Manet created these five "dessins" as illustrations for Mallarmé's translation of Edgar Allan Poe's *The Raven*, and in 1876, Manet produced four drawings for wood engravings illustrating Mallarmé's *L'après-midi d'un faune*. In 1874 and 1876, Mallarmé wrote two articles that supported Manet's work.

20. In literature, a raven has long been considered a bird of ill omen, as well as of darkness, mocking, and the untenable and mysterious.

21. Or, in Mallarmé's French translation, *jamais plus*.

22. Edgar Allan Poe, "The Philosophy of Composition," *Graham's Magazine* 28, no. 4 (April 1846): 164. Poe's wife, Virginia, died of tuberculosis in 1842, three years before the publication of *The Raven*, and many believe the themes of love and loss/death are to some degree autobiographical. Poe himself died in 1849.

23. The process was developed in 1850 by Firmin Gillot. After transferring the drawings to zinc plates, the plates were dusted with resin (tree sap) that acted as an acid resist. The plates were then

submerged in an etching (acid) bath, the areas around the drawings responding to the acid and wearing away. After the plates are etched, the designs stand out in relief. The plates were then inked and printed in relief, like woodcuts or wood engravings. See Jay McKean Fisher, *The Prints of Édouard Manet* (Washington, D.C.: International Exhibitions Foundation, 1985), 115. Fisher is citing the research of Douglas Druick and Peter Zegers on Edgar Degas's printmaking techniques and their influence on Manet; see Douglas Druick and Peter Zegers, "Degas and the Printed Image, 1856–1914," in Sue Welsh Reed and Barbara Stern Shapiro, *Edgar Degas: The Painter as Printmaker*, exh. cat. (Boston: Museum of Fine Arts, 1984), xxxiii.

24. The edition of *Le corbeau* (The Raven) in the Arthur Ross Collection was issued by Richard Lesclide in 1875, on Asian paper, together with an ex libris, an illustrated cover, and a slipcover on vegetable parchment. The publication was not a commercial success. Although advertised as an edition of 240, Lesclide's *Déclarations d'imprimeur* at the Dépôt legal de Paris notes that only 150 copies were printed, signed by both Mallarmé and Manet.

25. The collection of the Yale University Art Gallery includes a copy of the printed poster; inv. no. 1955.52.1.

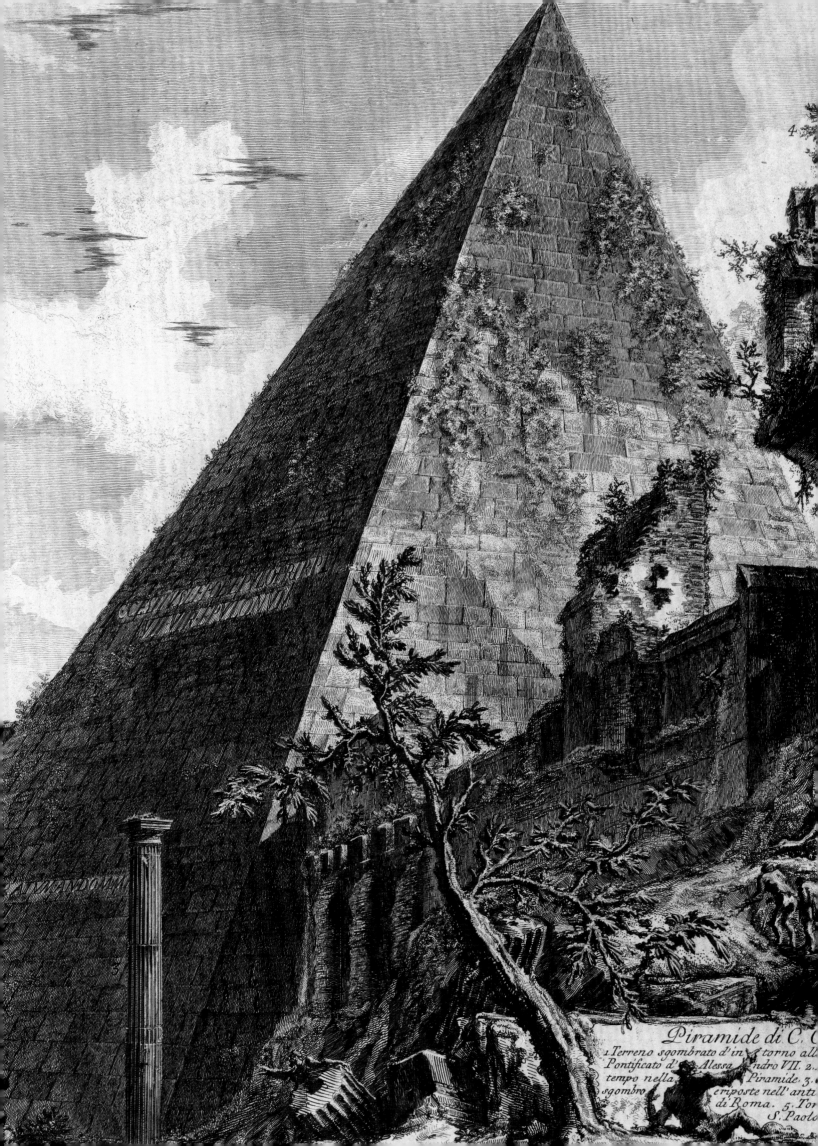

4.

O·CESTIVS·L·F·PORL·EPVLO·N·PR·TR·PL·
VII·VIR·EPVLONVM

Piramide di C.
1 Terreno sgombrato d'in torno alla
Pontificato d' Alessandro VII. 2.
tempo nella Piramide 3.
sgombro e riposte nell' antr
di Roma. 5. Tor
S. Paol

Exhibition History

SINCLAIRE MARBER

FOR NEARLY THIRTY YEARS, Arthur Ross proved generous and inventive in sharing his expertise, financial resources, and vast collection of exceptional prints. Sometimes he lent just a single work of art, though more often he shared large percentages of his foundation's collection while also funding exhibitions and accompanying publications. Indeed, from 1979 until Ross's death in 2007, pieces from the Arthur Ross Collection were exhibited (often multiple times) at nearly fifty venues—including more than fifteen academic museums—in locations around the world. Today, prints in the collection continue to travel in honor of Ross's generous spirit.

The personal involvement of both Arthur Ross and his foundation in overseeing exhibitions of the collection can be described in much the same way Ross himself summarized the inventiveness of the eighteenth- and nineteenth-century printmakers he so admired: "They poured their skills and imaginative genius into making these works."[1] Ross lent prints and financial support, but that was only the beginning of his very active and welcomed participation in every step of the exhibition process. Over the years, his influence touched everything from the approval of the venue and selection of works to be included in shows to the planning of opening events and marketing. The archives of the foundation, now held in their entirety at the Yale University Art Gallery, are replete with evidence: Ross's handwritten marks can be found on proof copies of catalogues, and his correspondence demonstrates his involvement in the installation of objects, signage, and didactic materials. Equally important to Ross and the foundation were related exhibition events, as the menus and annotated seating charts tucked away in planning folders attest. Marked-up lists show that Ross personally invited or suggested guests for the openings and lectures that he himself always made an effort to attend.

Moreover, he often spoke at these functions, his prepared remarks displaying both his erudition and his personal connection to the collection.

As described by Alexa A. Greist in her essay in this volume, Ross developed a passion early on for works by Francisco Goya, the Spanish artist whom he considered to be "the supreme iconoclast and cynic of his era."[2] Tracing the exhibition history of Goya works from the Arthur Ross Collection reveals some interesting trends. The foundation's first print acquisitions in 1980 were series by Goya, which ultimately formed the root of the collection from which all other purchases grew. In subsequent years, prints by Giovanni Battista Piranesi came to make up the majority of the collection, but a link to Goya remained: Piranesi was a great influence on his younger Spanish contemporary. Works in the collection by later artists, such as Édouard Manet and Pablo Picasso, display themes also found in Goya's oeuvre, such as the bullfight. The Ross exhibitions followed these collecting patterns: initial exhibitions presented the works from post-Enlightenment Spain, while later ones featured eighteenth-century Italian and nineteenth-century French prints.

The collection was intended to be shared—records of the Goya purchases indicate that many were sent directly from galleries or auction houses to the framer and then to storage in preparation for exhibitions, and this practice was often repeated later, especially with the French prints. Almost immediately following the acquisition of Goya's *Caprichos* for Ross's personal collection (see donor's foreword), the prints were exhibited at Ross's alma maters, the University of Pennsylvania and Columbia University, where he would also endow galleries. They then made their way to the Yale University Art Gallery for an exhibition, *Goya's "Los Caprichos" from the Collection of Arthur Ross*, in 1981. In the exhibition catalogue, Richard S. Field, Curator of

Prints, Drawings, and Photographs at the time, described Ross's wishes: "[He] has supported the entire exhibition and its catalogue with only one proviso: that the public be given an opportunity to enjoy and to learn."[3]

The frequent choice of academic institutions as venues for exhibitions and the foundation's willingness to fund publications, symposia, and generous honoraria to scholars demonstrate how important education was to Ross. He responded favorably to loan and exhibition requests for worthy, often interdisciplinary, educational endeavors. For example, in 2007 an exhibition at the Syracuse University Art Galleries of Goya's *Disasters of War* helped enrich Syracuse University's semester-long symposium dedicated to the theme of justice.[4] Even at civic museums, academic outreach was of the utmost importance to Ross. Many museum curators and directors provided the foundation with reports on exhibition attendance and publicity.

Others, like J. D. Talasek, Director of Exhibitions and Cultural Programs at the National Academy of Sciences, in Washington, D.C., provided more personal notes; after the 2004–5 exhibition at the museum, Talasek wrote to Ross, "Many college and university groups were brought in by the exhibition, which pleased me greatly as we strive to become a stronger resource for our community."[5]

While additional essays in this catalogue address the biography and collecting patterns of Arthur Ross and the high quality and importance of the collection that he amassed, the following exhibition history demonstrates how the man who so deeply valued education and accessibility put these principles into practice.

1985

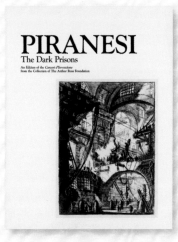

1988

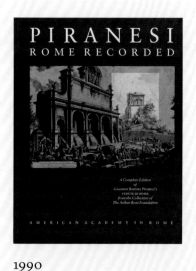

1990

2001

2002

2004

1. Arthur Ross, final draft of "Mr. Ross's Remarks," exhibition planning folders, *Bearded, Turbaned, and Wise: Heads by Tiepolo, A Collection of Etchings from the Arthur Ross Foundation and Lasting Impressions: Nineteenth-Century French Prints from the Arthur Ross Foundation* (both Art Gallery of the Graduate Center, City University of New York, 2004), Arthur Ross Foundation Archive, Department of Prints and Drawings, Yale University Art Gallery.

2. Arthur Ross, final draft of "Remarks on Occasion of Piranesi Opening," exhibition planning folders, *Piranesi: Rome Recorded, A Complete Edition of Giovanni Battista Piranesi's "Vedute di Roma" from the Collection of the Arthur Ross Foundation* (American Academy in Rome, 1990), Arthur Ross Foundation Archive.

3. *Goya/Los caprichos*, exh. broch. (New Haven, Conn.: Yale University Art Gallery, 1981), 3, exhibition planning folders, Arthur Ross Foundation Archive.

4. Domenic J. Iacono, Director, Syracuse University Art Galleries, New York, letter to Arthur Ross, December 19, 2006, exhibition planning folders, *Goya: The Disasters of War* (Syracuse University Art Galleries, N.Y., 2007), Arthur Ross Foundation Archive.

5. J. D. Talasek, letter to Arthur Ross, May 4, 2005, exhibition planning folders, *Giovanni Piranesi and Vik Muniz: Prisons of the Imagination* (National Academy of Sciences, Washington, D.C., 2004–5), Arthur Ross Foundation Archive.

1994

1997–98

1999

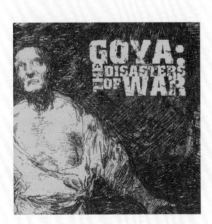

2007

2008

These illustrations represent a selection of the books and brochures published in conjunction with the exhibitions that appear in the following exhibition history. Copies of these materials can be found in the Arthur Ross Foundation Archives, Department of Prints and Drawings, Yale University Art Gallery.

Reader's Note

Exhibitions marked with an asterisk (*) are those that were composed, primarily or exclusively, of works from the Arthur Ross Collection; those with a dagger (†) contained works not part of the collection at the time; those with a section symbol (§) contained works not part of the gift to the Gallery. Those with a double asterisk (**) were accompanied by an exhibition catalogue.

1979

*§*Goya: Los Caprichos*
Low Memorial Library, Columbia University, New York
April 30–May 18, 1979

†*Urban Open Spaces: Temporary and Accidental*
Mount Sinai Medical Center, New York
June 26–August 6, 1979

1981

*§*Los Caprichos y Los Proverbios*
Lessing J. Rosenwald Gallery, Van Pelt Library, University of Pennsylvania, Philadelphia
January 27–March 6, 1981
The Century Association, New York
April 8–May 3, 1981

†*Breaking Ground: Open Spaces, Temporary and Accidental*
The Urban Center, Municipal Art Society, New York
February 3–March 3, 1981
Graduate School of Architecture, Planning, and Preservation, Columbia University, New York
March 6–31, 1989

*§*Goya's "Los Caprichos" from the Collection of Arthur Ross*
Yale University Art Gallery, New Haven, Conn.
September 16–November 15, 1981

1983

* ***"The Disasters of War," "La Tauromaquia," Spanish Entertainment, and Other Prints of Francisco Goya*
Arthur Ross Gallery, University of Pennsylvania, Philadelphia
February 8–March 31, 1983

1984

* ***Goya: "The Disasters of War" and Selected Prints from the Collection of the Arthur Ross Foundation*
Spanish Institute, New York
November 17, 1984–January 16, 1985

1985

* ***Tauromaquia: Goya-Picasso*
Peggy Guggenheim Collection, Venice
March 3–April 8, 1985
Warwick Arts Trust, London
September 24–October 26, 1986
Chateau Grimaldi, Antibes, France
December 13, 1986–January 30, 1987
Casón del Buen Retiro, Museo del Prado, Madrid
April 30–June 6, 1987
Palau de la Virreina, Barcelona, Spain
June 30–August 25, 1987
Beaverbrook Art Gallery, Fredericton, New Brunswick, Canada
May 15–August 29, 1993

1986

* ***La Tauromaquia: Goya, Picasso, and the Bullfight*
Milwaukee Art Museum
September 19–November 16, 1986
Fisher Gallery, University of Southern California (now Fisher Museum of Art), Los Angeles
January 13–February 28, 1987
Southern Methodist University, Dallas
March 26–May 16, 1987

Goya: Selected Prints from the Collection of the Arthur Ross Foundation
Corcoran Gallery of Art, Washington, D.C.
November 15, 1986–January 25, 1987

1988

* ***Piranesi: The Dark Prisons, an Edition of the "Carceri d'Invenzione" from the Collection of the Arthur Ross Foundation*
Italian Cultural Institute of New York
May 25–July 5, 1988
Arthur Ross Gallery, University of Pennsylvania, Philadelphia
May 5–June 15, 1989
Beaverbrook Art Gallery, Fredericton, New Brunswick, Canada
May 28–September 6, 2005

1989

* ***Graphic Evolutions: The Print Series of Francisco Goya*
Miriam and Ira D. Wallach Art Gallery, Columbia University, New York
February 2–March 18, 1989

* **Piranesi: Rome Recorded, A Complete Edition of Giovanni Battista Piranesi's "Vedute di Roma" from the Collection of the Arthur Ross Foundation*
Arthur Ross Gallery, University of Pennsylvania, Philadelphia
May 5–June 14, 1989
Italian Consulate for the American Academy in Rome, New York
April 5–28, 1990
American Academy in Rome
October 16–December 16, 1990
Sotheby's, Palazzo Capponi, Florence
January 15–31, 1991
Museo Correr, Venice
February 16–April 17, 1991
Royal Institute of British Architects, London
April 30–May 17, 1991

1991
Giovanni Battista Piranesi: The Prisons and the Views of Rome from the Collection of the Arthur Ross Foundation
Mona Bismarck Foundation (now Mona Bismarck American Center for Art and Culture), Paris
June 19–July 26, 1991

La Tauromaquia: Etchings by Goya and Picasso from the Collection of the Arthur Ross Foundation
The Century Association, New York
September 11–October 11, 1991

1992
Giovanni Battista Piranesi: Roman Antiquities from the Republican Era
Casa Italiana Zerilli-Marimò, New York University
October 1992–January 1993

* **The Imagined and Real Landscapes of Piranesi*
Arthur Ross Architectural Gallery, Columbia University, New York
October 13–December 12, 1992

1994
18th Century Italian Vedute Prints from the Arthur Ross Foundation
Gibbes Museum of Art, Charleston, S.C.
May 25–June 30, 1994

§*Francisco Goya y Lucientes: "Los Caprichos," "Los Disparates," and Spanish Entertainment from the Arthur Ross Foundation*
Gibbes Museum of Art, Charleston, S.C.
May 25–June 30, 1994

1995
Image and Eye: The Art of Goya and Picasso, Selected Works from the Collection of the Arthur Ross Foundation and Other Major Loans
New York Studio School of Drawing, Painting, and Sculpture
October 25–November 11, 1995

1997
Celebrating Canaletto: Etchings from the Collection of the Arthur Ross Foundation
Italian Cultural Institute of New York
November 6–December 30, 1997
Boca Raton Museum of Art, Fla.
January 22–March 15, 1998

1998
**Fountains: Splash and Spectacle*
Cooper-Hewitt, National Design Museum, Smithsonian Institution (now Cooper-Hewitt, Smithsonian Design Museum), New York
June 8–October 11, 1998

1999
* **Two Views of Venice: Canaletto and Menpes*
Arthur Ross Gallery, University of Pennsylvania, Philadelphia
April 9–June 13, 1999
Cooper-Hewitt, National Design Museum, Smithsonian Institution (now Cooper-Hewitt, Smithsonian Design Museum), New York
October 26–December 19, 1999
Vanderbilt University Fine Arts Gallery, Nashville
September 20–November 1, 2001

**Manet's "The Dead Toreador" and "The Bullfight": Fragments of a Salon Canvas Reunited*
Frick Collection, New York
May 28–August 22, 1999

Eccentric Visions: A Loan Exhibition of Prints from the 16th through the 20th Century
Gallery of the College of Staten Island, City University of New York
November 17–December 18, 1999

Piranesi's Roman Basilicas: A Virtual Pilgrimage
La Salle University Art Museum, Philadelphia
November 22, 1999–January 30, 2000

2000
European Masterpiece Series: Canaletto
Beaverbrook Art Gallery, Fredericton, New Brunswick,
Canada
June 28–October 29, 2000

2001
*Elective Affinities: Prints by Goya and Manet, A Loan
Exhibition from the Arthur Ross Foundation and New York
Public Library*
Art Gallery of the Graduate Center (now Amie and Tony
James Gallery), City University of New York
March 1–April 17, 2001

2002
Leaving a Mark: The Art of Print in 19th-Century France
Arthur Ross Gallery, University of Pennsylvania,
Philadelphia
April 6–June 9, 2002

European Masterpiece Series: Etchings by Tiepolo
Beaverbrook Art Gallery, Fredericton, New Brunswick,
Canada
May 19–September 29, 2002

*Canaletto/Piranesi: Views, Real and Invented, Etchings
from the Arthur Ross Foundation*
Art Gallery of the Graduate Center (now Amie and Tony
James Gallery), City University of New York
September 20–November 16, 2002

2003
**Whistler and His Circle in Venice*
Corcoran Gallery of Art, Washington, D.C.
February 8–May 5, 2003
Grolier Club of New York
September 17–November 22, 2003
Columbia Museum of Art, S.C.
May 1–July 3, 2004

*European Masterpiece Series: Nineteenth-Century French
Prints from the Arthur Ross Foundation*
Beaverbrook Art Gallery, Fredericton, New Brunswick,
Canada
May 10–September 21, 2003

2004
Giovanni Piranesi and Vik Muniz: Prisons of the Imagination
National Academy of Sciences, Washington, D.C.
August 1, 2004–May 1, 2005

*Lasting Impressions: Nineteenth-Century French Prints
from the Arthur Ross Foundation*
Art Gallery of the Graduate Center (now Amie and Tony
James Gallery), City University of New York
September 23–November 13, 2004

*Bearded, Turbaned, and Wise: Heads by Tiepolo, A
Collection of Etchings from the Arthur Ross Foundation*
Art Gallery of the Graduate Center (now Amie and Tony
James Gallery), City University of New York
October 28–November 27, 2004

2005
***Manet*
Complesso del Vittoriano, Rome
October 8, 2005–February 5, 2006

2006
*§*Francisco Goya y Lucientes: "Los Caprichos," An Early
Edition from the Collection of Mr. and Mrs. Arthur Ross*
Arthur Ross Gallery, University of Pennsylvania,
Philadelphia
October 27, 2006–January 7, 2007

2007
Goya: The Disasters of War
Syracuse University Art Galleries, N.Y.
August 21–December 2, 2007

***Piranesi as Designer*
Cooper-Hewitt, National Design Museum, Smithsonian
Institution (now Cooper-Hewitt, Smithsonian Design
Museum), New York
September 14, 2007–January 20, 2008
Teylers Museum, Haarlem, the Netherlands
February 9–May 18, 2008

2008
*Dark Dreams: The Prints of Francisco Goya, A Selection
from the Collection of the Arthur Ross Foundation*
Jane Voorhees Zimmerli Art Museum, Rutgers University,
New Brunswick, N.J.
September 2–December 14, 2008

2011
*Two Venetian Masters: Canaletto and Domenico Tiepolo,
Etchings from the Arthur Ross Foundation*
Jane Voorhees Zimmerli Art Museum, Rutgers University,
New Brunswick, N.J.
September 6, 2011–January 8, 2012

2013

La Tauromaquia: Carnicero, Goya, and Picasso
Arthur Ross Gallery, University of Pennsylvania, Philadelphia
April 18–July 28, 2013

2015

Whistler in Paris, London, and Venice
Yale University Art Gallery, New Haven, Conn.
January 30–July 19, 2015

*Meant to Be Shared: Selections from the Arthur Ross Collection
of European Prints at the Yale University Art Gallery*
Yale University Art Gallery, New Haven, Conn.
December 18, 2015–April 24, 2016
Samuel P. Harn Museum of Art, University of Florida,
Gainesville
January 29–May 8, 2017
Syracuse University Art Galleries, N.Y.
August 17–November 19, 2017

2016

Goya: Mad Reason
Blanton Museum of Art, University of Texas at Austin
June 19–September 25, 2016

When in Rome: Prints and Photographs, 1550–1900
Smith College Museum of Art, Northampton, Mass.
September 30–December 30, 2016

Collection Highlights

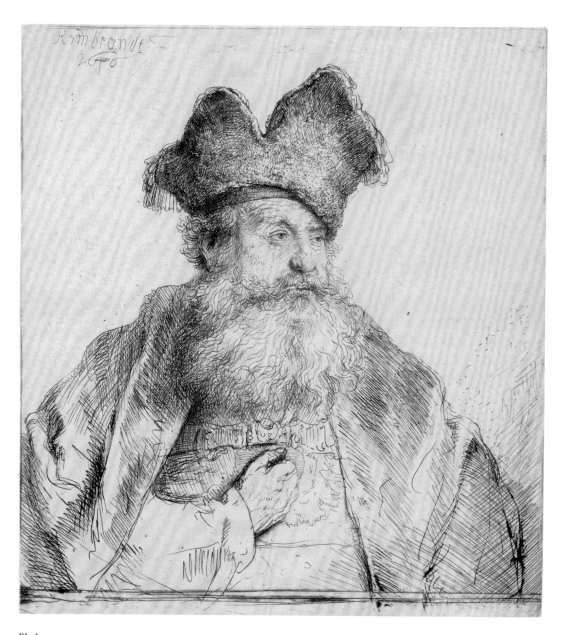

PL. 1.

REMBRANDT HARMENSZ. VAN RIJN,
Old Man with a Divided Fur Cap, 1640

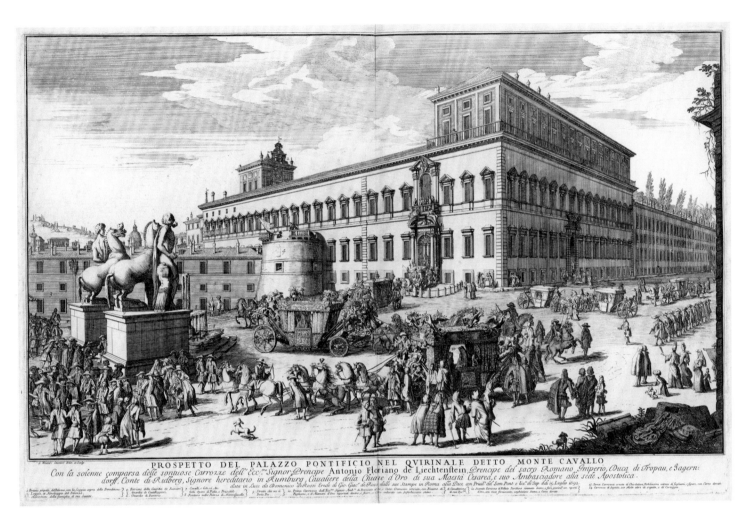

PROSPETTO DEL PALAZZO PONTIFICIO NEL QVIRINALE DETTO MONTE CAVALLO

Con la solenne comparsa delle sontuose Carrozze dell' Ecc.mo Signor Prencipe Antonio Floriano de Liechtenstein, Prencipe del sacro Romano Imperio, Duca di Tropau, e Jagern-dorff, Conte di Rulberg, Signore hereditario in Rumburg, Cavaliere della Chiave d'Oro di sua Maestà Cesarea, e suo Ambasciadore alla sede Apostolica.

data in Luce da Domenico de Rossi Erede di Gio. Giac. de Rossi dalle sue Stampe in Roma alla Pace con Priuil. del Som Pont. e lic. de Sup. ddi 14. Luglio 1692.

PL. 2.

GOMMARUS WOUTERS, *Prospetto del palazzo pontificio nel Quirinale detto Monte Cavallo* (View of the Papal Palace on the Quirinal Hill, called Monte Cavallo), 1692

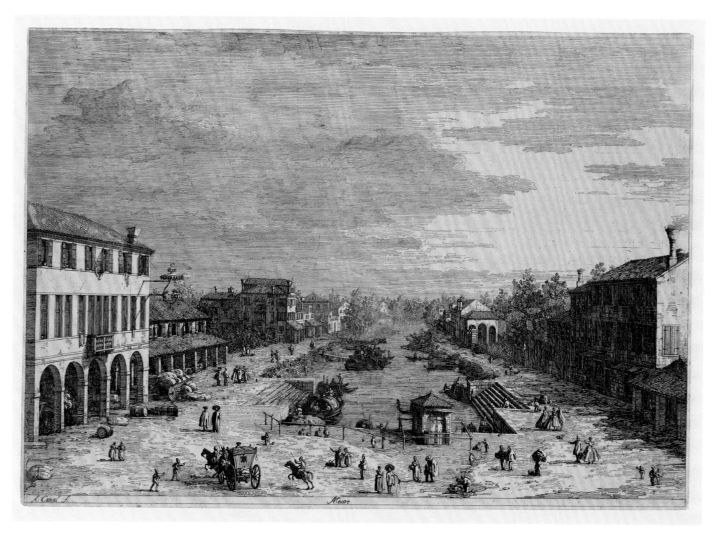

PL. 3.
**GIOVANNI ANTONIO CANAL, CALLED
CANALETTO**, *Mestre*, from *Vedute*
(Views), 1741–44

90 *Collection Highlights*

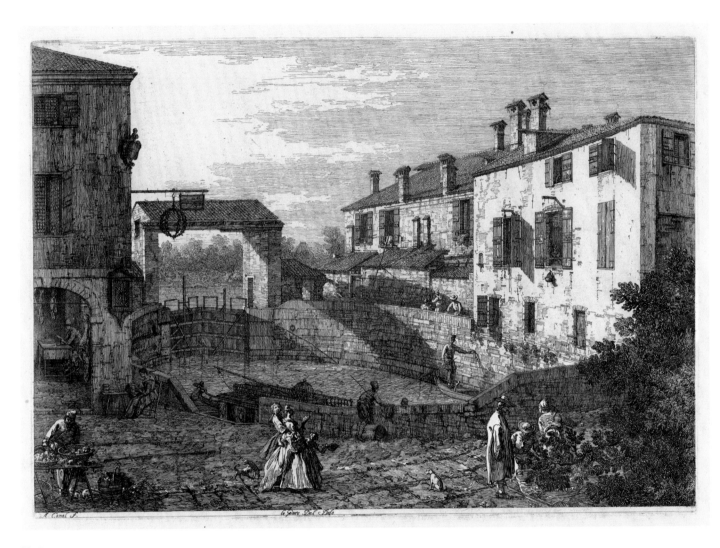

PL. 4.
**GIOVANNI ANTONIO CANAL, CALLED
CANALETTO**, *Le porte del Dolo (The Locks
of Dolo)*, from *Vedute* (Views), 1741–44

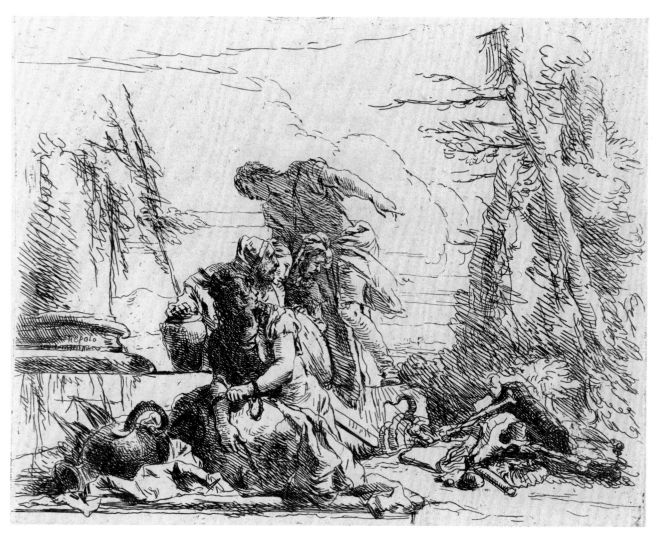

PL. 5.

GIOVANNI BATTISTA TIEPOLO,
*A Woman with Her Arms in Chains and
Four Other Figures,* from *Vari capricci*
(Various Capriccios), 1740–42

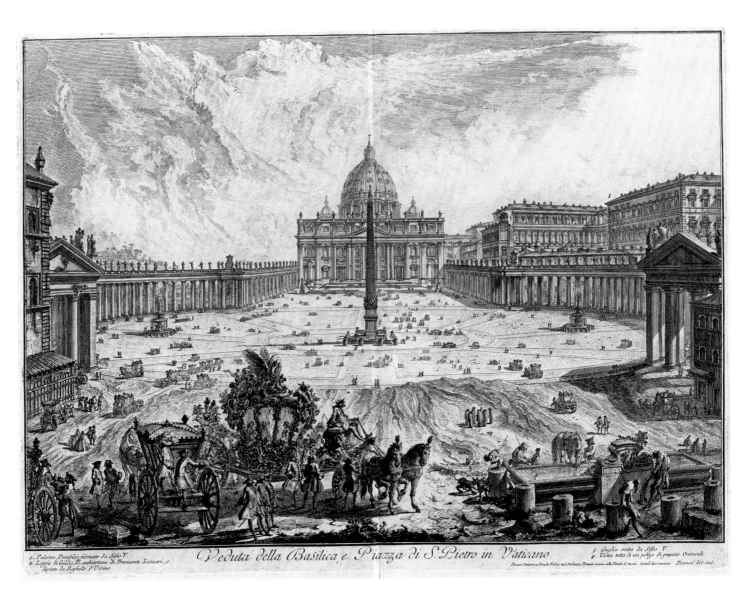

Veduta della Basilica, e Piazza di S. Pietro in Vaticano

PL. 6.

GIOVANNI BATTISTA PIRANESI, *Veduta della Basilica, e Piazza di S. Pietro in Vaticano* (View of the Basilica, and Piazza of Saint Peter's in the Vatican), from *Vedute di Roma* (Views of Rome), 1748

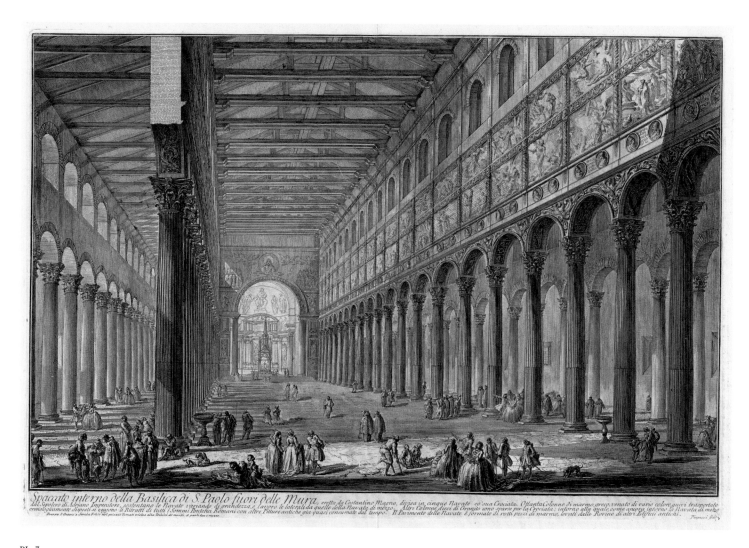

GIOVANNI BATTISTA PIRANESI, *Spaccato interno della Basilica di S. Paolo fuori delle Mura . . .* (Cross-Section of the Interior of the Basilica of San Paolo fuori delle Mura . . .), from *Vedute di Roma* (Views of Rome), 1749

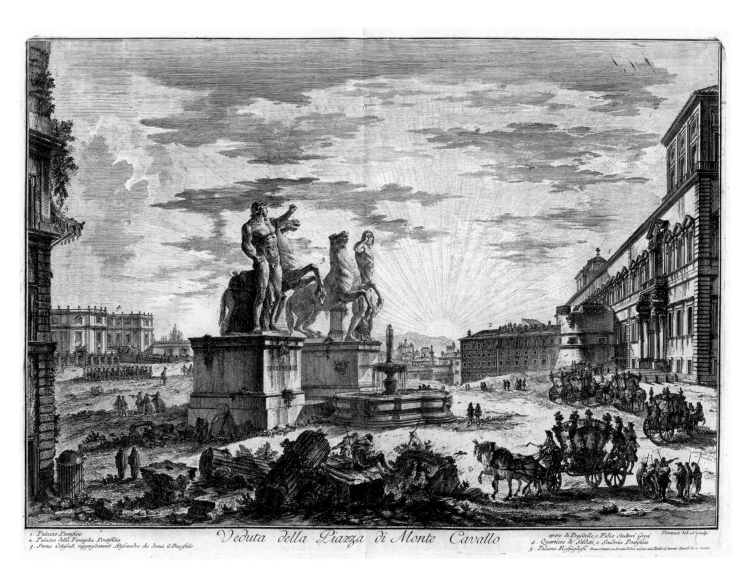

Veduta della Piazza di Monte Cavallo

PL. 8.

GIOVANNI BATTISTA PIRANESI, *Veduta della Piazza di Monte Cavallo* (View of the Piazza di Monte Cavallo [now the Piazza del Quirinale with the Quirinal Palace]), from *Vedute di Roma* (Views of Rome), 1750

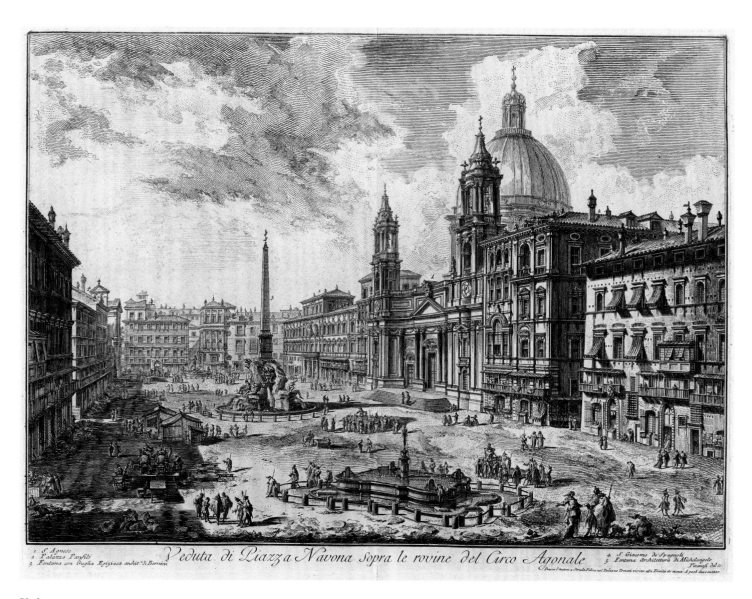

PL. 9.

GIOVANNI BATTISTA PIRANESI, *Veduta di Piazza Navona sopra le rovine del Circo Agonale* (View of the Piazza Navona above the Ruins of the Circus of Domitian), from *Vedute di Roma* (Views of Rome), 1751

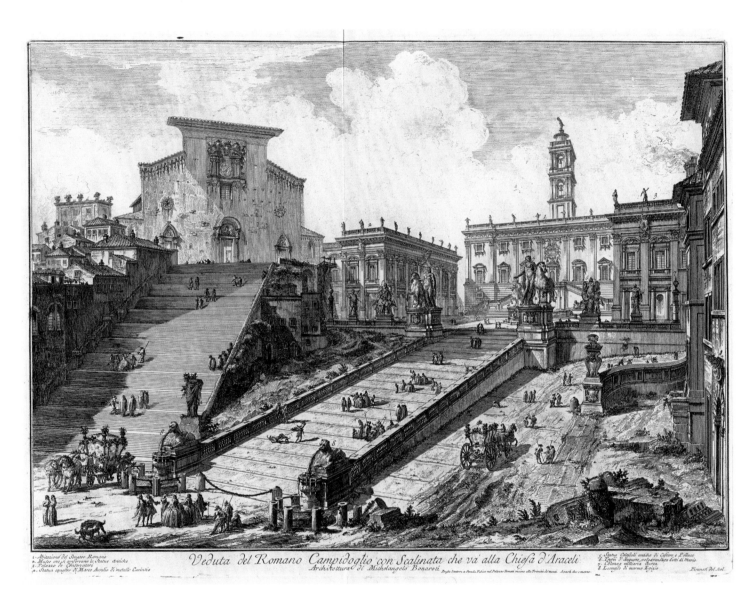

Veduta del Romano Campidoglio con Scalinata che va' alla Chiesa d'Araceli
Architettura di Michelangelo Bonaroti.

PL. 10.

GIOVANNI BATTISTA PIRANESI,
Veduta del Romano Campidoglio con scalinata che va' alla Chiesa d'Araceli (View of the Capitoline Hill with the Steps That Go to the Church of [Santa Maria] d'Aracoeli), from *Vedute di Roma* (Views of Rome), 1757?

Colonna Antonina

PL. 11.

GIOVANNI BATTISTA PIRANESI,
Colonna Antonina (Column of Marcus
Aurelius), from *Vedute di Roma* (Views
of Rome), 1758

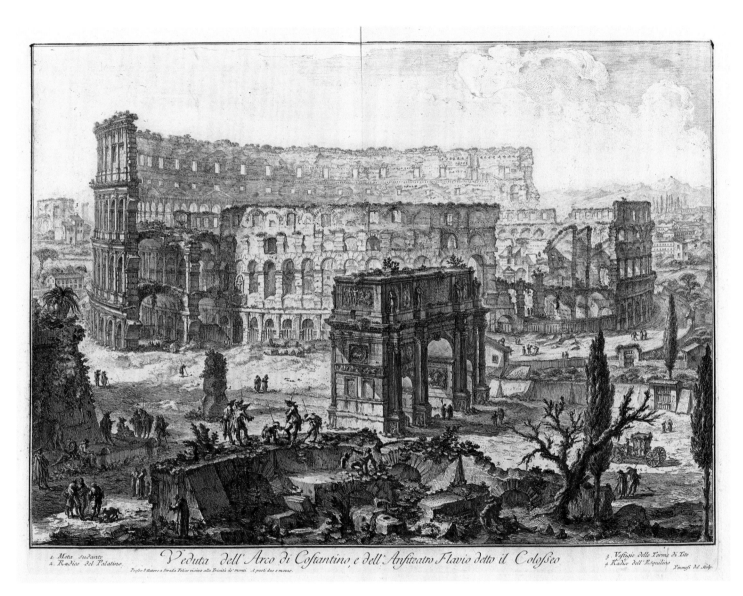

1. Meta Sudans
2. Radice del Palatino

Veduta dell'Arco di Costantino, e dell'Anfiteatro Flavio detto il Colosseo

Preßo l'Autore a Strada Felice vicino alla Trinità de' monti A paoli due e mezzo

3. Vestigie delle Terme di Tito
4. Radice dell'Esquilino

Piranesi del Scolp.

PL. 12.

GIOVANNI BATTISTA PIRANESI,
*Veduta dell'Arco di Constantino, e
dell'Anfiteatro Flavio detto il Colosseo*
(View of the Arch of Constantine,
and the Flavian Amphitheater, called
the Colosseum), from *Vedute di Roma*
(Views of Rome), 1760

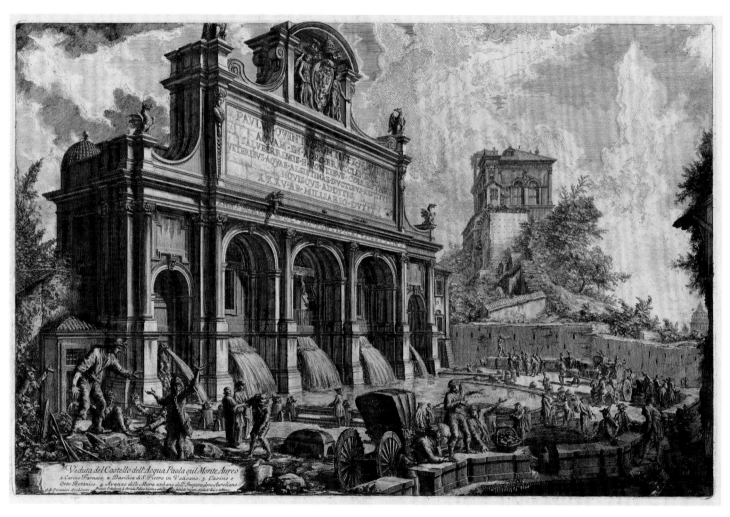

PL. 13.

GIOVANNI BATTISTA PIRANESI, *Veduta del Castello dell'Acqua Paola sul Monte Aureo* (View of the Fountainhead of the Acqua Paola on Monte Aureo), from *Vedute di Roma* (Views of Rome), 1751

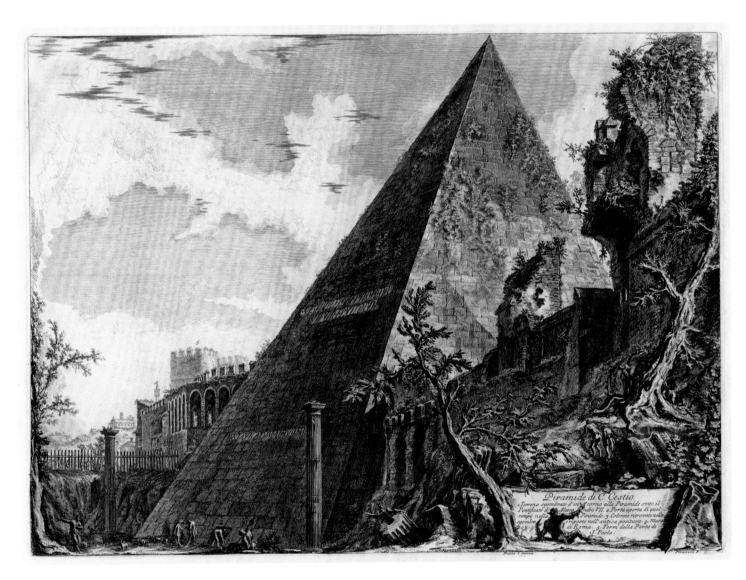

PL. 14.

GIOVANNI BATTISTA PIRANESI,
Piramide di C. Cestio (Pyramid of Gaius
Cestius), from *Vedute di Roma* (Views of
Rome), 1756

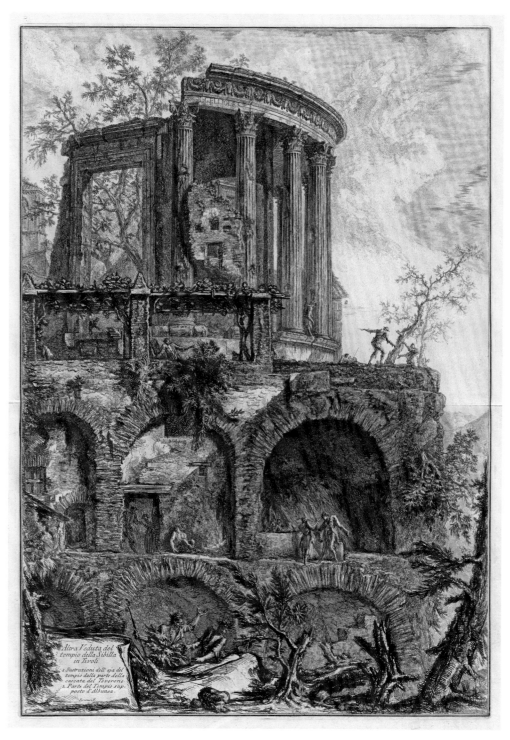

PL. 15.

GIOVANNI BATTISTA PIRANESI, *Altra veduta del Tempio della Sibilla in Tivoli* (Another View of the Temple of the Sibyl in Tivoli), from *Vedute di Roma* (Views of Rome), 1761

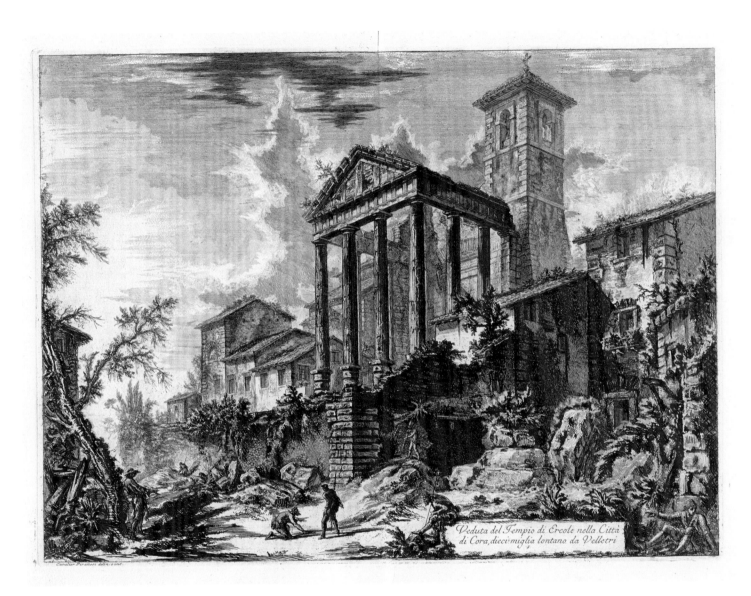

PL. 16.

GIOVANNI BATTISTA PIRANESI,
*Veduta del Tempio di Ercole nella città
di Cora, dieci miglia lontano da Velletri*
(View of the Temple of Hercules at Cori,
Ten Miles Distant from Velletri), from
Vedute di Roma (Views of Rome), 1769

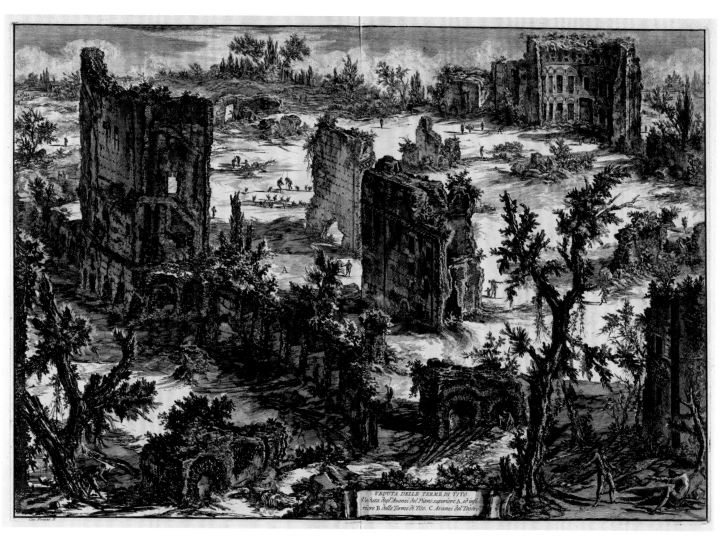

PL. 17.

GIOVANNI BATTISTA PIRANESI,
Veduta delle Terme di Tito (View of the
Baths of Titus), from *Vedute di Roma*
(Views of Rome), 1775

PL. 18.

GIOVANNI BATTISTA PIRANESI, *Letter P*, page 1 from
volume 1 of *Antichità romane* (Roman Antiquities), 1756

PL. 19.

GIOVANNI BATTISTA PIRANESI, *Stylobata columnae cochliodis Imp. Caes. M. Aurelii
Antonini Pii . . .* (Base of the Spiral Column of the Emperor Marcus Aurelius . . .), page 69
from *Il Campo Marzio dell'antica Roma* (The Campus Martius of Ancient Rome), 1762

C. Latus Stylobatae columnae apotheoseos Antonini Pii, et Faustinae, posticum lateri A praecedentis tabulae. D. Alterum Latus, posticum lateri B, in praecedente tabula item demonstrato, dexterumque lateri C. E. Tessellae recens factae ad resarciendum Stylobatam.

Piranesi F.

PL. 20.

GIOVANNI BATTISTA PIRANESI, *Latus Stylobatae columnae apotheoseos Antonini Pii, et Faustinae . . .*
(Base of the Column of the Apotheosis of Antoninus Pius and Faustina . . .), plate 33 from *Il Campo Marzio dell'antica Roma* (The Campus Martius of Ancient Rome), 1762

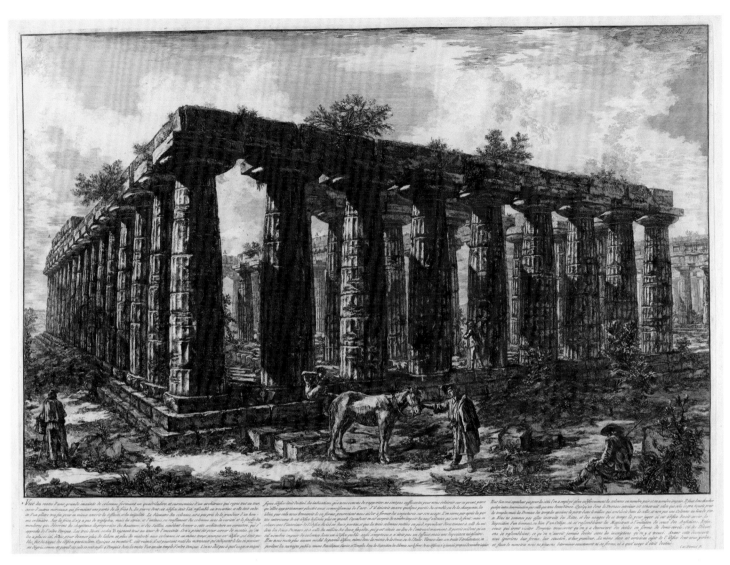

PL. 21.

GIOVANNI BATTISTA PIRANESI, *Vuë des restes d'une grande enceinte de colonnes* . . . (View Showing the Remains of a Large Enclosure of Columns . . .), from *Différentes vues de* . . . *Pesto* (Different Views of . . . Paestum), 1778–79

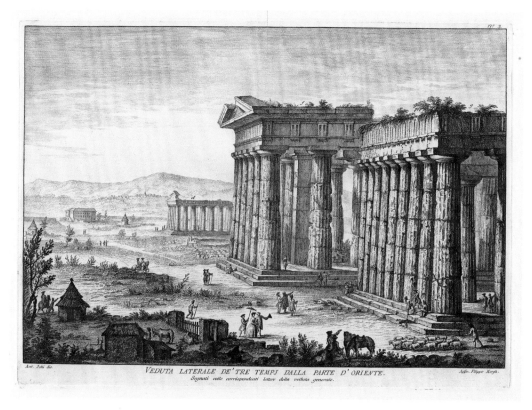

VEDUTA LATERALE DE' TRE TEMPJ DALLA PARTE D' ORIENTE.
Segnati colle corrispondenti lettere della veduta generale.

PL. 22.

FILIPPO MORGHEN, AFTER ANTONIO JOLI, *Veduta laterale de' tre tempj dalla parte d'oriente* (Side View of the Three Temples from the East), from *Antichità di Pesto* (Antiquities of Paestum), 1765

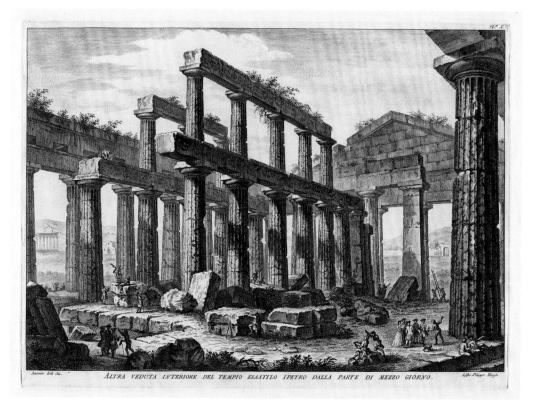

ALTRA VEDUTA INTERIORE DEL TEMPIO ESASTILO IPETRO DALLA PARTE DI MEZZO GIORNO.

PL. 23.

FILIPPO MORGHEN, AFTER ANTONIO JOLI, *Altra veduta interiore del tempio esastilo ipetro dalla parte di mezzo giorno* (Another Interior View of the Hexastyle Hypaethral Temple from the South), from *Antichità di Pesto* (Antiquities of Paestum), 1765

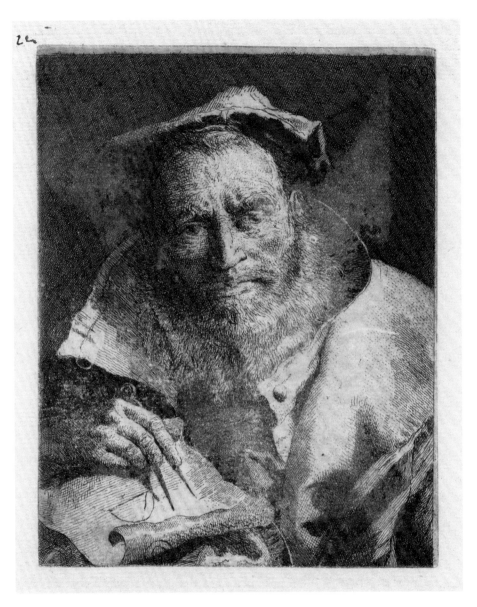

PL. 24.
GIOVANNI DOMENICO TIEPOLO,
AFTER GIOVANNI BATTISTA TIEPOLO,
The Mathematician, from *Raccolta di teste*
(Collection of Heads), ca. 1757

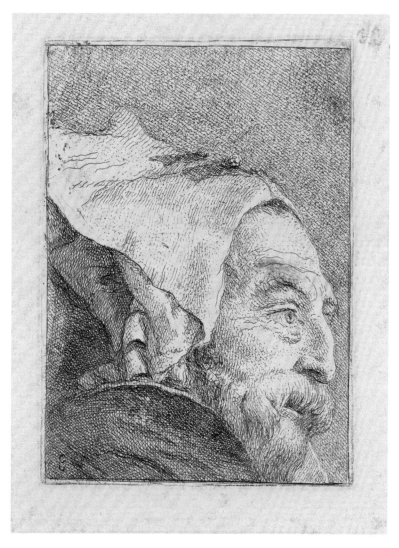

PL. 25.
**GIOVANNI DOMENICO TIEPOLO,
AFTER GIOVANNI BATTISTA
TIEPOLO,** *Profile of an Old Man*, from
Raccolta di teste (Collection of Heads),
ca. 1771–74

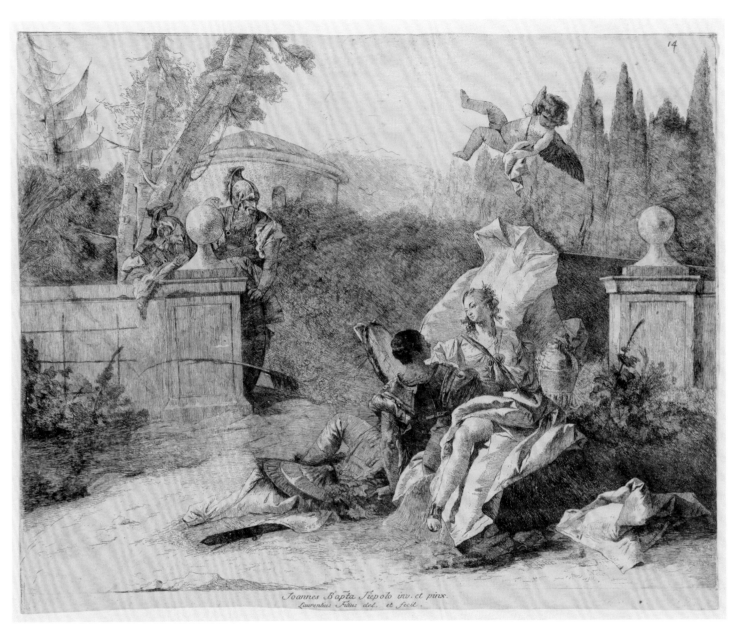

PL. 26.
LORENZO BALDISSERA TIEPOLO, AFTER
GIOVANNI BATTISTA TIEPOLO, *Rinaldo and*
Armida, ca. 1758

Fuoco artificiale detto la Girandola
Che s'incendia sul Castel S. Angelo già Mausoleo d'Elio Adriano

PL. 27.

FRANCESCO PIRANESI, AFTER LOUIS-JEAN DESPREZ, *Fuoco artificiale detto la girandola che s'incendia sul Castel S. Angelo già Mausoleo d'Elio Adriano* (Fireworks known as the *Girandola,* Which Explode above the Castel Sant'Angelo formerly the Mausoleum of Hadrian), ca. 1790

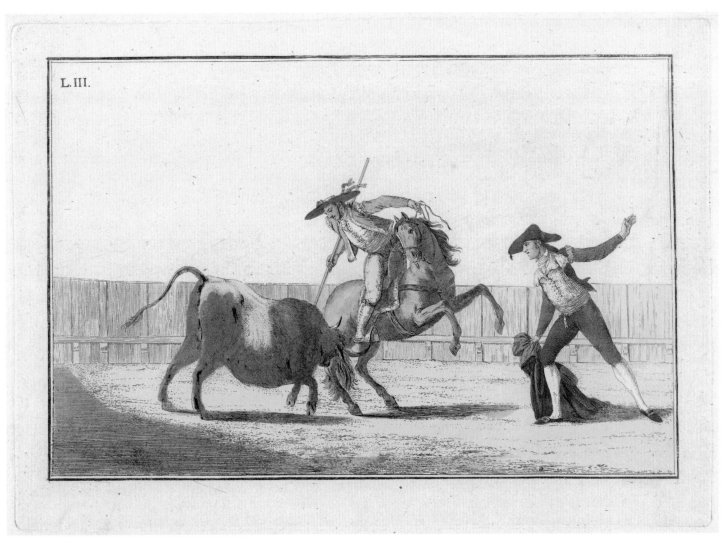

PL. 28.
ANTONIO CARNICERO, plate 3 from
Colección de las principales suertes de una
corrida de toros (Collection of the Main
Actions in a Bullfight), 1790

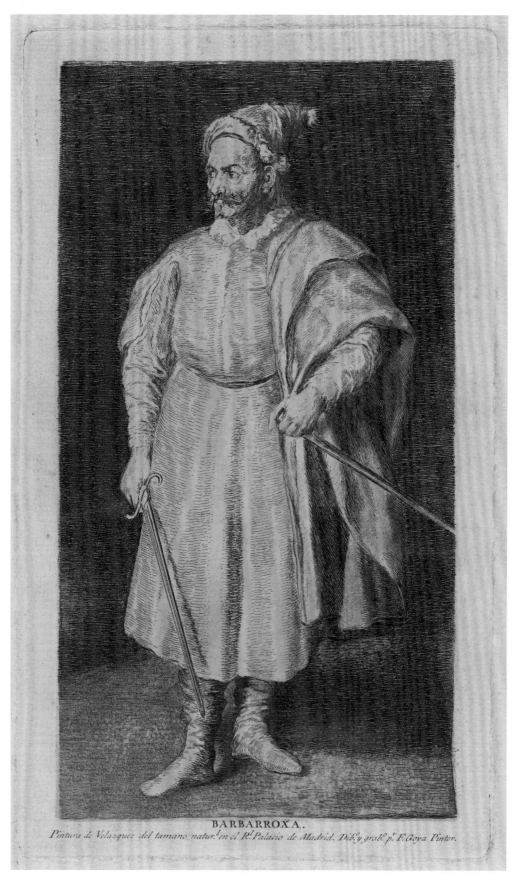

BARBARROXA.

Pintura de Velazquez del tamaño natur.¹ en el R.¹ Palacio de Madrid. Dib.º y grab.º p.ʳ F. Goya Pintor.

PL. 29.
FRANCISCO GOYA, AFTER DIEGO VELÁZQUEZ, *Barbarroxa*, 1778

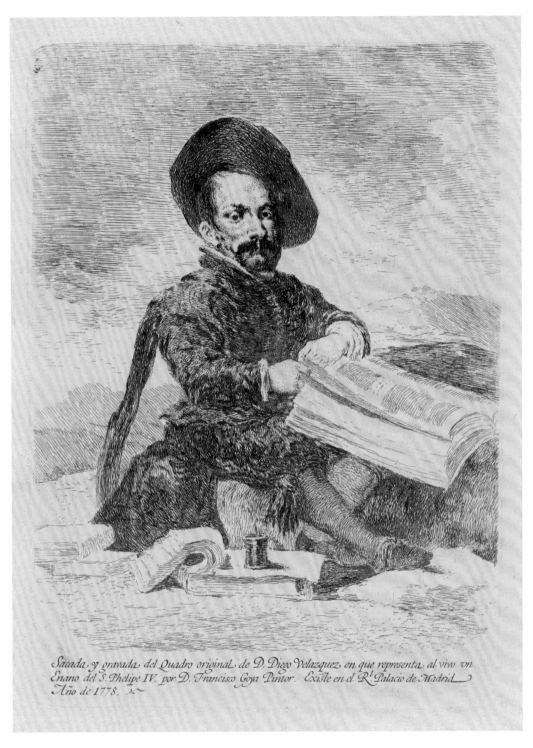

Sacada y gravada del Quadro original de D. Diego Velazquez en que representa al vivo un Enano del S. Phelipe IV. por D. Francisco Goya Pintor. Existe en el R.l Palacio de Madrid Año de 1778.

PL. 30.
FRANCISCO GOYA, AFTER DIEGO VELÁZQUEZ, *Un enano* (A Dwarf), 1778–79

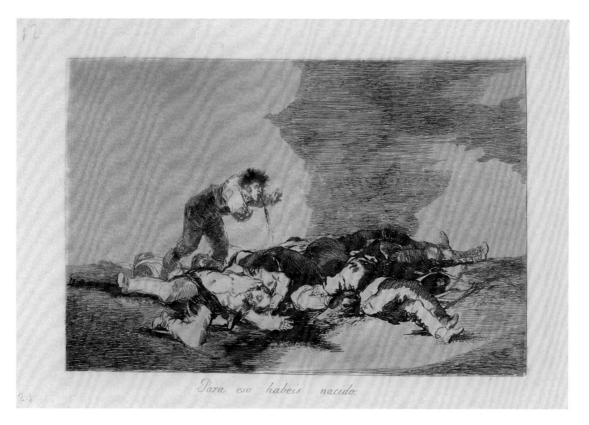

PL. 31.
FRANCISCO GOYA, *Para eso habeis nacido* (This Is What
You Were Born For), plate 12 from *Los desastres de la guerra*
(The Disasters of War), ca. 1810–11, published 1863

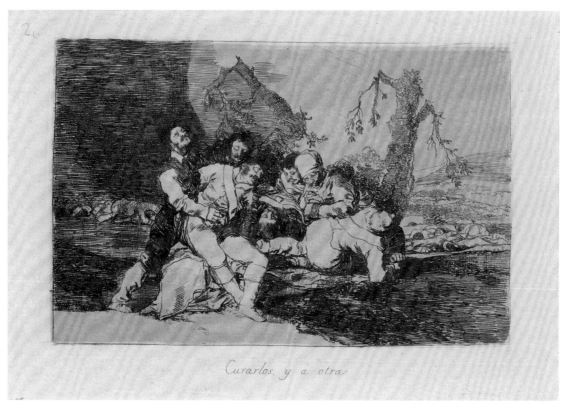

PL. 32.
FRANCISCO GOYA, *Curarlos, y á otra* (Get Them Well, and
on to the Next), plate 20 from *Los desastres de la guerra*
(The Disasters of War), 1810, published 1863

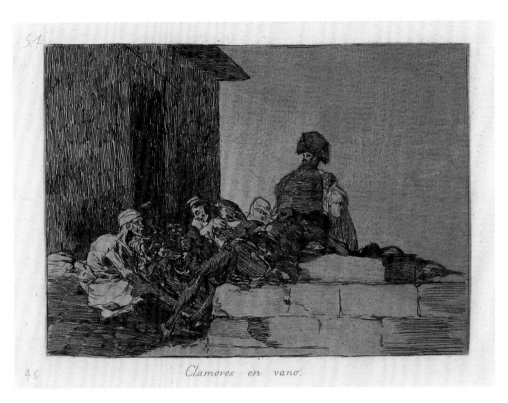

PL. 33.

FRANCISCO GOYA, *Clamores en vano* (Appeals Are in Vain),
plate 54 from *Los desastres de la guerra* (The Disasters of
War), ca. 1812, published 1863

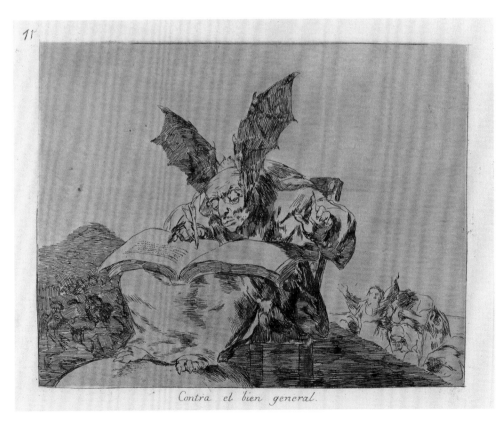

PL. 34.

FRANCISCO GOYA, *Contra el bien general* (Against the
Common Good), plate 71 from *Los desastres de la guerra*
(The Disasters of War), ca. 1813–14, published 1863

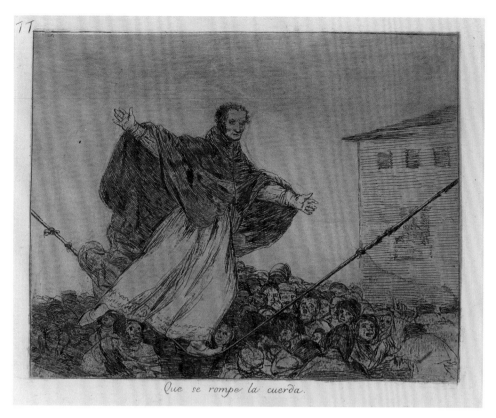

PL. 35.

FRANCISCO GOYA, *Que se rompe la cuerda* (May the Cord Break),
plate 77 from *Los desastres de la guerra* (The Disasters of War),
ca. 1813–14, published 1863

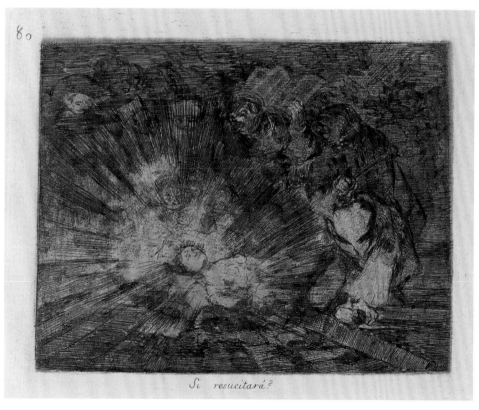

PL. 36.

FRANCISCO GOYA, *Si resucitará?* (Will She Rise Again?),
plate 80 from *Los desastres de la guerra* (The Disasters of
War), ca. 1813–14, published 1863

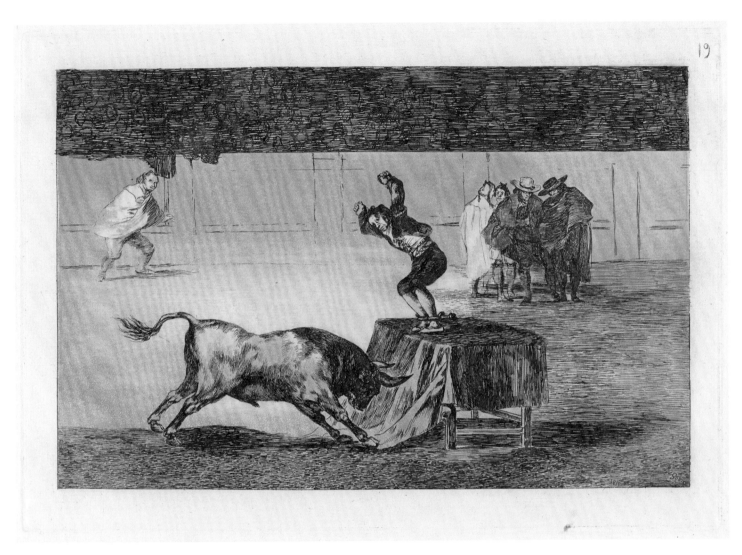

PL. 37.

FRANCISCO GOYA, *Otra locura suya
en la misma plaza* (Another Madness
of His in the Same Ring), plate 19
from *La tauromaquia* (The Art of
Bullfighting), 1815, published 1816

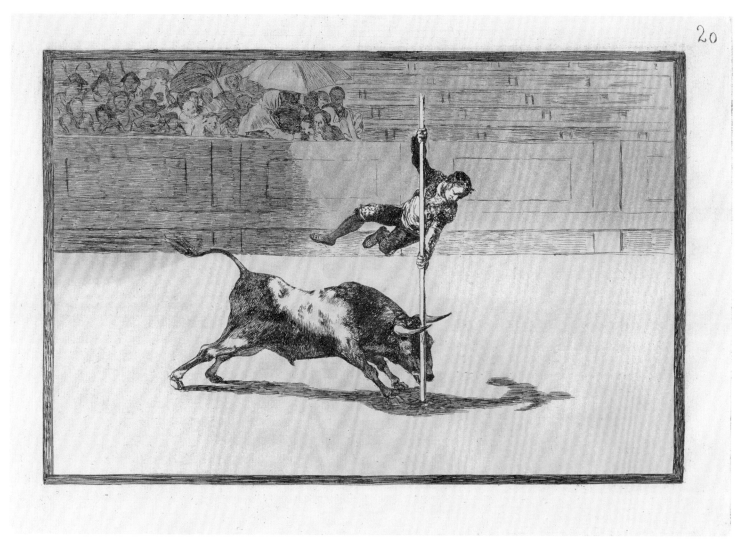

PL. 38.

FRANCISCO GOYA, *Ligereza y atrevimiento de Juanito Apiñani en la de Madrid* (The Agility and Audacity of Juanito Apiñani in the [Ring] at Madrid), plate 20 from *La tauromaquia* (The Art of Bullfighting), 1816, published 1816

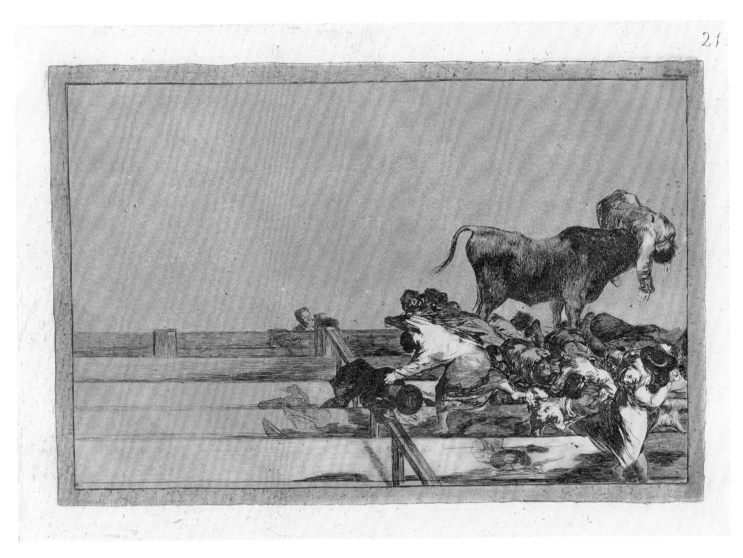

PL. 39.
FRANCISCO GOYA, *Desgracias acaecidas
en el teniendo de la plaza de Madrid, y
muerte del alcalde de Torrejon* (Dreadful
Events in the Front Rows of the Ring
at Madrid, and Death of the Mayor of
Torrejon), plate 21 from *La tauromaquia*
(The Art of Bullfighting), 1816,
published 1816

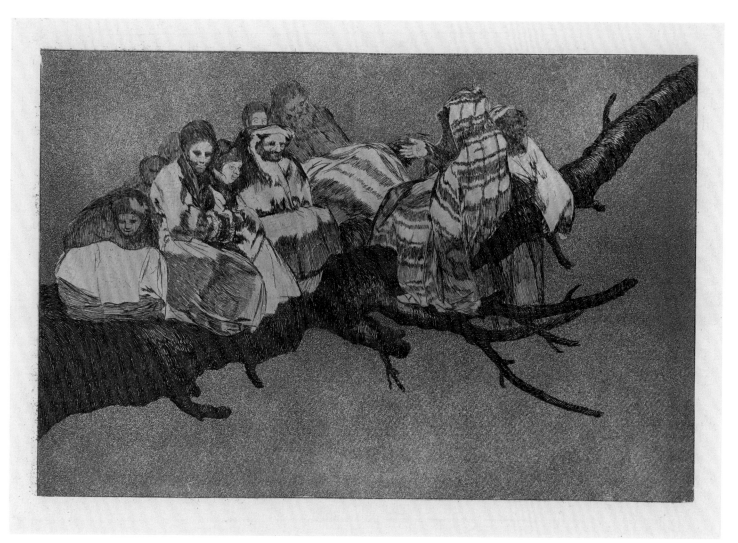

PL. 40.

FRANCISCO GOYA, *Disparate ridiculo* (Ridiculous Folly), also known as *Andarse por las ramas* (To Go among the Branches), from *Los disparates* (*Los proverbios*) (Follies [Proverbs]), ca. 1816–19, published 1864

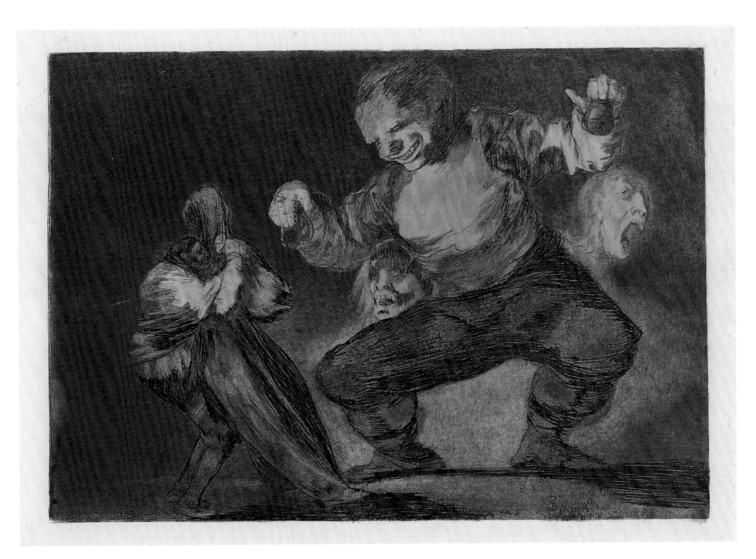

PL. 41.
FRANCISCO GOYA, *Bobalicón*
(Simpleton), also known as *Tras el vicio*
viene el fornicio (After Vice Comes
Fornication), from *Los disparates*
(Los proverbios) (Follies [Proverbs]),
ca. 1816–19, published 1864

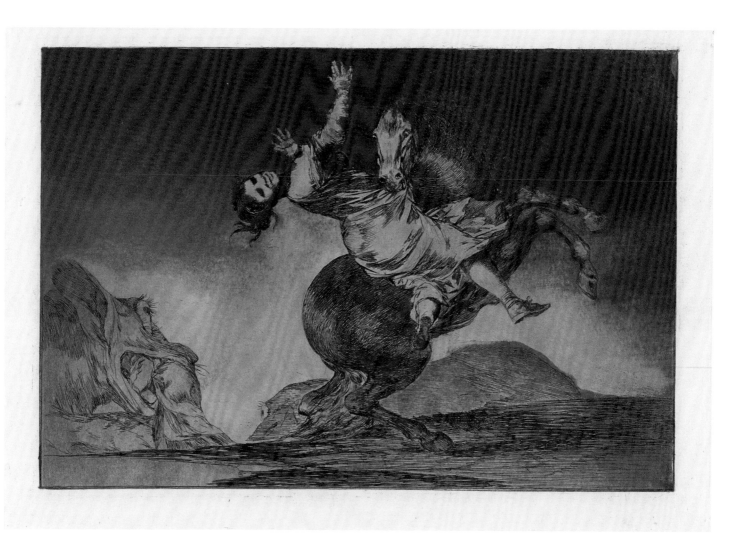

PL. 42.

FRANCISCO GOYA, *El caballo raptor*
(The Horse Abductor), also known as
La mujer y el potro, que los dome otro
(A Woman and a Horse, Let Someone
Else Master Them), from *Los disparates
(Los proverbios)* (Follies [Proverbs]),
ca. 1816–19, published 1864

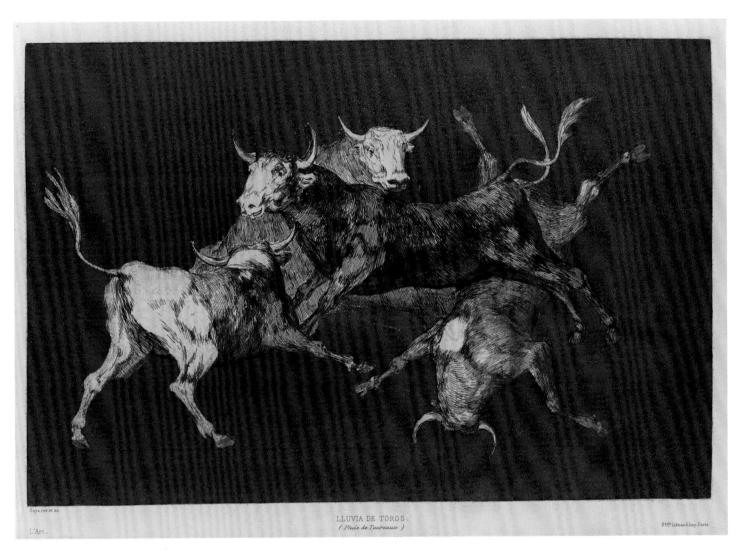

LLUVIA DE TOROS.
(Pluie de taureaux)

PL. 43.

FRANCISCO GOYA, *Disparate de tontos (or toritos)* (Fools'—or Little Bulls'— Folly), also known as *Al toro y al aire darles calle* (Make Way for Bulls and Wind), published in *L'art* as *Lluvia de toros (Pluie de taureaux)* (Rain of Bulls), ca. 1816–19, published 1877

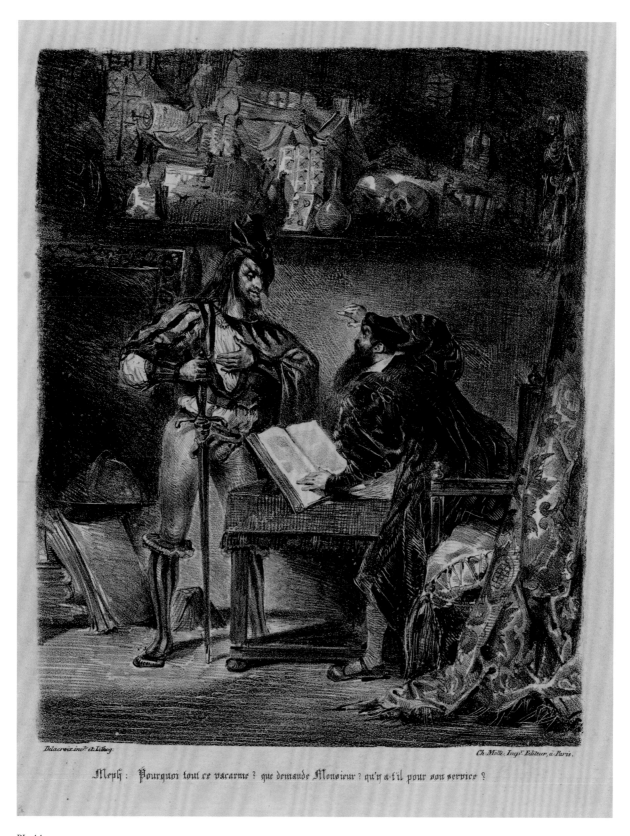

Meph: Pourquoi tout ce vacarme ? que demande Monsieur ? qu'n a-t-il pour son service ?

PL. 44.

EUGÈNE DELACROIX, *Méphistophélès apparaissant à Faust* (Mephistopheles Appearing to Faust), from Johann Wolfgang von Goethe's *Faust*, 1827, published 1828

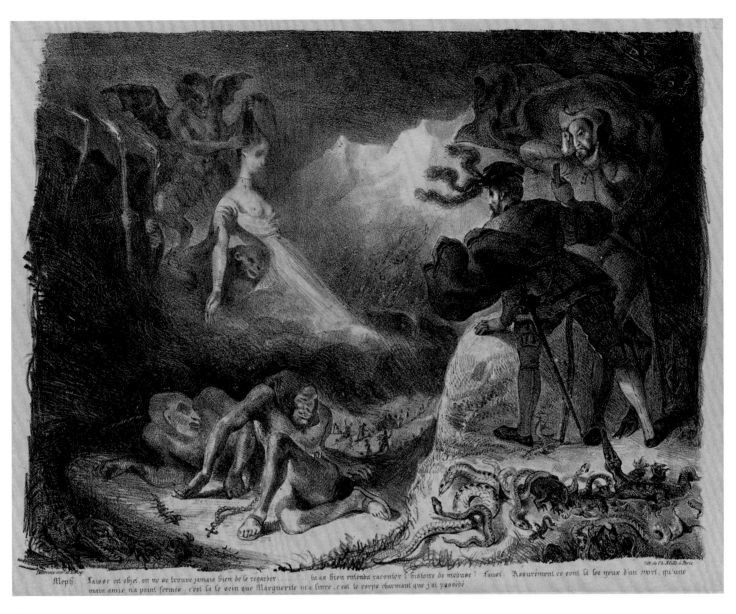

PL. 45.
EUGÈNE DELACROIX, *L'ombre de Marguerite apparaissant à Faust* (Marguerite's Ghost Appearing to Faust), from Johann Wolfgang von Goethe's *Faust*, 1827, published 1828

Je suis l'esprit de ton père ! Venge le d'un meurtre infâme et dénaturé.

PL. 46.
EUGÈNE DELACROIX, *Le fantôme sur la
terrasse* (The Ghost on the Terrace), Act 1,
Scene 5, from William Shakespeare's
Hamlet, 1843, published 1843

............Ses vêtements appesantis et trempés d'eau ont entrainé la pauvre malheureuse.

PL. 47.
EUGÈNE DELACROIX, *Mort d'Ophélie*
(Death of Ophelia), Act 4, Scene 7, from
William Shakespeare's *Hamlet*, 1843,
published 1843

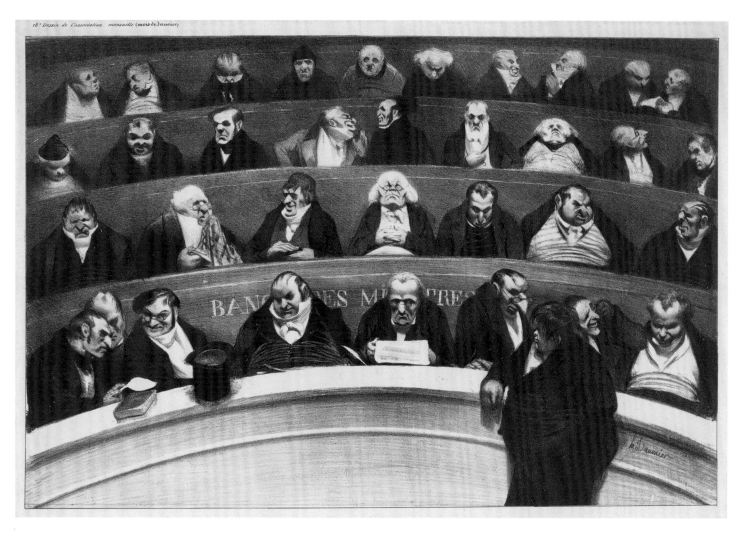

PL. 48.
HONORÉ DAUMIER, *Le ventre législatif*
(The Legislative Belly), 1834

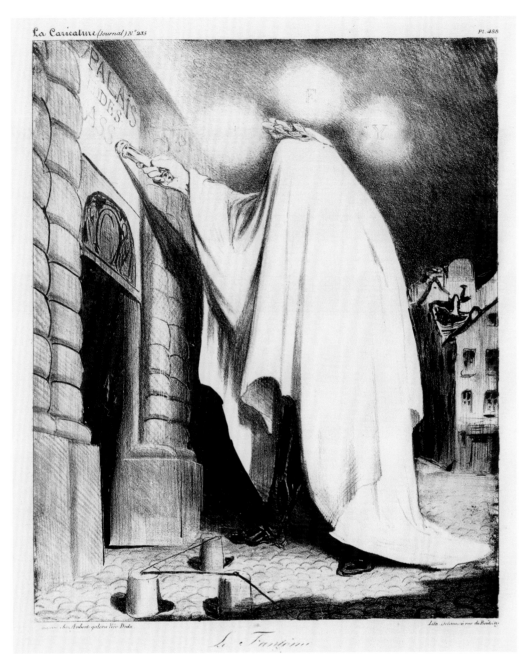

PL. 49.
HONORÉ DAUMIER, *Le fantôme*
(The Phantom), 1835

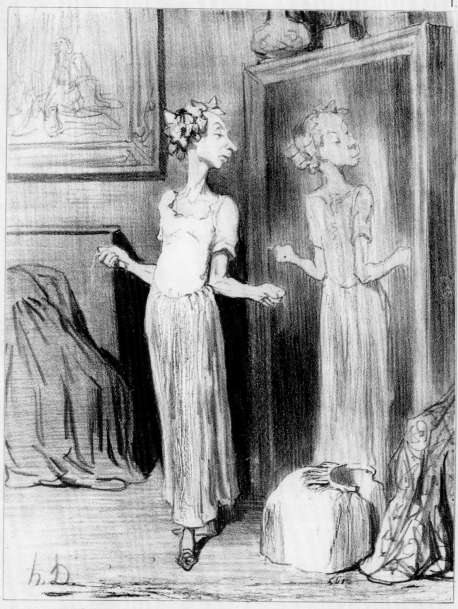

PL. 50.

HONORÉ DAUMIER, *C'est singulier comme ce miroir m'applatit la taille et me maigrit la poitrine!... Que m'importe?... Mme de Staël et Mr de Buffon l'ont proclamé:... **le génie n'a point de sexe** (It's curious how this mirror flattens my figure and slims my bust! ... What do I care?... Mme de Staël and M. de Buffon proclaimed it:... *Genius has no sex*), from *Les bas-bleus* (The Bluestockings), 1844

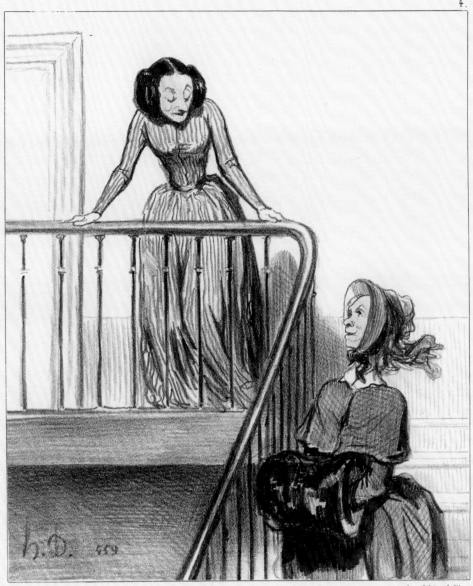

PL. 51.

HONORÉ DAUMIER, *Au revoir, Ophélia! . . . ne manquez pas de venir mardi soir . . . c'est une réunion littéraire en petit comité . . . nous lirons des élégies et nous ferons du bischoff! . . .* (Farewell, Ophélia! . . . and be sure to come Tuesday evening . . . it's a literary meeting of a select group . . . we'll read elegies and make mulled wine! . . .), from *Les bas-bleus* (The Bluestockings), 1844

Chez Aubert, Pl. de la Bourse, 29.

Imp. d'Aubert & Cⁱᵉ.

Comment! encore une caricature sur nous, ce matin, dans le **Charivari**!... ah! jour de ma vie! j'espère bien que cette fois c'est la dernière!... et si jamais ce Daumier me tombe sous la main, il lui en coutera cher pour s'etre permis de tricoter des **Bas bleus**.

PL. 52.

HONORÉ DAUMIER, *Comment! encore une caricature sur nous, ce matin, dans le **Charivari**!... ah! jour de ma vie! j'espère bien que cette fois c'est la dernière!... et si jamais ce Daumier me tombe sous la main, il lui en coutera cher pour s'être permis de tricoter des **Bas bleus*** (How could it be! another caricature about us, this morning, in *Charivari*!... ah, my days! I hope that this time it's the last!... and if ever I get my hands on this Daumier, it will cost him dearly to have allowed himself to knit up some *Bluestockings*), from *Les bas-bleus* (The Bluestockings), 1844

_ En Chemin de Fer _ Un Voisin agréable.

PL. 53.
HONORÉ DAUMIER, *En chemin de fer _
Un voisin agréable* (On the Railway _
A Pleasant Neighbor), 1862

PL. 54.

JEAN-BAPTISTE-CAMILLE COROT,
Le grand cavalier sous bois (The Large Rider
in the Woods), 1854

PL. 55.
JEAN-BAPTISTE-CAMILLE COROT,
Le dormoir des vaches (The Cow Pasture), 1871

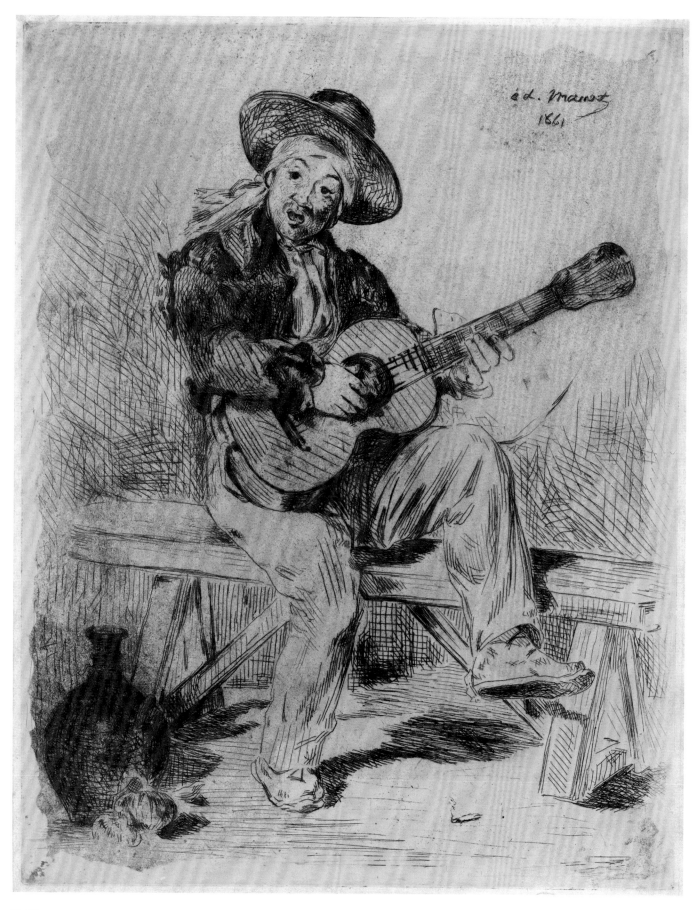

PL. 56.
ÉDOUARD MANET, *The Spanish Singer,* 1861

Imp. Lemercier & C.ᵉ Paris.

Féroce & rose avec du feu dans sa prunelle,
Effronté, saoul, divin, c'est lui Polichinelle!

Théodore de Banville.

PL. 57.
ÉDOUARD MANET, *Polichinelle*, 1874–76

PL. 58.

ÉDOUARD MANET, *The Raven on the Bust of
Pallas,* from Edgar Allan Poe's *The Raven,* 1875

PL. 59.
ÉDOUARD MANET, *The Chair*, from
Edgar Allan Poe's *The Raven*, 1875

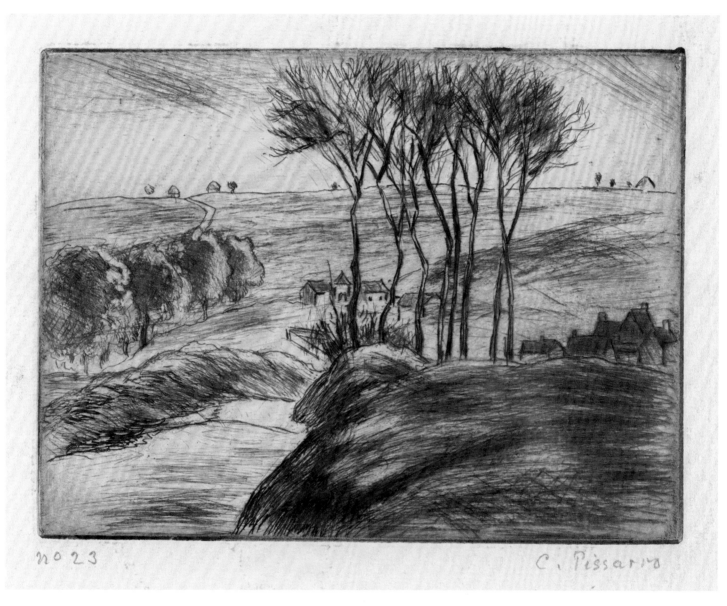

PL. 60.

CAMILLE PISSARRO,
Landscape at Osny, 1887, printed 1894

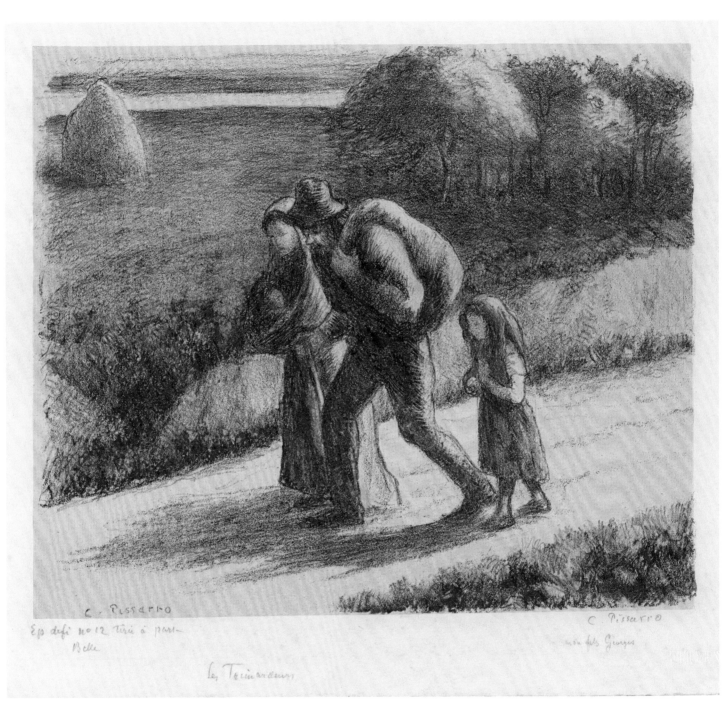

PL. 61.

CAMILLE PISSARRO,
The Vagabonds, 1896

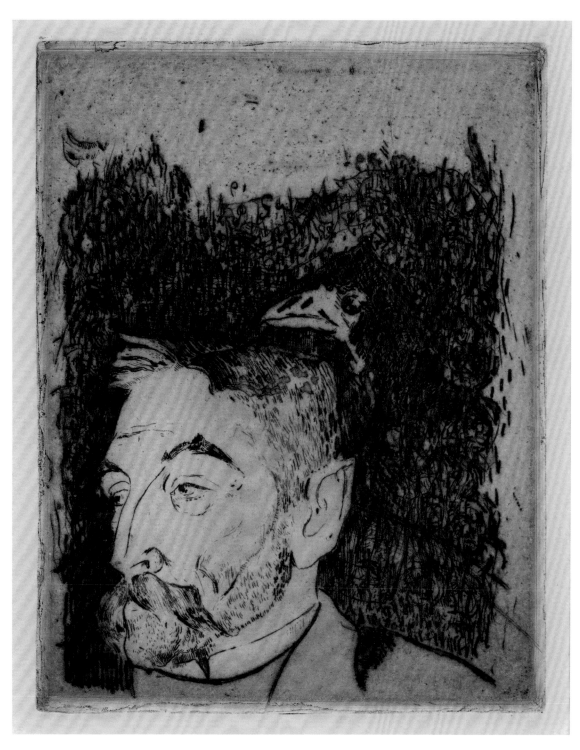

PL. 62.
PAUL GAUGUIN, *Portrait of Stéphane Mallarmé*, 1891

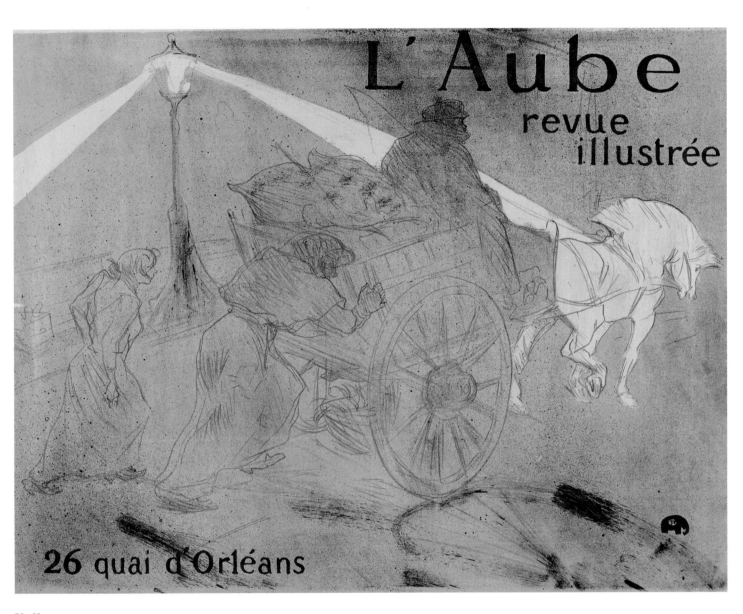

PL. 63.
HENRI DE TOULOUSE-LAUTREC,
cover of *L'aube* (Dawn), 1896

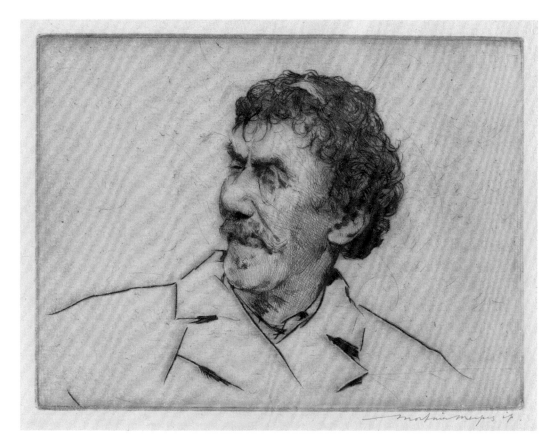

PL. 64.
MORTIMER MENPES, *Whistler, Looking Right,*
Monocle Left Eye, 1902–3

PL. 65.
MORTIMER MENPES, *The Piazza of St. Mark,*
Venice, 1910–11

PL. 66.
**ÉDOUARD VUILLARD, AFTER PAUL
CÉZANNE,** *Portrait of Paul Cézanne,*
1914

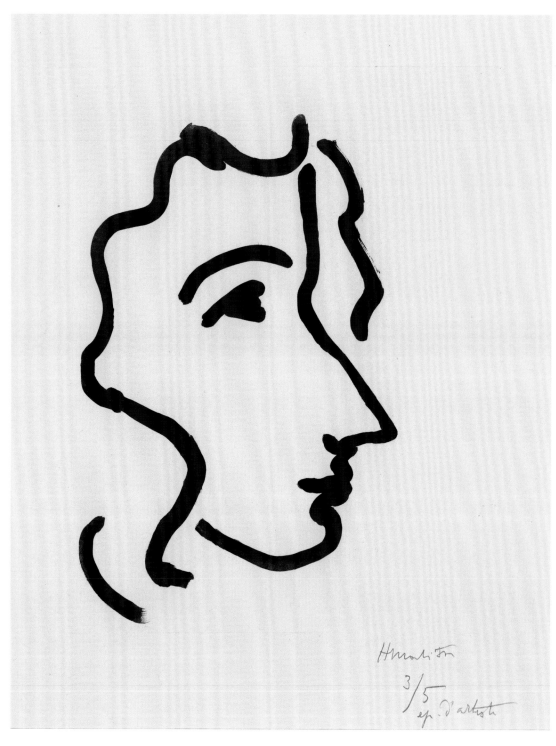

PL. 67.
HENRI MATISSE, *Nadia in Sharp Profile*, 1948

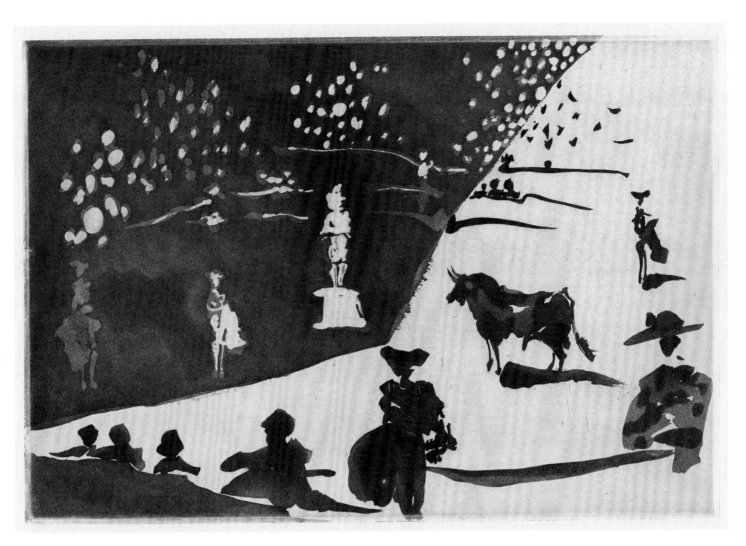

PL. 68.
PABLO PICASSO, *Suerte llamada de Don Tancredo* (Don Tancredo Says Good Luck), from *La tauromaquia* (The Art of Bullfighting), 1957, published 1959

PL. 69.

MARVIN E. NEWMAN, *Site of the Philip Morris Building
under Construction at the Southwest Corner of 42nd Street
and Park Avenue, opposite Grand Central Station,* from
Open Spaces, Temporary and Accidental, 1979

PL. 70.
MARVIN E. NEWMAN, *Roadways Leading to the Brooklyn Bridge with the World Trade Center Towers and Woolworth Building in the Distance,* from *Open Spaces, Temporary and Accidental,* 1970s

Collection Checklist

Reader's Note

In general, in this checklist titles inscribed on prints have been transcribed exactly and retain the capitalization used. Titles of Delacroix's illustrations for Goethe's *Faust* (2012.159.54.1–.18) and Shakespeare's *Hamlet* (2012.159.56.1–.13), however, follow those in Delteil; translations of Goya's works follow Harris; Menpes titles follow Morgan; and Piranesi titles, translations, and states, and the order of the *Vedute* follow Wilton-Ely. Unless otherwise noted, dimensions for etchings, engravings, and drypoint are those of the plate; for lithographs, screenprints, woodcuts, photographs, and *clichés-verre*, the image; and for drawings, the sheet.

Abbreviations

ADHÉMAR AND CACHIN. Adhémar, Jean, and Françoise Cachin. *Degas: The Complete Etchings, Lithographs, and Monotypes.* New York: Viking Press, 1974.

BROMBERG. Bromberg, Ruth. *Canaletto's Etchings: Revised and Enlarged Edition of the Catalogue Raisonné.* San Francisco: Alan Wofsy Fine Arts, 1993.

CALABI AND DE VESME. Calabi, Augusto, and Alessandro Baudi de Vesme. *Francesco Bartolozzi.* Milan: Guido Modiano, 1928.

CHERPIN. Cherpin, Jean. *L'oeuvre gravé de Cézanne.* Bulletin 82. Marseille, France: Arts et Livres de Provence, 1972.

CLÉMENT-JANIN. Clément-Janin, Nöel. *La curieuse vie de Marcellin Desboutin: Peintre, graveur, poète.* Paris: H. Floury, 1922.

DELTEIL. Delteil, Loys. *Le peintre-graveur illustré.* 32 vols. 1906–26; reprint, New York: Collectors Editions Ltd. and Da Capo Press, 1969.

DELTEIL-HYMAN 1999a. Delteil, Loys. *Camille Pissarro: L'oeuvre gravé et lithographié, The Etchings and Lithographs, Catalogue Raisonné.* Ed. Alan Hyman, supplemented by Jean Cailac. 1923; revised ed., San Francisco: Alan Wofsy Fine Arts, 1999.

DELTEIL-HYMAN 1999b. Delteil, Loys. *Pierre-Auguste Renoir: L'oeuvre gravé et lithographié.* Ed. Alan Hyman. 1923; revised ed., San Francisco: Alan Wofsy Fine Arts, 1999.

DELTEIL-STRAUBER. Delteil, Loys. *Delacroix: The Graphic Work, A Catalogue Raisonné.* Translated and revised by Susan Elizabeth Strauber. 1908; San Francisco: Alan Wofsy Fine Arts, 1997.

D-R. Noack, Dieter, and Lilian Noack. *The Daumier Register.* http://daumier-register.org.

DUTHUIT. Duthuit-Matisse, Marguerite, Claude Duthuit, and Françoise Garnaud. *Henri Matisse: Catalogue raisonné de l'oeuvre gravé.* 2 vols. Paris: C. Duthuit, 1983.

FIORANI AND DINOIA. Fiorani, Fabio, with Rosalba Dinoia. *De Nittis incisore/De Nittis the Printmaker.* Exh. cat. Rome: Artemide, 1999.

GEISER-BAER. Geiser, Bernhard, and Brigitte Baer. *Picasso, peintre-graveur.* Vol. 4, *Catalogue illustré de l'oeuvre gravé et les monotypes, 1946–1958.* Bern: Editions Kornfeld, 1988.

GUÉRIN 1965–67. Guérin, Marcel. *Catalogue raisonné de l'oeuvre gravé et lithographié de Aristide Maillol.* 2 vols. Geneva: Pierre Cailler, 1965–67.

GUÉRIN 1969. Guérin, Marcel. *L'oeuvre gravé de Manet: Avec un supplément nouvellement ajouté.* New York: Da Capo Press, 1969.

HARRIS. Harris, Tomás. *Goya: Engravings and Lithographs.* 2 vols. Oxford: B. Cassirer, 1964.

HARRIS 1990. Harris, Jean C. *Édouard Manet, Graphic Works: A Definitive Catalogue Raisonné.* San Francisco: Alan Wofsy, 1990.

HIND. Hind, Arthur Mayger. *Giovanni Battista Piranesi: A Critical Study, with a List of His Published Works and Detailed Catalogues of the Prisons and the Views of Rome.* 1922; reprint, New York: Da Capo Press, 1967.

HOLLSTEIN. Hollstein, Friedrich Wilhelm Heinrich. *Dutch and Flemish Etchings, Engravings, and Woodcuts, ca. 1450–1700.* 72 vols. Amsterdam: Menno Hertzberger, 1949–87; Roosendaal, the Netherlands: Koninklijke van Poll, 1988–93; Rotterdam, the Netherlands: Sound and Vision, 1995–2007; and Ouderkerk aan den Ijssel, the Netherlands: Sound and Vision, 2008–10.

LE BLANC. Le Blanc, Charles. *Manuel de l'amateur d'estampes, contenant le dictionnaire des graveurs de toutes les nations . . .* 4 vols. Paris: Émile Bouillon, 1854–89.

MONGAN, KORNFELD, AND JOACHIM. Mongan, Elizabeth, Eberhard W. Kornfeld, Harold Joachim, with the assistance of Christine E. Stauffer. *Paul Gauguin: Catalogue Raisonné of His Prints.* Bern: Galerie Kornfeld, 1988.

MORGAN. Morgan, Gary. *The Etched Works of Mortimer Menpes (1855–1938).* 3 vols. Crafers West, South Australia: Stuart Galleries, 2012.

NAGLER. Nagler, Georg Kaspar. *Neues allgemeines Künstler-Lexicon; oder, Nachrichten von dem Leben und den Werken der Maler, Bildhauer, Baumeister, Kupferstecher . . .* 22 vols. Munich: E. A. Fleischmann, 1835–52.

NEW HOLLSTEIN. Hollstein, Friedrich Wilhelm Heinrich. *The New Dutch and Flemish Etchings, Engravings, and Woodcuts, ca. 1450–1700.* Roosendaal, the Netherlands: Koninklijke van Poll, 1993–.

RIZZI. Rizzi, Aldo. *The Etchings of the Tiepolos.* Translated by Lucia Wildt. London: Phaidon, 1971.

ROBISON. Robison, Andrew. *Piranesi—Early Architectural Fantasies: A Catalogue Raisonné of the Etchings.* Washington, D.C.: National Gallery of Art, 1986.

ROGER-MARX. Roger-Marx, Claude. *The Graphic Work of Édouard Vuillard.* Translated by Susan Fargo Gilchrist. 1948; English ed., San Francisco: Alan Wofsy Fine Arts, 1990.

STELLA. Stella, Joseph G. *The Graphic Work of Renoir: Catalogue Raisonné.* London: Lund-Humphries, 1975.

VENTURI. Venturi, Lionello. *Cézanne: Son art, son oeuvre.* 2 vols. 1936; reprint, San Francisco: Alan Wofsy Fine Arts, 1989.

WILTON-ELY. Wilton-Ely, John. *Giovanni Battista Piranesi: The Complete Etchings.* 2 vols. San Francisco: Alan Wofsy Fine Arts, 1994.

WITTROCK. Wittrock, Wolfgang. *Toulouse-Lautrec: The Complete Prints.* Edited and translated by Catherine E. Kuehn. 2 vols. London: For Sotheby's Publications by P. Wilson Publishers, 1985.

WOLLIN. Wollin, Nils Gustaf Axelsson. *Gravures originales de Desprez ou exécutées d'après ses dessins.* Malmö, Sweden: Kroon, 1933.

FRANCESCO BARTOLOZZI

See under Guercino

LEONARDO BUFALINI

See under Francesco Monaco

PIETRO CAMPANA

Italian, 1727–1779

CARLO NOLLI

Italian, 1710–1785

AND ROCCO POZZI

Italian, 1700–1780

La pianta grande di Roma (The Large Plan of Rome), after Giovanni Battista Nolli (Italian, 1701–1756) and Giovanni Paolo Panini (Italian, 1691–1765), 1748
Engraving on 12 plates, overall 67 9/16 × 80 7/8 in. (171.6 × 205.5 cm); each 16 3/4 × 26 5/8 in. (42.6 × 67.7 cm)
2012.159.8.1–.6
 BOORSCH, FIG. 20

GIOVANNI ANTONIO CANAL, CALLED CANALETTO

Italian, 1697–1768

Vedute (Views), 1741–44

Title plate
11 9/16 × 16 3/4 in. (29.4 × 42.6 cm)
Bromberg 1, state ii/ii

la Torre di Malghera (The Tower of Malghera)
11 11/16 × 16 13/16 in. (29.7 × 42.7 cm)
Bromberg 2, state ii/ii

Mestre
11 3/4 × 16 7/8 in. (29.9 × 42.8 cm)
Bromberg 3, state i/ii
 HIGHLIGHTS, PL. 3

Al Dolo (At Dolo)
11 3/4 × 16 13/16 in. (29.8 × 42.7 cm)
Bromberg 4, state ii/iii

Ale Porte del Dolo (At the Locks at Dolo)
11 1/8 × 17 1/8 in. (28.3 × 43.4 cm)
Bromberg 5, state ii/iii

le Porte Del Dolo (The Locks of Dolo)
11 3/4 × 16 7/8 in. (29.8 × 42.8 cm)
Bromberg 6, state ii/iii
 HIGHLIGHTS, PL. 4

S.a Giustina in prà della Vale [sic] and *Prà della Valle* (Santa Giustina in Prato della Valle *and* Prato della Valle)
Etching on 2 plates, overall 11 3/4 × 33 11/16 in. (29.9 × 85.6 cm); each 11 11/16 × 16 7/8 in. (29.7 × 42.8 cm) and 11 3/4 × 16 7/8 in. (29.9 × 42.8 cm)
Bromberg 7–8, state i/ii
 BOORSCH, FIG. 21

View of a Town on a River Bank
11 5/8 × 16 3/4 in. (29.6 × 42.6 cm)
Bromberg 9, state ii/iii

Imaginary View of Padua
11 3/4 × 16 13/16 in. (29.8 × 42.7 cm)
Bromberg 11, state ii/iii

The House with the Inscription
11 3/4 × 8 1/2 in. (29.8 × 21.5 cm)
Bromberg 13, state ii/ii

The House with the Peristyle
11 11/16 × 8 1/2 in. (29.7 × 21.5 cm)
Bromberg 14, state ii/ii

The Bishop's Tomb
8 11/16 × 5 1/8 in. (22 × 13 cm)
Bromberg 15, only state

View of a Town with a Bishop's Tomb
11 3/4 × 11 7/8 in. (29.9 × 30.1 cm)
Bromberg 16, state iii/iii

la Piera del Bando. V. (The Piera del Bando. V[enice])
5 9/16 × 8 1/4 in. (14.2 × 20.9 cm)
Bromberg 19, state ii/iii

The Market on the Molo
5 5/8 × 8 3/16 in. (14.3 × 20.8 cm)
Bromberg 20, state iii/iv

le Preson. V. (The Prisons. V[enice])
5 5/8 × 8 1/4 in. (14.3 × 20.9 cm)
Bromberg 21, state ii/iii

Mountain Landscape with Five Bridges
5 5/8 × 8 1/4 in. (14.3 × 20.9 cm)
Bromberg 22, state iia/iib

The Equestrian Monument
5 9/16 × 8 3/16 in. (14.2 × 20.8 cm)
Bromberg 23, only state

The Terrace
5 5/8 × 8 1/4 in. (14.3 × 21 cm)
Bromberg 24, state ii/iii

The Market at Dolo
5 11/16 × 8 3/16 in. (14.4 × 20.8 cm)
Bromberg 26, state iii/iv

Landscape with the Pilgrim at Prayer
5 9/16 × 8 1/4 in. (14.2 × 20.9 cm)
Bromberg 27, state iii/iii

Landscape with Tower and Two Ruined Pillars
5 5/8 × 8 1/4 in. (14.3 × 20.9 cm)
Bromberg 28, state ii/ii

Landscape with a Woman at a Well
5 1/2 × 8 1/16 in. (13.9 × 20.5 cm)
Bromberg 29, state ii/iii

Imaginary View of S. Giacomo di Rialto
5 5/8 × 8 7/16 in. (14.3 × 21.4 cm)
Bromberg 30, state i/ii

Landscape with Ruined Monuments
5 11/16 × 8 1/2 in. (14.4 × 21.6 cm)
Bromberg 31, only state

The Wagon Passing over a Bridge
5 5/8 × 4 15/16 in. (14.3 × 12.5 cm)
Bromberg 32, state ii/ii

The Little Monument
4 11/16 × 3 5/16 in. (11.9 × 8.4 cm)
Bromberg 33, state ii/ii

le Preson. V. (The Prisons. V[enice]), *la libreria. V.* (The Library. V[enice]), *la Piera del Bando. V.* (The Piera del Bando. V[enice]), and *le Procuratie niove e S. Ziminian. V.* (The Procuratie Nuove and San Geminiano. V[enice]), 1744
Printed on 1 sheet, overall 17 5/16 × 23 1/2 in. (44 × 59.7 cm); each, clockwise from top left: 5 5/8 × 8 1/4 in. (14.3 × 20.9 cm), 5 11/16 × 8 3/16 in. (14.4 ×

20.8 cm), 5⅝ × 8¼ in. (14.2 × 20.9 cm), and 5¹¹⁄₁₆ × 8⅜ in. (14.4 × 21.2 cm)
Bromberg 21, state ii/iii; Bromberg 18, state ii/iii; Bromberg 19, state ii/iii; Bromberg 25, state i/ii

Etchings
2012.159.6.1–.29

MICHELANGELO MERISI, CALLED CARAVAGGIO

See under Guercino

ANTONIO CARNICERO

Spanish, 1748–1814

Colección de las principales suertes de una corrida de toros (Collection of the Main Actions in a Bullfight), 1790
Title plate and plates 1–7
Etchings, hand-colored, ranging from 7¹⁵⁄₁₆ × 11¹⁵⁄₁₆ in. (20.1 × 30.4 cm) to 8⁵⁄₁₆ × 11⅞ in. (21.1 × 30.4 cm)
Le Blanc I, p. 594
2012.159.45.1–.8
GREIST, FIG. 4; BOORSCH, FIG. 4; HIGHLIGHTS, PL. 28

PAUL CÉZANNE

French, 1839–1906
See also under Édouard Vuillard

Entrance to a Farm, 1873
Etching, 5¼ × 4¼ in. (13.4 × 10.8 cm)
Venturi 1161, only state; Cherpin 5, only state
2012.159.86

Head of a Young Girl, 1873
Etching, 5¼ × 4¼ in. (13.4 × 10.8 cm)
Venturi 1160, only state; Cherpin 4, state ii/iii
2012.159.85

Self-Portrait, 1898–1900
Lithograph, 13 × 11⁷⁄₁₆ in. (38 × 29.1 cm)
Venturi 1158, only state; Cherpin 8, only state
2012.159.84

JEAN-BAPTISTE-CAMILLE COROT

French, 1796–1875

Le grand cavalier sous bois (The Large Rider in the Woods), 1854

Cliché-verre, 10¹⁵⁄₁₆ × 8⁹⁄₁₆ in. (27.8 × 21.8 cm)
Delteil 46, only state
2012.159.51
HIGHLIGHTS, PL. 54

Self-Portrait, 1858
Cliché-verre printed in *bistre*, 8⅜ × 6¹⁄₁₆ in. (21.3 × 15.4 cm)
Delteil 69, only state
2012.159.52

Souvenir d'Italie (Memory of Italy), 1866
Etching, 11⁹⁄₁₆ × 8¾ in. (29.4 × 22.2 cm)
Delteil 5, state ii/iv
2012.159.49

Le dormoir des vaches (The Cow Pasture), 1871
Lithograph printed in red, 6¼ × 5⅜ in. (15.8 × 13.6 cm)
Delteil 26, state i/ii
HIGHLIGHTS, PL. 55

HONORÉ DAUMIER

French, 1808–1879

Baissez le rideau, la farce est jouée (Lower the Curtain, the Farce Has Ended), 1834
Lithograph, 7⅞ × 10¹⁵⁄₁₆ in. (20 × 27.8 cm)
Delteil 86, only state; D-R 86, only state
2012.159.59
BOORSCH, FIG. 28

Le ventre législatif (The Legislative Belly), 1834
Lithograph, 11¹⁄₁₆ × 17 in. (28.1 × 43.2 cm)
Delteil 131, only state; D-R 131, only state
2012.159.61
HIGHLIGHTS, PL. 48

Le Fantôme (The Phantom), 1835
Lithograph, 10⅝ × 8¾ in. (27 × 22.3 cm)
Delteil 115, state ii/iii; D-R 115, state ii/iii
2012.159.60
HIGHLIGHTS, PL. 49

Les bas-bleus (The Bluestockings), 1844

*C'est singulier comme ce miroir m'applatit la taille et me maigrit la poitrine!... Que m'importe?... Mme de Staël et Mr de Buffon l'ont proclamé:... **le génie n'a point de sexe** *(It's curious how this mirror flattens my figure and slims my bust!... What do I care? ... Mme de Staël and M. de Buffon proclaimed it:... Genius has no sex)

Delteil 1221, state iii/iii; D-R 1221, state iii/iv
HIGHLIGHTS, PL. 50

*Dis donc... mon mari... j'ai bien envie d'appeler mon drame **Arthur** et d'intituler mon enfant **Oscar**!... mais non... toute réflexion faite, je ne déciderai rien avant d'avoir consulté mon collaborateur!...* (Listen... my husband... I am tempted to call my drama *Arthur* and my child *Oscar*!... but no... all things considered, I will not decide anything before having consulted my collaborator!...)
Delteil 1222, state iii/iii; D-R 1222, state iii/iii

Adieu, mon cher, je vais chez mes éditeurs;... je ne rentrerai probablement que fort tard... ne manquez pas de donner encore deux fois la bouillie à Dodore... s'il a besoin... d'autre chose... vous trouverez ça sous le lit... (Goodbye, my dear, I am off to my publisher's;... I probably won't be back until very late... make sure to give Dodore his pap twice more... if he needs... something else... you'll find it under the bed...)
Delteil 1223, state iii/iii; D-R 1223, state iii/iii

Au revoir, Ophélia!... ne manquez pas de venir mardi soir... c'est une réunion littéraire en petit comité... nous lirons des élégies et nous ferons du bischoff!... (Farewell, Ophélia!... and be sure to come Tuesday evening... it's a literary meeting of a select group... we'll read elegies and make mulled wine!...)
Delteil 1224, state iii/iii; D-R 1224, state iii/iii
HIGHLIGHTS, PL. 51

—Dis donc, Bichette... à quoi songes-tu donc de te promener comme ça la nuit? ... est-ce que t'es somnambule, ou bien, est-ce que t'as la colique?...—Non... je cherche un moyen neuf de tuer un mari... je ne me recouche pas que je n'ai trouvé mon moyen!... il me le faut pour terminer mon roman!...—Saperlotte! pourvu qu'elle ne l'essaye pas sur moi! (—Listen, Dear... what are you thinking about to be wandering around like this during the night?... are you sleep-walking, or do you have colic?...—No, I'm looking for a new way to kill a husband... I'm not going

back to bed until I've found one! . . . I need it to finish my novel! . . . —Good Lord! as long as she doesn't try it on me!)
Delteil 1225, state iv/iv; D-R 1225, state iv/iv

—Messieurs, je viens offrir à votre journal, un roman-feuilleton qui, je crois, lui conviendra parfaitement! . . . il a pour titre **Eloa, ou huit jours de bonheur intime** . . . la première partie formera dix ou douze volumes . . . à la manière d'Eugène Sue! . . . —Pardon madame! . . . mais ceci me paraît effrayant . . . à ce compte-là vos **huit jours** dureront trois ans! (—Gentlemen, I come to offer your paper a serialized novel that, I believe, will suit it perfectly! . . . the title is *Eloa, or Eight Days of Intimate Happiness* . . . the first part will consist of ten or twelve volumes . . . in the manner of Eugène Sue! . . . —Pardon madame! . . . but this seems terrifying . . . at that rate your *eight days* will last three years!)
Delteil 1226, state iii/iii; D-R 1226, state iii/iii

La mère est dans le feu de la composition, l'enfant est dans l'eau de la baignoire! (The mother is in the heat of composition, the baby is in the bathwater!)
Delteil 1227, state ii/ii; D-R 1227, state ii/ii

O Lune! . . . inspire-moi ce soir quelque petite pensée un peu grandiose! . . . car je t'aime ainsi, lorsque tu me présentes en entier ta face pâle et mélancolique! . . . mais, ô Lune, je t'affectionne moins lorsque tu m'apparais sous la forme d'un croissant . . . parceque alors tu me rappelles tout bonnement mon mari! (O Moon! . . . inspire in me tonight some small thought with a touch of grandeur! . . . because I love you like this, when you present your full face to me, pale and melancholy! . . . yet, o Moon, I love you less when you appear to me in the form of a crescent . . . for then, frankly, you remind me of my husband!)
Delteil 1228, state iii/iii; D-R 1228, state iii/iii

—*Madame, comment trouvez-vous cette cigarette? . . . —C'est bien fadasse*

*. . . et bon tout au plus pour des femmes d'agens de change en goguette! . . . quant à moi, je n'aime que les plus gros cigarres du plus Gros-Caillou possible . . . du reste je compose en ce moment un sonnet sur le tabac caporal . . . je le publierai dans un volume intitulé: **Fumées de ma pipe*** (—Madame, how do you find that cigarette? . . . —It's pretty tasteless . . . and good at most for stockbrokers' wives on a spree! . . . as for me, I like only the Biggest Cigars, as strong as possible . . . moreover I am just composing a sonnet on shag . . . I shall publish it in a volume titled: *Smoke from My Pipe*)
Delteil 1229, state ii/ii; D-R 1229, state ii/ii

Allons! . . . on n'a pas encore rendu compte de mon roman aujourd'hui! ces journalistes s'occupent maintenant tous les matins des Lièvres . . . des Perdreaux . . . des Bécasses! . . . et ils ne pensent pas à moi . . . c'est inconcevable! . . . (Come on! . . . they did not review my novel yet today! these journalists now attend every morning to Rabbits . . . Partridges . . . Geese! . . . and they don't think of me . . . it's inconceivable! . . .)
Delteil 1230, state ii/ii; D-R 1230, state ii/ii

Emportez donc ça plus loin . . . il est impossible de travailler au milieu d'un vacarme pareil . . . allez vous promener à la petite provence, et en revenant, achetez de nouveaux biberons passage Choiseul! . . . Ah! Mr Cabassol c'est votre premier enfant, mais je vous jure que ce sera votre dernier! (Take that farther away . . . it is impossible to work in the midst of this racket . . . go for a walk in the park, and on the way back, buy some new baby bottles in the passage Choiseul! . . . Ah! Mr. Cabassol, this is your first child, but I swear it will be your last!)
Delteil 1231, state ii/ii; D-R 1231, state ii/ii

Dire qu'Arsinoé n'était pas contente d'être portraiturée, Dagueréotypée, lithographiée et biographiée! . . . il faut maintenant que je paie trois mille francs pour son buste en marbre . . . c'est dur! . . . pour comble de malheur me voilà obligé d'épousseter ma femme tous les matins . . . et c'est qu'elle en fait de la poussière, ma femme! (To think that Arsinoé was not satisfied to have been

painted, photographed, lithographed, and her biography written! . . . now I have to pay three thousand francs for her marble bust . . . it's hard! . . . and, to crown it all, I have to dust my wife every morning . . . and she makes a lot of dust, my wife!)
Delteil 1232, state iii/iii; D-R 1232, state iii/iv

—*Monsieur, pardon si je vous gêne un peu . . . mais vous comprenez qu'écrivant en ce moment un roman nouveau, je dois consulter une foule d'auteurs anciens! . . . —(Le Monsieur à part.) Des auteurs anciens! . . . parbleu elle aurait bien dû les consulter de leur vivant, car elle a dû être leur contemporaine! . . .* (—Monsieur, pardon me if I get in your way a little . . . but you understand that now writing a new novel, I must consult a host of ancient authors! . . . —[Man, aside] Ancient authors! . . . by golly she should have consulted them while they were alive, for she must have been their contemporary! . . .)
Delteil 1233, state iii/iii; D-R 1233, state iii/iv

Satané piallard d'enfant va! . . . laisse moi donc composer en paix mon ode sur le bonheur de la maternité! . . . —C'est bon, c'est bon, . . . il va se taire . . . je vais aller lui donner le fouet dans l'autre pièce . . . (à part.) dans le fait, de tous les ouvrages de ma femme c'est bien celui qui fait le plus de bruit dans le monde! . . . (Damned squealing child! . . . let me compose in peace my ode to the joys of motherhood! . . . —All right, all right, . . . he will be quiet . . . I am going to give him a whipping in the other room . . . [aside] in fact, of all my wife's creations, it is this one that makes the most noise in the world! . . .)
Delteil 1234, state iii/iii; D-R 1234, state iii/iii

BOORSCH, FIG. 26

*Femme de lettre humanitaire se livrant sur l'homme a des réflexions **crânement** philosophiques!* (A humanist woman of letters studying the subject of man has *cerebral* philosophic reflections!)
Delteil 1235, state iii/iv; D-R 1235, state iii/iv

—*Bichette . . . viens donc arranger ma rosette! . . . —Voilà bien les hommes! . . . comme ils abusent de leurs droits!*

parce qu'on a eu un jour la faiblesse de
serrer avec eux les noeuds de l'hymenée,
ils voudraient ensuite vous faire serrer
à perpétuité ceux de leurs cravattes!
...mais je suis décidée à suivre
désormais les principes émis ce matin
même par **Artémise Jabutot** dans son
remarquable article de la **Gazette des
femmes libres:** ... **A bas les noeuds de
cravattes et les boutons de pantalons!**
(Dear...come and adjust my tie!
...—These men!...how they abuse
their rights! just because one day one
had the weakness to tie the marriage
knot with them, they then want
you perpetually to tie those of their
neckties!...but I've decided to follow
from now on the principles put forward
this very morning by *Artémise Jabutot*
in her remarkable article in the *Gazette
of Free Women:*...*Down with the knots
of ties and buttons of trousers!*)
Delteil 1236, state iii/iii; D-R 1236,
state iii/iii

(Le parterre de l'Odéon)
—L'auteur!...l'auteur!...l'auteur!
...—Messieurs, votre impatience va
être satisfaite...vous désirez connaître
l'auteur de l'ouvrage remarquable
qui vient d'obtenir un si grand, et je
dois le dire, si légitime succès...cet
auteur...c'est môa! ([The audience
at the Odéon Theater] —Author...
author!...author!...—Gentlemen,
your impatience will be satisfied...
you want to know the author of the
remarkable work that has just obtained
such a great, and I must say, so
justified success...that author...
is MEEEEE!)
Delteil 1237, state ii/ii; D-R 1237,
state ii/ii

—O mon Victor idolatré...il me vient
une idée poétique!! précipitons nous
ensemble et à l'instant du haut de
cette grise falaise dans les flots bleus
de l'Océan!...—Nous noyer dans la
mer!...nous y réfléchirons, Anastasie,
...je tiens à descendre encore pendant
quelque temps le fleuve de la vie!...
(O Victor, my idol...a poetic idea has
come to me!! let us throw ourselves
together at this instant from the top
of this gray cliff into the blue waves
of the Ocean!...—Drown ourselves
in the sea!...we will reflect on this,
Anastasia,...I would like to descend

yet a while the river of life!...)
Delteil 1238, state ii/ii; D-R 1238,
state ii/ii

Enfer et damnation!...siflée!...**siflée!**
...**Siiiiflée!**...(Hell and damnation!...
hissed!...hissed!...Hisssed!)
Delteil 1239, state iii/iii; D-R 1239, state
iii/iii

O douleur!...avoir rêvé pendant toute
ma vie de jeune fille un époux, qui, ainsi
que moi, adorât la sainte poésie, et tomber
sur un mari qui n'aime que les goujons...
cet homme-là était né pour être brochet!
...(O sorrow!...to have dreamed all
my girlhood of a spouse who, like me,
would adore blessed poetry, and to wind
up with a husband who likes only bait...
that man was born to be a pike!...)
Delteil 1240, state ii/ii; D-R 1240,
state ii/ii

—Adieu ma chère Flora...ne manquez
pas d'adresser au bureau du journal deux
exemplaires de vos bulles de savon...et
je ferai mousser cela dans mon feuilleton.
(—Goodbye my dear Flora...be sure to
send to the newspaper office two copies
of your soap-bubbles...and I shall puff
them in my article.)
Delteil 1241, state ii/ii; D-R 1241,
state ii/ ii

Le bas bleu déclamant sa pièce —Acte
sixième, premier tableau...le théâtre
représente un tigre endormi dans le désert
...**Rosalba** s'avance en se traînant avec
peine et en traînant avec plus de peine
encore ses cinq enfants et son vieux père;
—**Rosalba** tombe au pied d'un dattier
couvert de noix de cocos et s'écrie avec
désespoir: **O ciel quand finiront nos
tourmens!**...**Tous les auditeurs (À
voix basse)** et les nôtres quand donc
finiront-ils, o ciel!...(The bluestocking
reciting her play —Act six, scene one
...the scene represents a tiger asleep
in the desert...Rosalba crawls forward
with difficulty and trailing with even
more difficulty her five children and her
old father; —Rosalba falls at the foot of
a palm tree covered with coconuts and
exclaims in despair: *O heaven, when will
our torments be finished!*...*The whole
audience [under their breath]* and ours
when will they ever end, o heaven!...)
Delteil 1242, state iii/iii; D-R 1242,
state iii/iii

L'artiste m'a représentée au moment
où j'écris mon sombre volume intitulé:
"Vapeurs de mon âme!..." l'oeil n'est
pas mal, mais le nez me semble pas
suffisamment affligé!...(Le monsieur
à part) —Oui...il n'est qu'affligeant...
(The artist represented me as I was
writing my somber book titled: "*Vapors
of my soul!...*" the eye is not bad, but
the nose seems to me not sufficiently
afflicted!...[Man, aside] Yes...it is
only afflicting...)
Delteil 1243, state iii/iii; D-R 1243,
state iii/iii

Depuis que Virginie a obtenu la septième
accessit de poésie à l'Académie française
il faut que ce soit moi...moi capitaine
de la garde nationale...qui compte
tous les samedis le linge à donner à la
blanchisseuse...et je le fais parceque
sans cela ma femme me laverait la tête!
(Ever since Virginie received the
seventh honorable mention for poetry
at the Académie Française it must be I
...a captain of the national guard...
who counts the linens every Saturday
to give to the laundress...and I do it
because if I don't my wife will wring
me out!)
Delteil 1244, state iii/iii; D-R 1244,
state iii/iii

LA PRÉSIDENTE CRIANT À
TUE-TÊTE. Mesdames!...vous
violez formellement l'article 3 de
notre réglement...lequel porte que les
académiciennes ne parleront jamais
plus de cinq à la fois!...je vous rappelle
toutes à l'ordre...et au silence!...
puisque ma sonnette est impuissante
...je lève la séance et je mets mon
chapeau!...jettez maintenant tant que
vous voudrez vos bonnets par dessus les
moulins!...(The president shouting
at the top of her voice. Ladies!...you
are formally violating article three of
our regulations...which states that
no more than five academicians may
talk at once!...I call you to order...
silence!...since ringing my bell is
powerless...I suspend the meeting
and put on my hat!...now you can
throw your hats over the windmills
[throw propriety to the winds] as much
as you want!...)
Delteil 1245, state iii/iv; D-R 1245,
state iii/iv

O plaisir de l'opium, que tu me ravis!... *il me semble que j'habite l'Orient...du reste, je ne sais quelle voix secrète me criait depuis longtemps que ma véritable patrie aurait dû être le désert!* (O pleasure of opium, you ravish me!...it seems as though I dwell in the Orient...indeed, I don't know what secret voice has been calling out to me for a long time that my true home should have been the desert!)
Delteil 1246, state iii/iv; D-R 1246, state iii/iv

—C'est singulier...il ne me vient plus d'idées maintenant que lorsque je suis au bois de Boulogne et que je trotte avec M. Edouard!...—Quelles idées peuvent donc venir à ma femme, quand elle trotte avec M. Edouard?...ceci m'intrigue...je suis fâché de voir qu'elle se soit faite amazone...j'aurais mieux aimé qu'elle restât simplement à cheval sur la vertu!... (—It's odd...I now get good ideas only when I am in the Bois de Boulogne horseback riding with Mr. Edouard!...—What ideas could come to my wife when she rides with Mr. Edouard?...it intrigues me...I am angry to see that she has made herself an amazon...I would much prefer she'd ride the path of virtue!...)
Delteil 1247, state ii/ii; D-R 1247, state ii/ii

—Une femme comme moi...remettre un bouton?...vous êtes fou!...—Allons bon!...voilà qu'elle ne se contente plus de porter les culottes...il faut encore qu'elle me les jette à la tête!... (—A woman like me...sew on a button?...you are crazy!...—There now!...it's not enough for her to wear the pants...she must also throw them at my head!...)
Delteil 1248, state iii/iii; D-R 1248, state iii/iv

—Ma bonne amie, puis-je entrer!... as-tu fini de collaborer avec monsieur?... (—My dear, may I come in!... have you finished collaborating with Monsieur?...)
Delteil 1249, state ii/ii; D-R 1249, state ii/ii

Nos comptes sont faciles à établir...vous m'aviez confié mille exemplaires de votre recueil poétique intitulé **"soupirs de mon âme..."** *vingt sept volumes ont été donnés aux journaux...et en défalquant ce que j'ai vendu je trouve qu'il me reste*
juste neuf cent soixante treize **"soupirs de votre âme"** *dans mon magasin!* ... (Our accounts are easy to establish ...you gave me one thousand copies of your poetry collection entitled *"sighs of my soul..."* twenty-seven volumes were given to the newspapers...and deducting what I have sold I find that I have exactly 973 *"sighs of your soul"* left in my shop!...)
Delteil 1250, state iii/iii; D-R 1250, state iii/iii

—Suivez-bien mon raisonnement, Eudoxie...tout doit tendre à un but humanitaire, en conséquence chaque ligne que nous écrivons doit procéder de l'analyse pour arriver à la synthèse... sans quoi le socialisme n'est plus que de l'égoïsme...engendrant le matérialisme et...vous offrirai-je encore une tasse de thé?... (—Follow carefully my reasoning, Eudoxie...everything must tend toward a humanitarian goal, consequently every line we write must proceed from analysis to arrive at synthesis...without which socialism is no more than egoism... engendering materialism and...may I offer you another cup of tea?...)
Delteil 1251, state ii/ii; D-R 1251, state ii/ii

Saperlotte!...que je voudrais donc que ma femme ait fini d'improviser son quatrain sur **les beautés de la nature dans la plaine S.t Denis...!** *nous marchons toujours, mais ses vers n'avancent pas!...* (Good Lord!... how I wish that my wife would finish improvising her quatrain on *the beauties of nature on the plain of St. Denis...!* we keep walking, but her verses don't advance at all!...)
Delteil 1252, state ii/ii; D-R 1252, state ii/ii

Nous voilà donc réunies pour écrire le premier numéro de notre journal... **Le Sans Culotte —littéraire** *...qu'est-ce que nous allons commencer par échiner? ...—Pour commencer...échignons tout!* ... (Here we are gathered to write the first issue of our newspaper...The Literary Sans-Culotte...what are we going to tear apart first?...—To begin ...let's tear everything apart!...)
Delteil 1253, state ii/ii; D-R 1253, state ii/iii

Ah vous trouvez que mon dernier roman n'est pas tout-à-fait à la hauteur de ceux de Georges [sic] Sand...! Adélaïde, je ne vous reverrai de la vie! (Oh, you find that my latest novel is not quite up to the level of those of George Sand...! Adélaïde, I will never see you again in my life!)
Delteil 1254, state ii/ii; D-R 1254, state ii/ii

Ah! ma chère, quelle singulière éducation vous donnez à votre fille?...mais à douze ans, moi, j'avais déjà écrit un roman en deux volumes...et même une fois terminé, ma mère m'avait défendu de le lire, tellement elle le trouvait avancé pour mon âge... (Ah! my dear, what a strange education you are giving your daughter?...when I was twelve, I had already written a novel in two volumes ...and even, once it was finished, my mother forbade me to read it, she found it so much too advanced for my age...)
Delteil 1255, state ii/ii; D-R 1255, state ii/ii

"...dussent-ils me maudire" / "Ces barbares parens qui m'ont donné le jour," / "Ô Victor, ô mon âme, a toi tout mon amour!"—Bravo...bravo...bravo ...qu'une mère est heureuse d'avoir une petite fille pareille!... ("...let them curse me" / "These barbaric parents who gave birth to me," / "O Victor, o my soul, all my love is just for you!"—Bravo...bravo...bravo... how happy a mother is to have such a daughter!...)
Delteil 1256, state ii/ii; D-R 1256, state ii/ii

Allons bon!...la v'là qui au lieu de lait, verse du cirage dans mon chocolat!... satané roman va!... (There now!... instead of milk she pours polish into my hot chocolate!...enough with that damned novel!...)
Delteil 1257, state ii/ii; D-R 1257, state ii/ii

Ce Journal trouve mon ouvrage pitoyable...cette fois encore je suis donc incomprise!... (This Paper finds my work pitiful...once again I am misunderstood!...)
Delteil 1258, state ii/ii; D-R 1258, state ii/ii

*Comment! encore une caricature sur nous, ce matin, dans le **Charivari!** . . . ah! jour de ma vie! j'espère bien que cette fois c'est la dernière! . . . et si jamais ce Daumier me tombe sous la main, il lui en coutera cher pour s'être permis de tricoter des **Bas bleus*** (How could it be! another caricature about us, this morning, in *Charivari!* . . . ah, my days! I hope that this time it's the last! . . . and if ever I get my hands on this Daumier, it will cost him dearly to have allowed himself to knit up some *Bluestockings*)
Delteil 1259, state ii/ii; D-R 1259, state ii/ii
HIGHLIGHTS, PL. 52

—Voyez-donc un peu, Isménie! . . . comment le Gouvernement permet-il d'afficher de pareilles turpitudes? . . . (—Have a look, Isménie! . . . how could the Government allow postering of such depravity? . . .)
Delteil 1260, state ii/iii; D-R 1260, state ii/iii

Lithographs, ranging from 8⁹⁄₁₆ × 6¹⁵⁄₁₆ in. (21.7 × 17.6 cm) to 9¹⁄₁₆ × 7¹⁵⁄₁₆ in. (23 × 20.1 cm)
2012.159.62.1–.40

Il défend l'orphelin et la veuve, à moins pourtant qu'il n'attaque la veuve et l'orphelin (The People of Justice/He Defends the Orphan and the Widow, Unless He Attacks the Widow and the Orphan), from *Les gens de justice* (The Lawyers), 1846
Lithograph, 9 × 7⅝ in. (22.9 × 19.3 cm)
Delteil 1358, state ii/ii; D-R 1358, state ii/ii
2012.159.63

Une idylle dans les blés (An Idyll in the Fields), 1847
Lithograph, 9⅝ × 8¹¹⁄₁₆ in. (24.4 × 22 cm)
Delteil 1548, state ii/ii; D-R 1548, state ii/ii
2012.159.64

En Chemin de Fer _ Un Voisin agreable (On the Railway _ A Pleasant Neighbor), 1862
Lithograph, 7¹¹⁄₁₆ × 9⁹⁄₁₆ in. (19.5 × 24.3 cm)
Delteil 3252, state iii/iii; D-R 3252, state iii/iii
2012.159.65
HIGHLIGHTS, PL. 53

EDGAR DEGAS
French, 1834–1917

The Infanta Margarita, after a painting attributed to Juan Bautista Martínez del Mazo (Spanish, ca. 1612–1667), ca. 1861–62
Etching and drypoint, 6⅝ × 4¾ in. (16.9 × 12.1 cm)
Delteil 12, state i/ii; Adhémar and Cachin 16, state i/ii
2012.159.83
FRONTISPIECE

EUGÈNE DELACROIX
French, 1798–1863

Macbeth consultant les sorcières (Macbeth Consulting the Witches), from William Shakespeare's *Macbeth*, 1825
Lithograph, 13 × 10⅛ in. (33 × 25.7 cm)
Delteil-Strauber 40, state v/v
2012.159.53

Illustrations to Johann Wolfgang von Goethe's *Faust*, 1827, published 1828

Portrait de Goethe (Portrait of Goethe)
6¹⁄₁₆ × 5¹⁵⁄₁₆ in. (15.4 × 15.1 cm)
Delteil-Strauber 57, state i/iv

Méphistophélès dans les airs (Mephistopheles in the Skies)
10¾ × 9⁷⁄₁₆ in. (27.3 × 24 cm)
Delteil-Strauber 58, state ii/v

Faust dans son cabinet (Faust in His Study)
9¼ × 6⅞ in. (23.5 × 17.5 cm)
Delteil-Strauber 59, state iii/viii

Faust et Wagner (Faust and Wagner)
7¾ × 10³⁄₁₆ in. (19.6 × 25.8 cm)
Delteil-Strauber 60, state iii/vii

Faust, Wagner et le barbet (Faust, Wagner, and the Spaniel)
10³⁄₁₆ × 8³⁄₁₆ in. (25.8 × 20.8 cm)
Delteil-Strauber 61, state i/iv

Méphistophélès apparaissant à Faust (Mephistopheles Appearing to Faust)
10¼ × 8³⁄₁₆ in. (26 × 20.8 cm)
Delteil-Strauber 62, state ii/v
HIGHLIGHTS, PL. 44

Méphistophélès recevant l'écolier (Mephistopheles Receiving the Student)
10¼ × 8⁹⁄₁₆ in. (26 × 21.7 cm)
Delteil-Strauber 63, state ii/ii

Méphistophélès dans la taverne des étudiants (Mephistopheles in the Students' Tavern)
10⁷⁄₁₆ × 8⅝ in. (26.5 × 22 cm)
Delteil-Strauber 64, state ii/vi

Faust cherchant à séduire Marguerite (Faust Seeking to Seduce Marguerite)
10¼ × 8¹⁄₁₆ in. (26 × 20.5 cm)
Delteil-Strauber 65, state ii/vii

Méphistophélès se présente chez Marthe (Mephistopheles Presents Himself in Marthe's Home)
9¼ × 8 in. (23.5 × 20.3 cm)
Delteil-Strauber 66, state iii/vii

Marguerite au rouet (Marguerite at the Spinning Wheel)
8¹³⁄₁₆ × 7³⁄₁₆ in. (22.3 × 18.2 cm)
Delteil-Strauber 67, state ii/vi

Duel de Faust et de Valentin (Duel between Faust and Valentin)
8¹¹⁄₁₆ × 10¹³⁄₁₆ in. (22.1 × 27.5 cm)
Delteil-Strauber 68, state iii/vi

Méphistophélès et Faust fuyant après le duel (Mephistopheles and Faust Fleeing after the Duel)
10⁵⁄₁₆ × 8⅝ in. (26.2 × 22 cm)
Delteil-Strauber 69, state iii/vii

Marguerite à l'église (Marguerite in Church)
10⁹⁄₁₆ × 8⅞ in. (26.8 × 22.5 cm)
Delteil-Strauber 70, state ii/v

Faust et Méphistophélès dans les montagnes du Hartz (Faust and Mephistopheles in the Hartz Mountains)
9⁷⁄₁₆ × 8¹⁄₁₆ in. (24 × 20.5 cm)
Delteil-Strauber 71, state iii/vii

L'ombre de Marguerite apparaissant à Faust (Marguerite's Ghost Appearing to Faust)
10⁵⁄₁₆ × 13¹¹⁄₁₆ in. (26.2 × 34.7 cm)
Delteil-Strauber 72, state iii/vi
HIGHLIGHTS, PL. 45

Faust et Méphistophélès galopant dans la nuit du Sabbat (Faust and Mephistopheles Galloping on the Night of the Witches' Sabbath)
8³⁄₁₆ × 10¹³⁄₁₆ in. (20.8 × 27.5 cm)
Delteil-Strauber 73, state ii/v

Faust dans la prison de Marguerite (Faust in Marguerite's Prison)
10 × 8⅝ in. (25.3 × 21.8 cm)
Delteil-Strauber 74, state ii/vii

Lithographs
2012.159.54.1–.18
HODERMARSKY, FIG. 1

Cheval sauvage (Wild Horse), 1828
Lithograph, 9 15/16 × 8 7/8 in.
(23.7 × 22.5 cm)
Delteil-Strauber 78, state ii/ii
2012.159.55

Illustrations to William Shakespeare's
Hamlet, 1834–43, published 1843

La reine s'efforce de consoler Hamlet
(The Queen Tries to Console
Hamlet), Act 1, Scene 2
9 15/16 × 7 13/16 in. (25.3 × 19.9 cm)
Delteil-Strauber 103, state ii/iv

Hamlet veut suivre l'ombre de son père
(Hamlet Wants to Follow His Father's
Ghost), Act 1, Scene 4
10 1/4 × 8 1/16 in. (26 × 20.5 cm)
Delteil-Strauber 104, state ii/iv

Le fantôme sur la terrasse (The Ghost
on the Terrace), Act 1, Scene 5
10 3/16 × 7 5/8 in. (25.8 × 19.3 cm)
Delteil-Strauber 105, state i/iii
HIGHLIGHTS, PL. 46

Polonius et Hamlet (Polonius and
Hamlet), Act 2, Scene 2
9 3/4 × 7 1/4 in. (24.8 × 18.4 cm)
Delteil-Strauber 106, undescribed
state between i and ii/iv

Hamlet et Guildenstern (Hamlet and
Guildenstern), Act 3, Scene 2
9 13/16 × 8 1/16 in. (25 × 20.4 cm)
Delteil-Strauber 108, state ii/iv

*Hamlet fait jouer aux comédiens la
scène de l'empoisonnement de son père*
(Hamlet Has the Actors Play the
Scene of the Poisoning of His Father),
Act 3, Scene 2
9 7/8 × 12 13/16 in. (25 × 32.5 cm)
Delteil-Strauber 109, state ii/iv
GREIST, FIG. 9

Hamlet tente de tuer le roi (Hamlet
Attempts to Kill the King), Act 3,
Scene 3
10 5/16 × 7 1/16 in. (26.2 × 18 cm)
Delteil-Strauber 110, state i/iii

Le meurtre de Polonius (The Murder of
Polonius), Act 3, Scene 4
9 7/16 × 7 9/16 in. (23.9 × 19.2 cm)
Delteil-Strauber 111, state ii/iii

Hamlet et la reine (Hamlet and the
Queen), Act 3, Scene 4
10 3/16 × 7 1/16 in. (25.9 × 17.9 cm)
Delteil-Strauber 112, state iii/v

Hamlet et le cadavre de Polonius
(Hamlet and the Corpse of Polonius),
Act 3, Scene 4
10 1/16 × 7 1/16 in. (25.6 × 18 cm)
Delteil-Strauber 113, undescribed state
between i and ii/iv

Mort d'Ophélie (Death of Ophelia),
Act 4, Scene 7
7 7/16 × 10 1/8 in. (18.8 × 25.6 cm)
Delteil-Strauber 115, undescribed state
between i and ii/iv
HIGHLIGHTS, PL. 47

Hamlet et Horatio devant les fossoyeurs
(Hamlet and Horatio before the Grave
Diggers), Act 5, Scene 1
11 1/4 × 8 7/16 in. (28.5 × 21.4 cm)
Delteil-Strauber 116, state ii/iv

Mort d'Hamlet (Death of Hamlet),
Act 5, Scene 2
11 3/8 × 8 1/16 in. (28.8 × 20.4 cm)
Delteil-Strauber 118, undescribed state
between i and ii/iv

Lithographs
2012.159.56.1–.13
HODERMARSKY, FIG. 2

*Frère Martin serrant la main de fer
de Goetz* (Brother Martin Clasping
Goetz's Gauntlet), Act 1, Scene 2, from
Johann Wolfgang von Goethe's *Goetz de
Berlichingen*, 1836
Lithograph, 22 1/4 × 15 11/16 in. (56.5 ×
39.9 cm)
Delteil-Strauber 119, state ia/ii
2012.159.57

MARCELLIN-GILBERT DESBOUTIN
French, 1823–1902

Three-Quarter Portrait of Edgar Degas,
1875–82
Drypoint, 3 3/8 × 2 3/4 in. (8.5 × 7 cm)
Clément-Janin, p. 228; Fiorani and
Dinoia 51
2012.159.66

LOUIS-JEAN DESPREZ
See under Francesco Piranesi

FERDINANDO GALLI BIBIENA
Italian, 1657–1743

*L'ARCHITETTURA CIVILE
PREPARATA SÚ LA GEOMETRIA, E
RIDOTTA ALLE PROSPETTIVE* (Civil
Architecture Prepared According to
Geometry, and Rendered in Perspective),
Parma: Paolo Monti, 1711
Book with 69 engravings, book: 17 15/16 ×
12 1/2 × 1 15/16 in. (45.5 × 31.8 × 4.9 cm);
engravings: 13 5/8 × 10 3/4 in. (34.5 × 27.3 cm)
2012.159.4

PAUL GAUGUIN
French, 1848–1903

Pastorales Martinique, 1889
Zincograph, 7 5/16 × 8 11/16 in. (18.5 × 22 cm)
Mongan, Kornfeld, and Joachim 6,
only state
2012.159.89

Portrait of Stéphane Mallarmé, 1891
Etching and drypoint with engraving,
7 3/16 × 5 5/8 in. (18.3 × 14.3 cm)
Mongan, Kornfeld, and Joachim 12,
state ii/iv
2012.159.90
HIGHLIGHTS, PL. 62

Manao Tupapau (Spirit of the Dead
Watching), 1893–94
Woodcut, 8 1/16 × 14 in. (20.5 × 35.5 cm)
Mongan, Kornfeld, and Joachim 20,
state iii/iv
2012.159.92

Noa Noa (Fragrance), 1893–94
Woodcut, 14 × 8 1/8 in. (35.5 × 20.6 cm)
Mongan, Kornfeld, and Joachim 13,
state iii/iii
2012.159.91
GREIST, FIG. 8

Women, Animals, and Foliage, 1898
Woodcut, 6 7/16 × 12 in. (16.3 × 30.5 cm)
Mongan, Kornfeld, and Joachim 43,
state ii/ii
2012.159.93
BOORSCH, FIG. 25

PIER LEONE GHEZZI
See under Guercino

FRANCISCO GOYA
Spanish, 1746–1828

Barbarroxa, after Diego Velázquez
(Spanish, 1599–1660), 1778
Etching, aquatint, burin, and roulette,
11 1/16 × 6 1/2 in. (28.1 × 16.5 cm)
Harris 12, III, 1
2012.159.33
 HIGHLIGHTS, PL. 29

Aesopus, after Diego Velázquez (Spanish,
1599–1660), after 1778
Etching, 11 13/16 × 8 7/16 in. (30 × 21.5 cm)
Harris 13, III, 1
2012.159.34
 BOORSCH, FIG. 7

Un enano (A Dwarf), after Diego Velázquez
(Spanish, 1599–1660), 1778–79
Etching, 8 1/16 × 6 1/8 in. (20.5 × 15.5 cm)
Harris 16, III, 1
2012.159.36
 HIGHLIGHTS, PL. 30

Moenippus, after Diego Velázquez (Spanish,
1599–1660), 1778–79
Etching, 11 13/16 × 8 11/16 in. (30 × 22 cm)
Harris 14, III, 1
2012.159.35

Cari[tas] [San Francisco de Paula] (Charity
[Saint Francis de Paul]), ca. 1780
Etching and drypoint, 5 1/8 × 3 3/4 in.
(13 × 9.5 cm)
Harris 3, III, 1
2012.159.32

*Los desastres de la guerra. Coleccion de
ochenta làminas inventadas y grabades
al agua fuerte por Don Francisco Goya*
(The Disasters of War, Collection of
Eighty Plates Designed and Etched by Don
Francisco Goya), ca. 1810–14, published
1863 (first edition)

 Title plate, 1863

 *Tristes presentimientos de lo que ha de
 acontecer* (Sad Forebodings of What Is
 Going to Happen), plate 1, ca. 1813

 Con razon ó sin ella (Rightly or Wrongly),
 plate 2, ca. 1811–12

 Lo mismo (The Same), plate 3, ca. 1811–12

 Las mugeres dan valor (The Women Give
 Courage), plate 4, ca. 1811–12

 Y son fieras (And They are Like Wild
 Beasts), plate 5, ca. 1811–12

Bien te se está (It Serves You Right),
plate 6, ca. 1811–12

Que valor! (What Courage!), plate 7,
ca. 1811–12

Siempre sucede (It Always Happens),
plate 8, ca. 1813–14

No quiren [sic] (They Don't Like It),
plate 9, ca. 1811–12

Tampoco (Nor [Do These] Either),
plate 10, ca. 1811–12

Ni por esas (Neither Do These), plate 11,
ca. 1811–12
 CUSHING, FIG. 2

Para eso habeis nacido (This Is
What You Were Born For), plate 12,
ca. 1810–11
 HIGHLIGHTS, PL. 31

Amarga presencia (Bitter to Be
Present), plate 13, ca. 1811–12

Duro es el paso! (It's a Hard Step!),
plate 14, ca. 1811–12

Y no hai remedio (And There's No Help
for It), plate 15, ca. 1811–12

Se aprovechan (They Make Use of
Them), plate 16, ca. 1810–11

No se convienen (They Do Not Agree),
plate 17, ca. 1811–12

Enterrar y callar (Bury Them and Keep
Quiet), plate 18, ca. 1810–11

Ya no hay tiempo (There Isn't Time
Now), plate 19, ca. 1811–12

Curarlos, y á otra (Get Them Well, and
on to the Next), plate 20, 1810
 HIGHLIGHTS, PL. 32

Será lo mismo (It Will Be the Same),
plate 21, ca. 1811–12

Tanto y mas (Even Worse), plate 22,
1810

Lo mismo en otras partes (The Same
Elsewhere), plate 23, ca. 1810–11

Aun podrán servir (They Can Still Be of
Use), plate 24, ca. 1810–11

Tambien estos (These Too), plate 25,
ca. 1813

No se puede mirar (One Can't Look),
plate 26, ca. 1811–12

Caridad (Charity), plate 27, 1810

Populacho (Rabble), plate 28, ca. 1813

Lo merecia (He Deserved It), plate 29,
ca. 1813

Estragos de la guerra (Ravages of War),
plate 30, ca. 1811–12

Fuerte cosa es! (That's Tough!), plate 31,
ca. 1811–12

Por que [sic]? (Why?), plate 32,
ca. 1811–12

Que [sic] *hai que hacer mas?* (What
More Can Be Done?), plate 33,
ca. 1811–12

Por una nabaja [sic] (On Account of a
Knife), plate 34, ca. 1811–12
 BOORSCH, FIG. 6

No se puede saber por que [sic] (One
Can't Tell Why), plate 35, ca. 1811–12

Tampoco (Not [in This Case] Either),
plate 36, ca. 1811–12

Esto es peor (This Is Worse), plate 37,
ca. 1811–12

Bárbaros! (Barbarians!), plate 38,
ca. 1811–12

Grande hazaña! Con muertos!
(A Heroic Feat! With Dead Men!),
plate 39, ca. 1811–12

Algun partido saca (He Gets
Something out of It), plate 40,
ca. 1813–14

Escapan entre las llamas (They
Escape through the Flames), plate 41,
ca. 1810–11

Todo va revuelto (Everything Is Topsy-
Turvy), plate 42, ca. 1813

Tambien esto (This Too), plate 43,
ca. 1810–11

Yo lo vi (I Saw It), plate 44, ca. 1810–11

Y esto tambien (And This Too), plate 45,
ca. 1813

Esto es malo (This Is Bad), plate 46,
ca. 1811–12

Así sucedió (This Is How It Happened),
plate 47, ca. 1811–12

Cruel lástima! (Cruel Tale of Woe!),
plate 48, ca. 1812

Caridad de una muger (A Woman's
Charity), plate 49, ca. 1812

Madre infeliz! (Unhappy Mother!), plate 50, ca. 1812

Gracias á la almorta (Thanks to the Millet), plate 51, ca. 1812

No llegan á tiempo (They Do Not Arrive in Time), plate 52, ca. 1812

Espiró sin remedio (There Was Nothing to Be Done and He Died), plate 53, ca. 1812

Clamores en vano (Appeals Are in Vain), plate 54, ca. 1812
 HIGHLIGHTS, PL. 33

Lo peor es pedir (The Worst Is to Beg), plate 55, ca. 1812

Al cementerio (To the Cemetery), plate 56, ca. 1812

Sanos y enfermos (The Healthy and the Sick), plate 57, ca. 1812

No hay que dar voces (It's No Use Crying Out), plate 58, ca. 1812

De qué sirve una taza? (What Is the Use of a Cup?), plate 59, ca. 1812

No hay quien los socorra (There Is No One to Help Them), plate 60, ca. 1812

Si son de otro linage (Perhaps They Are of Another Breed), plate 61, ca. 1812

Las camas de la muerte (The Beds of Death), plate 62, ca. 1813

Muertos recogidos (Harvest of the Dead), plate 63, ca. 1812

Carretadas al cementerio (Cartloads to the Cemetery), plate 64, ca. 1812

Qué alboroto es este? (What Is This Hubbub?), plate 65, ca. 1813–14

Extraña devocion! (Strange Devotion!), plate 66, ca. 1813–14

Esta no lo es menos (This Is Not Less So), plate 67, ca. 1813–14

Que locura! (What Madness!), plate 68, ca. 1813–14

Nada. [Ello dirá] (Nothing. [The Event Will Tell]), plate 69, ca. 1813

No saben el camino (They Do Not Know the Way), plate 70, ca. 1813–14

Contra el bien general (Against the Common Good), plate 71, ca. 1813–14
 HIGHLIGHTS, PL. 34

Las resultas (The Consequences), plate 72, ca. 1813–14

Gatesca pantomima (Feline Pantomime), plate 73, ca. 1813–14

Esto es lo peor! (That Is the Worst of It!), plate 74, ca. 1813–14

Farándula de charlatanes (Charlatans' Show), plate 75, ca. 1813–14
 CUSHING, FIG. 1

El buitre carnívoro (The Carnivorous Vulture), plate 76, ca. 1813–14

Que se rompe la cuerda (May the Cord Break), plate 77, ca. 1813–14
 HIGHLIGHTS, PL. 35

Se defiende bien (He Defends Himself Well), plate 78, ca. 1813–14

Murió la verdad (Truth Has Died), plate 79, ca. 1813–14

Si resucitará? (Will She Rise Again?), plate 80, ca. 1813–14
 HIGHLIGHTS, PL. 36

Etchings with lavis, aquatint, burin, drypoint, and/or burnisher, ranging from 5 ½ × 6¹¹⁄₁₆ in. (14 × 17 cm) to 7¹⁄₁₆ × 8¹¹⁄₁₆ in. (18 × 22 cm)
Harris 121–200, III, 1a except plates 36 and 47, Harris 156 and 167, III, 1b
2012.159.37.1–.81

La tauromaquia (The Art of Bullfighting), published 1816 (first edition)

Explanatory sheet listing titles

Modo con que los antiguos españoles cazaban los toros á caballo en el campo (The Way in Which the Ancient Spaniards Hunted Bulls on Horseback in the Open Country), plate 1, 1816

Otro modo de cazar á pie (Another Way of Hunting on Foot), plate 2, 1816

Los moros establecidos en España, prescindiendo de las supersticiones de su Alcorán, adoptaron esta caza y arte, y lancean un toro en el campo (The Moors Settled in Spain, Giving Up the Superstitions of the Koran, Adopted This Art of Hunting, and Spear a Bull in the Open), plate 3, 1816

Capean otro encerrado (They Play Another with the Cape in the Enclosure), plate 4, 1816

El animoso moro Gazul es el primero que lanceó toros en regla (The Spirited Moor Gazul Is the First to Spear Bulls According to the Rules), plate 5, 1816

Los moros hacen otro capeo en plaza con su albornez (The Moors Make a Different Play in the Ring Calling the Bull with Their Burnous), plate 6, 1816

Origen de los arpones ó banderillas (Origin of the Harpoons or Banderillas), plate 7, 1816

Cogida de un moro estando en la plaza (A Moor Caught by the Bull in the Ring), plate 8, 1816

Un caballero español mata un toro despues de haber perdido el caballo (A Spanish Knight Kills the Bull after Having Lost His Horse), plate 9, 1816

Carlos V. lanceando un toro en la plaza de Valladolid (Charles V Spearing a Bull in the Ring at Valladolid), plate 10, 1816

El Cid Campeador lanceando otro toro (The Cid Campeador Spearing Another Bull), plate 11, 1816

Desjarrete de la canalla con lanzas, medias-lunas, banderillas y otras armas (The Rabble Hamstring the Bull with Lances, Sickles, Banderillas, and Other Arms), plate 12, 1816

Un caballero español en plaza que brando rejoncillos sin auxilio de los chulos (A Spanish Mounted Knight in the Ring Breaking Short Spears without the Help of Assistants), plate 13, 1816

El diestrísmo estudiante de Falces, embozado burla al toro con sus quiebros (The Very Skillful Student of Falces, Wrapped in His Cape, Tricks the Bull with the Play of His Body), plate 14, 1816

El famoso Martincho poniendo banderillas al quiebro (The Famous Martincho Places the Banderillas Playing the Bull with the Movement of His Body), plate 15, 1816

El mismo vuelca un toro en la plaza de Madrid (The Same Man Throws a Bull in the Ring at Madrid), plate 16, 1816

Palenque de los moros hecho con burros para defenderse del toro embolado

(The Moors Use Donkeys as a Barrier to Defend Themselves against the Bull Whose Horns Have Been Tipped with Balls), plate 17, 1816

Temeridad de Martincho en la plaza de Zaragoza (The Daring of Martincho in the Ring at Saragossa), plate 18, 1816

Otra locura suya en la misma plaza (Another Madness of His in the Same Ring), plate 19, 1815
 HIGHLIGHTS, PL. 37

Ligereza y atrevimiento de Juanito Apiñani en la de Madrid (The Agility and Audacity of Juanito Apiñani in the [Ring] at Madrid), plate 20, 1816
 HIGHLIGHTS, PL. 38

Desgracias acaecidas en el teniendo de la plaza de Madrid, y muerte del alcalde de Torrejon (Dreadful Events in the Front Rows of the Ring at Madrid, and Death of the Mayor of Torrejon), plate 21, 1816
 HIGHLIGHTS, PL. 39

Valor varonil de la célebre Pajuelera en la de Zaragoza (Manly Courage of the Celebrated Pajuelera in the [Ring] at Saragossa), plate 22, 1816

Mariano Ceballos, alias el Indio, mata el toro desde su caballo (Mariano Ceballos, Alias the Indian, Kills the Bull from His Horse), plate 23, 1816

El mismo Ceballos montado sobre otro toro quiebra rejones en la plaza de Madrid (The Same Ceballos Mounted on Another Bull Breaks Short Spears in the Ring at Madrid), plate 24, 1816

Echan perros al toro (They Loose Dogs on the Bull), plate 25, 1816
 BOORSCH, FIG. 2

Caida de un picador de su caballo debajo del toro (A Picador Is Unhorsed and Falls under the Bull), plate 26, 1816

El célebre Fernando del Toro, barilarguero, obligando a la fiera con su garrocha (The Celebrated Picador, Fernando del Toro, Draws the Fierce Beast On with His Pique), plate 27, 1816

El esforzado Rendon picando un toro, de cuya suerte murió en la plaza de Madrid (The Forceful Rendon Stabs a Bull with the Pique, from Which Pass He Died in the Ring of Madrid), plate 28, 1816

Pepe Illo haciendo el recorte al toro (Pepe Illo Making the Pass of the *Recorte*), plate 29, 1815
 CUSHING, FIG. 3

Pedro Romero matando á toro parado (Pedro Romero Killing the Halted Bull), plate 30, 1816

Banderillas de fuego (Banderillas with Firecrackers), plate 31, 1816

Dos grupos de picadores arrolados de seguida por un solo toro (Two Teams of Picadors Thrown One after the Other by a Single Bull), plate 32, 1816

La desgraciada muerte de Pepe Illo en la plaza de Madrid (The Unlucky Death of Pepe Illo in the Ring at Madrid), plate 33, 1816

Etchings; aquatints; or etchings with aquatint, drypoint, and/or engraving, each 9 ⅝ × 14 in. (24.5 × 35.5 cm); explanatory sheet: 12 ³⁄₁₆ × 17 ⁵⁄₁₆ in. (31 × 44 cm)
Harris 204–36, III, 1
2012.159.38.1–.34

La taureaumachie (The Art of Bull-fighting), 1815–16, published 1876 (third edition)

Title page, with *Portrait of Goya*, by Eugène Loizelet (French, 1842–1882)

Portrait of Goya (also used on title page), by Eugène Loizelet (French, 1842–1882)

Explanatory sheet listing titles

Mode des anciens Espagnols de chasser le taureau à cheval et dans les campagnes (The Way in Which the Ancient Spaniards Hunted Bulls on Horseback in the Open Country), plate 1

Autre manière de chasser à pied (Another Way of Hunting on Foot), plate 2

Les Maures établis en Espagne éludant les préceptes du Coran, adoptent l'art de combattre les taureaux (The Moors Settled in Spain, Eluding the Precepts of the Koran, Adopt the Art of Fighting Bulls), plate 3

Autres Maures qui capean dans une lice fermée (Other Moors Who Play with the Cape within an Enclosure), plate 4

Le courageux Maure Gazul, le premier qui combattit avec la lance suivant les règles (The Courageous Moor Gazul, the First Who Fought with the Lance According to the Rules), plate 5

Maures qui "capean" avec leurs burnous dans la plaza (Moors Who Play with Their Burnous in the Ring), plate 6

Origine des harpons ou banderillas (Origin of the Harpoons or Banderillas), plate 7

Coup de corne reçu par un Maure dans la place (A Horn Wound Received by a Moor in the Ring), plate 8

Chevalier espagnol tuant un taureau après avoir perdu son cheval (A Spanish Knight Killing a Bull after Having Lost His Horse), plate 9

Charles-Quint "lanceado" un taureau dans la place de Valladolid (Charles V Spearing a Bull in the Ring at Valladolid), plate 10

Le Cid Campeador "lanceado" un autre taureau (The Cid Campeador Spearing Another Bull), plate 11

Desjarette de la canaille avec leurs lances banderillas, demi-lunes et autres armes (The Rabble Hamstring the Bull with Spears, Banderillas, Sickles, and Other Arms), plate 12

Un cavalier espagnol brisant des rejoncillos sans l'aide des chulos (A Spanish Knight Breaking Short Spears without the Help of Assistants), plate 13

Le très-adroit étudiant de Falces joue avec le taureau, enveloppé dans son manteaux (The Very Skillful Student of Falces Tricks the Bull, Wrapped in His Cape), plate 14

Le fameux Martincho posant les banderillas (The Famous Martincho Placing the Banderillas), plate 15

Martincho faisant tourner un taureau dans la place de Madrid (Martincho Throwing a Bull in the Ring at Madrid), plate 16

Maures combattant un taureau embollado et s'abritant derrière des ânes (Moors Fighting a Bull Whose Horns Are Tipped with Balls and Taking Cover behind the Donkey), plate 17

Témérité de Martincho dans la place de Saragosse (The Recklessness of Martincho in the Ring at Saragossa), plate 18

Autre folie du même dans la place de Saragosse (Another Foolishness of the Same [Martincho] in the Ring at Saragossa), plate 19

Légèreté et audace de Juanito Apinani dans la place de Madrid (The Agility and Audacity of Juanito Apinani in the Ring at Madrid), plate 20

Malheur arrivé dans le tendido de la place de Madrid et mort de l'alcade Torrejos (Misfortune Arrived in the Front Rows of the Ring at Madrid and the Death of the Mayor [of] Torrejon), plate 21

Courage viril de la célèbre Pajuelera dans la place de Saragosse (Manly Courage of the Celebrated Pajuelera in the Ring at Saragossa), plate 22

Mariano Ceballos l'Indien tue le taureau de dessus son cheval (Mariano Ceballos the Indian Kills the Bull from His Horse), plate 23

Le même Ceballos monté sur un taureau brise des rejoncillos dans la place de Madrid (The Same Ceballos Mounted on a Bull Breaks Short Spears in the Ring at Madrid), plate 24

Les chiens lâchés sur le taureau (Dogs Loosed on the Bull), plate 25

Chute d'un picador tombé de son cheval sous les pieds du taureau (The Fall of an Unhorsed Picador under the Feet of a Bull), plate 26

Le célèbre Fernando del Toro invitant le taureau avec sa lance (The Celebrated Fernando del Toro Enticing the Bull with His Spear), plate 27

Le courageux Randon piquant un taureau avec sa lance (The Courageous Randon Stabbing a Bull with His Lance), plate 28

Pepe Illo faisant la recorte au taureau (Pepe Illo Making the Pass of the *Recorte*), plate 29

Pedro Romero tuant un taureau indolent (Pedro Romero Killing the Halted Bull), plate 30

Les banderillas avec artifices (The Banderillas with Firecrackers), plate 31

Deux groupes de Picadores renversés coup sur coup par le même taureau (Two Groups of Picadors Thrown in Quick Succession by the Same Bull), plate 32

Mort malheureuse de Pepe Illo, arrivée dans la place de Madrid le 11 mai 1801 (The Unfortunate Death of Pepe Illo, Which Took Place in the Ring at Madrid 11 May 1801), plate 33

PLANCHES INÉDITES (Unpublished Plates)

Portrait de Goya, dessiné et gravé par E. Loizelet (Portrait of Goya, Designed and Etched by E. Loizelet)

Un cavalier espagnol brisant des rejoncillos avec l'aide des chulos (A Spanish Knight Breaking Short Spears with the Help of His Assistants), plate A

Cheval renversé par un taureau (Horse Thrown by a Bull), plate B

Les chiens lâchés sur le taureau (Dogs Loosed on the Bull), plate C

Un torero monté sur les épaules d'un chulo lanceado un taureau (A Torero Mounted on the Shoulders of an Assistant Spearing a Bull), plate D

Mort de Pepe Illo (2e composition) (Death of Pepe Illo [2nd Composition]), plate E

Mort de Pepe Illo (3e composition) (Death of Pepe Illo [3rd Composition]), plate F

Combat dans une voiture attelée de deux mulets (Battle in a Carriage Drawn by Two Mules), plate G

Etchings; aquatints; or etchings with aquatint, drypoint, and/or engraving, each 9 5/8 × 14 in. (24.5 × 35.5 cm); explanatory sheet: 12 7/8 × 19 1/4 in. (32.7 × 48.9 cm)
Harris 204–43, III, 3
2012.159.39.1–.43

Los disparates (Los proverbios) (Follies [Proverbs]), ca. 1816–19, published 1864 (first edition)

Title page

Disparate femenino (Feminine Folly), also known as *Pesa mas que un burro muerto* (Heavier Than a Dead Donkey)

Disparate de miedo (Folly of Fear), also known as *Por temor no pierdas honor* (Do Not Lose Honor through Fear)
CUSHING, FIG. 4

Disparate ridiculo (Ridiculous Folly), also known as *Andarse por las ramas* (To Go among the Branches)
HIGHLIGHTS, PL. 40

Bobalicón (Simpleton), also known as *Tras el vicio viene el fornicio* (After Vice Comes Fornication)
HIGHLIGHTS, PL. 41

Disparate volante (Flying Folly), also known as *Reniego al amigo que cubre con las alas y muerde con el pico* (Renounce the Friend Who Covers You with His Wings and Bites You with His Beak)

Disparate furioso (Furious Folly), also known as *Hizonos dios y maravillamos nos* (It Is Amazing and We Were Made by God)

Disparate desordenado (Disorderly Folly) or *Disparate matrimonial* (Matrimonial Folly), also known as *La que mal marida nunca le falta que diga* (She Who Is Ill Wed Never Misses a Chance to Say So)

Los ensacados (The Men in Sacks), also known as *So el sayal, hay al* (There Is Something beneath the Sackcloth)
BOORSCH, FIG. 1

A proof impression of *Los ensacados*

Disparate general (General Folly), also known as *Unas de gato y habito de beato* (The Claws of a Cat and the Dress of a Devotee)

A proof impression of *Disparate general*

El caballo raptor (The Horse Abductor), also known as *La mujer y el potro, que los dome otro* (A Woman and a Horse, Let Someone Else Master Them)
HIGHLIGHTS, PL. 42

Disparate pobre (Poor Folly), also known as *Two Heads Are Better Than One*

Si Marina bayló, tome lo que halló (If Marion Will Dance, Then She Has to Take the Consequences)

Modo de volar (A Way of Flying), also known as *Donde hay ganas hay maña* (Where There's a Will There's a Way)
GREIST, FIG. 3

Disparate de carnabal (Carnival Folly), also known as *Alegrias antruejo, que mañana seras ceniza* (Rejoice Carnival, for Tomorrow Thou Will Be Ashes)

Disparate claro (Clear Folly), also known as *Sin recomendarse a Dios ni al diablo* (Without Commending Himself to Either God or the Devil)

Sanan cuchilladas mas no malas palabras (Wounds Heal Quicker Than Hasty Words)

La lealtad (Loyalty), also known as *El que no te ama, burlando te difama* (He Who Does Not Like Thee Will Defame Thee in Jest)

Dios los cria y ellos se juntan (God Creates Them and They Join Up Together)

Etchings with aquatint, lavis, burin, drypoint, and/or burnisher, each 9⅝ × 13¾ in. (24.5 × 35 cm); title page: 13¼ × 19⅝ in. (33.6 × 49.9 cm)
Harris 248–65, III, 1
2012.159.40.1–.19, .41–.42

Four additional subjects from *Los disparates (Los proverbios)* (Follies [Proverbs]), ca. 1816–19, published in *L'art*, 1877

Disparate conocido (Well-Known Folly), also known as *Dos a uno, meten la paja en el culo* (If Two to One, Stuff Your Arse with Straw), published as *¡QUE GUERRERO! (Quel guerrier!)* (What a Warrior!)

Disparate puntual (Punctual Folly), also known as *Bailando en una cuerda floja* (Dancing on a Slack Rope, [Skating on Thin Ice], published as *UNA REINA DEL CIRCO (Une reine du Cirque)* (A Queen of the Circus)

Disparate de bestia (Animal Folly), also known as *Quien se pondrà el cascabel al gato?* (Who Will Bell the Cat?), published as *OTRAS LEYES POR EL PUEBLO (Autres lois pour le peuple)* (Other Laws for the People)

Disparate de tontos (or toritos) (Fools'— or Little Bulls'—Folly), also known as *Al toro y al aire darles calle* (Make Way for Bulls and Wind), published as *LLUVIA DE TOROS (Pluie de taureaux)* (Rain of Bulls)
HIGHLIGHTS, PL. 43

Etchings with aquatint, lavis, burin, drypoint, and/or burnisher, each 9⅝ × 14 in. (24.5 × 35.5 cm)
Harris 266–69, III, 1
2012.159.44 (between pages 6–7, 40–41, 56–57, 82–83)

Bullfight in a Divided Ring, from the *Bulls of Bordeaux*, 1825
Lithograph, 11¹³⁄₁₆ × 16⁵⁄₁₆ in. (30 × 41.5 cm)
Harris 286, III, 1
2012.159.43
BOORSCH, FIG. 5

AFTER GIOVANNI FRANCESCO BARBIERI, CALLED GUERCINO (UNLESS OTHERWISE NOTED)
Italian, 1591–1666

RACCOLTA DI ALCUNI DISEGNI DEL BARBERI [sic] DA CENTO DETTO IL GUERCINO (Collection of Some Drawings by Barbieri da Cento, called Guercino), 1764

Title page, with *Saint Jerome*, plate 1, by Giovanni Ottaviani (Italian, 1735–1808)
Etching, 4¾ × 4⁷⁄₁₆ in. (12.1 × 11.2 cm)
Le Blanc III.132.14, only state

Half-title page with *Saint Joseph*, plate 2, by Giovanni Battista Piranesi (Italian, 1720–1778)
Etching and engraving with red and black ink, 18⅞ × 13¹⁵⁄₁₆ in. (48 × 35.4 cm)
Wilton-Ely 1015
BOORSCH, FIG. 13

Holy Family, plate 3, by Francesco Bartolozzi (Italian, 1727–1815)
Etching, 15¹¹⁄₁₆ × 11⁵⁄₁₆ in. (39.9 × 28.8 cm)
Calabi and de Vesme 2111, only state

The Head of Saint John the Baptist on a Platter with Angels Holding a Cloth with His Face Imprinted Above, plate 4, by Giacomo Nevay (Italian, 1764–1791)
Etching, 8⅜ × 7³⁄₁₆ in. (21.3 × 18.3 cm)

A Woman Holding a Flower, plate 5, by Giacomo Nevay (Italian, 1764–1791)
Etching, 9⅞ × 7³⁄₁₆ in. (25.1 × 18.3 cm)

Saint Francis in Prayer, plate 6, by Francesco Bartolozzi (Italian, 1727–1815)
Etching, 16 × 11⅝ in. (40.6 × 29.5 cm)
Calabi and de Vesme 2112, only state

The Virgin and Child with Saint Anne, plate 7, by Francesco Bartolozzi (Italian, 1727–1815)
Etching in black and sanguine with sanguine plate tone, 16 × 11¹¹⁄₁₆ in. (40.7 × 29.7 cm)
Calabi and de Vesme 2113, only state

Christ with Saint Joseph, plate 8, by Francesco Bartolozzi (Italian, 1727–1815)
Etching in black and sanguine with sanguine plate tone, 13⁷⁄₁₆ × 10⅛ in. (34.2 × 25.7 cm)
Calabi and de Vesme 2114, only state

Virgin and Child Appearing to Three Kneeling Monks (La Madonna del Carmine), plate 9, by Francesco Bartolozzi (Italian, 1727–1815)
Etching in black and sanguine, 13⅜ × 10¼ in. (34 × 26 cm)
Calabi and de Vesme 2115, only state

Virgin and Child with the Infant Saint John, plate 10, by Francesco Bartolozzi (Italian, 1727–1815)
Etching in black and sanguine, 12⁷⁄₁₆ × 17½ in. (31.6 × 44.4 cm)
Calabi and de Vesme 2116, only state

An Angel Playing a Violin and *Bust of an Old Man*, plate 11, by Giovanni Ottaviani (Italian, 1735–1808)
2 etchings on 1 plate in black and sanguine, 9³⁄₁₆ × 7⁵⁄₁₆ in. (23.4 × 18.5 cm) and 6⅞ × 7⅝ in. (17.5 × 19.3 cm)
Le Blanc III.132.17 (as Saint Cecilia) and .91, only states

Saint Theresa with the Christ Child in Her Arms, plate 12, by Francesco Bartolozzi (Italian, 1727–1815)
Etching in black and sanguine, 12⁷⁄₁₆ × 17½ in. (31.6 × 44.4 cm)
Calabi and de Vesme 2117, only state

A Family in Prayer, plate 13, by Francesco Bartolozzi (Italian, 1727–1815)
Etching in black and sanguine, 9⁵⁄₁₆ × 13⅛ in. (23.6 × 33.4 cm)
Calabi and de Vesme 2118, only state

A Sacrifice, plate 14, by Francesco Bartolozzi (Italian, 1727–1815) Etching in black and sanguine with sanguine plate tone, 11½ × 16 in. (29.2 × 40.6 cm) Calabi and de Vesme 2119, only state

Diana at the Bath, plate 15, by Giovanni Ottaviani (Italian, 1735–1808) Etching in black and sanguine with sanguine plate tone, 9 5/16 × 13 1/8 in. (23.6 × 33.4 cm) Le Blanc III.132.92, only state

Virgin and Child with the Infant Saint John, plate 16, by Giovanni Battista Piranesi (Italian, 1720–1778) Etching in black and sanguine with sanguine plate tone, 12 3/8 × 16 9/16 in. (31.5 × 42 cm) Wilton-Ely 1016

Four Naked Children in the Country, plate 17, by Francesco Bartolozzi (Italian, 1727–1815) Etching in black and sanguine with sanguine plate tone, 9 7/8 × 7 3/16 in. (25.1 × 18.3 cm) Calabi and de Vesme 2120, only state

The Adoration of the Magi, plate 18, by Francesco Bartolozzi (Italian, 1727–1815) Etching in black and sanguine with sanguine plate tone, 12 5/8 × 17 9/16 in. (32 × 44.6 cm) Calabi and de Vesme 2121, only state

Holy Family with an Angel, plate 19, by Francesco Bartolozzi (Italian, 1727–1815) Etching in black and sanguine with sanguine plate tone, 11 3/16 × 15 11/16 in. (28.4 × 39.9 cm) Calabi and de Vesme 2122, only state

The Liberation of a Prisoner, plate 20, by Giovanni Ottaviani (Italian, 1735–1808) Etching in black and sanguine with sanguine plate tone, 12 × 16 7/16 in. (30.5 × 41.7 cm) Not in Le Blanc

Venus and Mars, plate 21, by Giovanni Ottaviani (Italian, 1735–1808) Etching in black and sanguine with sanguine plate tone, 12 1/4 × 17 3/16 in. (31.1 × 43.7 cm) Le Blanc III.132.19, only state

An Old Man Leaning against a Stone Wall, plate 22, by Giovanni Battista Piranesi (Italian, 1720–1778) Etching in black and sanguine with sanguine plate tone, 15½ × 10 in. (39.4 × 25.4 cm) Wilton-Ely 1017

Sig.re Nicola Zabbaglia, Ingegnere della Reverenda Fabbrica di S. Pietro (Signore Nicola Zabbaglia, Engineer of the Holy Fabric of Saint Peter's), plate 23, by Giovanni Battista Piranesi (Italian, 1720–1778), after Pier Leone Ghezzi (Italian, 1674–1755) Etching in black and sanguine with sanguine plate tone, 12 × 8 1/16 in. (30.5 × 20.4 cm) Wilton-Ely 1018

Head of an Old Man Looking to the Right, Head of a Young Woman Looking to the Right, Head of an Old Man in a Turban Looking to the Left, and *Head of a Bearded Man in Profile Looking to the Right*, plate 24, by Giacomo Nevay (Italian, 1764–1791), after his own designs Etchings in black and sanguine with sanguine plate tone, printed on 1 sheet (clockwise from top left), ranging from 4 × 2 11/16 in. (10.1 × 6.9 cm) to 4¾ × 3¾ in. (12.1 × 9.6 cm)

Entombment, plate 25, by Tommaso Piroli (Italian, 1747–1829), after Michelangelo Merisi, called Caravaggio (Italian, 1571–1610) Engraving, 18 1/8 × 12½ in. (46.1 × 31.8 cm) Le Blanc III.208.1, only state

Angelica and Medoro, plate 26, by Giovanni Ottaviani (Italian, 1735–1808) Etching in black and sanguine with sanguine plate tone, 11 5/8 × 15 7/8 in. (29.5 × 40.3 cm) Le Blanc III.132.21, only state

Furius Camillus Liberating Rome from Bennus, plate 27, by Francesco Bartolozzi (Italian, 1727–1815), after Sebastiano Ricci (Italian, 1659–1734) Etching in black and sanguine with sanguine plate tone, 17 × 22 3/8 in. (43.2 × 56.9 cm) Calabi and de Vesme 505, state iiib/iii

Venus Distraught over the Death of Adonis, plate 28, by Tommaso Piroli (Italian, 1747–1829)

Etching in black and sanguine with sanguine plate tone, 16 13/16 × 21 1/16 in. (42.7 × 53.5 cm) Le Blanc III.209.7, only state

2012.159.1.1–.28

ANTONIO JOLI
See under Filippo Morghen

THOMAS LAWRENCE
See under Unknown artist

EUGÈNE LOIZELET
See under Francisco Goya

ARISTIDE MAILLOL
French, 1861–1944

Illustrations in Ovid, *L'art d'aimer* (The Art of Love), Lausanne: Gonin, 1935 Book with 24 lithographs and 14 woodcuts, in an exterior case: 15 9/16 × 11 × 1 5/8 in. (39.5 × 28 × 4.2 cm); book: 15 3/16 × 11 1/16 × 1 ¼ in. (38.6 × 28 × 3.1 cm); prints: ranging from 2 13/16 × 2 5/8 in. (7.2 × 6.7 cm) to 13 ¾ × 4 15/16 in. (35 × 12.5 cm) Guérin 1965, vol. 1, nos. 64–75, all only states except nos. 66, state ii/ii; 72, state i/ii; and 74, state ii/ii, followed by impressions of no. 66, state i/ii, state ii/ii; and no. 74, state i/ii; Guérin 1965, vol. 2, nos. 307–18, all only states, followed by another set of impressions in sanguine, nos. 307–18 2012.159.153

ÉDOUARD MANET
French, 1832–1883

The Absinthe Drinker, 1860 Etching and aquatint, 11 ¼ × 6 5/16 in. (28.6 × 16.1 cm) Guérin 1969, 9, state iii/iii; Harris 1990, 16, state iii/iii 2012.159.74

The Spanish Singer, 1861 Etching and aquatint, 11 11/16 × 9 5/8 in. (29.7 × 24.4 cm) Guérin 1969, 16, state ii/v; Harris 1990, 12, state ii/v 2012.159.72
HIGHLIGHTS, PL. 56

Don Mariano Camprubi, primer bailarin del teatro royal de Madrid (Don Mariano

Camprubi, First Dancer of the Teatro Royal de Madrid), 1862
Etching, 11¾ × 7¾ in. (29.9 × 19.7 cm)
Guérin 1969, 24, only state; Harris 1990, 34, only state
2012.159.77
 BOORSCH, FIG. 24

Les gitanos (The Gypsies), 1862
Etching, 12⁷⁄₁₆ × 9⁵⁄₁₆ in. (31.6 × 23.6 cm)
Guérin 1969, 21, state ii/ii; Harris 1990, 18, state ii/ii
2012.159.75

Philip IV, after Diego Velázquez (Spanish, 1599–1660), 1862
Etching and aquatint, 13¾ × 9⅜ in. (35 × 23.8 cm)
Guérin 1969, 7, state v/vii; Harris 1990, 15, state iv/vii
2012.159.73

The Toilette, 1862
Etching, 11³⁄₁₆ × 8¾ in. (28.4 × 22.3 cm)
Guérin 1969, 26, state ii/ii; Harris 1990, 20, state ii/ii
2012.159.76

Exotic Flower, 1868
Etching and aquatint, 6⅞ × 5⁵⁄₁₆ in. (17.4 × 13.5 cm)
Guérin 1969, 51, state ii/ii; Harris 1990, 57, state ii/ii
2012.159.78

Portrait of Berthe Morisot, 1872
Lithograph, 4¾ × 3⅛ in. (12 × 7.9 cm)
Guérin 1969, 59, state ii/ii; Harris 1990, 73, state ii/ii
2012.159.79

Polichinelle, 1874–76
Lithograph printed in 7 colors, 18⅛ × 13³⁄₁₆ in. (46 × 33.5 cm)
Guérin 1969, 79, state iii/iii; Harris 1990, 80, state iii/iii
2012.159.80
 HIGHLIGHTS, PL. 57

Illustrations to Edgar Allan Poe's *The Raven*, 1875

 Under the Lamp
 10¾ × 14⅞ in. (27.3 × 37.8 cm)
 Guérin 1969, 86a, only state; Harris 1990, 83b, only state

 Another impression of *Under the Lamp*

 At the Window
 15⅛ × 12⅛ in. (38.4 × 30.8 cm)

Guérin 1969, 86c, state i/ii; Harris 1990, 83c, state i/ii

Another impression of *At the Window*
Undescribed state before i/ii

The Raven on the Bust of Pallas
18⅞ × 12⁵⁄₁₆ in. (48 × 31.2 cm)
Guérin 1969, 86b, state ii/ii; Harris 1990, 83d, state ii/ii
 HIGHLIGHTS, PL. 58

The Chair
11⅛ × 10⅞ in. (28.2 × 27.7 cm)
Guérin 1969, 86d, only state; Harris 1990, 83e, only state
 HIGHLIGHTS, PL. 59

Flying Raven (ex libris)
2½ × 9⁷⁄₁₆ in. (6.3 × 24 cm)
Guérin 1969, 86, only state; Harris 1990, 83f, only state

Transfer lithographs
2012.159.81.1–.6, 2012.159.82
 HODERMARSKY, FIG. 3

JUAN BAUTISTA MARTÍNEZ DEL MAZO
 See under Edgar Degas

HENRI MATISSE
 French, 1869–1954

Dancer on a Stool, 1927
Lithograph, 18 × 11 in. (45.7 × 28 cm)
Duthuit 481, only state
2012.159.158

Nadia in Sharp Profile, 1948
Aquatint, 16¹⁵⁄₁₆ × 13¹¹⁄₁₆ in. (43 × 34.7 cm)
Duthuit 810, only state
2012.159.159
 HIGHLIGHTS, PL. 67

MORTIMER MENPES
 British, 1855–1938

Whistler, Looking Right, Monocle Left Eye, 1902–3
Etching and drypoint, 9³⁄₁₆ × 11 in. (23.3 × 28 cm)
Morgan 235, only state
2012.159.150
 HIGHLIGHTS, PL. 64

Whistler no. 2, also known as *Whistler: Monocle Left Eye*, 1902–3
Etching and drypoint, 7³⁄₁₆ × 5⁵⁄₁₆ in. (18.3 × 13.5 cm)

Morgan 239, only state
2012.159.94

Another impression of *Whistler no. 2*
Morgan 239, canceled plate (unknown to Morgan)
2012.159.149

Grand Canal Showing Tower of St. Geremia, 1904
Etching and drypoint, 5³⁄₁₆ × 5⅞ in. (13.2 × 15 cm)
Not in Morgan
2012.159.100

Sicilian Street, 1907–8
Etching and drypoint, 5⅞ × 5¼ in. (14.9 × 13.4 cm)
Morgan 332, only state
2012.159.151

Another impression of *Sicilian Street*
2012.159.152

A Side Canal, Venice, 1907–8
Etching and drypoint, 5⁵⁄₁₆ × 6 in. (13.5 × 15.2 cm)
Morgan 275, only state
2012.159.137

Another impression of *A Side Canal, Venice*
2012.159.138

Bridge of Sighs, Venice, 1910–11
Etching and drypoint, 11¹¹⁄₁₆ × 7¹⁵⁄₁₆ in. (29.7 × 20.2 cm)
Morgan 362, only state
2012.159.102

Façade of the Scuola di San Marco, Venice, 1910–11
Etching and drypoint, 11¾ × 8 in. (29.8 × 20.3 cm)
Morgan 359, only state
2012.159.117

Palazzi on the Canal, 1910–11
Etching and drypoint, 3¾ × 11⅞ in. (9.5 × 30.2 cm)
Morgan 363, only state
2012.159.119

The Piazza of St. Mark, Venice, 1910–11
Etching and drypoint, 7⅞ × 11⅞ in. (20 × 30.1 cm)
Morgan 368, only state
2012.159.103
 HIGHLIGHTS, PL. 65

A Quiet Rio, 1910–11
Soft-ground etching, 5¹⁵⁄₁₆ × 5¼ in.
(15.1 × 13.4 cm)
Morgan 358, only state
2012.159.107

St. Maria della Misericordia, 1910–11
Etching and drypoint, 7¹⁵⁄₁₆ × 11⅞ in.
(20.2 × 30.1 cm)
Morgan 361, only state
2012.159.123

Back by Way Canal, 1910–13
Etching and drypoint, 11⅞ × 4 in.
(30.2 × 10.1 cm)
Morgan 370, only state
2012.159.118

An Old Bridge, Venice, 1910–13
Etching, 7¹⁵⁄₁₆ × 11⅞ in. (20.2 × 30.2 cm)
Morgan 355, only state
2012.159.144

Panorama from St. Mark's Basin (1),
1910–13
Etching, 4¹⁄₁₆ × 11⅞ in. (10.3 × 30.2 cm)
Morgan 371, only state
2012.159.145

Panorama from St. Mark's Basin (3),
1910–13
Etching and drypoint, 4 × 11⅞ in.
(10.2 × 30.1 cm)
Morgan 373, only state
2012.159.99

San Giorgio Maggiore, 1910–13
Etching and drypoint, 7¹³⁄₁₆ × 11⅞ in.
(19.8 × 30.1 cm)
Morgan 367, only state
2012.159.101
 GREIST, FIG. 7

Interior of St. Mark's, 1910–18
Etching and drypoint, 11⅞ × 7¹⁵⁄₁₆ in.
(30.1 × 20.1 cm)
Morgan 366, state ii/ii
2012.159.115

A Palazzo, ca. 1910–20
Etching and drypoint, 6 × 5¼ in.
(15.2 × 13.3 cm)
Not in Morgan
2012.159.146

A Side Street in Chioggia, 1911–13
Etching and drypoint, 5⅞ × 5¼ in.
(15 × 13.3 cm)
Morgan 374, state ii/ii
2012.159.109

A Back Canal, Venice, also known as
Palaces, 1912–13
Etching and drypoint, 5⅞ × 6½ in.
(14.9 × 16.5 cm)
Morgan 467, only state
2012.159.95

Another impression of *A Back Canal,
Venice*
2012.159.125

Boats on a Canal, Venetian Island,
1912–13
Etching and drypoint, 5¹³⁄₁₆ × 6½ in.
(14.8 × 16.5 cm)
Morgan 416, only state
2012.159.97

Another impression of *Boats on a Canal,
Venetian Island*
2012.159.134

Bridge of Luciano, Grand Canal, 1912–13
Etching and drypoint, 7⅞ × 5⅞ in.
(20 × 15 cm)
Morgan 470, only state
2012.159.135

Bridge, Rotterdam, also known as
Chioggia: Fishing Boats, 1912–13
Etching and drypoint, 5⅝ × 6⁵⁄₁₆ in.
(14.3 × 16.1 cm)
Morgan 422, only state
2012.159.112

Another impression of *Bridge,
Rotterdam*
2012.159.141

Fête Day, Venice, 1912–13
Etching and drypoint on *chine-collé*,
5¼ × 5¹⁵⁄₁₆ in. (13.3 × 15.1 cm)
Morgan 471, only state
2012.159.120

Another impression of *Fête Day, Venice*
2012.159.126

A Market Scene, 1912–13
Etching and drypoint, 5¹⁵⁄₁₆ × 5³⁄₁₆ in.
(15.1 × 13.2 cm)
Morgan 479, only state
2012.159.108

A Narrow Canal, Venice, 1912–13
Etching and drypoint, 7¹³⁄₁₆ × 5¹³⁄₁₆ in.
(19.9 × 14.8 cm)
Morgan 468, only state
2012.159.105

Another impression of *A Narrow Canal,
Venice*
2012.159.139

Reflections, Venice, also known as *Bridge
of Luciano, Grand Canal*, 1912–13
Etching and drypoint, 7⅞ × 5¹³⁄₁₆ in.
(20 × 14.8 cm)
Morgan 469, only state
2012.159.113

Another impression of *Reflections,
Venice*
2012.159.143

Abbazia, 1915–16
Etching and drypoint, 7¹³⁄₁₆ × 11¾ in.
(19.9 × 29.8 cm)
Morgan 648, only state
2012.159.124

Evening, Venice, also known as *Late
Afternoon*, 1915–16
Etching and drypoint on *chine-collé*,
4½ × 10¹³⁄₁₆ in. (11.5 × 27.5 cm)
Morgan 573, only state
2012.159.116

Giudecca, Venice, 1915–16
Etching and drypoint, 4½ × 10¹¹⁄₁₆ in.
(11.5 × 27.1 cm)
Morgan 570, only state
2012.159.98

Two additional impressions of *Giudecca,
Venice*
2012.159.128–.129

In the Eye of the Sun, Venice, 1915–16
Etching and drypoint, 6½ × 8⁷⁄₁₆ in.
(16.5 × 21.4 cm)
Morgan 647, only state
2012.159.130

Another impression of *In the Eye of the
Sun, Venice*
2012.159.131

Osmarin Canal, 1915–16
Etching and drypoint, 11⅝ × 6⅞ in.
(29.6 × 17.4 cm)
Morgan 610, only state
2012.159.106

Santa Maria della Salute (2), 1915–16
Etching and drypoint, 11¾ × 9⅛ in.
(29.9 × 23.2 cm)
Morgan 611, only state
2012.159.121

Another impression of *Santa Maria della Salute (2)*
2012.159.122

Timber Shore of the Brenta, 1915–16
Etching and drypoint, 6⅞ × 10 ¹¹⁄₁₆ in. (17.4 × 27.2 cm)
Morgan 572, only state
2012.159.111

Another impression of *Timber Shore of the Brenta*
2012.159.127

Festival Day, 1916–18
Etching, 3¹⁵⁄₁₆ × 4¹⁵⁄₁₆ in. (10 × 12.5 cm)
Morgan 662, only state
2012.159.147

Lion of St. Mark, 1916–20
Etching and drypoint on *chine-collé*, 16 ⅞ × 10⅞ in. (42.8 × 27.7 cm)
Morgan 683, only state
2012.159.104

Rialto Markets, Venice, 1916–20
Etching and drypoint, 5¼ × 6 in. (13.4 × 15.2 cm)
Morgan 690, only state
2012.159.136

Canal, 1918–20
Etching and drypoint on *chine-collé*, 6 ⅜ × 3 in. (16.2 × 7.6 cm)
Morgan 702, only state
2012.159.148

A Jewish Merchant, 1918–20
Etching and drypoint on *chine-collé*, 5 ¹⁵⁄₁₆ × 3¹⁵⁄₁₆ in. (15.1 × 10 cm)
Morgan 695, only state
2012.159.114

Two additional impressions of *A Jewish Merchant*
2012.159.132–.133

Late Afternoon, Venice, 1918–20
Etching, 5¹⁵⁄₁₆ × 5¼ in. (15.1 × 13.3 cm)
Morgan 700, only state
2012.159.96

Another impression of *Late Afternoon, Venice*
2012.159.140

Loading Barges, 1918–20
Etching and drypoint, 5¹¹⁄₁₆ × 5⅞ in. (14.4 × 14.9 cm)

Morgan 697, only state
2012.159.110

Another impression of *Loading Barges*
2012.159.142

FRANCESCO MONACO
Italian, 1733–1795

AND CARLO NOLLI
Italian, 1710–1785

Urbis romae iconographia (Iconography of the City of Rome), after Giovanni Battista Nolli (Italian, 1701–1756), after Leonardo Bufalini (Italian, 1486/1500–1552), 1755
Engraving on 4 plates, hand-colored, overall 28¹³⁄₁₆ × 38¾ in. (73.2 × 98.4 cm); each 14⁷⁄₁₆ × 19⅜ in. (36.6 × 49.2 cm)
2012.159.10.1–.4

FILIPPO MORGHEN
Italian, 1730–after 1807

Antichità di Pesto (Antiquities of Paestum), after Antonio Joli (Italian, 1700–1777), 1765

 Spiegazione delle VI tavole delle antichità di Pesto (Explanation of the Six Plates of the Antiquities of Paestum)

 Dedication page

 Veduta general degl' avanzi di Pesto dalla parte di mezzo giorno (General View of the Remains of Paestum from the South)

 Veduta laterale de' tre tempj dalla parte d'oriente (Side View of the Three Temples from the East)
 HIGHLIGHTS, PL. 22

 Veduta interiore del tempio esastilo ipetro dalla parte di settentrione (Interior View of the Hexastile Hypaethral Temple from the North)
 BOORSCH, FIG. 18

 Altra veduta interiore del tempio esastilo ipetro dalla parte di mezzo giorno (Another Interior View of the Hexastyle Hypaethral Temple from the South)
 HIGHLIGHTS, PL. 23

 Veduta del tempio esastilo perittero dalla parte di mezzo giorno (View of the Peripteral Hexastyle Temple from the South)

Etchings, each 10⅞ × 15¼ in. (27.6 × 38.8 cm)
Le Blanc III, p. 48, only state
2012.159.30.1–.7

GIACOMO NEVAY
 See under Guercino

MARVIN E. NEWMAN
 American, born 1927

Open Spaces, Temporary and Accidental

 Aerial View of Columbus Circle from the Gulf and Western Building, 1970s
Chromogenic print, 20¹⁄₁₆ × 30 in. (50.9 × 76.2 cm)

 Aerial View of the Fisher Brothers Building, Part of a New Skyline, 1970s
Gelatin silver print, 32⅜ × 19⅞ in. (82.2 × 50.5 cm)

 Backhoe at 535 Madison Avenue Construction Site, 1970s
Chromogenic print, 27⁹⁄₁₆ × 20¹⁄₁₆ in. (70 × 50.9 cm)

 Bowling Green, at the Foot of Broadway, 1970s
Gelatin silver print, 20 × 30¹⁄₁₆ in. (50.8 × 76.4 cm)

 Broadway and 9th Avenue at 72nd Street, Looking South, 1970s
Gelatin silver print, 21¹⁵⁄₁₆ × 30⅛ in. (55.8 × 76.5 cm)

 Chatham Square, Chinatown, 1970s
Gelatin silver print, 23¹⁄₁₆ × 30⅛ in. (58.6 × 76.5 cm)

 The Excavation Site of the AT&T Building, between 55th and 56th Streets, Looking North, 1970s
Chromogenic print, 40¹⁄₁₆ × 26 in. (101.7 × 66 cm)

 The Excavation Site of the AT&T Building, between 55th and 56th Streets, Looking North, with the Future I.B.M. Building under Construction behind It, 1970s
Chromogenic print, 40¹⁄₁₆ × 26 in. (101.7 × 66 cm)

 The Fisher Brothers Building Construction Site, 1970s
Chromogenic print, 30⅛ × 20 in. (76.5 × 50.8 cm)

 The Fisher Brothers Building, Glass Reflection, 1970s

Chromogenic print, 30 × 13 in.
(76.2 × 33 cm)

The Fisher Brothers Building, Glass Reflection, 1970s
Chromogenic print, 30 1/16 × 13 in.
(76.3 × 33 cm)

Looking South Down Broadway, from Times Square, 1970s
Gelatin silver print, 37 3/16 × 14 1/2 in.
(94.4 × 36.8 cm)

Herald Square at the Intersection of Broadway and 6th Avenue, 1970s
Gelatin silver print, 23 1/16 × 29 3/4 in.
(58.5 × 75.5 cm)

The I.B.M. and AT&T Buildings Construction Site, 1970s
Chromogenic print, 40 1/16 × 28 1/16 in.
(101.7 × 71.2 cm)

The I.B.M. Building under Construction in front of the General Motors Building, 1970s
Chromogenic print, 30 × 20 1/16 in.
(76.2 × 50.9 cm)

The I.B.M. Building Site, Madison Avenue and 57th Street, Before and After, 1970s
Gelatin silver prints, 18 1/16 × 26 1/4 in.
(45.8 × 66.7 cm) and 39 13/16 × 26 5/16 in.
(101.2 × 66.8 cm)

The I.B.M. Building Site, Madison Avenue and 57th Street, Before and After, 1970s
Gelatin silver prints, 18 1/16 × 26 1/4 in.
(45.8 × 66.7 cm) and 40 1/8 × 26 5/16 in.
(101.9 × 66.8 cm)

The Last Stages of Construction of the Fisher Brothers Building, 1970s
Gelatin silver print, 14 5/16 × 19 15/16 in.
(36.3 × 50.6 cm)

Looking East toward 5th Avenue from West 56th Street, 1970s
Chromogenic print, 30 1/8 × 17 9/16 in.
(76.5 × 44.6 cm)

Madison Avenue Skyscrapers, 1970s
Chromogenic print, 20 × 13 5/16 in.
(50.8 × 33.8 cm)

Madison Square, Where Broadway Crosses 5th Avenue at 23rd Street, 1970s
Gelatin silver print, 35 5/8 × 14 9/16 in.
(90.5 × 37 cm)

Moonrise Looking East to the Triborough Bridge from 30 Rockefeller Center, 1970s
Chromogenic print, 46 × 67 3/4 in.
(116.9 × 172.1 cm)

Preparing the Site for a Building at 535 Madison Avenue, 1970s
Chromogenic print, 29 7/8 × 20 1/16 in.
(75.9 × 51 cm)

Roadways Leading to the Brooklyn Bridge with the World Trade Center Towers and Woolworth Building in the Distance, 1970s
Gelatin silver print, 44 3/16 × 30 3/8 in.
(112.2 × 77.1 cm)
 HIGHLIGHTS, PL. 70

Site of the Fisher Brothers Building before the Start of Construction, 1970s
Gelatin silver print, 14 15/16 × 19 1/8 in.
(37.9 × 48.5 cm)

The Steelwork of the I.B.M. Building Reflecting in the Windows of the Fisher Brothers Building, 1970s
Chromogenic print, 20 × 13 3/4 in.
(50.8 × 35 cm)

Steelwork underway on the AT&T Building, 1970s
Chromogenic print, 20 × 13 3/4 in.
(50.8 × 34.9 cm)

St. Regis Hotel Façade, on 55th Street and 5th Avenue, 1970s
Gelatin silver print, 30 1/16 × 20 in.
(76.4 × 50.8 cm)

Times Square, Looking North, 1970s
Chromogenic print, 40 × 23 1/16 in.
(101.6 × 58.5 cm)

Unfinished Steelwork, I.B.M. Building, 1970s
Chromogenic print, 20 × 30 in.
(50.8 × 76.2 cm)

56th Street Traffic between the I.B.M. and AT&T Construction Sites, 1979
Gelatin silver print, 10 1/4 × 13 9/16 in.
(26 × 34.5 cm)
 BOORSCH, FIG. 27

Construction Workers Clearing the AT&T Site, 1979
Gelatin silver print, 9 7/16 × 13 9/16 in.
(23.9 × 34.5 cm)

The Excavation Site of the AT&T Building, between 55th and 56th Streets, Looking North, 1979
Gelatin silver print, 19 5/16 × 12 5/8 in.
(49.1 × 32 cm)

I.B.M. Construction Site Spectators, 1979
Gelatin silver print, 6 15/16 × 13 9/16 in.
(17.7 × 34.5 cm)

I.B.M. Site North Wall at 57th Street, 1979
Gelatin silver print, 9 15/16 × 13 9/16 in.
(25.2 × 34.5 cm)

Ivan Chermayeff Butterfly Peephole at the Philip Morris Construction Site, 1979
Gelatin silver print, 10 11/16 × 14 1/16 in.
(27.2 × 35.7 cm)

Ivan Chermayeff Butterfly Peephole at the Philip Morris Construction Site, 1979
Gelatin silver print, 13 9/16 × 11 3/16 in.
(34.5 × 28.4 cm)

Looking Southwest at the I.B.M. and AT&T Site from 58th Street and Madison Avenue, 1979
Gelatin silver print, 10 1/4 × 13 9/16 in.
(26 × 34.5 cm)

Parking Lot, Open Space at Fraunces Tavern Block, Lower Manhattan, 1979
Gelatin silver print, 9 7/8 × 13 9/16 in.
(25.1 × 34.5 cm)

Site of the Philip Morris Building under Construction at the Southwest Corner of 42nd Street and Park Avenue, opposite Grand Central Station, 1979
Gelatin silver print, 14 3/16 × 19 1/16 in.
(36.1 × 48.4 cm)
 HIGHLIGHTS, PL. 69

Site of the Second Madison Square Garden, Occupying a Full Block between 49th and 50th Streets and 8th and 9th Avenues, 1979
Gelatin silver print, 9 × 14 in.
(22.8 × 35.6 cm)

Workers on the I.B.M. East Wall at 56th Street, 1979
Gelatin silver print, 9 3/16 × 13 9/16 in.
(23.4 × 34.5 cm)

2012.159.163.1–.42

GIUSEPPE DE NITTIS
 Italian, 1846–1884

Portrait of Edgar Degas, 1875–82
Drypoint, 3 3/8 × 2 3/4 in. (8.5 × 7 cm)
Clément-Janin, p. 228; Fiorani and Dinoia 50
2012.159.67

CARLO NOLLI
 Italian, 1710–1785
 See also under Pietro Campana;
 Francesco Monaco

**AND GIOVANNI BATTISTA
PIRANESI**
Italian, 1720–1778

Nuova pianta di Roma (New Plan of
Rome), after Giovanni Battista Nolli
(Italian, 1701–1756), published 1748
Etching and engraving, 18½ × 27 1/16 in.
(47 × 68.8 cm)
Wilton-Ely 1007, only state
2012.159.9.1–.11

GIOVANNI BATTISTA NOLLI
See under Pietro Campana; Francesco
Monaco; Carlo Nolli

GIOVANNI OTTAVIANI
See under Guercino

GIOVANNI PAOLO PANINI
Italian, 1691–1765
See under Pietro Campana

PABLO PICASSO
Spanish, active in France, 1881–1973

The Wounded Picador, 1952
Aquatint, 20 3/8 × 26¼ in. (51.8 × 66.6 cm)
Geiser-Baer 895B
2012.159.160

La tauromaquia (The Art of Bullfighting),
1957, published 1959

 Toros en el campo (Bulls in the Field)

 A los toros (To the Bulls)

 Paseo de cuadrillas (Passage of the
 Quadrilles)

 Suerte llamada de Don Tancredo (Don
 Tancredo Says Good Luck)
 HIGHLIGHTS, PL. 68

 El toro sale del toril (The Bull Leaves
 the Bullpen)

 Citando al toro con la capa (Provoking
 the Bull with the Cape)

 Toreando a la verónica (The Passing of
 the Cape in Bullfighting)

 Salto con la garrocha (Leap with the
 Spear)

 Los cabestros retiran al toro manso (The
 Lead Bulls Leave the Meek Bull)

 Suerte de varas (Opening Stage of the
 Bullfight with Playing of the Capes)

 Echan perros al toro (They Loose Dogs
 on the Bull)
 BOORSCH, FIG. 3

 El picador obligando al toro con su pica
 (Picador Forcing the Bull with His
 Goad)

 Citando a banderillas (Provoking with
 Banderillas)

 Clavando un par de banderillas
 (Nailing in a Pair of Banderillas)

 *Citando al toro a banderillas sentado
 en una silla* (Provoking the Bull with
 Banderillas While Seated in a Chair)

 El matador brinda la muerte del toro
 (The Matador Dedicates the Death of
 the Bull)

 Suerte de muleta (Act of the Muleta)

 La cogida (The Tossing)

 Citando a matar (Inciting the Kill)

 La estocada (The Estocada [Killing
 Thrust]), 1957

 *Después de la estocada, el torero señala
 la muerte del toro* (After the Estocada,
 the Bullfighter Signals the Death of
 the Bull)

 Muerte del toro (Death of the Bull)

 El arrastre (The Dragging)

 *El torero sale en hombros de los
 aficionados* (The Bullfighter Leaves on
 the Shoulders of the Fans)

 Citando al toro con el rejón (Inciting the
 Bull with the Lance)

 Alaceando a un toro (Spearing the Bull)

Aquatints, each 7 13/16 × 11¾ in. (19.9 ×
29.9 cm)
Geiser-Baer 971–96, state i/ii except
no. 974, state ii/iii
2012.159.161.1–.26

Another series of *La tauromaquia*,
with accompanying text of *LA
TAUROMAQUIA O ARTE DE TOREAR:
OBRA UTILÍSIMA PARA LOS
TOREROS DE PROFESIÓN, PARA LOS
AFICIONADOS Y PARA TODA CLASE
DE SUJETOS QUE GUSTEN DE TORO*
(Tauromaquia, or The Art of Bullfighting,
Work Useful for Professional Bull-
fighters, for Aficionados, and for All
Kinds of People Who Like the Bulls), by

José Delgado alias Pepe Illo,
Barcelona: Gustavo Gili, 1959
Portfolio with 26 aquatints and 38
unbound folios with text, in an exterior
case, portfolio cover: 14½ × 20 × 2¼ in.
(36.8 × 51 × 5.5 cm); case: 14 15/16 × 20 3/8 ×
2 15/16 in. (38 × 51.8 × 7.4 cm); aquatints:
7 13/16 × 11¾ in. (19.9 × 29.9 cm)
Geiser-Baer 970–96B
2012.159.162.1–.27

FRANCESCO PIRANESI
Italian, 1756–1810

TOPOGRAFIA DELLE FABRICHE [*sic*]
SCOPERTE NELLA CITTÀ DI POMPEI
. . . (Topography of the Buildings
Uncovered in the City of Pompeii . . .),
ca. 1789
Etching, 17 7/16 × 31 15/16 in. (44.3 ×
81.2 cm)
Le Blanc III.207.7; Nagler XI.363.7,
only state
2012.159.46.1

*Veduta del Tempio d'Iside quale oggi esiste
fragli avanzi dell'antica Città di Pompei*
(View of the Temple of Isis Which Today
Exists among the Ruins of the Ancient
City of Pompeii), after Louis-Jean
Desprez (French, 1743–1804), 1788
Etching, 18 3/8 × 27 9/16 in. (46.7 × 70 cm)
Nagler XI.363.8, only state; Wollin, p. 113,
no. 7, state ii/ii
2012.159.46.2

*Veduta della Porta dell'antica Città di
Pompei* (View of the Gate of the Ancient
City of Pompeii), after Louis-Jean
Desprez (French, 1743–1804), 1789
Etching, 19 × 27½ in. (48.2 × 69.8 cm)
Wollin, p. 114, no. 8, state ii/ii
2012.159.46.3

*Veduta del Sepolcro di Mamia negl'avanzi
dell'antica Città di Pompei* (View of the
Tomb of Mamia among the Ruins of the
Ancient City of Pompeii), after Louis-
Jean Desprez (French, 1743–1804), 1789
Etching, 19 × 27½ in. (48.2 × 69.8 cm)
Wollin, p. 114, no. 9, state ii/ii
2012.159.46.4

*Fuoco artificiale detto la Girandola
Che s'incendia sul Castel S. Angelo già
Mausoleo d'Elio Adriano* (Fireworks
known as the *Girandola*, Which
Explode above the Castel Sant'Angelo

formerly the Mausoleum of Hadrian), after Louis-Jean Desprez (French, 1743–1804), ca. 1790
Color etching and aquatint, 30 9/16 × 20 1/4 in. (77.7 × 51.5 cm)
Wollin, p. 111, no. 3, state ii/iii
2012.159.47
 HIGHLIGHTS, PL. 27

The Villa Medici, ca. 1795
Etching and engraving, 17 1/4 × 26 5/16 in. (43.8 × 66.8 cm)
2012.159.48

GIOVANNI BATTISTA PIRANESI
Italian, 1720–1778
See also under Guercino

ANTICHITÀ ROMANE DE' TEMPI DELLA REPUBBLICA E DE' PRIMI IMPERATORI (Roman Antiquities from the Time of the Republic and the First Emperors), generally known as *Alcune Vedute di Archi Triomphali* (Some Views of Triumphal Arches), 1748

Title page

Dedication page

Transcription of inscriptions from the monuments

Transcription of inscriptions from the monuments, and index

PARTE DEL FORO DI NERVA (Part of the Forum of Nerva), plate 5

1. Arco di Tito in Roma 2. Villa Farnese 3. Colon.e del Tem.o di G.ve St.re 4. Ar.co di Set.o Sev.ro 5. T.o della pace (1. Arch of Titus in Rome 2. Villa Farnese 3. Columns of the Temple of Jupiter Stator [the Supporter] 4. Arch of Septimius Severus 5. Temple of Peace), plate 6

Tempio di Giove Tonans 1. Tempio della Concordia (Temple of Jupiter Tonans 1. Temple of Concord), plate 7

Arco di Druso alla Porta di Sebastiano in Roma (Arch of Drusus at the Porta di Sebastiano in Rome), plate 8

Arco di Costantino in Roma (Arch of Constantine in Rome), plate 9

Vestigi del Tempio di Giova Statore 1. Tempio d'Antonio e Faustin 2. Tempio della Pace (Ruins of the Temple of Jupiter Stator 1. Temple of

Antoninus and Faustin 2. Temple of Peace), plate 10

Tempio di Giano (Temple of Janus), plate 11

Anfiteatro Flavio detto il Colosseo in Roma 1. Arco di Costantino 2. Monte Palatino (Flavian Amphitheater called the Colosseum in Rome 1. Arch of Constantine 2. Palatine Hill), plate 12

Arco di Settimio Severo 1. Tempio della Concordia 2. Salita di Campidoglio (Arch of Septimius Severus 1. Temple of Concord 2. Ascent to the Capitoline Hill), plate 13

Ponte Senatorio oggi detto Ponte rotto 1. Tempio di Vesta 2. Tempio della Fortuna Virile 3. Parte dell'antico Palatino (Senatorial Bridge today called the Ponte Rotto 1. Temple of Vesta 2. Temple of Fortuna Virilis 3. Part of the Ancient Palatine), plate 14

Foro di Augusto (Forum of Augustus), plate 15

Title page, *ANTICHITÀ ROMANE FUORI DI ROMA DISEGNATE ED INCISA DA GIAMBAT[TIS]TA PIRANESI, ARCHITETTO VENEZIANO. PARTE SECONDA* (Roman Antiquities Outside Rome Drawn and Etched by Giambat[tis]ta Piranesi, Venetian Architect. Part Two)

Ponte di Rimino fabbricato da Augusto e da Tiberio Imperatori (Bridge at Rimini Built by the Emperors Augustus and Tiberius), plate 16

Arco di Rimino fabbricato da Augusto (Arch at Rimini Built by Augustus), plate 17

Sepolcro della famiglia de' Scipioni (Tomb of the Scipios), plate 18

Parte dell'antica Via Appia fuori di Porta S. Sebastiano circa tre miglia (Part of the Ancient Appian Way outside Porta San Sebastiano about Three Miles), plate 19

Sepolcro di Metela detto Capo Bove (Tomb of Metella called Capo di Bove), plate 20

Tempio di Pola in Istria (Temple of Pola in Istria), plate 21

Rovescio del Tempio di Pola in Istria 1. Rovescio di un Altro Tempio (Rear View of the Temple of Pola in Istria 1. Rear View of Another Temple), plate 22

Anfiteatro di Pola in Istria vicino al mare (Amphitheater of Pola in Istria near the Sea), plate 23

Arco di Pola in Istria vicino alla Porta (Arch of Pola in Istria near the Gate), plate 24

Anfiteatro di Verona (Ampitheater of Verona), plate 25

Tempio di Clitumno tra Fuligno e Spoletti . . . (Temple of Clitumnus between Foligno and Spoleto . . .), plate 26

Sepolcro delle tre fratelli Curiati in Albano (Tomb of the Three Curiatii Brothers in Albano), plate 27

Arco di Trajano in Ancona (Arch of Trajan in Ancona), plate 28

Arco di Galieno 1. Facciata della Chiesa di S. Vito (Arch of Galienus 1. Façade of the Church of San Vito), plate 29

Etchings, 2012.159.15.1–.4: 9 7/16 × 14 3/16 in. (24 × 36 cm); 2012.159.15.5–.30: ranging from 4 5/16 × 9 13/16 in. (11 × 25 cm) to 9 7/16 × 14 3/16 in. (24 × 36 cm)
Wilton-Ely 103–6, 108–33, only state
2012.159.15.1–.30

VEDUTE DI ROMA DISEGNATE ED INCISE DA GIAMBATTISTA PIRANESI ARCHITETTO VE[NEZ]IANO (Views of Rome Drawn and Etched by Giambattista Piranesi, Venetian Architect)

Title page, 1748

Frontispiece, *Fantasy of Ruins with a Statue of Minerva in the Center Foreground*, ca. 1748?

Veduta della Basilica, e Piazza di S. Pietro in Vaticano (View of the Basilica, and Piazza of Saint Peter's in the Vatican), 1748
 HIGHLIGHTS, PL. 6

Veduta interna della Basilica di S. Pietro in Vaticano (Interior View of the Basilica of Saint Peter's in the Vatican), 1748

Spaccato interno della Basilica di S. Paolo fuori delle Mura . . .

(Cross-Section of the Interior of the Basilica of San Paolo fuori delle Mura . . .), 1749
HIGHLIGHTS, PL. 7

Veduta della Basilica di S. Giovanni Laterano (View of the Basilica of San Giovanni Laterano), 1749

Veduta della Basilica di S.ta Maria con le due Fabbriche laterali di detta Basilica (View of the Basilica of Santa Maria [Maggiore] with Its Two Flanking Wings), 1749
BOORSCH, FIG. 8

Veduta della Piazza del Popolo (View of the Piazza del Popolo), 1750

Veduta della Piazza di Monte Cavallo (View of the Piazza di Monte Cavallo [now the Piazza del Quirinale with the Quirinal Palace]), 1750
HIGHLIGHTS, PL. 8

Veduta di Piazza Navona sopra le rovine del Circo Agonale (View of the Piazza Navona above the Ruins of the Circus of Domitian), 1751
HIGHLIGHTS, PL. 9

Another impression of *Veduta di Piazza Navona*

Veduta della Piazza della Rotunda (View of the Piazza della Rotonda), 1751

Veduta della vasta Fontana di Trevi anticamente detta l'Acqua Vergine (View of the Large Trevi Fountain formerly called the Acqua Vergine), 1751

Veduta del Sepolcro di Cajo Cestio (View of the Pyramidal Tomb of Caius Cestius), 1755

Veduta del Romano Campidoglio con Scalinata che va' alla Chiesa d'Araceli (View of the Capitoline Hill with the Steps That Go to the Church of [Santa Maria] d'Aracoeli), 1757?
HIGHLIGHTS, PL. 10

Veduta di Campo Vaccino (View of the Campo Vaccino [the Forum Romanum]), 1757?

Veduta degli avanzi di due Triclini che appartenevano alla Casa aurea di Nerone . . . (View of the Ruins of Two Triclinia Which Belonged to the

Golden House of Nero . . . [actually the Temple of Venus and Rome]), 1759

Colonna Trajana (Trajan's Column), 1758

Colonna Antonina (Column of Marcus Aurelius), 1758
HIGHLIGHTS, PL. 11

Veduta dell'Arco di Constantino, e dell'Anfiteatro Flavio detto il Colosseo (View of the Arch of Constantine, and the Flavian Amphitheater, called the Colosseum), 1760
HIGHLIGHTS, PL. 12

Veduta dell'esterno della gran Basilica di S. Pietro in Vaticano (View of the Exterior of the Large Basilica of Saint Peter's in the Vatican), 1748

Veduta di Piazza di Spagna (View of the Piazza di Spagna), 1750

Veduta del Porto di Ripetta (View of the Port of Ripetta), 1753

Veduta del Ponte e Castello Sant'Angelo (View of the Bridge and Castel Sant'Angelo), 1754

Teatro di Marcello. Questo fu fabricato da Augusto, e dedicato a Marcello suo Nipote (The Theater of Marcellus. This Building was Built by Augustus, and Dedicated to His Nephew Marcellus), 1757

Veduta interna del Sepolcro di S. Costanza, fabbricato da Constantino Magno, ed erroneamente detto il Tempio di Bacco, inoggi Chiesa della medesima Santa (View of the Interior of the Tomb of Santa Costanza, Built by Constantine the Great, and erroneously called the Temple of Bacchus, now the Church of the Same Saint), 1756

Veduta del Sito, ov'era l'antico Foro Romano (View of the Site of the Ancient Roman Forum), 1756

Veduta del piano superiore del Serraglio delle Fiere fabbricato da Domiziano a uso dell'Anfiteatro Flavio e volgarmente detto la Curia Ostilia (View of the Upper Story of the Cages for Wild Animals Built by the Emperor Domitian, Associated with the Flavian Amphitheater and commonly called the Curia Hostilia [actually the

substructure of the Temple of Claudius near the Church of Santi Giovanni e Paolo]), 1757

Veduta degli avanzi del Tablino della Casa Aurea di Nerone, detti volgarmente il Tempio della Pace (View of the Remains of the Dining Room of the Golden House of Nero, commonly called the Temple of Peace [actually the Basilica of Maxentius and Constantine]), 1757

Veduta del Tempio della Fortuna virile. Oggi S. Maria Egizziaca degli Armeni (View of the Temple of Fortuna Virilis. Now the Armenian Church of Santa Maria Egizziaca [now thought to be the Temple of Portunus]), 1758

Veduta del Tempio di Antonino e Faustina in Campo Vaccino (View of the Temple of Antoninus and Faustina in the Roman Forum), 1758

Obelisco Egizio. Questo fu erreto da Sisto V. nella Piazza di S. Gio. Laterano (Egyptian Obelisk. This Was Erected by Pope Sixtus V in the Piazza of San Giovanni Laterano), 1759

Arco di Settimio Severo. Nel mezzo di questo passava l'antica Via Sacra che portava i Trionf.ti in Campid.o (Arch of Septimius Severus through Which Passed the Ancient Sacred Way that Brought the Victors to the Capitol), 1759

Veduta dell'Atrio del Portico di Ottavia (View of the Atrium of the Portico of Octavia), 1760

Veduta interna dell'Atrio del Portico di Ottavia (Internal View of the Atrium of the Portico of Octavia), 1760

Veduta della Dogana di Terra a Piazza di Pietra. Questo fu fabbricata sulle rovine del Tempio di M. Aurelio Antonino Pio nel suo Foro (View of the Customs House in Piazza di Pietra. This Was Built within the Ruins of the Temple of Marcus Aurelius Antonius Pius in His Forum [actually the Temple of Divine Hadrian]), 1753

Veduta dell'avanzo del Castello, che prendendo una porzione dell'Acqua Giulia . . . (View of the Remains of the Fountainhead of the Acqua Giulia . . .), 1753

Veduta del Mausoleo d'Elio Adriano (ora chiamato Castello S. Angelo) nella parte opposta alla Facciata dentro al Castello (View of the Mausoleum of the Emperor Hadrian [now called Castel Sant'Angelo] from the Rear), 1754

Veduta della Basilica di S. Paolo fuor delle mura, eretta da Constantino Magno (View of the Basilica of San Paolo fuori delle Mura, Built by Constantine the Great), 1748

Veduta della Facciata di dietro della Basilica di S. Maria Maggiore (View of the Façade at the Back of the Basilica of Santa Maria Maggiore), 1749?

Veduta della Facciata della Basilica di S. Croce in Gerusalemme (View of the Façade of the Basilica of the Holy Cross in Jerusalem), 1750

Veduta del Castello dell'Acqua Paola sul Monte Aureo (View of the Fountainhead of the Acqua Paola on Monte Aureo), 1751
 HIGHLIGHTS, PL. 13

Veduta del Palazzo fabbricato sul Quirinale per le Segreterie de Brevi et della Sacra Consulta (View of the Palazzo Built on the Quirinal for the Secretary of the Briefs and the Sacred Council), 1749?

Another impression of *Veduta del Palazzo fabbricato sul Quirinale*

Veduta della Gran Curia Innocenziana . . . (View of the Palazzo di Montecitorio . . .), 1752

Veduta, nella Via del Corso, del Palazzo dell'Accademia instituita da Luigi XIV, Re di Francia per i Nazionale Francesi studiosi della Pittura, Scultura, e Architettura . . . (View Along the Via del Corso of the Palazzo dell'Accademia Established by Louis XIV, King of France for French Students of Painting, Sculpture, and Architecture . . .), 1752

Veduta del Palazzo Odescalchi (View of the Odescalchi Palace), 1753

Veduta del Porto di Ripa Grande (View of the Port of Ripa Grande), 1753

Veduta del Ponte Salario (View of the Salario Bridge), 1754

Veduta degli avanzi del Foro di Nerva (View of the Remains of the Forum of Nerva), 1757

Veduta del Tempio di Giove Tonante (View of the Temple of Jupiter Tonans [actually the Temple of Vespasian and Titus]), 1756

Veduta del Tempio di Cibele a Piazza della Bocca della Verità (View of the Temple of Cybele in the Piazza of the Bocca della Verità), 1758

Veduta del Tempio di Bacco, inoggi Chiesa di S. Urbano, distante due miglia da Roma fuori della Porta S. Sebastiano . . . (View from the Temple of Bacchus, now the Church of San Urbano, Two Miles Away from Rome beyond the Porta San Sebastiano . . .), 1758

Veduta dell'Arco di Tito. Esso fu eretto a questo Imperadore dopo la di lui morte in memoria della distruzione di Gerosolima (View of the Arch of Titus. It Was Erected for this Emperor After His Death in Memory of the Destruction of Jerusalem), 1760

Veduta della Basilica di S. Lorenzo fuor delle mura (View of the Basilica of San Lorenzo fuori delle Mura), 1750

Veduta del Castello dell'Acqua Felice . . . (View of the Fountainhead of the Acqua Felice . . .), 1751

Veduta sul Monte Quirinale del Palazzo dell'Eccellentissima Casa Barberini, Architettura del Cav.r Bernino (View of the Palace of the Illustrious Barberini Family on the Quirinal Hill, Designed by Cavaliere [Gian Lorenzo] Bernini), 1749?

Veduta del Campidoglio di fianco (View of the Campidoglio from the Side), 1757?

Piramide di C. Cestio (Pyramid of Gaius Cestius), 1756
 HIGHLIGHTS, PL. 14

Veduta dell'Anfiteatro Flavio, detto il Colosseo (View of the Flavian Amphitheater, called the Colosseum), 1757

Veduta della Basilica di S. Sebastiano fuori delle mura di Roma, su la Via Appia (View of the Basilica of San Sebastiano fuori delle Mura of Rome, on the Appian Way), 1750

Veduta del Pantheon d'Agrippa oggi Chiesa di S. Maria ad Martyres (View of the Pantheon of Agrippa [actually the Pantheon of Hadrian], today Santa Maria ad Martyres), 1761
 MOORE, FIG. 7

Veduta del tempio della Sibilla in Tivoli (View of the Temple of the Sibyl in Tivoli), 1761

Altra Veduta del Tempio della Sibilla in Tivoli (Another View of the Temple of the Sibyl in Tivoli), 1761

Altra Veduta del Tempio della Sibilla in Tivoli (Another View of the Temple of the Sibyl in Tivoli), 1761
 HIGHLIGHTS, PL. 15

Veduta del Ponte Molle sul Tevere due miglia lontan da Roma (View of the Milvian Bridge over the Tiber Two Miles outside Rome), 1762

Avanzi della Villa di Mecenate a Tivoli . . . (Remains of the Villa of Maecenas at Tivoli . . .), 1763

Veduta delle due Chiese, l'una detta 1. della Madonna di Loreto l'altra 2. del Nome di Maria presso 3. la Colona Trajana. 4. Salita al monte Quirinale (View of Two Churches, one called 1. the Santa Maria di Loreto, the Other 2. in the Name of Mary near 3. Trajan's Column. 4. The Ascent to the Quirinal), 1762

Sepolcro di Cecilia Metella . . . (Tomb of Caecilia Metella . . .), 1762

Veduta del Ponte Lugano su l'Anione . . . (View of the Ponte Lugano on the Anio . . .), 1763

Veduta del Tempio, detto della Tosse su la Via Tiburtina, un miglio vicino a Tivoli (View of the so-called Temple of the Cough on the Via Tiburtina, a Mile from Tivoli), 1763

Veduta interna del Tempio della Tosse . . . (Interior View of the Temple of the Cough . . .), 1764

Tempio antico volgarmente detto della Salute su la Via d'Albano, cinque miglia lontan da Roma . . . (Ancient Temple commonly called the Temple of Health on the Via d'Albano Five Miles outside Rome . . .), 1763

A. *Veduta del Sepolcro di Pisone Liciniano su l'antico via Appia* . . . B. *Sepolcro della famiglia Cornelia* . . . (A. View of the Tomb of Piso Licinianus on the Ancient Appian Way . . . B. Tomb of the Cornelii . . .), 1764

Veduta interna della Villa di Mecenate . . . (Interior View of the Villa of Maecenas . . .), 1764

Veduta del Tempio ottangolare di Minerva Medica (View of the Octagonal Temple of Minerva Medica [now considered to have been a nymphaeum in the Horti Liciniani or Gardens of Licinius]), 1764

Veduta della Cascata di Tivoli (View of the Waterfall of Tivoli), 1765, engraved on plate 1766

Rovine delle Terme Antoniniane (Ruins of the Antonine Baths [Baths of Caracalla]), 1765
 MOORE, FIG. 8

Rovine del Sisto, o sia della gran sala delle Terme Antoniniane (Ruins of the Xystus, or It Could Be of the Central Hall of the Antonine Baths [Baths of Caracalla]), 1765

Veduta dell'interno dell'Anfiteatro Favio detto il Colosseo (View of the Interior of the Flavian Amphitheater, called the Colosseum), 1766

Avanzi d'un portico coperto, o criptoportico in una villa di Domiziano cinque miglia lontan da Roma su la via di Frascati (Remains of a Covered Portico, or a Cryptoporticus in a Villa of Domitian, Five Miles outside Rome on the Road of Frascati), 1766

Veduta della fonte e delle Spelonche d'Egeria fuor della porta Capena or di S. Seb.no . . . (View of the Fountain and the Grotto of Egiria outside the Porta Capena or of San Sebastiano . . .), 1766

Veduta interna dell'antico Tempio di Baccio in oggi Chiesa di S. Urbano due miglia distante da Roma fuori di porta S. Sebastiano . . . (Interior View of the Ancient Temple of Bacchus, today the Church of Saint Urban Two Miles from Rome outside the Gate of San Sebastiano . . . [now considered to have been the Temple of Ceres and Faustina]), 1767

Veduta interna del Pronao del Panteon (Interior View of the Pronaos of the Pantheon), 1769

Veduta degl'avanzi del sepolcro della famiglia Plauzia sulla via Tiburtina vicino al ponte Lugano due miglia lontano da Tivoli (View of the Remains of the Tomb of the Plautii on the Via Tiburtina Near the Ponte Lugano Two Miles from Tivoli), 1765–69?

Altra veduta interna della Villa di Mercenate in Tivoli (Another View of the Villa of Maecenas in Tivoli), 1767

Avanzi del Tempio detto di Appollo nella Villa Adriana vicino a Tivoli (Remains of the Temple Said to Be of Apollo in Hadrian's Villa near Tivoli), 1765–69?

Veduta interna del Panteon . . . (Interior View of the Pantheon . . .), 1768

Veduta interna della Basilica di S. Maria Maggiore (Interior View of the Basilica of Santa Maria Maggiore), 1768

Veduta interna della Basilica di S. Giovanni Laterano (Interior View of the Basilica of San Giovanni Laterano), 1768

Veduta della Villa dell'Emo Sig.n Card. Alesandro Albani fuori di Porta Salaria (View of the Villa of His Eminence Cardinal Alessandro Albani, outside Porte Salaria), 1769

Avanzi del Tempio del Dio Canopo nella Villa Adriana in Tivoli (Remains of the Temple of the God Canopus at Hadrian's Villa in Tivoli), 1768

Veduta del Tempio di Ercole nella Città di Cora, dieci miglia lontano da Velletri (View of the Temple of Hercules at Cori, Ten Miles Distant from Velletri), 1769
 HIGHLIGHTS, PL. 16

Veduta delle Cascatelle a Tivoli (View of Small Waterfalls at Tivoli), 1769

Rovine d'una Galleria di Statue nella Villa Adriana a Tivoli (Ruins of a Sculpture Gallery at Hadrian's Villa at Tivoli [actually the large baths]), 1770

Veduta degli avanzi del Castro Pretorio nella Villa Adriana a Tivoli (View of the Remains of the Praetorian Fort [the Poecile] in Hadrian's Villa at Tivoli), 1770

Veduta degli avanzi del Foro di Nerva (View of the Remains of the Forum of Nerva), 1770

Tempio detto volgarm.te di Giano. A. Arco detto degl'Argentieri . . . (The so-called Temple of Janus. A. Arch of the Argentari [or Moneychangers]), 1771

Veduta dell'Arco di Constantino (View of the Arch of Constantine), 1771

Veduta dell'Arco di Tito (View of the Arch of Titus), 1771

Veduta dell'Arco di Settimio Severo (View of the Arch of Septimius Severus), 1772

Veduta di Campo Vaccino (View of the Campo Vaccino [the Roman Forum]), 1772

Veduta della gran Piazza e Basilica di S. Pietro (View of the Large Piazza and Basilica of Saint Peter's), 1772
Veduta interna della Basicilia di S. Pietro in Vaticano vicino alla Tribuna (Interior View of the Basilica of Saint Peter's in the Vatican near the Tribune), 1773

Veduta della Piazza di Monte Cavallo (View of the Piazza di Monte Cavallo [Piazza del Quirinale]), 1773

Veduta in prospettiva della gran Fontana dell'Acqua Vergine detta di Trevi Architettura di Nicola Salvi (Perspective View of the Large Fountain of the Acqua Vergine, called the Trevi Fountain Architecture by Nicola Salvi), 1773

Veduta della Villa Estnse in Tivoli (View of the Villa d'Este in Tivoli), 1773

Veduta del Tempio delle Camene anticamente circondato da un bosco nella valle Egeria . . . (View of the Temple of the Camenae Once Surrounded by a Forest in the Valley of Egeria . . .), 1773

Veduta del Palazzo Farnese (View of the Palazzo Farnese), 1773

Veduta di Piazza Navona sopra le rovine del Circo Agonale (View of the Piazza Navona above the Ruins of the Circus Agonalis [Circus of Domitian]), 1773

Veduta del Tempio detto della Concordia (View of the so-called Temple of Concord [the Temple of Saturn]), 1774

Altra Veduta degli avanzi del Pronao del Tempio del Concordia (Another View of the Remains of the Pronaos of the Temple of Concord [the Temple of Saturn]), 1774

Veduta della Piazza del Campidoglio (View of the Piazza del Campidoglio), 1774

Avanzi di una Sala appartenente al Castro Pretorio nella Villa Adriana in Tivoli (Remains of a Room Belonging to the Praetorian Fort at Hadrian's Villa in Tivoli [the so-called Hall of the Philosophers, now considered to have been a library]), 1774

Rovine di uno degli alloggiamente de'Soldati presso ad una delle eminenti fabbriche di Adriano nella sua Villa in Tivoli (Ruins of One of the Soldiers' Barracks near One of the Eminent Buildings of Hadrian's in His Villa in Tivoli [the so-called Pretorio, now considered to have been a warehouse or storage room]), 1774

Veduta degli avanzi del Tablino della Casa aurea di Nerone detti volgarmente il Tempio della Pace (View of the Remains of the Dining Room of the Golden House of Nero commonly called the Temple of Peace [the Basilica of Maxentius and Constantine]), 1774

Veduta degli avanzi superiori delle Terme di Dioclezione a S. Maria degli Angeli (View of the Upper Remains of the Baths of Diocletian at Santa Maria degli Angeli), 1774

Veduta degli avanzi superiori delle Terme di Diocleziano (View of the Upper Ruins of the Baths of Diocletian), 1774

Veduta della Piazza, e Basilica di S. Giovanni in Laterano (View of the Square, and Basilica of San Giovanni in Laterano), 1775

Avanzi degl'Aquedotti Neroniani che si volevano distruggere per la loro vecchiezza, ma per ordine di N'ro. Sig.re Papa Clemento XIV sono restati in piedi (Remains of the Acqueduct of Nero Which Were to be Destroyed on Account of Their Age, but by Order of Our Signore Pope Clement XIV They Remained Standing), 1775

Veduta del Monumento eretto dall'Imperador Tito Vespasiano per aver ristaurati gl'Aquedotti dell'acque dell'Anione . . . (View of the Monument Erected by the Emperor Titus Commemorating His Restoration of the Acqueducts of the Anio . . . [the Porta Maggiore]), 1775

Veduta dell'insigne Basilica Vaticana coll'ampio Portico, e Piazza adjacente (View of the Famous Vatican Basilica with Its Spacious Portico, and Adjacent Piazza), 1775

Veduta dell'Isola Tibertina (View of the Tiber Island), 1775

Veduta della Facciata della Basilica di S. Giovanni Laterano . . . (View of the Façade of the Basilica of San Giovanni Laterano . . .), 1775

Veduta delle Terme di Tito (View of the Baths of Titus), 1775
HIGHLIGHTS, PL. 17

Villa Panfili fuori di Porta S. Pancrazio (Villa Pamphilj outside the Porta San Pancrazio), 1776

Veduta delle antiche Sostruzioni fatte da Tarquinio Superbo dette il Bel Lido, e come altri erette da Marco Agrippa a tempi di Augusto, in occasione ch'Egli fece ripurgare tutte le Cloache fino al Tevere (View of the Ancient Substructures Built by Tarquinius Superbus called the Bel Lido, and Like Others, Erected by Marcus Agrippa in the Time of Augustus, When He Had All of the Sewers Leading to the Tiber Cleaned [the Cloaca Maxima]), 1776
MOORE, FIG. 9

Veduta dell'Anfiteatro Flavio detto il Colosseo (View of the Flavian Amphitheater, called the Colosseum), 1776

Veduta degli Avanzi delle Fabbriche del Secondo Piano delle Terme di Tito (View of the Remains of the Buildings on the Second Floor of the Baths of Titus), 1776

Veduta del Palazzo Stopani. Architettura di Rafaele d'Urbino (View of the Palazzo Stopani. Architecture of Raphael of Urbino), 1776

Veduta interna della Chiesa della Madonna degli Angioli detta della Certosa che anticam.e era la principal Sala delle Terme di Diocleziano (Interior View of the Church of Santa Maria degli Angioli, known as the Certosa Which in Antiquity Was the Principal Hall of the Baths of Diocletian), 1776

Avanzi di un antico Sepolcro, oggi detto la Conocchia, che si vede poco lungi dalla Porta di Capua per andar a Napoli . . . (Remains of an Ancient Tomb, today called La Conocchia, That One Sees Not Far from the Porta di Capua on the Road to Naples . . .), 1776

Interno del Tempio d.o di Canopo nella Villa Adriana (Interior of the Temple Said to Be of Canopus at Hadrian's Villa), 1776

Veduta degli Avanzi della Circonferenza delle antiche Fabbriche di una delle Piazze della Villa Adriana oggidi chiamata Piazza d'oro (View of the Remains of the Perimeter of Ancient Buildings in One of the Squares of Hadrian's Villa, called the Piazza d'Oro, 1776

Veduta di un Eliocamino per abitarvi l'Inverno, il quale era rescaldato dal Sole, che s'introduceva per le Finestra (View of the Heliocaminus Used for Winter Habitation, As It Was Heated by the Sun, Which Entered through the Windows), 1777

Dieta, o sia Luogo che da ingressso a diversi grandiosi Cubicoli, e ad altre magnifiche Stanze, esistente nella Villa Adriana . . . (Meeting Hall, or the Location That Gives Entry to Various Grandiose Cells, and Other Magnificent Rooms, That Exist in Hadrian's Villa . . .), 1777

Veduta dell'Arco di Benevento nel Regno di Napoli (View of the Arch of Beneventum in the Kingdom of Naples), 1778

Etchings, horizontal: ranging from 14 × 20 11/16 in. (35.5 × 52.5 cm) to 19 15/16 × 20 1/8 in. (49.1 × 71.5 cm); vertical: ranging

from 20 ⅞ × 15 ¾ in. (53 × 40 cm) to
28 ⅛ × 18 ¹¹⁄₁₆ in. (71 × 47.5 cm)
Hind 1–135; Wilton-Ely 134–268
2012.159.11.1–.135, 2012.159.22–.23

*Carceri d'invenzione di G[iovanni]
Battista Piranesi, archit[etto] Vene[ziano]*
(Imaginary Prisons of Giovanni Battista
Piranesi, Venetian Architect), published
1761

Title plate, plate 1, ca. 1750

The Man on the Rack, plate 2, ca. 1761

The Round Tower, plate 3, ca. 1750

The Grand Piazza, plate 4, ca. 1750

The Lion Bas-Reliefs, plate 5, ca. 1761

The Smoking Fire, plate 6, ca. 1750
 GREIST, FIG. 6

The Drawbridge, plate 7, ca. 1750
 BOORSCH, FIG. 11

First-state impression of *The
Drawbridge*, ca. 1750, published
ca. 1750
 BOORSCH, FIG. 10

The Staircase with Trophies, plate 8,
ca. 1750

The Giant Wheel, plate 9, ca. 1750

Prisoners on a Projecting Platform, plate
10, ca. 1750

The Arch with a Shell Ornament, plate
11, ca. 1750

The Sawhorse, plate 12, ca. 1750

The Well, plate 13, ca. 1750

The Gothic Arch, plate 14, ca. 1750

The Pier with a Lamp, plate 15, ca. 1750

The Pier with Chains, plate 16, ca. 1750

Etchings, horizontal: ranging from
15 ¾ × 21 ⁷⁄₁₆ in. (40 × 54.5 cm) to 16 ⅛ ×
22 ¹⁄₁₆ in. (41 × 56 cm); vertical: ranging
from 21 ¼ × 15 ¾ in. (54 × 40 cm) to
22 ¹⁄₁₆ × 16 ⅛ in. (56 × 41 cm)
Hind 1–16; Robison 29–44; Wilton-Ely
26–41, state ii/ii, and Wilton-Ely 32,
state i/ii
2012.159.18.1–.16, 2012.159.19

Grotteschi (Grotesques), 1740s

The Skeletons
Robison 21, state iii/iv; Wilton-Ely 21

The Triumphal Arch
Robison 22, state i/v; Wilton-Ely 22
 BOORSCH, FIG. 9

The Tomb of Nero
Robison 23, state ii/iv; Wilton-Ely 23

The Monumental Tablet
Robison 24, state ii/iv; Wilton-Ely 24

Etchings, ranging from 15 ⅜ × 21 ⁷⁄₁₆ in.
(39 × 54.5 cm) to 15 ⁹⁄₁₆ × 21 ⅝ in. (39.5 ×
55 cm)
2012.159.16.1–.4

ANTICHITÀ ROMANE (Roman
Antiquities), Rome: Buchard and Gravier,
1756
Book with 255 etchings in 4 volumes,
book: 22 ⅜ × 16 ⁹⁄₁₆ × 2 ¹¹⁄₁₆ in. (56.9 × 42 ×
6.9 cm); etchings: ranging from 3 ³⁄₁₆ ×
4 ¹⁄₁₆ in. (8 × 10.3 cm) to 15 ⁹⁄₁₆ × 47 ¹⁄₁₆ in.
(39.5 × 119.5 cm)
Title page, vol. 1, Wilton-Ely 279, state
ii/iii; Wilton-Ely 280–502, 504–13, 516–28,
only state
2012.159.12.1.1–.80, 2012.159.12.2.1–.63,
2012.159.12.3.1–.54, 2012.159.12.4.1–.57
 GREIST, FIG. 5; BOORSCH, FIG. 14;
 MOORE, FIG. 2; HIGHLIGHTS, PL. 18

*ICHNOGRAPHIAM Campi Martii
Antiquae Urbis* (*Ichnographia* or Plan of the
Campus Martius of the Ancient City), 1757
Etching, overall: 53 × 45 ⁹⁄₁₆ in. (134.6 ×
115.7 cm); each plate: 17 ¹¹⁄₁₆ × 23 ¹⁄₁₆ in.
(45 × 58.5 cm)
Wilton-Ely 571, only state
2012.159.14
 BOORSCH, FIGS. 16–17

*LE ROVINE DEL CASTELLO
DELL'ACQUA GIULIA* (The Ruins of the
Fountainhead of the Aqua Giulia), Rome:
1761
Book with 25 etchings, book: 22 ¹¹⁄₁₆ ×
17 ½ × ⁹⁄₁₆ in. (57.7 × 44.4 × 1.43 cm);
etchings: ranging from 3 ¼ × 3 ¹⁵⁄₁₆ in.
(8.2 × 10 cm) to 18 ⅛ × 11 in. (46 × 28 cm)
Wilton-Ely 269, 529–52, only state
2012.159.21
 BOORSCH, FIG. 15

*CATALOGO DELLE OPERE DATE
FINORA ALLA LUCE DA GIO.BATTISTA
PIRANESI* (Catalogue of Works Brought
to Light So Far by Gio[vanni] Battista
Piranesi), 1761–62
Etching and engraving, 15 ¾ × 11 ¾ in.
(40 × 29.8 cm)

Wilton-Ely A, state before i/xxv; Robison
(forthcoming), state vi/xxxv
2012.159.12.4.58
 MOORE, FIG. 3

*DELLA MAGNIFICENZA ED
ARCHITETTURA DE' ROMANI* (On
the Splendor and Architecture of the
Romans; 1761), bound with *Osservazioni*
(Observations; 1765), *PARERE* (Opinions;
1765), and *DELLA INTRODUZIONE* (Of the
Introduction; 1765), Rome
4 books with 56 etchings (*Della
Magnificenza*: 46; *Osservazioni*: 2; *Parere*: 2;
Della introduzione: 6) in 1 volume, book:
23 ¹⁵⁄₁₆ × 17 ¹⁵⁄₁₆ × 2 ⅛ in. (60.8 × 45.5 ×
5.3 cm); etchings: ranging from 2 ¹⁵⁄₁₆ ×
5 ¾ in. (7.5 × 14.5 cm) to 16 ⅙ × 48 ⅝ in.
(40.8 × 123.5 cm)
Wilton-Ely 753–98, 799–800, 801–2, 803–8
2012.159.20a–d

*IOANNIS BAPTISTAE PIRANESII
ANTIQUARIORUM REGIAE SOCIETATIS
LONDINENSIS SOCII CAMPUS MARTIUS
ANTIQUAE URBIS* (Giovanni Battista
Piranesi, Fellow of the Royal Society of
Antiquaries, The Campus Martius of
Ancient Rome), generally known as *Il
Campo Marzio dell'antica Roma*, Rome:
1762
Book with 53 etchings, book: 21 ⅞ × 16 ⅛ ×
1 ⅞ in. (55.5 × 41 × 4.8 cm); etchings:
ranging from 4 ⁵⁄₁₆ × 11 ⁵⁄₁₆ in. (11 × 28.7 cm)
to 53 ⅛ × 46 ¹⁄₁₆ in. (135 × 117 cm)
Wilton-Ely 559–70, 572–612
2012.159.13
 HIGHLIGHTS, PLS. 19–20

Pianta di Roma e del Campo Marzio (Plan of
Rome and the Campus Martius), ca. 1774
Etching, 37 × 27 ¾ in. (94 × 70.5 cm)
Wilton-Ely 1008, only state
2012.159.11.136

Différentes vues de . . . Pesto (Different Views
of . . . Paestum), 1778–79

Frontispiece, *Vue des restes intérieures du
Temple de Neptune . . .* (View Showing the
Remains of the Interior of the Temple of
Neptune . . .)

*Vuë de ce qui reste encore des Murs A. de l'
ancienne Ville de Pesto . . .* (View Showing
the Remains of the Ancient City Walls A.
of Paestum . . .)

Vuë des restes d'une grande enceinte de colonnes . . . (View Showing the Remains of a Large Enclosure of Columns . . .)
HIGHLIGHTS, PL. 21

Vuë A. de quelques unes des Colonnes de la façade opposée à celle de la planche précédente . . . (View A. of Some Columns of the Façade opposite the One Shown in the Preceding Plate . . .)

A. Vuë des 18 Colonnes de côté dessinées du côté opposé à celles qui sont indiquées dans la première planche . . . (A. View of the Eighteen Side Columns, Drawn from the Side Opposite Those Shown in the First Plate . . .)

A. Vuë des restes du Pronaos de l'édifice, que l'on peut considérer comme le Collège des Anfictions . . . (A. View of the Remains of the Pronaos of the Building known as the College des Anfictions . . .)

Autre Vuë de la Façade du Pronaos, dessiné et décrit dans la planche V . . . (Another View of the Pronaos Façade Drawn and Described in Plate 5 . . .)

Vuë interieure du Collège supposé des Anfictions . . . (Interior View of the so-called College des Anfictions . . .)

Autre vuë de l'interieure du Pronaos, qui a déjà été décrit, et dessiné, dans la planche précédente . . . (Another View of the Pronaos Described and Drawn in the Preceding Plate . . .)

Autre vuë interieure des restes du Collège supposé des Anfictions . . . (Another Interior View of the Remains of the so-called College des Anfictions . . .)

Vuë du temple de Neptune, Dieu tutélaire de l'ancienne Ville de Pesto, quoi que on n'y voye aucune marque qui puisse indiquer si ce temple appartenait à cette Divinite, ou à quelque autre . . . (View of the Temple of Neptune, Tutelary God of the Ancient City of Paestum, Although No Indication Has Been Found to Show Whether This Temple Was Related to That Divinity or to Some Other . . .)

Temple de Neptune à Pesto, vu de côté, et dessiné plus en grand qu'on ne le voit dans la première planche (Temple of Neptune at Paestum, Seen from the Side and Drawn on a Larger Scale Than in the First Plate)

Another impression of *Temple de Neptune à Pesto*

Vuë interieure du Temple de Neptune decrit dans la planche X . . . (Interior View of the Temple of Neptune, Described in Plate 10 . . .)

A., B. Vuë des restes interieurs d'un des Pronaos du Temple de Neptune qui regarde du côté de la Terre . . . (A., B. Interior View of the Remains of One of the Pronaoi of the Temple of Neptune That Faces Inland . . .)

Vuë des restes du derrière du Pronaos du Temple de Neptune dessiné dans les deux planches précédentes . . . (Rear View of the Remains of the Pronaos of the Temple of Neptune Drawn in the Two Preceding Plates . . .)

Vuë des restes de la Celle du Temple de Neptune . . . (View of the Remains of the Cella of the Temple of Neptune . . .)

A., B. Vuë des deux restes de rangs de Colonnes qui étoient au Temple de Neptune qui latéralement formoient les Portiques dans la Celle, et soutenaient le Comble de l'édifice . . . (A., B. View of the Remains of the Two Rows of Columns in the Temple of Neptune That Formed the Colonnades along the Sides of the Cella and Supported the Uppermost Part of the Roof . . .)
BOORSCH, FIG. 19

Vuë des restes de la celle du temple de Neptune . . . (View of the Remains of the Cella of the Temple of Neptune . . .)

Vuë d'un autre temple, dans la Ville de Pesto, que l'on croit communement avoir été dédié à Junon . . . (View of Another Temple in the City of Paestum, Which Is Commonly Believed to Have Been Dedicated to Juno . . .)

Vuë latérale du Temple de Junon . . . (Side View of the Temple of Juno . . .)

Vuë intérieure du Temple, que l'on croit avoir été dédié à Junon . . . (Interior View of the Temple That Is Believed to Have Been Dedicated to Juno . . .)

Etchings, ranging from 17½ × 6⅜ in. (44.5 × 67 cm) to 19½ × 26⁹⁄₁₆ in. (49.5 × 67.5 cm)

Wilton-Ely 717–37, only state
2012.159.17.1–.21, 2012.159.24

TOMMASO PIROLI
See under Guercino

CAMILLE PISSARRO
French, 1830–1903

Portrait of Paul Cézanne, 1874, second printing 1920
Etching, 10⅝ × 8⁷⁄₁₆ in. (27 × 21.4 cm)
Delteil-Hyman 1999a, 13, only state
2012.159.68

Landscape at Osny, 1887, printed 1894
Etching, 4⁹⁄₁₆ × 6⅛ in. (11.6 × 15.5 cm)
Delteil-Hyman 1999a, 70, state i/ii
2012.159.69
HIGHLIGHTS, PL. 60

Firewood Carriers, 1896
Lithograph, 7⅞ × 9 in. (20 × 22.9 cm)
Delteil-Hyman 1999a, 153, only state
2012.159.70

The Vagabonds, 1896
Lithograph on *chine-collé*, 9¹³⁄₁₆ × 11⅞ in. (25 × 30.2 cm)
Delteil-Hyman 1999a, 154, state v/v
2012.159.71
HIGHLIGHTS, PL. 61

FELICE FRANCESCO POLANZANI
Italian, 1700–1783

Portrait of Giovanni Battista Piranesi, 1750
Etching and engraving, 15³⁄₁₆ × 11⅜ in. (38.6 × 28.9 cm)
Hind, p. 83; Wilton-Ely, pp. 81 and 330
2012.159.7
MOORE, FIG. 1

ROCCO POZZI
See under Pietro Campana

REMBRANDT HARMENSZ. VAN RIJN
Dutch, 1606–1669

Old Man with a Divided Fur Cap, 1640
Etching and drypoint, 5⅞ × 5⁵⁄₁₆ in. (14.9 × 13.5 cm)
New Hollstein 182, state i/ii
2012.159.2
HIGHLIGHTS, PL. 1

PIERRE-AUGUSTE RENOIR
French, 1841–1919

The Country Dance, ca. 1890
Etching, 8⅝ × 5⁹⁄₁₆ in. (21.9 × 14.1 cm)
Stella 2, only state; Delteil-Hyman 1999b,
2, only state
2012.159.88

Bust of a Young Woman (Mlle Diéterle),
1899
Lithograph, 20¹⁵⁄₁₆ × 15⅞ in. (53.2 ×
40.3 cm)
Stella 26, only state; Delteil-Hyman
1999b, 26, only state
2012.159.87

SEBASTIANO RICCI
See under Guercino

GIOVANNI BATTISTA TIEPOLO
Italian, 1696–1770
See also under Giovanni Domenico
Tiepolo; Lorenzo Baldissera Tiepolo

Vari capricci (Various Capriccios),
published 1785

Title page, 1785

Seated Youth Leaning against an Urn,
1740–42

Three Soldiers and a Boy, 1740–42

Two Soldiers and Two Women, 1740–42

*A Woman with Her Hands on a Vase,
a Soldier, and a Slave*, 1740–42

*A Nymph with a Small Satyr and Two
Goats*, 1740–42

*Standing Philosopher and Two Other
Figures*, 1740–42

*A Woman with Her Arms in Chains and
Four Other Figures*, 1740–42
 HIGHLIGHTS, PL. 5

Death Giving Audience, 1740–42
 BOORSCH, FIG. 12

The Astrologer and the Young Soldier,
1740–42

The Rider Standing by His Horse,
1740–42

Etchings, each 5⁵⁄₁₆ × 6¹⁵⁄₁₆ in. (13.5 ×
17.6 cm) (approx.)
Rizzi 29–38, only state
2012.159.5.1–.11

GIOVANNI DOMENICO TIEPOLO
Italian, 1727–1804

The Holy Family on a Rocky Path, from
Idee pittoresche sulla fuga in Egitto
(Picturesque Ideas on the Flight into
Egypt), ca. 1750
Etching, 7½ × 9⅝ in. (19.1 × 24.4 cm)
Rizzi 77, undescribed state before Rizzi's
only state
2012.159.26

Head of a Bearded Oriental, 1752
Black and white chalk on blue paper,
17⁵⁄₁₆ × 11⁹⁄₁₆ in. (44 × 29.4 cm) (irreg.)
2012.159.25

Raccolta di Teste (Collection of Heads),
after Giovanni Battista Tiepolo (Italian,
1696–1770)

Title page, ca. 1771–74
Rizzi 159, only state

Portrait of Giambattista Tiepolo,
ca. 1771–74
Rizzi 161, state i/ii

Bearded Old Man, ca. 1757
Rizzi 162, state ii/ii

Old Man with a Sword, ca. 1757
Rizzi 163, state ii/ii

Turbaned, Bearded Elderly Man,
ca. 1757
Rizzi 165, state i/ii

Old Man with a Small Turban, ca. 1757
Rizzi 166, state i/ii

Old Man Meditating, ca. 1757
Rizzi 169, state i/ii

Old Man with a Large Hat, ca. 1757
Rizzi 170, state i/ii
 BOORSCH, FIG. 22

Another impression of *Old Man with a
Large Hat*

Old Man with a Bare Head, ca. 1757
Rizzi 171, state i/ii

Old Man with a Bare Head, ca. 1757
Rizzi 173, state ii/ii

Head of an Oriental, a Book in Hand,
ca. 1757
Rizzi 175, only state

Old Man with a Helmet, ca. 1757
Rizzi 179, state i/ii

Old Man with a Beard, ca. 1771–74
Rizzi 182, state i/ii

Old Man in the Manner of Rembrandt,
ca. 1757
Rizzi 184, state i/ii

Old Man with a Bracelet, ca. 1757
Rizzi 185, state i/ii

Old Man with a Beard, ca. 1757
Rizzi 186, state i/ii

Old Man with His Hat on His Forehead,
ca. 1757
Rizzi 188, state i/ii

The Mathematician, ca. 1757
Rizzi 189, state ii/ii
 HIGHLIGHTS, PL. 24

Old Man with a Beard, ca. 1757
Rizzi 190, state ii/ii

Profile of an Old Man, ca. 1771–74
Rizzi 193, only state

Old Man with a Turban, ca. 1770
Rizzi 194, state i/ii

Old Man with a Beard and Long Hair,
ca. 1757
Rizzi 196, state ii/ii

Old Man with a Beard, ca. 1771–74
Rizzi 198, state i/ii

Profile of an Old Man, ca. 1771–74
Rizzi 199, state ii/ii
 HIGHLIGHTS, PL. 25

Turk Seen from the Front, ca. 1771–74
Rizzi 200, state i/ii

Turk with a Fur Hat, ca. 1771–74
Rizzi 201, state i/ii

*Old Man with a Beard and a Bare
Head*, ca. 1771–74
Rizzi 203, state i/ii

Turk Seen from Behind, ca. 1771–74
Rizzi 204, state i/ii

Bearded Old Man with a Hat, 1773–74
Rizzi 210, state i/ii

Old Man Looking Downward,
ca. 1771–74
Rizzi 211, state i/ii

Profile of an Old Man with a Beard,
ca. 1757
Rizzi 213, state ii/ii

Old Man with a Hat, 1773–74
Rizzi 216, state i/ii

Bearded Old Man with a Cap, ca. 1770
Rizzi 218, state i/ii

Etchings, ranging from 4⅛ × 3⁷⁄₁₆ in. (10.4 × 8.8 cm) to 6 × 4½ in. (15.3 × 11.5 cm)
2012.159.28.1–.33, 2012.159.29

Dwarves and Dogs, after Giovanni Battista Tiepolo (Italian, 1696–1770), ca. 1770
Etching, 8 × 11¹³⁄₁₆ in. (20.3 × 30 cm)
Rizzi 151, state ii/ii
2012.159.27
 BOORSCH, FIG. 23

LORENZO BALDISSERA TIEPOLO
 Italian, 1736–1776

Rinaldo and Armida, after Giovanni Battista Tiepolo (Italian, 1696–1770), ca. 1758
Etching, 10⅞ × 13⁹⁄₁₆ in. (27.7 × 34.5 cm)
Rizzi 225, state ii/ii
2012.159.31
 HIGHLIGHTS, PL. 26

HENRI DE TOULOUSE-LAUTREC
 French, 1864–1901

Portrait Bust of Mademoiselle Marcelle Lender, 1895
Color lithograph, 13⁹⁄₁₆ × 9⅝ in. (34.5 × 24.4 cm)
Delteil 102, state ii/iii; Wittrock 99, state iv/iv, Pan edition 1895
2012.159.154

Cover of *L'Aube* (Dawn), 1896
Color lithograph, 24¹⁄₁₆ × 31¾ in. (61.1 × 80.7 cm)
Delteil 363, only state; Wittrock P23, only state
2012.159.156
 HIGHLIGHTS, PL. 63

Portrait of Anna Held, 1898
Lithograph on *chine-volant*, 11⅝ × 9½ in. (29.5 × 24.2 cm)
Delteil 156, only state; Wittrock 251, only state
2012.159.155

UNKNOWN ARTIST, IN THE STYLE OF THOMAS LAWRENCE
 British(?), 18th–19th century

Woman in a Hat, ca. 1830–60
Graphite, 2¹⁵⁄₁₆ × 2¹⁄₁₆ in. (7.5 × 5.3 cm)
2012.159.58

VARIOUS ARTISTS
 French, Scottish, and Spanish, 19th century

Various prints, published in *L'art*, 1877

GOYA, by Félix Augustin Milius (French, 1843–94), after a self-portrait by Francisco Goya (Spanish, 1746–1828)
Etching and aquatint, 9⅝ × 14 in. (24.5 × 35.5 cm)

VOLTAIRE/D'après la statue de HOUDON au Théâtre-Français (Voltaire, after the Statue by Houdon in the Théâtre-Français), by Léon Alexandre Tourfaut (French, died 1883), after Étienne Gabriel Bocourt (French, 1821–after 1905)
Wood engraving, 13⁷⁄₁₆ × 9⁹⁄₁₆ in. (34.1 × 24.2 cm)

LES ORANGES (Souvenir d'Egypte) (The Oranges [Memory of Egypt]), by Edmond Hédouin (French, 1820–1889), after Henriette Browne (French, 1829–1901)
Etching, 5¹⁵⁄₁₆ × 7⅛ in. (15 × 18.1 cm)

LA GRILLE DE LA "LOGGETTA" A VENISE/Oeuvre d'ANTONIO GAI . . .) (The Grillwork on the "Loggetta" in Venice, Work of Antonio Gai . . .), by Jules-Jean-Marie-Joseph Huyot (French, 1841–1921), after Léon-Augustin Lhermitte (French, 1844–1925)
Wood engraving, 9⅜ × 10⅞ in. (23.9 × 27.6 cm)

À SAINT JEAN LE THOMAS (In Saint Jean le Thomas), by Théophile-Narcisse Chauvel (French, 1831–1910)
Etching, 11¹³⁄₁₆ × 9¹³⁄₁₆ in. (30 × 24.9 cm)

LA TÊTE DE SAINT JEAN (The Head of Saint John), by Edmond Yon (French, 1836–1897), after Jean-Jacques Henner (French, 1829–1905)
Wood engraving, 8½ × 11⅜ in. (21.5 × 28.8 cm)

FALAISES DE DIEPPE (Cliffs of Dieppe), by Théophile-Narcisse Chauvel (French, 1831–1910), after Jean Baptiste Antoine Guillemet (French, 1843–1918)
Etching, 11¹³⁄₁₆ × 16¹⁵⁄₁₆ in. (30 × 43 cm)

LES CADEAUX DE NOCE (The Wedding Presents), by Adolphe Lalauze (French, 1838–1905), after Gonzales (French or Spanish[?], 19th century)
Etching, 8¼ × 11¹⁄₁₆ in. (21 × 28 cm)

LA PÊCHE—PANNEAU DÉCORATIF (Fishing—Decorative Panel), by Edmond Yon (French, 1836–1897), after Ulysse Butin (French, 1838–1883)
Etching, 12⁷⁄₁₆ × 6⅛ in. (31.5 × 15.5 cm)

LA LISETTE DE BÉRANGER (La Lisette by Béranger), by Jean Louis Charbonnel (French, 19th century)
Etching, 11¹³⁄₁₆ × 9⁷⁄₁₆ in. (30 × 24 cm)

AN ATHLETE STRANGLING A PYTHON, by Eugène-Michel-Joseph Abot (French, 1836–1894), after Frederic Leighton (British, 1830–1896)
Etching and engraving, 9⁵⁄₁₆ × 6⅞ in. (23.6 × 17.4 cm)

LA CONSOLATION (Consolation), by Charles Albert Waltner (French, 1846–1925), after Franz Paczka (Hungarian, 1856–1925)
Etching, 9 × 11¹³⁄₁₆ in. (22.8 × 30 cm)

ÉTUDE À LA SANGUINE (Study in Red Chalk), after Andrea del Sarto (Italian, 1486–1530)
Photogravure, 12¾ × 8⅛ in. (32.4 × 20.6 cm)

ÉTUDE À LA SANGUINE (Study in Red Chalk), after Leonardo da Vinci (Italian, 1452–1519)
Photogravure, 6¼ × 4¹¹⁄₁₆ in. (15.9 × 11.9 cm)

ÉTUDE (Study), after Alphonse Legros (French, 1837–1911)
Photogravure, 12⅝ × 7¹¹⁄₁₆ in. (32 × 19.5 cm) (irreg.)

THE QUEEN OF THE SWORDS, by Adolphe Lalauze (French, 1838–1905), after William Quiller Orchardson (Scottish, 1832–1910)
Etching, 7¹³⁄₁₆ × 11⅜ in. (19.8 × 28.8 cm)

POTATO HARVEST IN THE FENS, by Robert Walker Macbeth (Scottish, 1848–1910)
Etching, 5¼ × 12⅜ in. (13.3 × 31.4 cm)

JEAN PAUL LAURENS, by Adrien Didier (French, 1838–1924), after a

self-portrait by Jean-Paul Laurens
(French, 1838–1921)
Etching, 7⅞ × 5¹⁵⁄₁₆ in. (19.9 × 15 cm)

PORTRAIT DE MME XXX (Portrait
of Madame XXX), by Edmond
Hédouin (French, 1820–1889), after
Charles Chaplin (French, 1825–1891)
Etching, 10¼ × 6⁷⁄₁₆ in. (26 × 16.3 cm)

LE BAS-DE-VILLIERS.—LE SOIR
(Bas-de-Villiers.—Evening), by
Jules-Laurent-Louis Langeval (born
Gallimardet) (French, 1863–1909),
after Edmond Yon (French,
1836–1897)
Engraving, 7⁷⁄₁₆ × 12⁹⁄₁₆ in.
(18.9 × 31.9 cm)

*FORÊT DE L'ISLE-ADAM (SEINE-ET-
OISE)* (Forest of L'Isle Adam [Seine-
et-Oise]), by Fortuné-Louis Méaulle
(French, 1844–ca. 1901), after Ch.
Gosselin (French, 1834–1892)
Engraving, 9¾ × 7½ in.
(24.8 × 19.1 cm)

PRÉLIMINAIRES DE COMBAT
(Preliminaries to Combat), by
Fortuné-Louis Méaulle (French,
1844–ca. 1901), after Karl Bodmer
(Swiss, 1809–1893)
Engraving, 7¹⁵⁄₁₆ × 10⅜ in.
(20.2 × 26.4 cm)

*SABOTIERS DANS LE BOIS DE
QUIMERC'H (Finistère)* (Sabot-
Makers in the Quimerc'h Woods
[Finistère]), by Gustave-Marie Greux
(French, 1838–1919), after Camille
Bernier (French, 1823–1902/3)
Etching, 8¼ × 11⁷⁄₁₆ in. (21 × 29 cm)

2012.159.44

DIEGO VELÁZQUEZ
See under Francisco Goya;
Édouard Manet

ÉDOUARD VUILLARD
French, 1868–1940

Portrait of Paul Cézanne, after Paul
Cézanne (French, 1839–1906), 1914
Lithograph, 9½ × 9¼ in. (24.1 × 23.5 cm)
Roger-Marx 51, state ii/ii
2012.159.157
HIGHLIGHTS, PL. 66

GOMMARUS WOUTERS
Flemish, 1644–1701

*PROSPETTO DEL PALAZZO PONTIFI-
CIO NEL QUIRINALE DETTO MONTE
CAVALLO* (View of the Papal Palace
on the Quirinal Hill, called Monte
Cavallo), 1692
Etching, 17¹³⁄₁₆ × 27¾ in. (45.2 ×
70.5 cm)
Hollstein LIV.51.4
2012.159.3
HIGHLIGHTS, PL. 2